125 *Masterpieces*

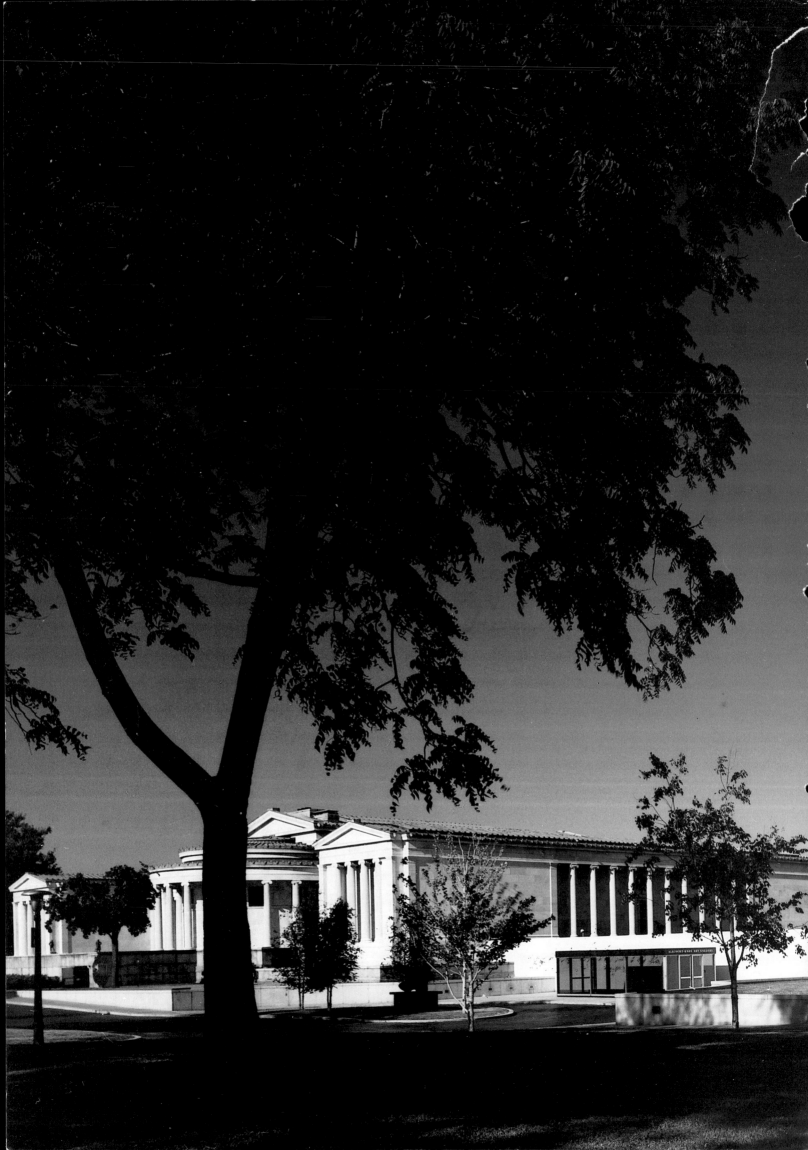

ALBRIGHT-KNOX ART GALLERY · BUFFALO, NEW YORK
RIZZOLI · NEW YORK

125 Masterpieces

FROM THE COLLECTION OF THE ALBRIGHT-KNOX ART GALLERY

The Buffalo Fine Arts Academy, 1862

125

Albright-Knox Art Gallery, 1987

The texts in this volume, written by Robert Evren, Katy Kline, Charlotta Kotik, Susan Krane, Ethel Moore, Steven Nash, Helen Raye and Emese Wood, are abridged and appear in full in *Contemporary Art 1942–72: Collection of the Albright-Knox Art Gallery* (New York: Praeger Publishers, 1973); *Albright-Knox Art Gallery: Painting and Sculpture from Antiquity to 1942* (New York: Rizzoli International Publications, 1979) and *Albright-Knox Art Gallery: Recent Acquisitions* (New York: Hudson Hills Press, 1987).

Published in the United States of America in 1987 by Rizzoli International Publications, Inc. in association with the Albright-Knox Art Gallery

LIBRARY OF CONGRESS CATALOGING-IN-PUBLICATION DATA

125 masterpieces from the collection of the Albright-Knox Art Gallery.
 Includes Index.
 1. Art, Modern—19th century—Catalogs. 2. Art, Modern—20th century—Catalogs. 3. Albright-Knox Art Gallery—Catalogs. I. Spaulding, Karen Lee.
II. Albright-Knox Art Gallery.
N6447.A13 1987 759.06′074′014797 86-14092
ISBN 0–914782–60–6

Rizzoli International Publications, Inc.
597 Fifth Avenue, New York, NY 10017
ISBN 0-8478-0786-X

General editor, Karen Lee Spaulding
Designed by Alex and Caroline Castro, Baltimore
Composition by Monotype Composition Company, Inc., Baltimore
Printed and bound in Japan

TABLE OF CONTENTS

FOREWORD

This volume, *125 Masterpieces from the Collection of the Albright-Knox Art Gallery*, celebrates the 125th anniversary of the founding of the Buffalo Fine Arts Academy. It highlights as well the remarkable artistic achievements of the last 125 years and underscores the skill and acumen with which a distinguished succession of directors, staff and board of directors have guided this institution and shaped its policies.

Founded officially in December 1862, the Buffalo Fine Arts Academy was the sixth public art institution to be created in America, preceded by museums in Philadelphia, Boston, Hartford, New Haven and Washington, D.C. Its exemplary commitment to collecting was established early on, in 1863, with thirteen donors pledging $500 each to a "Picture Fund"; only nine years later, Sherman S. Jewett generously endowed a fund bearing his name for the same purpose.

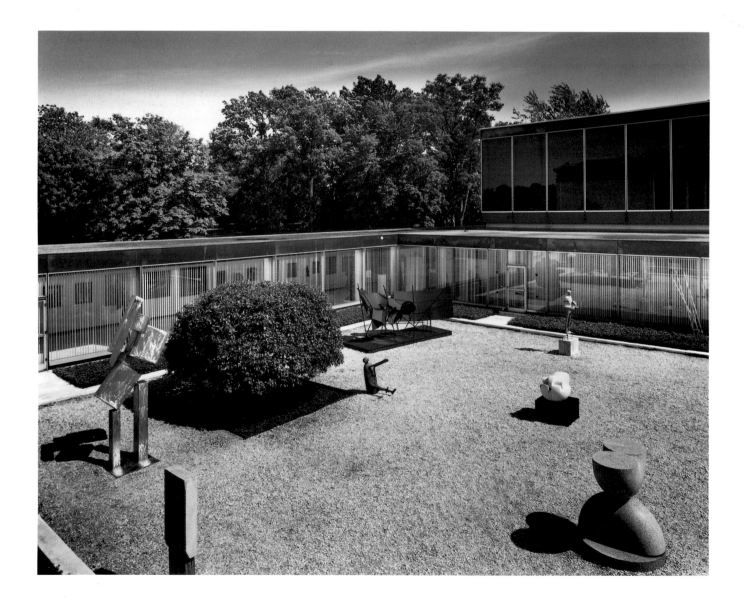

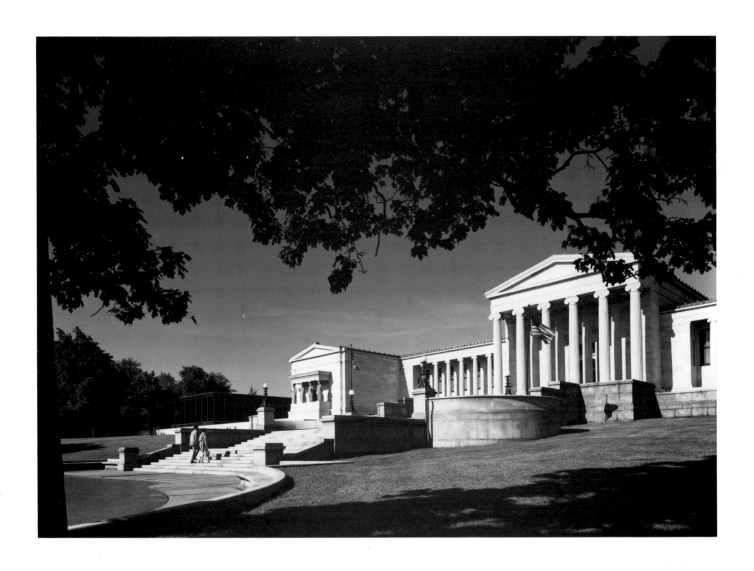

In 1863 as well, the Academy received its first gift, *Marina Piccola, Capri*, from Albert Bierstadt, who donated his work ". . .as a sincere expression of my best wishes for the true and abundant success of the Academy." In 1891, the foundation of the Academy's superb print collection was laid through the gifts of both Willis O. Chapin and Frederick H. James. By 1900, the Academy had already purchased such works as George Inness' *The Coming Storm*, 1878, and Thomas Moran's *Bringing Home the Cattle—Coast of Florida*, 1879.

The turning point in the Academy's history came also in 1900 when John Joseph Albright, a dedicated and generous supporter, offered to provide the funding for a permanent home for the Academy. With Edward B. Green as its architect, the Greek revival building was completed five years later and was dedicated on May 31, 1905.

Charles M. Kurtz was the first director of the Albright Art Gallery; his tenure lasted only four years but during that time, he introduced to Buffalo contemporary German painting, French Impressionist works and photographs by the Photo-Secession group. He was followed by Cornelia Bentley Sage Quinton, who served as director from 1910 to 1924. Mrs. Quinton, the first woman director of a major museum, was instrumental in showing the works of such artists as Constantin Meunier, Childe Hassam and Robert Henri. In

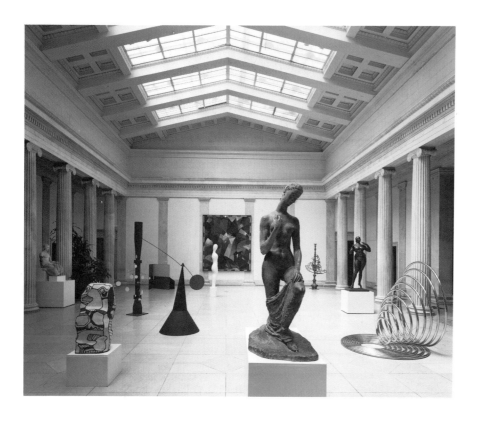

1924, William B. Hekking succeeded Mrs. Quinton; his directorship was marked by his commitment to public education.

During this time as well, the acquisitions policy of the Gallery was supported and guided in a singular way by A. Conger Goodyear. An active supporter of the Gallery, a director on the Academy's board, and an astute collector, Mr. Goodyear organized in 1926 the Fellows for Life Fund, which required a $1,000 annual donation from its subscribers. This fund made possible the acquisition of numerous works, most significantly, Picasso's *La Toilette* of 1906. Not only was Mr. Goodyear instrumental in bringing shows of such artists as Noguchi, Maillol, Rodin and Lachaise to Buffalo, thus broadening the scope of exhibitions, he also strengthened the Gallery's collection by his donation and bequest of many of the works seen herein, for example, van Gogh's *The Old Mill*, Balla's *Dynamism of a Dog on a Leash* and Dali's *The Transparent Simulacrum of the Feigned Image*.

During the thirties, Gordon Washburn, director from 1931 to 1942, sought to complement the modern collection and expand the scope of historical perspective presented in the Gallery by acquiring such ancient and older works as the 16th-17th century *Head of a King* from Benin, the 14th-15th century Indian *Boy Krishna* and Giovanni del Biondo's *Annunciation*, c. 1367. In 1939, the nature of the purchase fund took on a new meaning when Seymour H. Knox and his family, and other supporters, endowed the Room of Contemporary Art Fund. Its purpose was to "set aside a particular room . . . dedicated to the continuous display of contemporary art; . . . purchases are 'on probation'" and were subject to sale or exchange in order to refine the collection.

Once again, much of what comprises this volume—de Chirico's *Anguish of Departure*, Klee's *Child Consecrated to Suffering*, Léger's

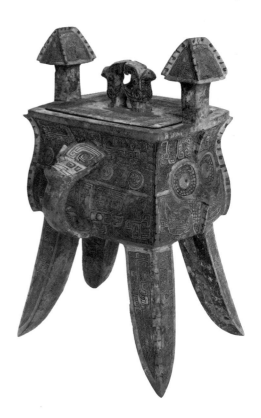

Chinese, late Shang Dynasty, Style IV
Ritual Vessel, Type Fang-Chia, 13th-11th century, B.C.
Bronze, 12⅛ × 8 × 7⅜"
Bequest of Arthur B. Michael, 1953

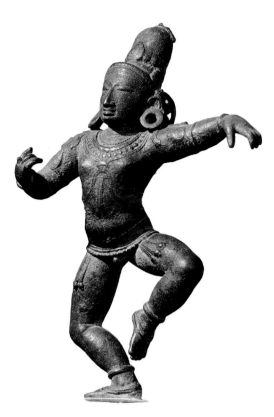

Indian
The Boy Krishna (Bala Krishna), 14th-
15th century A.D.
Bronze, 11¼ × 7 × 4″
Charlotte A. Watson Fund, 1937

Smoke, Kokoschka's *London, Large Thames View I*, Miró's *Carnival of Harlequin*, Matisse's *La Musique* and Mondrian's *Composition, London*, among so many others—was acquired then and reflects the remarkable foresight and judgement of those involved in the selection of works for the Room of Contemporary Art. In 1942, Mr. Washburn's goal of enlarging the scope of the collection was furthered by the generous bequest of Chinese bronzes, ceramics and other artifacts by Arthur B. Michael.

During the war, Andrew C. Ritchie served as director. A noted scholar and esteemed museum administrator, Mr. Ritchie not only guided the acquisitions policy to include purchases of such works as Gauguin's *Yellow Christ* and Degas' *Portrait of Rose Caron* but also began what was to be a continuing commitment to scholarly documentation of the collection in his two catalogues, *Paintings and Sculpture* and *Contemporary Paintings and Sculpture*. In 1945, the Knox family further enhanced the collection through their generous gift of important 18th-century English paintings by Gainsborough, Hogarth, Lawrence, Reynolds and Romney. Following Dr. Ritchie was Edgar Schenck who continued to advance the Gallery's role in public education and who presided over the fiftieth anniversary celebration of the Gallery's founding.

In 1955, Gordon M. Smith became director. For eighteen years, until 1973, a close collaboration existed between Mr. Smith and Seymour H. Knox, president of the board of directors since 1938 and undoubtedly the Gallery's chief benefactor. The highlight of this period was the addition of the new wing, funded by Mr. Knox and designed by Gordon Bunshaft, of the architectural firm of Skidmore, Owings and Merrill in New York. The wing not only doubled the exhibition space of the Gallery but also included a Sculpture Garden, an Auditorium with a capacity of 350, a Restaurant, new office space for the director and staff, and the Members' Gallery. Several years later, the Gallery Shop was expanded as well. The newly named

Giovanni del Biondo
The Annunciation: The Angel, c. 1366
The Annunciation: The Virgin, c. 1366
Tempera on wood, 23 × 15″ each
Elisabeth H. Gates Fund, 1934

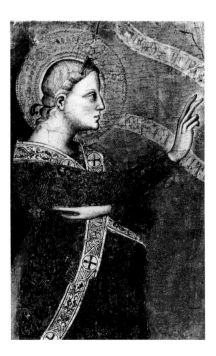

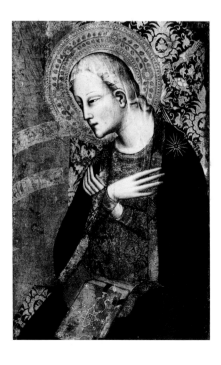

9

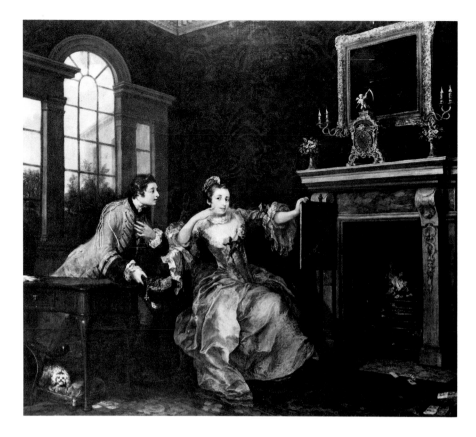

William Hogarth
The Lady's Last Stake, 1759
Oil on canvas, 36 × 41½″
Seymour H. Knox Fund through special
gifts to the fund by Mrs. Marjorie Knox
Campbell, Mrs. Dorothy Knox Rogers
and Seymour H. Knox, Jr., 1945

Albright-Knox Art Gallery was dedicated on January 19, 1962, one hundred years after the founding of the Buffalo Fine Arts Academy. And as much as the new building stands as a testimony to such generosity, so too do the works amassed during this time—from Derain's *Trees* and Morgan Russell's *Synchromy in Orange: To Form* to seminal works by the Abstract Expressionists including Clyfford Still, Jackson Pollock, Arshile Gorky, and Willem de Kooning to paintings by such artists as Richard Diebenkorn and Frank Stella— reflect Mr. Knox's daring spirit and discerning judgement. The group of works collected during this time represent the most intense period of growth for the Gallery's collection, a result of the unique relationship and shared vision of Gordon Smith and Seymour Knox.

After Mr. Smith's retirement in 1973, the directorship was assumed by Robert T. Buck, Jr., who served in that capacity until 1983. Mr. Buck's commitment to sustaining a level of excellence in not only exhibition and acquisitions policies but also in the field of important scholarly publications serves today as a standard against which we constantly measure ourselves and gauge our efforts. The presentation and maintenance of quality exhibitions and programs are ongoing concerns and goals.

This year we celebrate 125 years of service to the community, commitment to the scholar and student, and generosity from our donors and friends. We look to the future with enthusiasm, nourished and inspired by our distinguished past.

Douglas G. Schultz
Director

10

125 Masterpieces

FROM THE COLLECTION OF THE ALBRIGHT-KNOX ART GALLERY

All dimensions are given in inches with metric equivalents following in parentheses. Height precedes width and depth.

Authorship of entries and biographies are indicated by initials.

R.E.	Robert Evren
K.K.	Katy Kline
S.K.	Susan Krane
C.K.	Charlotta Kotik
E.M. ed.	Ethel Moore, editor
S.N.	Steven Nash
H.R.	Helen Raye
E.W.	Emese Wood

AMMI PHILLIPS
American, 1788–1865

Portrait of Mrs. Lewis Northrop, c. 1833-35

Oil on canvas
31⅞ x 26⅞ (80.9 x 68.3)
Gift of Seymour H. Knox in memory of Helen Northrup Knox, 1986

Portrait of Mr. Lewis Northrop, c. 1833-35

Oil on canvas
31¹⁵⁄₁₆ x 26⅞ (81.1 x 68.3)
Gift of Seymour H. Knox in memory of Helen Northrup Knox, 1986

AMMI Phillips was one of the most prolific itinerant American portrait painters of the 19th century. Over the fifty years of his career, he documented hundreds of the citizens within the relatively narrow channel of his commercial territory along eastern New York, western Massachusetts and Connecticut. He signed only a precious few of his canvases; however, he worked apparently with great stylistic consistency, and attributions of his work are thus based primarily on formal evaluations, frequently substantiated by genealogical study.

The Gallery's pendant portraits of Mr. and Mrs. Lewis Northrop are characteristic of Phillips' well–known paintings of his classic Kent Period of 1829–38. In these works, Phillips used dark back-grounds of warm hues, against which the awkwardness or anatomical inaccuracies of the silhouettes of his sitters, usually darkly clad, also became less visible. Phillips reduced background accoutrements during this period (such as swags of drapery or details of furniture common to previous portraits) and painted unessential areas more loosely, saving his attention for the faces which he painted in first, unlike many of his colleagues. Such pictorial formulas however were common practices of his trade and probably served to increase his rate of production; the great number of his portraits attests to the amazing and increasing popularity of such likenesses among the middle class, who were uncultured in the refinements of the academic portraits, based on European examples, that were commissioned by the traveled, patrician families.

Script on the document Mr. Northrop holds identifies him as "Mr. Lewis Northrop, Cairo, New York," which locates the subjects in Greene County. Lewis Northrop served as Justice of the Peace in Cairo in 1833, to which the seal on the paper is perhaps a reference. Mr. Northrop died in 1892 and his wife in 1866. The portraits came down through the family of Helen Northrup Knox whose father was Lewis G. Northrup, born in 1863 in Harpersville, Broome County, New York.

S.K.

AMMI PHILLIPS was born in 1788 in Colebrook in northwestern Connecticut and moved to New York state at an early age. He began painting by 1811 and was presumedly completely self–taught, although he may have known examples of work by Pieter Vanderlyn and Reuben Moulthrop. Phillips lived in Troy, New York from 1813–27, when he moved to Rhinebeck, New York. In the thirties, he moved again to Amenia, New York near the Connecticut border, then c. 1836 relocated in Kent, Connecticut. Through stylistic and documentary evidence, over 500 works have been attributed to Phillips in the course of the past twenty years, and the progression of his distinct styles and his regions of activity have been elucidated. Now accepted as examples of his hand are the primitive portraits previously ascribed both to the "Border Limner," of the eastern New York/western Massachusetts area and to the "Kent Limner," who practiced around Kent, Connecticut. Phillips painted primarily around the east bank of the Hudson River in New York and in Connecticut up to the Housatonic River, as far north as Bennington, Vermont and south to Putnam County, New York. He frequently executed portraits of numerous members of prominent families and their friends. He died in 1865 in Curtissville (now Interlaken) in Berkshire County, Massachusetts, where he had lived since the 1860s.

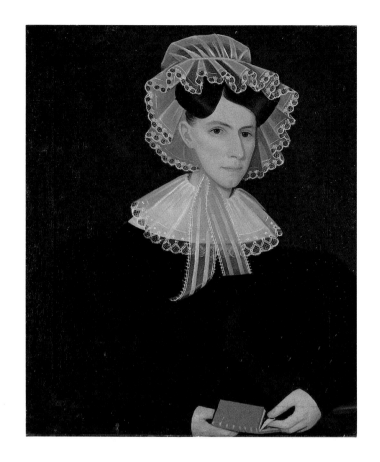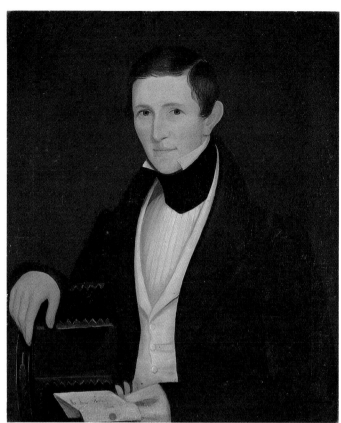

EDWARD HICKS

American, 1780–1849

Peaceable Kingdom, c. 1848

Oil on canvas
23⅞ x 31⅞ (60.7 x 81)
James G. Forsyth Fund, 1940

A man of staunch religious conviction, Hicks found in the Biblical theme of the *Peaceable Kingdom* an inexhaustible source of inspiration. He is thought to have repeated it in as many as a hundred different "painted sermons," of which some fifty survive today. These vary in date from about 1820, when Hicks first took up easel painting, to 1849, the year of his death, and generally were produced as gifts or commissioned work for relatives, neighbors and friends. His textual source was Isaiah XI:6–9, which prophesies the coming of the Messiah and his gift of peace:

> The wolf also shall dwell with the lamb, and the leopard shall lie down with the kid; and the calf and the young lion and the fatling together; and a little child shall lead them.
> And the cow and the bear shall feed; their young ones shall lie down together; and the lion shall eat straw like the ox.
> And the sucking child shall play on the hold of the asp, and the weaned child shall put his hand on the cockatrice's den;
> They shall not hurt nor destroy in all my holy mountain; for the earth shall be full of the knowledge of the Lord, as the waters cover the sea.

This painting is among those that illustrate the text most faithfully. It has been shown, however, that underlying the series as a whole is a strong element of personal symbolism, rooted in Hicks' Quaker beliefs. He interprets Isaiah not only as a message of salvation but also as a statement on human nature (he spoke of the animals as representing the four temperaments) and on man's ability to transcend his inward and worldly struggles. Understood in this broader sense, therefore, the "Kingdoms" may be seen as veiled comments on moral issues as diverse as pacifism, Hicks' torment over his artistic vocation (disapproved by many Quaker friends) and conflicts within the church. The small scene at the left in which William Penn signs a treaty with the Indians, derived from a print after Benjamin West's famous painting, underscores the painter's conviction that Penn's agreement announced a stage in the establishment of the foretold peaceable kingdom on earth.

C.K.

One of the best known of the so-called "primitive" artists of 19th–century America, EDWARD HICKS was born at Four Lanes' End (now Langhorne, Bucks County, Pennsylvania) into the family of a high ranking British colonial official. His mother died when he was eighteen months old and he was reared by David and Elizabeth Twining, devoted Quakers. At the age of thirteen he was apprenticed to two carriage makers from whom he received his entire artistic training. In 1803 Hicks joined the Society of Friends and in 1812 was recorded as a minister. He supported himself at the time decorating coaches, signs, furniture and other household articles. He moved to Newtown, Pennsylvania, in 1811. Unsuccessful at farming, he devoted himself fully to the ministry and to painting landscapes, historical subjects, a few portraits and, beginning about 1820, his long series of "Peaceable Kingdoms."

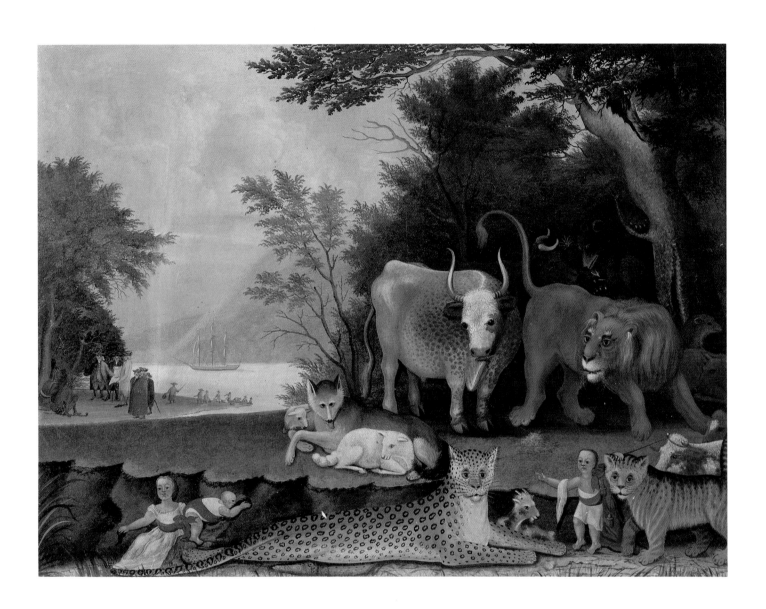

ALBERT BIERSTADT
American, born Germany, 1830–1902

The Marina Piccola, Capri, 1859

Oil on canvas
42 x 72 (106.7 x 184.1)
Gift of Albert Bierstadt, 1863

The 19th century saw a stream of American artists traveling to Italy attracted by the vestiges of antiquity and the beauties of the countryside. In this tradition Bierstadt spent the winter of 1856–57 in Rome in the company of Worthington Whittredge, and in May 1857 he and Sanford R. Gifford set out on a journey to the south. Traveling primarily on foot with knapsacks and sketching equipment they stopped wherever scenery or local subjects diverted them. Following the methods practiced at Dusseldorf, Bierstadt made many open-air sketches to be assembled later into finished paintings in his studio.

One product of this visit to Capri was the painting *The Marina Piccola, Capri* (for many years mistitled *Marina Grande*), which depicts the smaller of Capri's two bays, with the picturesque Faraglioni Rocks in the background. Gifford reports that the two artists spent fifteen days sketching at this location. The final painting, however, was not executed until the spring of 1859, well after Bierstadt's return to the United States.

Just beginning his professional career and obviously eager to make an impression at the National Academy exhibition of which he had become an Honorary Member that year, Bierstadt created a highly ambitious and complex composition. Multiple points of focus, from the carefully detailed genre scenes in the foreground to the distant, mist–enshrouded rocks, are unified through strong lighting and an emphatic perspective construction. Along the mountains at the left, color and atmosphere are evenly graded to create a gradual recession into space. In the water this transition is more abrupt, especially at the extreme right where perspective is foreshortened and the dark foreground rocks are poetically echoed by the eccentric formations in the distance. The center of the composition is commanded by a strip of dazzling reflections, despite the fact that this involves an overhead light source inconsistent with the long shadows on the beach. A lone sailboat, suspended in mist and light becomes the main focal point of the picture and summarizes its romantic mood.

The Marina Piccola, Capri was the first painting to enter the collection of the Buffalo Fine Arts Academy, a gift of the artist in 1863. At the time of its presentation, Bierstadt wrote: "May I ask you to accept whatever is good in it, as a sincere expression of my best wishes for the true and abundant success of the Academy, and a small payment on account of the large debt which every artist owes to his profession."

E.W.

Born in Solingen, Germany, near Dusseldorf, ALBERT BIERSTADT was brought as an infant to New Bedford, Massachusetts. He returned to Dusseldorf to study painting in 1853, and there met the American artists Emanuel Leutze and Worthington Whittredge. In 1856 he traveled with Whittredge through Germany and Switzerland to Italy where he lived for a year before his return to New Bedford in 1857. In 1859 he joined the surveying expedition of Col. Frederick William Lander through Nebraska and Wyoming, the first of a series of Western journeys which were to provide the subject matter for the majority of his heroic landscapes. Bierstadt established his studio in New York in 1859 and was elected a member of the National Academy of Design in 1860. The 1860s and 1870s saw great financial success, but by the end of his life critical and popular taste had turned against him.

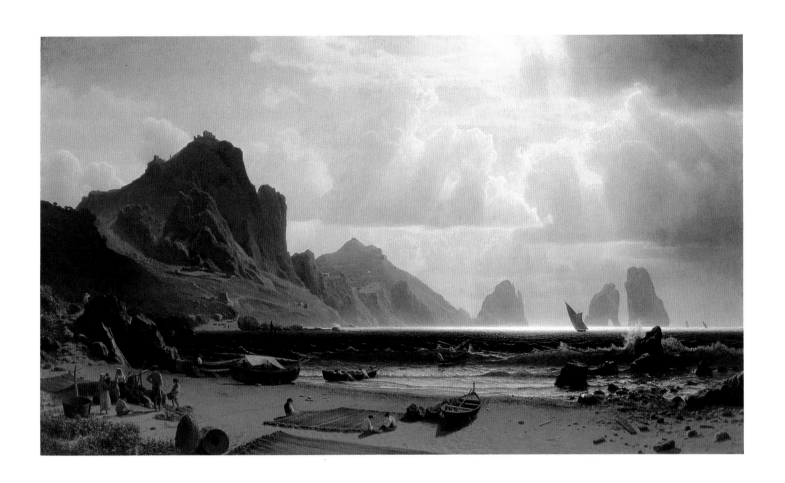

HONORÉ–VICTORIN DAUMIER

French, 1808–1879

Laundress on the Quai d'Anjou (Laveuse au Quai d'Anjou), c. 1860

Oil on wood panel, cradled
11¼ x 7¾ (28.5 x 19.7)
George B. and Jenny R. Mathews Fund, 1964

Daumier earned his living and primary renown by caricaturing the political upheavals and social manners of mid-19th century France. He would have preferred, however, to devote his energy and time to serious painting. Although attracted at first to Biblical and mythological scenes, he came to prefer simple subjects taken from the daily lives of the Parisian bourgeois milieu, possibly under the influence of J.F. Millet with whom Daumier became closely acquainted in the 1850s. From the vantage point of his home along the Quai d'Anjou (1845–63) on the Ile St. Louis, Daumier was able to observe closely a diverse and active population, such as the washerwomen who descended daily to the laundry boats moored along the Seine. He treated this subject in at least three compositions, each repeated in several versions. The women are never seen in the act of washing itself, but rather struggle under the weight of their heavy burdens up and down the embankment stairs or against the strong wind blowing along the Quai.

This painting is one of three closely related compositions in which the washerwoman is seen at the top of the stairs, grasping in one hand her wet bundle of linen and in the other the hand of a child who clutches a wooden laundry paddle. It is considerably smaller than the others, which are in the Metropolitan Museum of Art, New York and the Louvre, Paris.

K.K.

Born in Marseilles, HONORÉ-VICTORIN DAUMIER moved to Paris at the age of eight. In 1822 he announced his desire to draw and studied under a family friend, the archeologist Alexandre Lenois, and at the Académie Suisse. From 1825–29 he prepared lithographic stones for the publisher Belliard. In 1830 he produced the first of a long series of political cartoons, and in 1832 was imprisoned for six months for a caricature which offended Louis–Philippe. The following year, Daumier began to furnish scathing political satires to the journals *Caricature* and *Charivari*; the censorship laws of September 1835 forced him, however, to turn to social and literary subjects. Following the Revolution of 1848 he took part in the competition for an allegorical painting of the Republic. After the coup d'etat of December 1851, Daumier devoted himself increasingly to painting, though he never abandoned his caricatures, producing over 4,000 lithographs during the course of his career. He spent time with the Barbizon group outside Paris at Valmondois. His sight gradually failed and he grew increasingly disenchanted with the political situation after the Franco-Prussian War, but there is little substance to the legend that at his death he was destitute and unappreciated by his contemporaries.

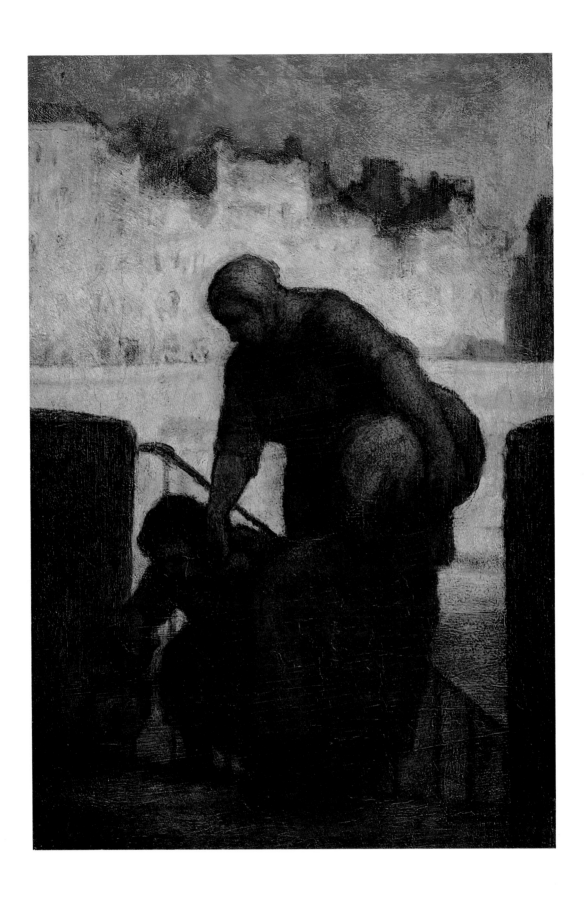

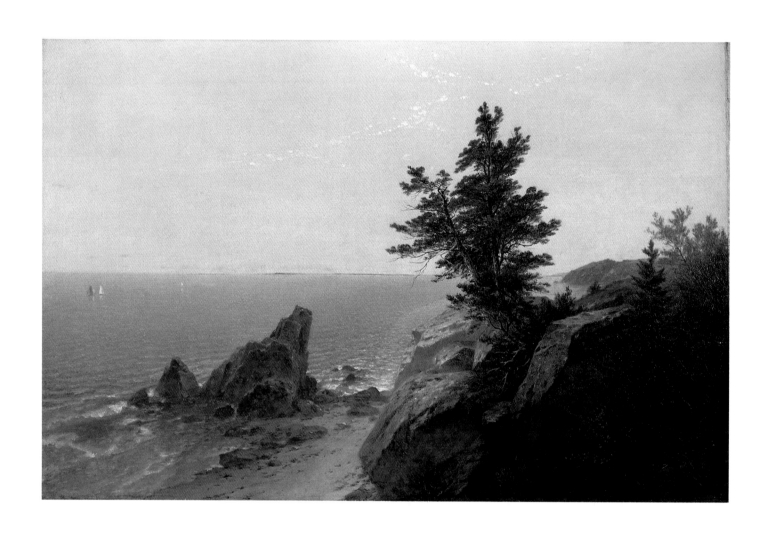

JOHN F. KENSETT
American, 1816–1872

Coast Scene, c. 1860–70

Oil on canvas
22¼ x 34¼ (57 x 87.1)
Anonymous gift in memory of Samuel Ellis 1866–1929, 1980

Born to an English father and American mother in Cheshire, Connecticut, JOHN FREDERICK KENSETT received his first artistic training in the engraving shop of his father and uncle, Alfred Dagget, in New Haven. Although expert in his profession, Kensett found engraving tedious, and in 1840, he set out for Europe to advance his training as a painter. Accompanied by John W. Casilear, Thomas P. Rossiter and Asher B. Durand, he went to England and then to Paris. There he made important contacts with the venerable American painters John Vanderlyn and Thomas Cole. Kensett spent 1843 to 1845 in England. Shortly after his return to Paris in 1845, he departed on a walking tour with Benjamin Champney and journeyed along the Rhine, through Switzerland, to Italy, where he remained for a year. In Rome, he became acquainted with the writer George Curtis, who later introduced him to Ralph Waldo Emerson; Emerson's transcendentalist views were to have a profound effect on the artist's approach to nature and art.

After Kensett's return to the United States in 1847, he gained membership to such exclusive, influential cultural organizations as the Century Association, the Council of the National Academy of Design, and the Sketch Club. A generous and civic–minded man, Kensett also helped establish the Artists' Fund Society to help families of deceased artists, served on the Art Commission to advise on the decoration of the United States Capitol Extension and was one of the founding trustees of the Metropolitan Museum of Art in New York.

In 1867, he purchased a tract of land on Contentment Island in Long Island Sound, and many of the most innovative paintings of his late career, known as the "Last Summer's Work," were executed in his studio there.

Along with Thomas Cole and Asher B. Durand, John Frederick Kensett figured as one of the primary artists who helped to shape the Hudson River School style of landscape painting in the mid–19th century. Transcendentalist philosophy, promulgated by such authors as Ralph Waldo Emerson and Henry David Thoreau, dominated American thought during that period: all of creation, the theory held, reflected the presence of God, and thus, contemplation of His work, particularly of nature in its untrammeled state, was a morally and spiritually uplifting pursuit.

Coast Scene was probably painted in the early to mid–1860s in the vicinity of Beverly, Massachusetts and evinces Kensett's mature style: his stippling technique gives a sense of palpability to the softly lapping waves and to the rugged boulders while remaining inconspicuous. Hence, the artist's hand does not intrude on the viewer's awareness and spoil the enjoyment of the scene as a direct transcription of nature. Emphasis is placed on the horizon line, as the asymmetrically arranged rocks and sailboats lead the eye from the foreground to the middle ground and ultimately to rest upon the thin stretch of land that separates sea from sky. In contrast to his notable contemporaries Frederic Church and Albert Bierstadt, who chose to depict nature at its most awe–inspiring, Kensett preferred a quietist interpretation of the sublime. The bold, simple forms of the rocks, the expansive composition, the subdued color and limpid light in *Coast Scene* all contribute to the feeling of peaceful solitude that characteristically pervades Kensett's works; these attributes are associated with the luminist mode of painting that became widespread in the third quarter of the century.

H.R.

GUSTAVE COURBET
French, 1819–1877

The Source of the Loue (La Source de la Loue), c. 1864

Oil on canvas
42¼ x 54⅛ (107.3 x 137.5)
George B. and Jenny R. Mathews Fund, 1959

Gustave Courbet left Paris for his native Ornans in the autumn of 1863 and remained in the Franche–Comté for most of 1864, a highly productive year during which he painted at least a dozen landscapes, including several views of the source of the Loue. The river Loue emerges from a huge grotto in the mountains close to Mouthier and flows westward through Ornans. Like the "Roche de Dix Heures," this motif seems to have held special interest for Courbet, as he painted it numerous times possibly from as early as 1850.

Courbet claimed to choose his landscape views at random, but he was obviously fascinated in this case by the powerful forms of his subject and the natural, geologic forces so strikingly embodied. Working with a palette knife, he laid the paint on thickly so as to recreate the rough texture of rock and cascading water. The somber colors—predominantly browns and dark greens enlivened with touches of red, pink, and blue—not only convey a sense of cool, damp atmosphere but also reinforce the general solemnity of presentation. Of the different versions of this scene, (Kunsthalle, Hamburg; Kunsthaus Zürich; National Gallery of Art, Washington, D.C.; and Metropolitan Museum of Art, New York), only the Buffalo painting is free of incidental detail such as figures, piers and waterworks, thus standing as the most boldly rendered and most elemental of the series.

This painting has the added distinction of having once been in the collection of Henri Matisse, who greatly admired Courbet and owned three of his works. Madame Georges Duthuit, Matisse's daughter, has related in conversation with Robert T. Buck, Jr., 1971, that she remembers accompanying her father when he visited a Paris dealer to buy the painting on the first day of World War I.

S.N.

Born in 1819 in Ornans (Doubs) into a family of farmers, GUSTAVE COURBET remained deeply attached to his native countryside and friends all his life. He studied art under Charles Flajoulot at the Ecole des Beaux–Arts in Besançon, 1838–39, and in Paris, from 1840, under Alexandre Steuben and Auguste Hesse, but was essentially self–taught. Particularly influenced by the paintings of the Venetian masters and Rembrandt, which he saw at the Louvre, Courbet made his debut at the Salon of 1844 with a romantic self–portrait; however, all but one of his works were rejected at the next three salons. With his *After Dinner at Ornans*, *Stone–Breakers* and *Burial at Ornans*, all of 1849, he achieved his mature style of vigorous realism and democratic content, which had so strong an impact on his era and younger painters such as Edouard Manet and the Impressionists. Though greeted by public scorn, Courbet's work had its defenders in critics such as Champfleury and Charles Baudelaire. In 1855, in conjunction with the Exposition Universelle, he staged a one–man realist exhibition. In the sixties and seventies he turned more to portraiture and landscape painting. He traveled to Belgium, Switzerland and Germany. For his role in the Commune of 1871 and destruction of the Vendôme column, Courbet was first imprisoned and then forced into exile in Switzerland, where he died.

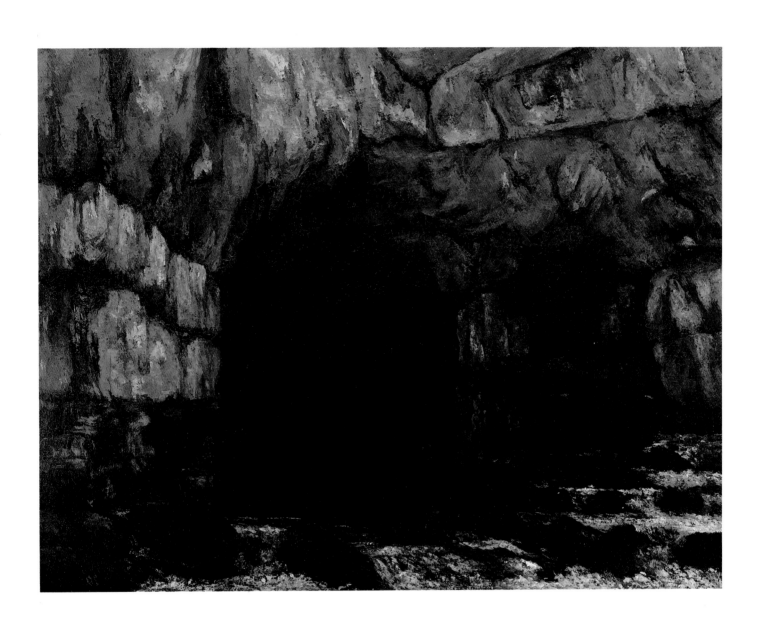

WINSLOW HOMER
American, 1836–1910

Croquet Players, 1865

Oil on canvas
16 x 26 (40.5 x 66)
Charles Clifton and James G. Forsyth Funds, 1941

This is the earliest of four oils Homer did between 1865 and 1870 on the theme of croquet playing, and is a fine example of the type of freshly observed, luminous country scenes which dominate his oeuvre in the period following the Civil War. Other canvases treating this subject are in the Art Institute of Chicago, the Wadsworth Atheneum, Hartford, and the collection of Mrs. Edwin S. Webster. The game of croquet, newly introduced into the United States in the early 1860s, quickly attained popularity, affording a stylish outdoor recreation in which men and women alike could participate. Homer, who in his earlier years led an active social life and was even a bit of a dandy, seems to have been attracted by the decorative aspects of color and fashion and the air of sociability which the game offered as a subject.

In technique as well as iconography, Homer's art at this time forms a parallel to some of the most advanced painting being done in Europe. *Croquet Players*, for example, has remarkable affinities with Monet's nearly contemporaneous *Women in a Garden*, 1866–67. Although Homer was not yet familiar with the early work of the French Impressionists, he manifests a similar interest in bright outdoor lighting, high–keyed color and flattened, simplified design. Like them he tends to render form through broad tonal patches. The voluminous skirts of the women are painted in strong local colors—red, white, blue and brown—with little value change interposed between highlights and shade. The influence of Japanese prints, possibly known to Homer through his friend John La Farge, shows itself in the decorative patterning of flat colored shapes against the green lawn, although at the same time a sense of deep space is retained through the use of receding diagonals.

S.N.

Born in Boston, WINSLOW HOMER was apprenticed to J.H. Bufford, a Boston lithographer, at age nineteen. He left Bufford in 1857 to work as a free–lance illustrator, and contributed regularly to *Harper's Weekly* from 1857 to 1875. After moving to New York in 1859, Homer studied briefly at the National Academy of Design and with Frederic Rondel. He visited Civil War battlefields and produced a number of works on war subjects, after which he turned to painting rural scenes. He was elected to the National Academy in 1865 and traveled to France, 1866–67 and to England, 1881–82. Homer's love of the wilder aspects of nature took him first to the mountains of New England and then to Prout's Neck, Maine, which was his home from 1883 except for frequent visits to the Bahamas, Bermuda and Florida during the winter and the Adirondacks and Quebec during the summer. Equally at ease with watercolor and oil, he treated many landscape, marine and genre subjects in a strong yet fluent realistic mode until his death at Prout's Neck.

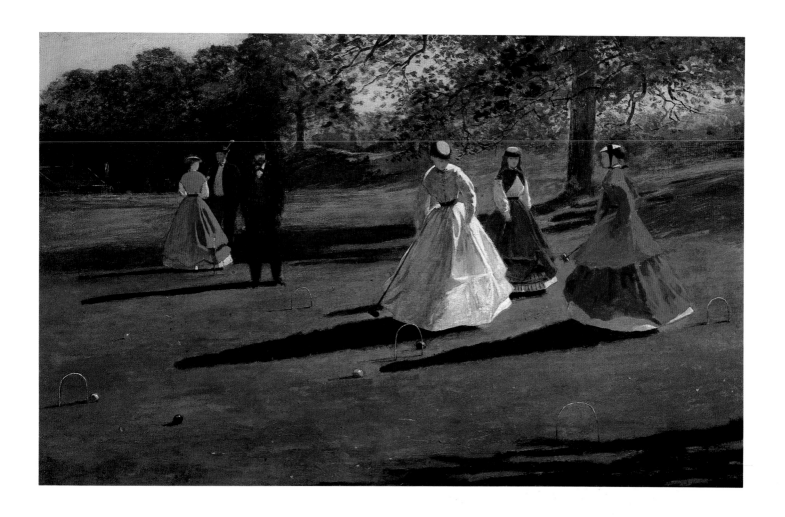

ALFRED SISLEY
French, 1839–1899

Village Street in Marlotte (Rue de village à Marlotte), 1866

Oil on canvas
25½ x 36 (64.8 x 91.4)
General Purchase Funds, 1956

One of Sisley's earliest known works, this painting reveals an already advanced talent developed primarily under the influence of Camille Corot and Gustave Courbet. Although he had begun painting some five or six years earlier and had worked both in Charles Glèyre's studio from 1862 to 1863 and then independently in the environs of Paris, little is known of Sisley's oeuvre prior to 1865 when he and Renoir moved from Paris to Marlotte, close to Moret and Fontainebleau. They were soon joined by Monet and Camille Pissarro, forming a small but vital artistic colony. In 1866 Sisley produced two views of Marlotte, this one and *Rue de village à Marlotte—femmes allant au bois*, both of which were exhibited at the 1866 Paris Salon.

For the Salon catalogue Sisley listed himself as "élève de Corot" in homage to the older master. Painted several years before the emergence of the fully-formed Impressionist style, this landscape is closely allied with the art of Corot in its quiet mood and cool range of greens, browns and grey-blues, its matte finish and its balanced geometry and design, although the more broad and earthy manner of Courbet can also be felt.

C.K. & S.N.

Born into a well-to-do English family living in Paris, ALFRED SISLEY at eighteen was sent to London for English and business studies but spent most of his time in galleries and museums. After his return to Paris, he abandoned his commercial career and in 1862 entered Glèyre's studio at the Ecole des Beaux-Arts. There he met Monet, Renoir and Frédéric Bazille, with whom he established lasting friendships. Working in close contact, they formed the vanguard of the Impressionist movement. In 1863 the group left Glèyre's studio to work "en plein air" and soon moved to the Fontainebleau region where the Barbizon painters were active. During the following years, Sisley lived first in Paris and then Louveciennes. He spent part of 1874 in England, then returned to France where he painted at Marly, Sèvres and Moret-sur-Loing. In 1874 Sisley took part in the first Impressionist exhibition, and later at the second, third and sixth exhibitions. A number of his works were purchased by Durand-Ruel gallery, but next to Pissarro he remained the most impoverished of the Impressionist painters.

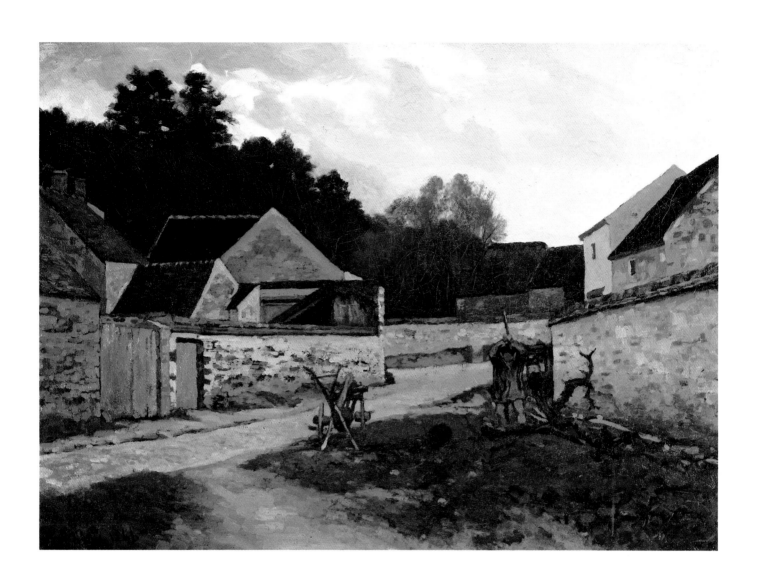

JEAN–FRANÇOIS MILLET
French, 1814–1875

The Cliffs of Greville (Les Falaises de Gréville), 1871–72

Oil on canvas
36¾ x 45⅞ (93.3 x 116.5)
Elisabeth H. Gates Fund, 1919

Although Millet's fame is based primarily on his moralizing depictions of French peasant life, landscape painting also played a central role in his art, at first in terms of settings for his figure compositions but increasingly after 1863, as an autonomous artistic interest. By the last years of his life it had become his main preoccupation. He worked in and drew inspiration from three distinct regions of France: Barbizon and its environs, Allier and Auvergne in south central France and Normandy, his birthplace. Particularly prominent among the works deriving from the latter locations is his *Cliffs of Greville* of 1871, a monumental essay on the harsh beauty of the Normandy coastline.

Greville lies in the parish in which Millet was born, and is situated a short distance west of Cherbourg along the coast. In order to avoid the Franco–Prussian War, Millet had returned to Cherbourg in August of 1870. His letters record poignantly emotional visits to his family home, as well as the fact that he was working at the time on several marine paintings. *The Cliffs of Greville* undoubtedly was among these works, although Millet probably did not finish it until after his return to Barbizon in November, 1871.

Prominent in the middleground is a promontory known as Le Castel Vendon, which itself is the subject of several works by Millet. The composition faithfully conveys the ruggedness of the Greville coastline, but as Robert Herbert has remarked, the distances seem much more vast than they actually are.

The precedents for Millet's fresh, naturalistic landscape vision clearly lie in the work of John Constable and the Barbizon school, although his palette here departs from their earthen browns and greens and takes on a pastel quality that again suggests a rapport with his drawings and reflects the increased luminosity and growing delicacy of color and handling in his later works as he evolved closer toward Impressionism.

S.N.

Born at Gruchy (Manche), JEAN-FRANÇOIS MILLET came from humble origins; although he was well–read and cultured, his art and entire life reflect a strong attachment to the French peasantry. After early training in Cherbourg, he went to Paris in 1837 and worked under Paul Delaroche, though he was greatly affected by his independent studies and by Camille Corot. He worked at first chiefly as a portraitist and also produced a number of arcadian landscapes and paintings in an 18th–century vein. Shortly after his success at the Salon of 1847 with his *Oedipus*, he developed a personal, rustic brand of naturalism, emphasizing the honesty and hardship of French peasant life. In 1849 he left Paris for Barbizon, where he worked closely with Théodore Rousseau, Charles–Emile Jacques and others, and made trips to Normandy in 1854 and 1870–71. Although not well understood at first, Millet gained increasing renown. He was awarded the Légion d'honneur in 1868 and was commissioned by the French government to decorate the Pantheon, but was able to make only a few drawings before his death.

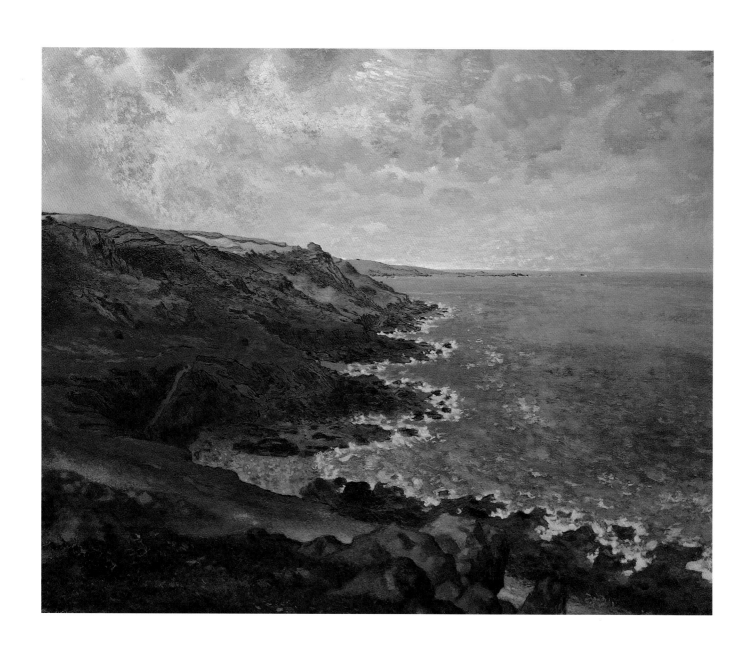

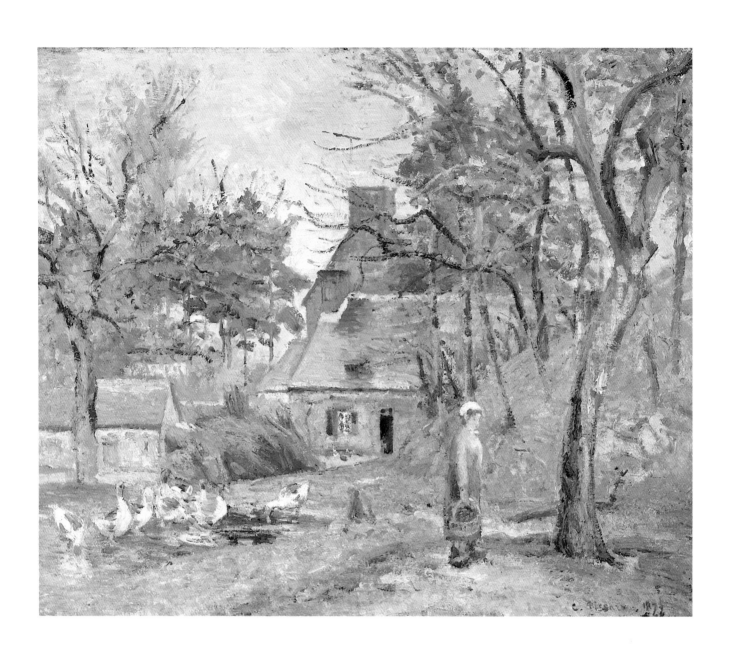

Farm at Montfoucault (La Ferme à Montfoucault), 1874

Oil on canvas
21½ x 25¾ (54.5 x 65.5)
Gertrude Watson Bequest, 1938

Born at St. Thomas in the Virgin Islands, CAMILLE PISSARRO was sent to boarding school in Paris for five years, where he took up drawing. From 1847–53 he was back in St. Thomas and then Caracas. In 1855 Pissarro returned to Paris to study art, working first with Antoine Melbye, then at the Ecole des Beaux–Arts and the Académie Suisse. Most important among his early influences, however, were Camille Corot and Courbet, and then Monet. Developing his own Impressionist style, he painted in his studio in Paris but also out–of–doors in the countryside. Pissarro had his first painting accepted at the Salon in 1859, then joined with Cézanne, Manet and others in the 1863 Salon des Refusés. He fled to England during the Franco–Prussian War. Back in Paris, he was a guiding force behind the first Impressionist exhibition in 1874 and participated in all seven succeeding exhibitions. His many city views date from the later phases of his career, when he at last achieved a moderate success.

Pissarro was a frequent visitor at the farm of his friend Ludovic Piette, located at Montfoucault in Mayenne, between Normandy and Brittany. Following the first Impressionist exhibition in 1874, a financial disaster, Pissarro availed himself of Piette's hospitality and spent the winter with his family at Montfoucault. During this visit he painted at least two views of the farm, the present picture and a slightly larger one in the Musée d'art et d'histoire in Geneva.

Pissarro's Impressionist style at the time he painted the *Farm at Montfoucault* was still in its formative stages. The opaque surface seen here, the short brushstrokes, dense composition and rather strong linear elements exemplify one of several stylistic strains in his work during the early 1870s, when Gustave Courbet's influence upon him was still quite prominent.

S.N.

CLAUDE MONET
French, 1840–1926

Tow–Path at Argenteuil, Winter (Chemin de halage à Argenteuil), c. 1875

Oil on canvas
23⅝ x 39⅜ (60 x 100)
Gift of Charles Clifton, 1919

The locale, and therefore the date and title, of this winter landscape by Monet have been the subject of debate for many years. Two early Durand–Ruel gallery labels on the back of the painting bear the title *Hiver à Vétheuil* (Winter at Vetheuil), a village on the Seine northwest of Paris where Monet lived from 1878 to 1881. Yet sales catalogues from 1903 and 1917 describe the painting respectively as *Près d'Argenteuil en hiver* (Near Argenteuil in Winter) and *Chemin de halage à Argenteuil* (Tow Path at Argenteuil), another Paris suburb where the painter lived from late 1871 to 1876.

The Argenteuil hypothesis is the more plausible. A very similar composition, simply reversing the view, is titled *Winter at Argenteuil*, 1875–76. Moreover, Daniel Wildenstein is convinced that the location can be conclusively fixed as Argenteuil: "This painting was done in 1875, near Argenteuil, not near Vétheuil, for the topographical disposition is not to be found anywhere in the area of Vétheuil. It represents the tow–path leading from Argenteuil to Epinay, a village located a few miles further up the river on the same bank. The artist was turning his back to Argenteuil and looking towards Epinay." A painting entitled *Route to Epinay, Snow Effect*, whose dimensions coincide with the work, was included in a sale in April 1876 and was shown in the second Impressionist exhibition in 1876. Wildenstein notes also that Monet is known to have produced another snowscape of identical dimensions on the same route from Argenteuil to Epinay.

The quiet scene conveys none of the melancholy and despair characteristic of the stark Vétheuil snowscapes, painted during a period of severe emotional and financial strain immediately following the death of Monet's first wife. This painting suggests a different mood; the sky is opening from the heavy leaden overcast of winter, the snow has melted leaving a wet and colorful mud along the river bank, and the faint flush of green in the trees at the left hints at early spring budding.

K.K.

Born in Paris, CLAUDE MONET moved with his family to Le Havre in 1845. There he became known as a caricaturist and studied under Jacques Ochard, though he was more significantly influenced by Eugène Boudin who encouraged him to paint out–of–doors. In 1859 he returned to Paris and studied briefly at the Académie Suisse. He was sent to Algeria for military service, but was dismissed for ill health. Back in Paris, Monet entered the studio of Charles Glèyre where he formed lasting friendships with Renoir, Frédéric Bazille and Alfred Sisley. He spent much time painting landscapes in Normandy and near Fontainebleau, but despite acceptance of paintings at the Salons of 1865 and 1866, suffered severe financial difficulties. He fled to London in 1870 during the Franco–Prussian War, returning to France via Holland in 1871 to settle at Argenteuil where he outfitted a small studio boat. In 1874 he helped organize the first Impressionist exhibition, where he showed twelve works. In 1878 he moved to Vétheuil. These were the years of his mature Impressionist style and there soon followed the great "series" paintings and, after the purchase of property at Giverny in 1890 and construction of a water garden, the many water–lily pictures. He traveled to London (winters of 1899–1901) and Venice (1908, 1909). In 1914, encouraged by Georges Clemenceau, an ardent admirer, he began the vast mural project of water landscapes to be housed in the Musée de l'Orangerie in Paris.

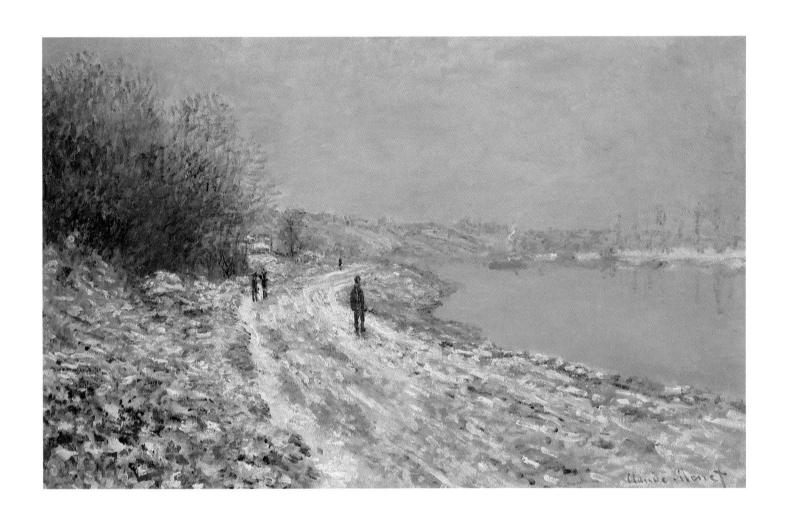

WILLIAM HARNETT

American, born Ireland 1848[?]–1892

Music and Literature, 1878

Oil on canvas
24 x 32⅛ (61 x 81.5)
Gift of Seymour H. Knox, 1941

Music and Literature of 1878, one of Harnett's best–known early compositions, gives ample evidence of how fully he had developed his style prior to studies and travels in Europe from 1880 to 1886. Presented with characteristically intense literalism, the objects comprising the composition are familiar within Harnett's still–life iconography. The book opened in the center is patterned after a similar one in *Mortality and Immortality* of 1876. The candlestick and translucent candle, the Arnold ink bottle and the folded letter are motifs that recur in numerous works, as does the pyramidal stack of leather bound books. This apparently is the first appearance of Harnett's ivory and ebony flute, which may have been modeled after a flute that figured in the sale of the contents of Harnett's studio after his death. Alfred Frankenstein has identified the music hanging over the edge of the table as "a set of trashy variations for flute solo on themes from *La Traviata.*" The music in the frayed, light blue music cover rolled up behind the candlestick is too fragmentary to be identified.

The composition, only seemingly casual, actually conforms to a carefully ordered plan. The open book with its fanned–out pages is the hub of a semi–circular design, which combines outward movements with the lively interaction of linear rhythms, contrasting juxtapositions, precarious balances and varied but repeated colors. The sense of structure and ample form that dominate, however, distinguish *Music and Literature* from the tendencies toward miniaturism or Victorian clutter that mark many of Harnett's later table–top still lifes.

As in most works by the artist, a sense of mysterious significance is conveyed by the silent, airless, closely observed groupings. Despite their almost scientific visual objectivity, Harnett's paintings have an expressive dimension which seems to relate most closely to the vanitas still–life tradition in European art. In the crumpled and tarnished surfaces of the carefully rendered objects and in the hermetic quality of his work there is a melancholic note and a reminder of the passage of time.

S.N.

WILLIAM HARNETT was born probably at Clonakilty, County Cork, Ireland, though his family had moved to Philadelphia by 1869. Trained as an engraver, Harnett briefly attended the Philadelphia Academy. He moved to New York in 1869 where he found work engraving silver and also attended art classes at Cooper Union. His earliest oil paintings date from 1874. His presence is recorded in Philadelphia, 1876–80. Harnett's trompe l'oeil style, undoubtedly influenced by such earlier American artists as Raphael Peale, was fully formed by the time of his departure for Europe in 1880. He worked in London and Munich and in 1884 submitted his famous *After the Hunt* to the Salon in Paris. By 1886 he was back in the United States occupying a studio in New York, where he died six years later at the peak of his career.

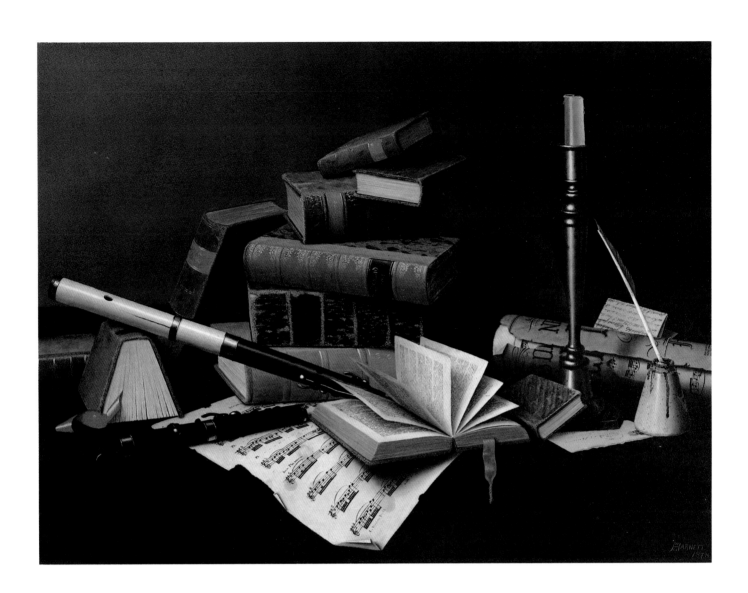

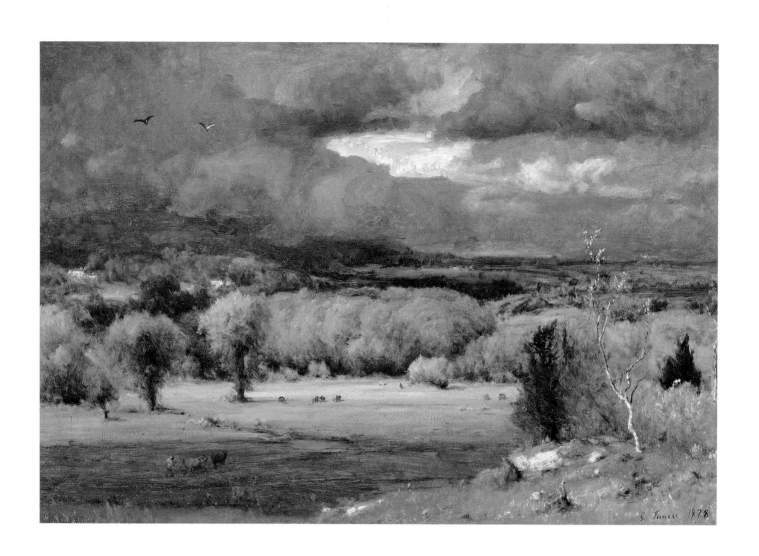

The Coming Storm, 1878

Oil on canvas
26 x 38½ (66 x 97.8)
Albert H. Tracy Fund, 1900

Born near Newburgh, New York, GEORGE INNESS subsequently moved with his family to New York City, and later to Newark, New Jersey. In 1845 he studied for one month with the landscape painter Regis Gignoux, but otherwise had no formal art training. Instead he turned to engravings after old masters and to the paintings of the Hudson River School for his inspiration. He traveled to Italy in 1850–52 and France in 1854–55, where he first saw the works of the Barbizon painters. He resided at various times in Brooklyn; Boston; Medfield, Massachusetts; Eagleswood, New Jersey; Rome; Perugia; Paris and New York City. In 1878 he moved to Montclair, New Jersey which became his permanent home, although he continued to spend summers elsewhere. He exhibited at the National Academy of Design in New York, where he was elected an Associate Member in 1853 and a full member only in 1868. In the 1860s he became interested in Swedenborgianism, a spiritual doctrine to which he remained devoted for the rest of his life, and which may have influenced the misty, light–suffused canvases of his late period. He died during a European journey in Bridge–of–Allan, Scotland.

The subject of *The Coming Storm*, a popular one in 19th–century romantic painting, appears more than two dozen times in Inness' oeuvre over a thirty–year period. Unlike many of his contemporaries who chose to portray untamed wilderness, Inness, like the French Barbizon painters, preferred an intimate, domesticated or, in his words, a "civilized" landscape.

A convert in middle age to Swedenborgian thought, Inness saw nature as reflecting a spiritual realm in which man is part of a harmonious whole, neither subordinate to nature nor totally its master. *The Coming Storm* presents a heroic vision in which the small human figure gives scale to the storm, psychologically as well as physically. Painted in 1878, it comes from Inness' middle period when he had achieved a balance between the requirements of realistic representation and painterly process. The billowing clouds and unnatural lighting caused by the storm enable him to explore painterly effects, but with a strong sense of structure usually lacking in his later, more diffuse compositions.

The Coming Storm was given by Inness to Mrs. William Bryan, headmistress of the boarding school attended by his daughters in Batavia, New York to help defray the expenses of their schooling. The locale depicted has not been conclusively identified but may be near North Conway, New Hampshire.

E.W.

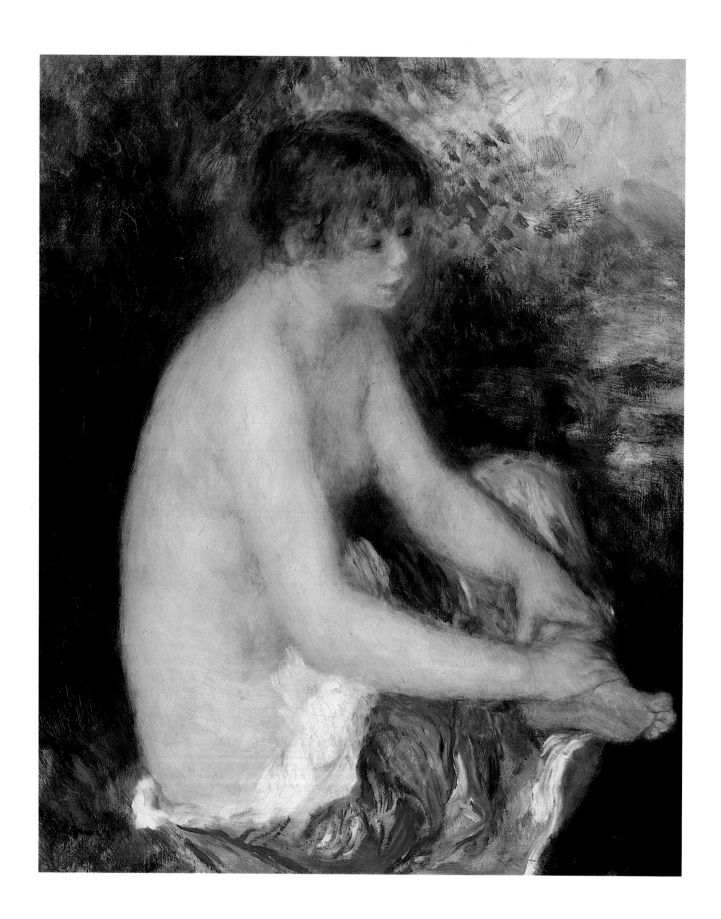

PIERRE–AUGUSTE RENOIR
French, 1841–1919

Little Blue Nude (Petit nu bleu), c. 1878–79

Oil on canvas
18¼ x 15 (46.4 x 38.2)
General Purchase Funds, 1941

Born in Limoges, PIERRE–AUGUSTE RENOIR moved with his family to Paris in 1844. Showing a precocious talent for drawing, he was apprenticed in 1854 to a porcelain manufacturer, where he painted decorations in a late rococo manner. From 1862–63, he attended the Ecole des Beaux–Arts in the studio of Charles Glèyre where he met Alfred Sisley, Camille Pissarro, Monet and Henri Fantin–Latour. In 1864 he painted in the Fontainebleau area with Frédéric Bazille and Monet in his first real contact with nature. He participated in the first Impressionist exhibition of 1874 and in all but the last of that group's subsequent exhibitions. In 1881–82, he traveled to Algeria and Italy, where his experience of ancient and Renaissance art led him to introduce into his Impressionism a new linear and sculptural direction. After a long period of financial insecurity, a major exhibition in 1892 at Durand–Ruel gallery signaled popular acceptance. Though his health declined markedly toward the end of the century, he continued to paint and even began to experiment in sculpture, until his death at Cagnes in December 1919.

Little Blue Nude was painted c. 1878–79 at the apogee of Renoir's early Impressionist period and just before his visits to Italy which would inspire him to adopt a heavier and drier manner. The bather, a subject which recurs frequently throughout his career, was ideally suited to Renoir's preoccupation with the behavior of light as it played over sensuous and receptive surfaces, such as translucent human skin and shimmering water, with its complex and multiple reflections. Here the sleepy, self–engrossed nude sits awash in a play of colored shadows.

The model in question has traditionally been identified as Margot, a young, carefree Parisian whose skin "took the light" in the manner Renoir required and who appears frequently in his work beginning in 1876. This assumption has been based on both the nude's resemblance to an early description of Margot by Georges Rivière, and the reminiscences of Albert André, an old and close friend of the artist. More recent research, however, has established that Margot developed a severe case of typhoid in January, 1879, and died a month later, thus refuting either the traditional identification of the figure or date of the painting, generally placed from 1879–81. Since the head of the young woman does accord with other verbal and pictorial representations of Margot, one is prompted to assign the painting to 1878. Internal stylistic evidence would not contradict this dating.

K.K.

JOHN SINGER SARGENT
American, born Italy, 1856–1925

Venetian Bead Stringers, 1880 or 1882

Oil on canvas
26⅜ x 30¾ (67 x 77.2)
Friends of the Albright Art Gallery Fund, 1916

Sargent probably painted this study of *Venetian Bead Stringers* during one of two trips to Venice, either the first in 1880 when he had a studio in the Palazzo Rezzonico, or the second in 1882, when he stayed with his cousin Daniel Curtis in the Palazzo Barbaro on the Grand Canal.

While Sargent undoubtedly witnessed scenes similar to that in this work during his stays in Venice, C.M. Mount suggests that the original idea for the picture may have come from a *Venetian Bead Stringers* by C. van Haanen exhibited at the Royal Academy in 1880. It is a subject treated also by J.M. Whistler. Sargent seems to have been attracted by its exoticism and the chance it offered for a study in muted tonal harmonies and he repeated it at least one other time, in a work in the National Gallery, Dublin. In the Gallery's painting, only one of the women holds the shallow wooden tray customarily used by the bead stringers for their work. The other two figures are grouped close together as if for conversation, although each seems absorbed in her own thoughts. The setting of the picture, a deep interior accented by shafts of light, is the *piano nobile* of an unidentified Venetian palace. Besides the influences of Spanish painting and of Velasquez in particular, the broad, liquid brushstroke and tonal contrasts reveal an indebtedness to Edouard Manet and Whistler. A further debt may be owed to Whistler for the device of a dim interior lighted from behind.

C.K. & S.N.

JOHN SINGER SARGENT was born in Florence, Italy, of American parents. His interest in art was encouraged by his mother and he received his first formal training in Rome in 1868 from the landscape painter Carl Welsch. After attending the Accademia delle Belle Arti in Florence in 1870 he passed the examination for the Ecole des Beaux–Arts in Paris and enrolled in the studio of the portrait painter Carolus–Duran between 1874 and 1879. In 1877 he exhibited at the Salon for the first time. He traveled extensively throughout Europe. After the great controversy aroused by his portrait of Madame Gautreau at the Salon of 1884, Sargent settled permanently in London. He came to the United States in 1887, had his first one–man show in Boston in 1888 and executed numerous commissions for portraits and murals. In the late 1880s Sargent visited and painted with Monet at Giverny. He was elected a member of the Royal Academy in London, the National Academy of Design in New York and awarded the Légion d'honneur in France. In 1918 he worked in France as the official war artist for the Imperial War Museum in London. He died in London.

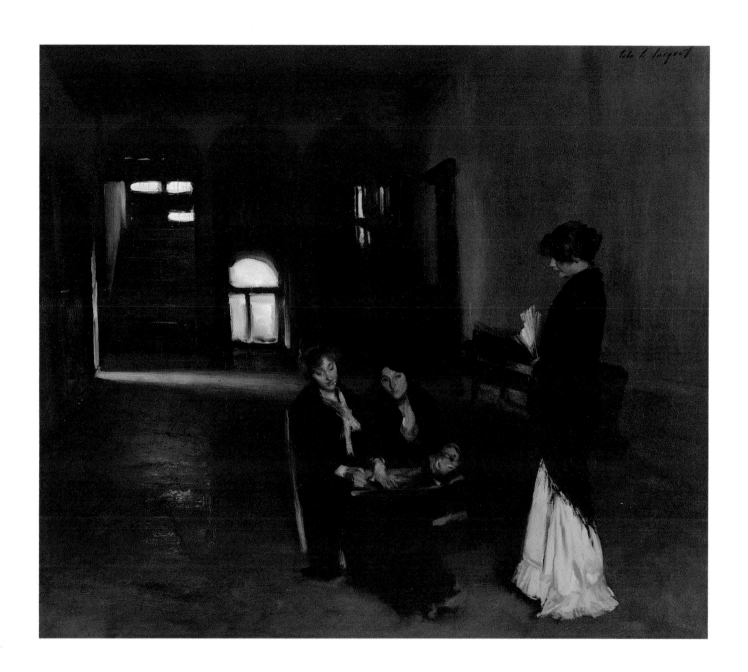

JAMES JACQUES JOSEPH TISSOT
French, 1836–1902

The Reception (L'Ambitieuse; Political Woman), c. 1883–85

Oil on canvas
56 x 40 (142.2 x 101.5)
Gift of William M. Chase, 1909

L'Ambitieuse, also called *The Reception* and *Political Woman*, belongs to a series of eighteen or more large paintings which Tissot executed between 1883 and 1885 and which contain some of his most trenchant observations and comments on modern Parisian society. The series was exhibited at the Galerie Sedelmeyer in Paris in 1885 and was shown again, with two paintings omitted and three added, at the Arthur Tooth Gallery in London in 1886. The Tooth catalogue describes the *Political Woman*:

> Another 'crush'—this time in the world of politics, and with a political (and indeed a politic) woman for its central figure. Her pink dress is a marvel of the dressmaker's art, with its multitude of tiny flounces, its black girdle, its pink sash, and the color of her pink ostrich feather fan has been carefully studied to match. She, too, is a beauty, and she has made what she believes to be a fair exchange of her beauty against her husband's position. Is he a minister? Possibly, or if he is not, he will be so one of these days, at least if dexterity and management on her part can contrive it.

Tissot made etchings of five pictures in the series, including this one.

Born in Nantes, France, to Marie Durand and Marcel–Theodore Tissot, a conchologist, JAMES TISSOT studied at Jesuit colleges in Brugelette in Flanders, Vannes in Brittany and Dôle, in the Jura. In 1856, he went to Paris and enrolled at the Ecole des Beaux–Arts; later he studied at the Louvre under Louis Lamothe and Hippolyte Flandrin. In Paris he met and became friends with J.M. Whistler and Edgar Degas. Tissot exhibited for the first time at the Paris Salon in 1859 and at the Royal Academy in London in 1864. Thereafter he would exhibit regularly in both cities. He took part in the Siege of Paris and in the Commune and was forced to flee to England in 1871 to escape punishment. In London he worked on cartoons for *Vanity Fair* and continued to paint. In 1885 the Galerie Sedelmeyer in Paris exhibited Tissot's *Quinze Tableaux sur la Femme à Paris*; most of these works were shown as well at the Tooth Gallery in London the next year. Tissot made the first of three trips to Palestine in 1886 to work on his Bible illustrations, drawings on which he would work for the rest of his life. In 1887, he resettled in Paris; later he divided his time between his home on the avenue Bois de Boulogne and at the Chateau de Bouillon near Besançon. He died at Bouillon in 1902.

42

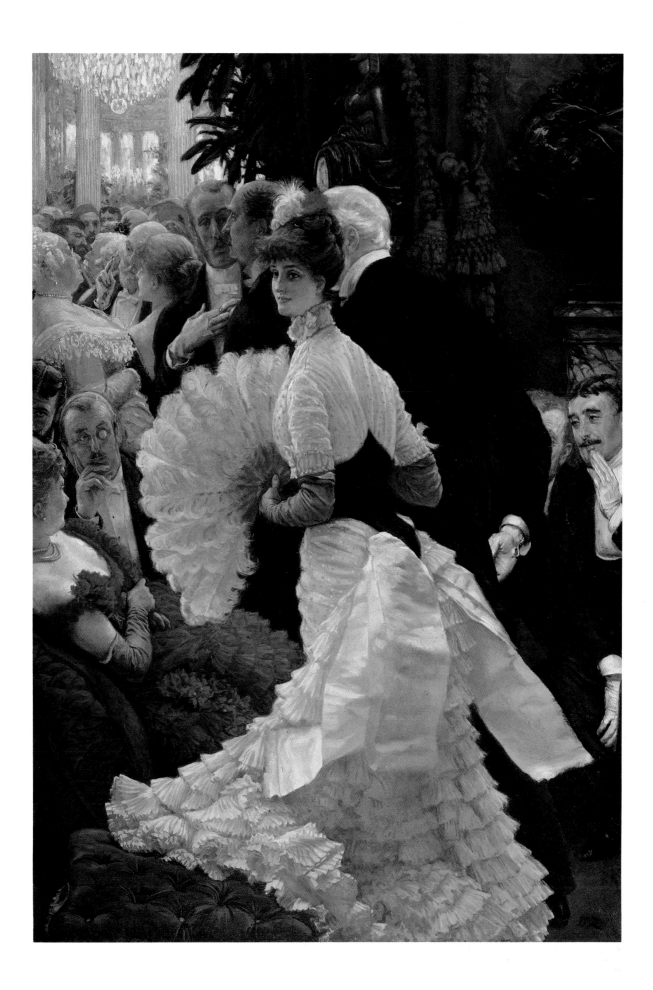

Edgar Degas
French, 1834–1917

Portrait of Rose Caron, c. 1885–90

Oil on canvas
30 x 32½ (76.2 x 82.6)
Charles Clifton, Charles W. Goodyear and Elisabeth H. Gates Funds, 1943

In this portrait, Degas seizes on the passing gesture of an elegant, worldly woman pulling on her long glove and makes it the fulcrum of both his formal composition and his penetrating insight into the sitter's personality. Although this picture was identified in early publications simply as "jeune femme assise, mettant des gants," Dr. Georges Viau and André Weil, previous owners of the work, determined that the sitter is, in fact, Rose Caron. This identification was confirmed by Jeanne Fèvre, Degas' niece and heir. Rose Caron (1857–1930) was a famous operatic soprano, particularly admired for her roles in *Sigurd, Salammbo, Tannhauser* and *Lohengrin*. Through his extensive social circle and consuming love of the theater, Degas came to know her quite well. Always acutely sensitive to the movements and physical traits which characterize an individual, he seems to have been particularly struck by her long and elegant arms.

Degas' portrayal of Mme. Caron, with her outstretched arms, distant gaze and regal posture, conveys a quiet dignity which is said to have characterized her performances. A few fluid strokes define the contours of the figure, strongly silhouetted against a light and colorful background. The cropped composition, slightly overhead view and the tendency toward flatness reflect Degas' interest in Japanese prints, while the richly brushed surface and varied color harmonies show the breadth of execution that typifies his later style.

C.K. & S.N.

Hilaire Germain Edgar Degas was born in 1834 in Paris, where his father was a prominent banker. Early schooling included studies at a lycée and one year as a law student, but his primary interest was art. After lessons from the painter Félix–Joseph Barrias, in 1854 he entered the studio of Louis Lamothe, a former pupil of J.A.D. Ingres who kindled Degas' interest in the classical tradition and introduced him to the Ecole des Beaux–Arts. He spent 1856–59 in Italy where he studied the old masters. Portraits from these early years were followed by several large historical compositions; he contributed regularly to the Salon from 1865 to 1870. It was a close acquaintance with Edouard Manet and several of the Impressionist painters, however, and a love of oriental prints which most determined his style. He visited his brothers, cotton merchants in New Orleans, in 1872. Back in Paris, he helped organize the first Impressionist exhibition in 1874, and exhibited in all but one of the eight Impressionist shows, though he himself remained independent of the true Impressionist style. His love of music and the stage and his personal acquaintance with many of the performers provided him with much of his subject matter. Plagued by eye trouble, he was almost totally blind by 1898.

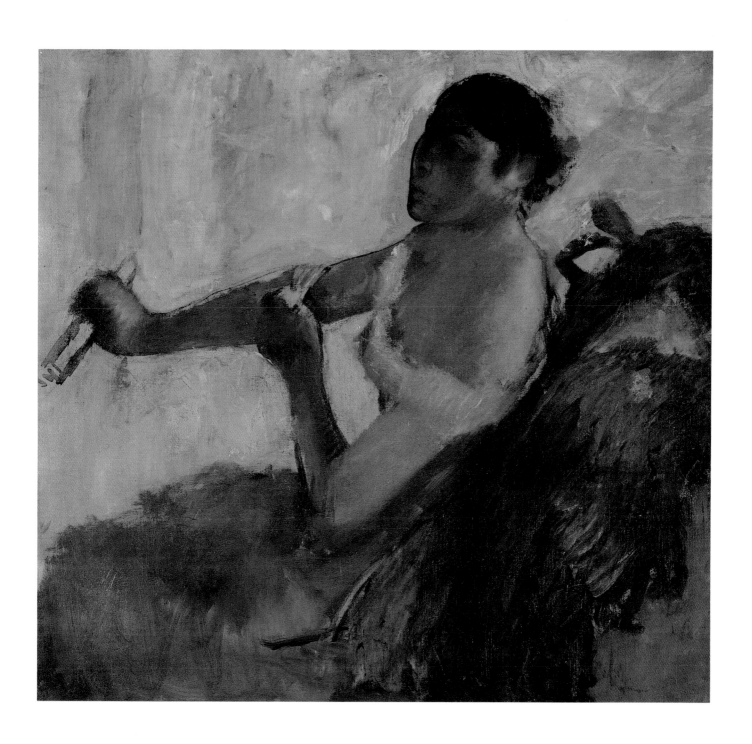

JAMES ENSOR
Belgian, 1860–1949

Fireworks (Le feu d'artifice), 1887

Oil and encaustic on canvas
40¼ x 44¼ (102 x 112.5)
George B. and Jenny R. Mathews Fund, 1970

*F*ireworks of 1887 is one of the most important statements of visionary, apocalyptic themes from Ensor's middle period. In a wide, slightly rolling landscape, many small figures stroll about as if enjoying a leisurely summer outing. They are vaguely defined with short, sketchy strokes. In the distance bursts an enormous explosion of fireworks against a sky of intense blue. Compared to other works from this period (for example, *Tribulations of St. Anthony*, 1887 or *Fall of the Rebellious Angels and Entry of Christ into Brussels*, 1888), *Fireworks*, with its simplified and symmetric composition and the ostensible theme of summer recreation, appears much less troubled and aggressively expressive. The force and scale of the explosion, however, the strong color and the bold surface treatment produce an unmistakable sense of cataclysm. This type of pictorial ambiguity is a common element in Ensor's fusing of the fantastic and the real. Both *Fireworks* and the somewhat related *Cataclysm*, an etching of 1888, can be seen as part of a tradition of holocaust scenes dating back to Goya, J.M.W. Turner, John Martin and other early 19th-century artists. The handling of color is also reminiscent of Turner and shows the extent to which Ensor had brightened his palette following his "somber" style of 1879–83. Pigment is applied in a thick wax medium which makes for a heavy impasto and a high degree of translucency. The broad scumbling of the surface, highly expressive in its rough directness, leaves much of the canvas visible.

S.N.

JAMES ENSOR was a Belgian painter and etcher whose fantastic and caustically satirical works constitute a prelude to 20th-century Expressionism. He was born in Ostend, the son of an English father and a Flemish mother who owned a small souvenir shop carrying masks, shells, puppets and other curios, from which he derived inspiration for many paintings. He studied from 1877–80 at the Brussels Academy and returned in 1880 to Ostend, where he spent the rest of his life. Ensor's early work was in a somber realist style derived from 19th-century northern artists. In 1883 he helped found "Les XX" and exhibited at the Paris Salon of 1882, but from 1884 onward, his highly personal works aroused heated criticism and were continuously rejected from exhibitions. He finally was given a one-man exhibition in Paris in 1898. After about 1900, Ensor's creative powers began to decline; from this time, however, his work gained increasing recognition.

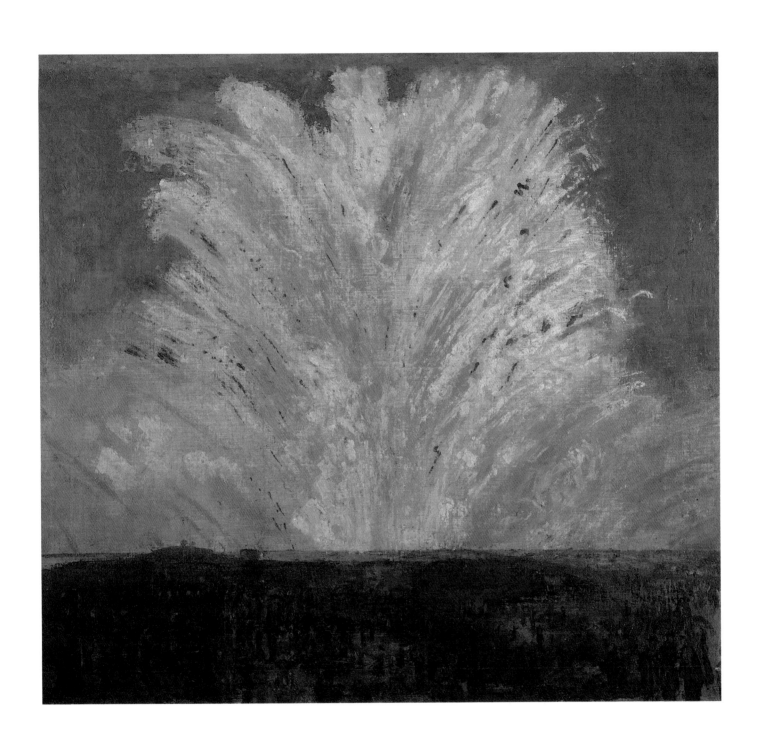

VINCENT VAN GOGH
Dutch, 1853–1890

The Old Mill, 1888

Oil on canvas
25½ x 21¼ (64.5 x 54)
Bequest of A. Conger Goodyear, 1966

In the fall of 1888, van Gogh was living at Arles in southern France, where he had moved from Paris the previous February. Relatively free from care during this period and stimulated by the southern light, he worked steadily and hard, developing his style to a new expressive intensity. Among the many paintings he did of the buildings and environs of Arles is *The Old Mill*, or *Maison de la Crau*, dateable to early September. In one of the letters to his brother Théo, van Gogh notes: "I have a study of an old mill painted in broken tones like the oak tree on the rock, that study you were saying you had had framed along with the 'Sower'." The letter is not dated but most likely is from the period between September 8th and 11th.

The mill depicted here, popularly known as the Jonquet Tower or *tabatière*, still stands although in somewhat altered condition. Van Gogh, while presenting a fairly literal description of the mill, took certain liberties with perspective and structure, accommodating the motif to his own expressive design. Thus the angles of the ground plane, stairs and thatched roof are sharply exaggerated as part of a rushing diagonal movement from lower left to upper right, heightened by the divided brushstrokes and strong color.

C.K. & S.N.

VINCENT VAN GOGH was born at Groot Zundert, the Netherlands, the son of a clergyman. After unsuccessfully attempting several careers—art salesman, teacher, minister—he resolved to become an artist. He received instruction from his cousin Anton Mauve at the Hague in 1881 and later at the Antwerp Academy in 1886 and was influenced by such artists as Jean–François Millet, Joseph Israels and Georg–Hendrik Breitner. From 1883 to 1885, the period of the *Potato–Eaters*, he lived and worked at Nuenen. He went to Paris in 1886 where he was greatly impressed by the Pointillists and Impressionists and by oriental prints. In February of 1888, van Gogh moved to Arles, where later he was joined briefly by Gauguin. His ensuing works show the full attainment of a personal, emotion–charged art based on strong color and vigorous brushwork. Increasing mental anguish finally led, however, to an attempt on Gauguin's life and van Gogh's mutilation of his own ear. From May 1889 to February 1890, he was a voluntary patient in an asylum at Saint–Rémy, continuing all the while to paint. In May of 1890 he went to Auvers near Paris and was placed in the care of Dr. Gachet. There he produced his last, highly poignant works. In July, van Gogh shot and killed himself at the age of thirty–seven.

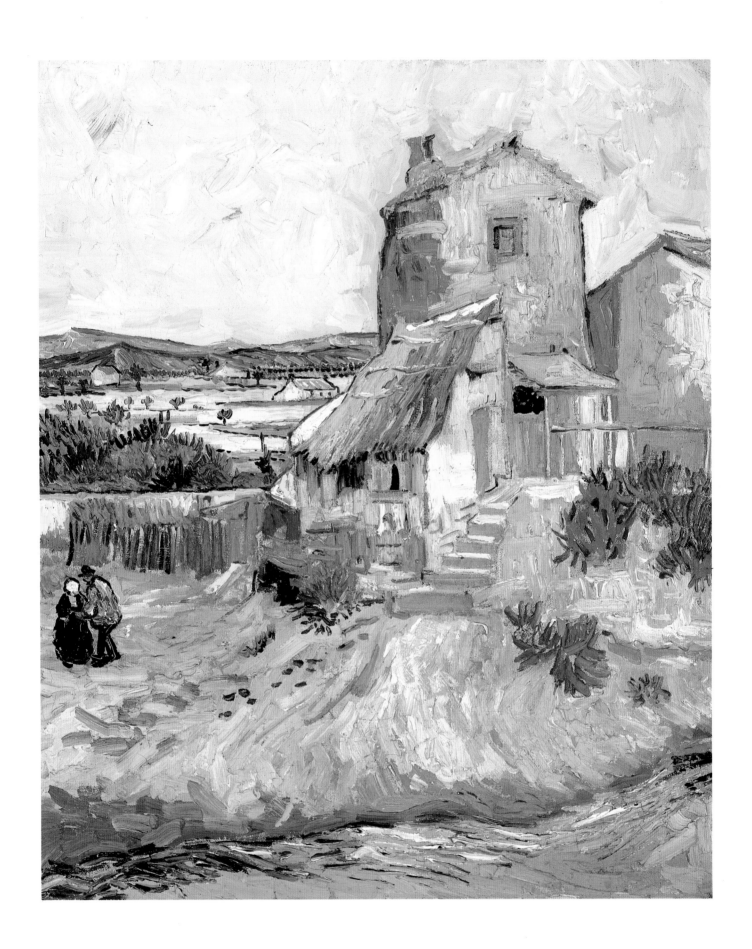

PAUL GAUGUIN
French, 1848–1903

The Yellow Christ (Le Christ jaune), 1889

Oil on canvas
36¼ x 28⅞ (92.1 x 73.4)
General Purchase Funds, 1946

According to most authorities the *Yellow Christ* was begun at Pont–Aven in Brittany, but finished at Le Pouldu, a more remote and primitive fishing village slightly to the south, to which Gauguin moved in late July 1889. The landscape configuration has been identified as the Colline Ste. Marguerite at Pont–Aven, and it is virtually certain that the visual source of the crucified Christ was an ancient wooden polychromed crucifix which hangs in the small Trémalo Chapel just outside Pont–Aven.

The mysticism and religious undertones so close to the surface in this primitive area appealed strongly to Gauguin. According to Breton agricultural folklore, for example, the autumn harvest possessed a deep spiritual significance. Wayne Andersen has explained that the grain was believed to undergo a kind of crucifixion, to be resurrected in the spring. The blazing autumn foliage in the *Yellow Christ* clearly had more than merely decorative importance for Gauguin.

This work is one of the most accomplished statements of Gauguin's Synthetist style, and one of the cardinal paintings of the 19th century. Its immediate impact upon the Pont–Aven group can be appreciated by the number of works of similar title or composition which soon appeared. Maurice Denis, for example, painted a *Yellow Christ*, a crucifix surrounded by three prostrate peasants, sometime shortly after Gauguin's work. Charles Filiger's gouache *Christ on the Cross*, c. 1896, bears a number of resemblances to Gauguin's work. The flat patterns of bold color shapes, often bounded by a distinct contour line, as well as the compression of space into a series of receding planes, would powerfully influence the Nabis and Gauguin's numerous other disciples.

K.K.

Born in Paris, PAUL GAUGUIN spent four years as a small child in Peru where his father had been forced into political exile. He returned to France at the age of seven and was raised in Orléans; at seventeen he went to sea in the merchant marine. In 1871, he joined a brokerage house and two years later married a bourgeois Danish girl who bore him five children. An amateur painter, he was interested in Impressionist painting, which he collected. He met Cézanne, Degas and Camille Pissarro, who particularly encouraged his growing involvement with painting. During the financial panic of 1883 he lost his job which led him eventually to separate from his family and dedicate himself entirely to his art.

In 1886, he made the first of several visits to Pont–Aven in Brittany where he worked in a pseudo–Impressionist style derived from Pissarro. After a brief trip to Panama and Martinique in 1887, he returned to Pont–Aven where he remained from February to October 1888. In this decisive period, together with Emile Bernard, he developed the theory and practice of Synthetism and Cloissonism, a flattened, outlined decorative style. After a brief time in Arles with van Gogh (October to December 1888) he returned to Brittany, first to Pont–Aven and later to Le Pouldu. On April 4, 1891, he left for Tahiti. Poverty forced him to return to France in 1893. In 1895 he returned to Tahiti where, despite the peaceful and idyllic climate, he grew sick and in 1898 unsuccessfully attempted suicide. In 1901 he left Tahiti for the Marquesas Isles where he died.

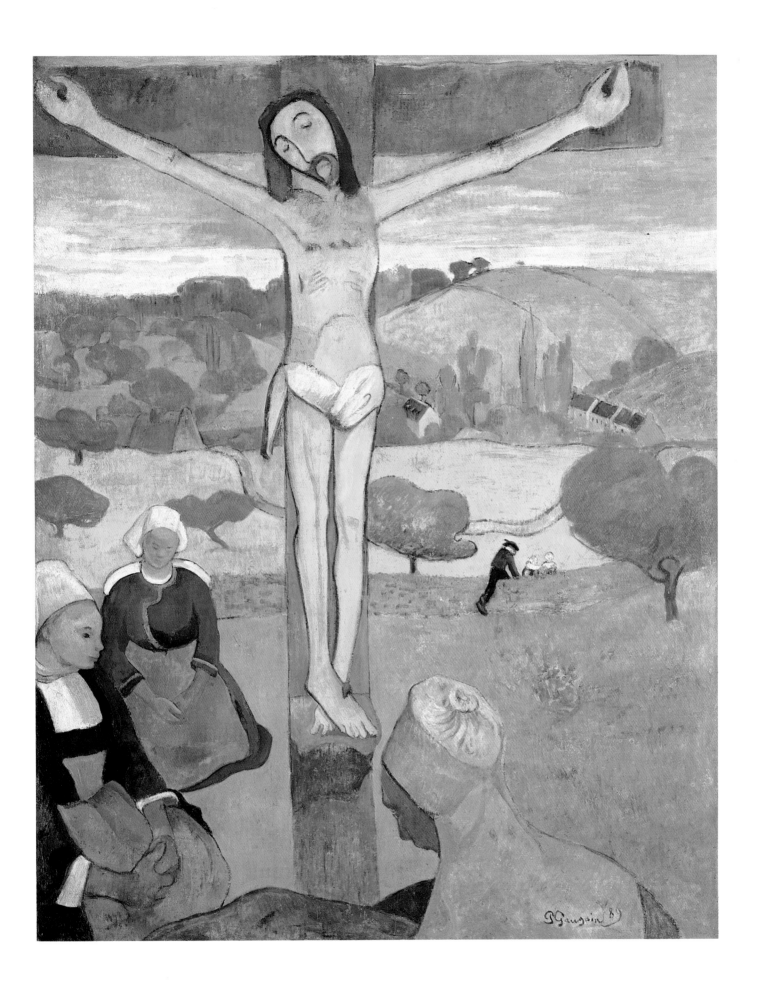

GEORGES SEURAT
French, 1859–1891

Study for Le Chahut, 1889

Oil on canvas
21⅞ x 18⅜ (55.5 x 46.5)
General Purchase Funds, 1943

This is the larger and later version of two oil studies for *Le Chahut*, 1890. The earlier oil study is in the Courtauld Collection, London and the final version is in the collection of the Rijksmuseum Kröller–Müller, Otterlo, the Netherlands. According to Gustave Coquiot, the subject was inspired by dancers performing the quadrille or chahut at the Concert de l'Ancien Monde, one of several café–concerts which Seurat frequented in Montmartre in the late 1880s. The earlier study differs by the inclusion of only three dancers (one may have been lost when the canvas was cut down), by its more predominantly green tonalities and by the squaring of the dark painted border at the top. In the development from first study to final composition, the touches of paint become progressively finer, details multiply and become sharper and elements such as the artificial lights are made more stylized and decorative.

Infra–red photographs reveal that the canvas was first covered with a grid–like network of lines. This formed the framework on which Seurat then constructed his composition, carefully developed in accordance with his theory of the different expressive values of varying shapes, colors and directionals. *Le Chahut* and *The Circus* of 1890–91 are the clearest illustrations we have of these theories and their translation into art. Seurat cast his themes from the world of urban entertainment into compositions which, with their lively rhythms, upward–moving lines and curves and brilliant color, project the gaiety and charm integral to the subject matter and thus mark a development away from Seurat's earlier, more solemn and ponderous style.

Pentimenti show that during work on this canvas Seurat repositioned both the conductor's arm and the fan held by the first dancer. There is a light image of the fan in a more upright position, and the conductor's arm originally intersected the bow of the bass viol. The top border, originally squared-off, was reworked at the corners so as to curve slightly downward. The painted outer frame is probably by Seurat himself.

S.N.

Born in Paris, GEORGES SEURAT took drawing lessons as a school boy and studied at the Ecole des Beaux–Arts under Henri Lehmann from 1878 to 1880. His classical academic training was soon modified by a knowledge of the work of Camille Corot and Jean–François Millet, and by 1883, the impact of the Impressionists was visible in his paintings. He exhibited *Bathing at Asnières* in 1884 at the first Salon des Indépendants which he helped to organize. He met Paul Signac in 1884. Under the influence of the color theories of Eugène Delacroix, M.E. Chevreul and Ogden Rood, he developed the Neo–Impressionist or Divisionist style, first crystallized in *La Grande Jatte* of 1884–86. He exhibited every year with the "Indépendants," and with "Les XX" in Brussels in 1887, 1889, and 1891. Seurat worked generally at the sea coast during the summer and in Paris the remainder of the year. He died in Paris at the age of thirty–one.

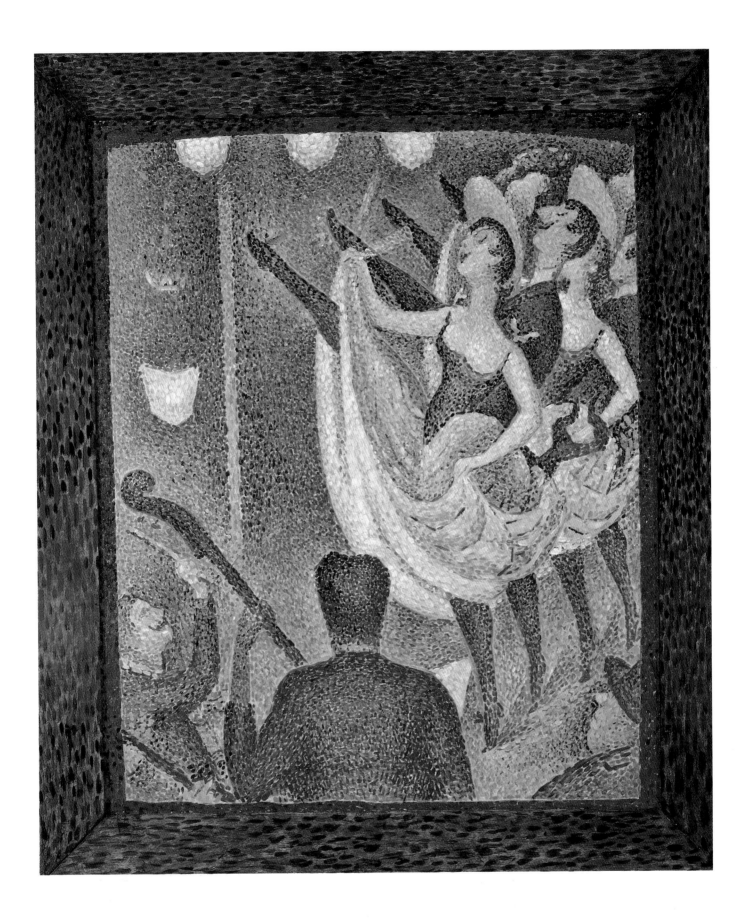

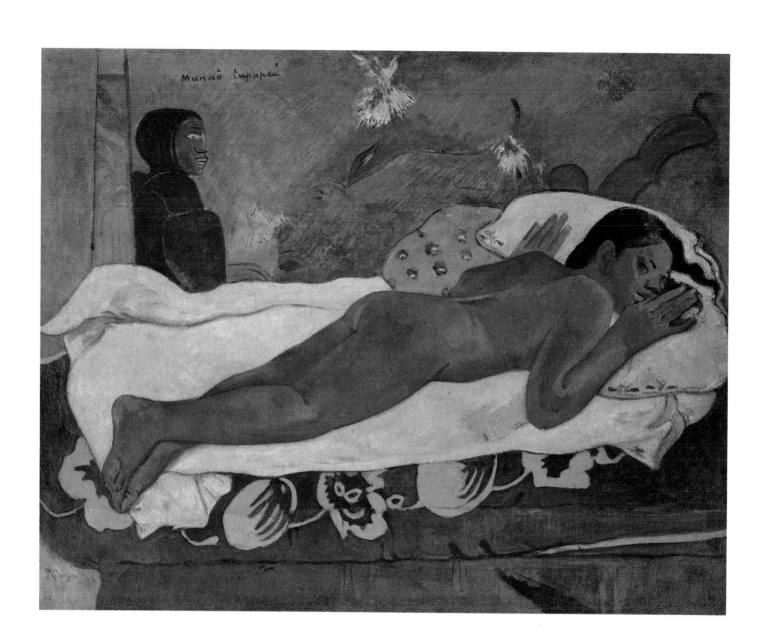

Spirit of the Dead Watching, 1892

Oil on burlap mounted on canvas
28½ x 36⅜ (72.4 x 92.4)
A. Conger Goodyear Collection, 1965

Born in Paris, PAUL GAUGUIN spent four years as a small child in Peru where his father had been forced into political exile. He returned to France at the age of seven and was raised in Orléans; at seventeen he went to sea in the merchant marine. In 1871, he joined a brokerage house and two years later married a bourgeois Danish girl who bore him five children. An amateur painter, he was interested in Impressionist painting, which he collected. He met Cézanne, Degas and Camille Pissarro, who particularly encouraged his growing involvement with painting. During the financial panic of 1883 he lost his job which led him eventually to separate from his family and dedicate himself entirely to his art.

In 1886, he made the first of several visits to Pont–Aven in Brittany where he worked in a pseudo–Impressionist style derived from Pissarro. After a brief trip to Panama and Martinique in 1887, he returned to Pont–Aven where he remained from February to October 1888. In this decisive period, together with Emile Bernard, he developed the theory and practice of Synthetism and Cloissonism, a flattened, outlined decorative style. After a brief time in Arles with van Gogh (October to December 1888) he· returned to Brittany, first to Pont–Aven and later to Le Pouldu. On April 4, 1891, he left for Tahiti. Poverty forced him to return to France in 1893. In 1895 he returned to Tahiti where, despite the peaceful and idyllic climate, he grew sick and in 1898 unsuccessfully attempted suicide. In 1901 he left Tahiti for the Marquesas Isles where he died.

Gauguin provided two different interpretations of this compelling nocturnal scene with its reclining nude and mysterious background figure. The more sensational explanation, written several years after the execution of the painting, recounts Gauguin's return to his hut as Mataiea late at night to discover his native mistress prostrate with fear. It has recently been established that this account was almost entirely fictional, designed to make Gauguin's work more comprehensible in France and actually based on a scene in Pierre Loti's *Mme. Chrysanthème*, a book known to have been in the artist's possession.

The more factual and substantive account appears first in letters from Gauguin to his wife Mette and friend Daniel de Monfried in 1892, and subsequently reappears with some variants in his early manuscript *Cahier pour Aline* under the title "Genèse d'un Tableau."

It is, of course, fear of a tupapau (a spirit of the dead). The Kanakas are much afraid of them and always leave a lamp lit at night. Nobody will venture out on the road when the moon is down without a lamp— and even then nobody will ever go alone. As soon as this idea of a tupapau has occurred to me, I concentrate on it and make it the theme of my picture. The nude thus becomes subordinate.

How does a native woman envisage a spectre? She has never visited a theatre or read novels. When she tries to imagine one, therefore, she has to think of some person she has seen. So my spectre is just like an ordinary little woman stretching out her hand as if to seize the prey. My feeling for the decorative leads me to strew the background with flowers. These are tupapau flowers (i.e. phosphorescent lights) and show that the spectres take an interest in us humans. That is the Tahitian belief. The title Manao Tupapau ("Thought or Belief and the Spectre") can have two meanings: either she is thinking of the spectre or the spectre is thinking of her.

Let me sum up. The musical composition: undulating lines, harmonics of orange and blue connected by the secondary colours of yellow and violet, and lit by greenish sparks. The literary theme: the soul of the living woman united with the spirit of the dead. The opposites of night and day.

But otherwise it is simply a nude from the South Seas.

This painting was particularly favored by Gauguin and its motif appears, either identically or in reverse, in several of his later works.

K.K.

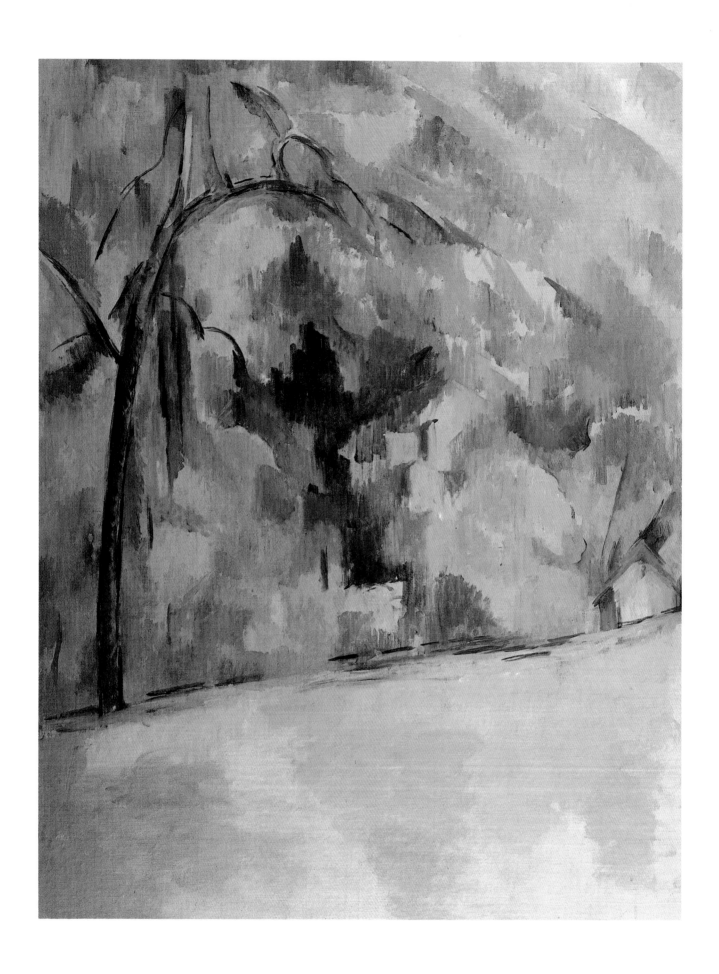

PAUL CÉZANNE
French, 1839–1906

Morning in Provence (Sous–Bois Provençal), c. 1900–06

Oil on canvas
32 x 24⅞ (81 x 63)
Gift of Mr. and Mrs. Charles A. Ribbel through the Frank E. Ribbel Bequest, 1936

Born in Aix–en–Provence, the son of a hat dealer who became a wealthy banker, PAUL CÉZANNE formed a close friendship with the writer Emile Zola while the two were schoolboys in Aix. Cézanne's father wanted him to become a lawyer, but even while studying at the university he attended classes at the local academy. In 1861 he finally received permission to study art in Paris. He failed the examination for admission to the Ecole des Beaux–Arts in 1862, but frequented the Académie Suisse and came to know older artists such as Camille Pissarro. Cézanne contributed in 1863 to the Salon des Refusés. His early work—imaginary themes treated in a dark and romantic manner—gave way during the 1870s to Impressionism, out of which he developed a new formalist style blending intense observation and abstract composition. He exhibited at the first Impressionist show in 1874. He divided his time between Paris and Provence, but settled permanently in Aix in 1899. A large exhibition of his work organized by Ambroise Vollard in 1895 brought belated recognition.

A small building at the right, the ground line, and two tree trunks are the only defined objects in this landscape of brilliant, dappled color. Lionello Venturi's date of 1900–06 holds for the present, since the chronology of Cézanne's late works, produced when he was living and painting in seclusion at Aix–en–Provence from 1899 to 1906, has yet to be defined. In contrast to the earlier, highly architectural compositions, Cézanne's late paintings are generally more open, sparsely composed and more permeated with a sense of light and air. The handling of oil paint in these works often closely approaches his watercolor technique. Thin washes of color are laid on in broad patches, with the uncovered white ground exposed in many areas for accent and luminosity. There is no relief from impasto; contours, when they appear, are fragmented or opened–up. A sense of the third dimension comes not from perspective or foreshortening, but rather, from contrasting tonalities and unequal degrees of brightness. The general effect is one of exuberance and dazzling light.

S.N.

HENRI DE TOULOUSE–LAUTREC
French, 1864–1901

Woman Lifting her Chemise (Femme retroussant sa chemise), 1901

Oil on wood panel
22 x 16⅝ (56 x 42.2)
Gift of A. Conger Goodyear, 1956

Extending social realism one step beyond the café society pictured by Edouard Manet and Degas, Lautrec's paintings, beginning about 1892, explored the cloistered, unsavory world of Montmartre brothels, recording without moral comment the daily lives of its inhabitants. Here a prostitute hoists up her slip, possibly in preparation for the examination routinely made by Parisian health officials, a subject Lautrec had dealt with in several earlier works. At the right is a bed; at the left a mirror and mantelpiece on which sit a large clock and candlesticks. The furnishings are fluidly painted in dark shades of blue and blue–green over a thin primary wash, left untouched to form the background wall at the right. The figure, her hair auburn and her slip white, is bathed in a dim light tinged by the blue–green tones of the interior.

This picture was painted during the last year of Lautrec's life, probably after his return from Bordeaux to Paris in April. It shows some evidence of the loss of incisive touch brought about by his accelerating mental and physical deterioration. The expressive brushed passages, particularly at the lower right, hint at personal turmoil.

S.N.

HENRI RAYMOND DE TOULOUSE–LAUTREC–MONFA was born in Albi in 1864 into one of France's oldest aristocratic families. Two childhood accidents in which he broke both legs left him permanently deformed but, by depriving him of other pastimes, encouraged him to pursue his artistic inclinations. He worked ardently at painting and drawing and in 1882 went to Paris to study first under René Princeteau and then Léon Bonnat and Fernand Cormon. The primary influences on his style, however, were the Impressionists, Degas and Japanese prints. He is known for his incisive recording of café society, celebrities and modern urban entertainments. Although trained as a painter, Lautrec's fame rests as much on his prints and posters, with their bold use of strong color and flat, arabesque design. He exhibited frequently at the Salon des Indépendants and had an important one–man show at the Goupil gallery in 1893. Lautrec's art tends to mask the torment of his personal life, which led eventually to severe alcoholism and a mental breakdown. He died in 1901 at thirty–seven.

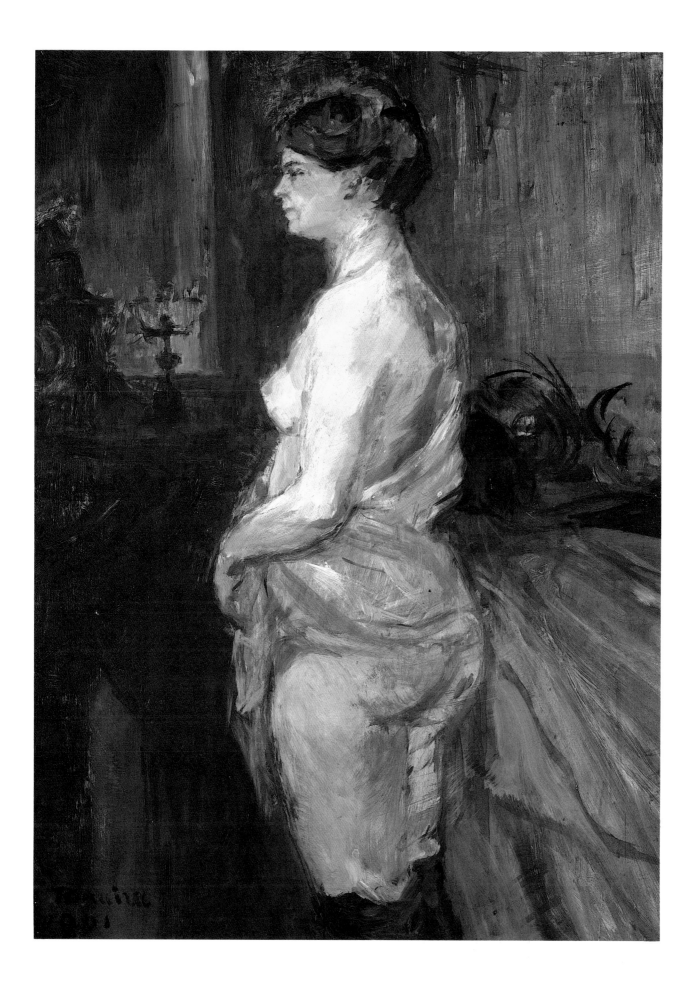

Henri Matisse
French, 1896–1954

A Glimpse of Notre Dame in the Late Afternoon (Notre–Dame, une fin d'après–midi), 1902

Oil on paper mounted on canvas
28½ x 21½ (72.5 x 54.5)
Gift of Seymour H. Knox, 1927

From February 1899 until 1907 Matisse and his wife lived in an apartment at 19 Quai St. Michel overlooking the Seine and the Ile de la Cité. From their window could be seen to the west the Palais de Justice and the Pont St. Michel, and to the east the facade of Notre Dame cathedral, views which Matisse painted many times over a period of fifteen years in varying stylistic modes. The Gallery's version differs significantly from earlier ones in a new confidence of composition and an absence of the shimmering Impressionist brushwork common among other versions, being rendered instead in broad flat areas of liquid pigment. The colors, ranging from violet and greyish–purples to blue–green, as well as the technique and the Japanese–like perspective are reminiscent of J.M. Whistler, although throughout there is a boldness of simplification and handling anticipating Matisse's Fauve development. Space is still rendered in traditional terms, with strong diagonals providing a visual path of recession, and there is a convincing sense of late–afternoon light and atmosphere, but newly prominent is the interest in closely related hues creating a solidly structured, abstract composition accentuated by the bold verticals of window jamb and shutter at the right.

S.N.

Born at Le Cateau–Cambresis, Henri Matisse studied law in Paris from 1887 to 1888; in 1889, however, he decided upon an art career and joined the drawing class at the Ecole Quentin–Latour. He also received training from William Bouguereau at the Académie Julian. In 1892, he began work in the studio of Gustave Moreau; soon after, he met Albert Marquet and Georges Rouault, exhibited at the Salon de la Société Nationale des Beaux–Arts in 1894 and was elected an associate in 1896. The next year, he met Camille Pissarro and came under the influence of Impressionism. Together with André Derain and Maurice de Vlaminck, Matisse led the group dubbed "Les Fauves" at the 1905 Salon d'Automne and developed an art of extreme color intensity. He took up sculpture and printmaking and received a great deal of support for his early work from Ambroise Vollard, the Steins and S.I. Shchukin. Matisse often worked at Collioure in the south of France and visited Spain, Moscow and Tangier; from 1916 on, he generally wintered in Nice. In 1920, he designed costumes and sets for Serge Diaghilev's ballet *Le Rossignol*. He also provided illustrations for numerous publications and in 1930–33, designed decorations for the Barnes Foundation in Merion, Pennsylvania. His late works include many large and colorful collages and decorations for the Chapel of the Rosary at Vence.

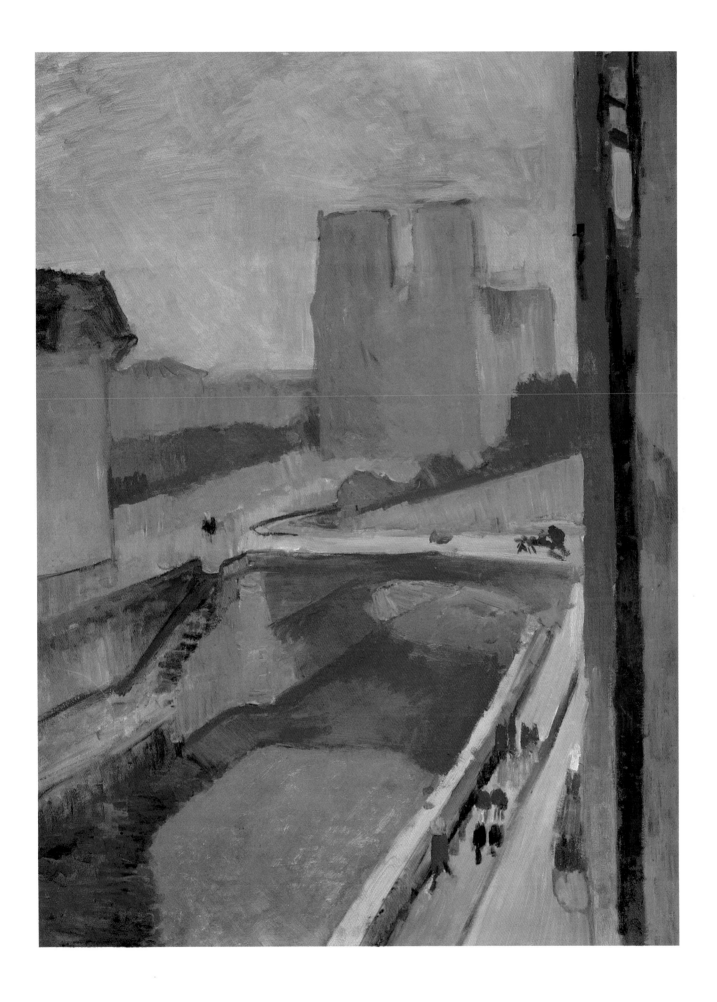

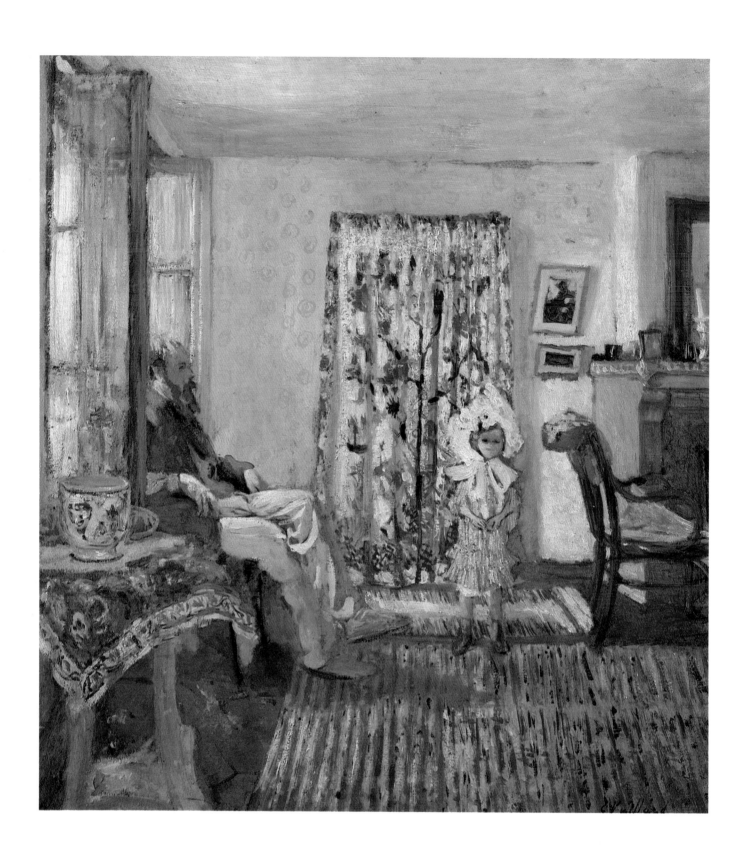

The Painter Ker–Xavier Roussel and his Daughter, 1903

Oil on cardboard
22⅞ x 21 7/16 (58 x 54.5)
Room of Contemporary Art Fund, 1943

Born in Cuiseaux in east central France, JEAN–EDOUARD VUILLARD moved with his family to Paris in 1877. In 1884 at the prestigious Lycée Condorcet he met K.X. Roussel, Maurice Denis and Aurélien Lugné–Poë, who soon became a leading avant–garde force in the theater. In 1886 he entered the Ecole des Beaux–Arts, but left two years later for William Bouguereau's class at the Académie Julian. Here he met the painters Pierre Bonnard and Paul Serusier who, together with Roussel, Denis and others banded together in 1890 under the name "Nabis." Much of his earliest work consisted of set and program designs for the theater and large mural decorations for the homes of bourgeois patrons. About 1896 he made his first lithograph. From 1903–14 he exhibited fairly regularly in Paris, but for the next thirty years, until a large selection of his work was included in a 1936 exhibition commemorating Symbolism, he preferred to avoid public exposure. In 1913 he visited London and Holland with Bonnard and in 1930 traveled briefly to Spain. In poor health, he fled the advance of the Germans and died in June 1940.

Unlike the other Symbolists and Nabis with whom he was associated at the beginning of his career, Vuillard never took his subject matter from the realm of the exotic, dreamlike or unfamiliar. He consistently chose themes and models close at hand, as in this painting of his best friend and brother–in–law, Ker–Xavier Roussel with his young daughter Annette, caught in a quiet moment at the Roussels' home near Mantes, west of Paris.

As in much of Vuillard's early easel work, oil paint is applied on cardboard. Vuillard originally adopted this technique for reasons of economy, since cardboard was more cheaply available than canvas, but he soon appreciated the manner in which the absorbent material soaked up the paint to create a tight and closely knit surface.

The multiplicity of pattern and detail in the calm, light–filled interior is prevented from becoming busy or overcrowded by Vuillard's careful organization of the surface. Architectural details, furniture and figures are all deliberately placed either parallel or perpendicular to the picture plane, constructing a clearly readable space. Furthermore, his short summarizing brushstrokes unify the surface while drawing upon prevailing Symbolist theory that the mere suggestion of an object or situation often produced a more powerful emotional impression than the careful description of it. Like Proust's novels, Vuillard's subtle evocation of the comfortable middle–class interior rises above the familiarity of its component elements.

K.K.

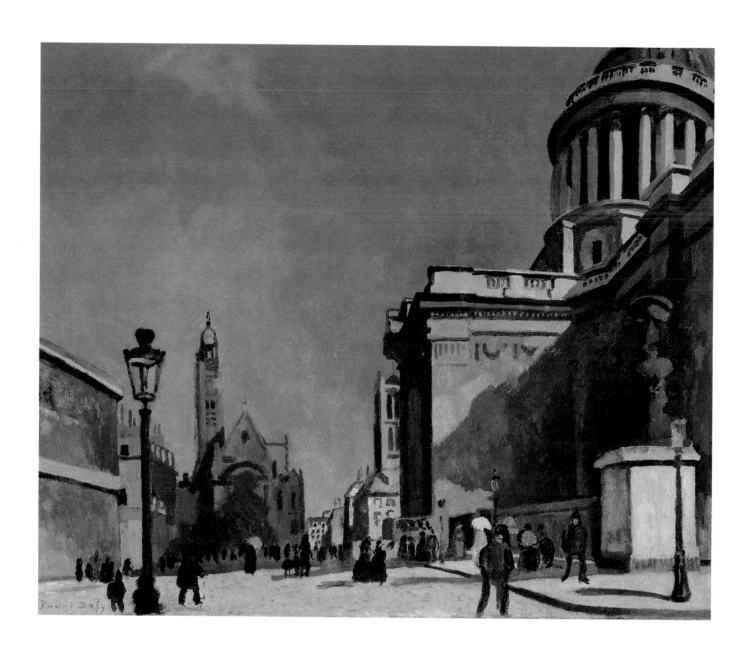

RAOUL DUFY

French, 1877–1953

Le Panthéon et Saint–Etiènne–du–Mont, c. 1903–06

Oil on canvas

25½ x 31¼ (65 x 79.5)

By exchange, George B. and Jenny R. Mathews Fund, 1980

Bequest of A. Conger Goodyear and Gift of Colonel Charles Clifton

RAOUL DUFY was born in Le Havre in 1877 and in 1891 went to work for a coffee import firm overlooking the harbor, which became a frequent subject of his later work. In 1892, he attended the Ecole Municipal des Beaux–Arts, where his colleagues included Othon Friesz and Georges Braque. Although his training was academic, he painted portraits and plein–air landscapes influenced by Boudin and the Impressionists through 1898, when he served in the military. In 1900, he joined Friesz in Paris and studied for two years at the Ecole Nationale des Beaux–Arts under Léon Bonnat. After seeing the Fauve paintings in the Salon d'Automne of 1905, Dufy was greatly impressed by their use of color and subsequently worked and exhibited with the group until its dissolution in 1907. With Braque, he painted at l'Estaque in the summer of 1908 and was influenced largely by the work of Cézanne and Cubism through 1920. A trip to Munich in 1909 kindled his interest in Expressionism and folk arts while an extended stay in Vence in 1919 further intensified the color of his palette. He created thousands of fabrics for couturier Paul Poiret and the Bianchini–Férier silk factory, designed for the stage, and created tapestries, furniture, ceramics and murals. He initiated the loose calligraphic style with flat overlays of color typical of his later work in the early twenties, and in 1922 began to work increasingly in watercolor. Dufy became known largely for his fashionable, vibrant renditions of regattas, racetracks and musical themes, and traveled extensively from 1923–39. He was afflicted by debilitating arthritis in the late thirties, and was confined to a wheelchair for the last decade of his life.

In the airy *Le Panthéon et St. Etiènne–du–Mont,* Dufy infused the urban scene with light and magnificent color, creating an image far removed from the activity of the city streets. With shadows composed of sumptuous colors and contrasts, the painting remains closely tied to Dufy's early Impressionism, still the dominant mode of the time. Painted a few years after Dufy's arrival in Paris from his native Normandy, the view here is orderly and reposed, framed by the massive blocks of architectural monuments. The Bibliothèque Ste. Geneviève is at the right; the Panthéon, which housed painting by his teacher Léon Bonnat, is on the left, seen facing east towards the late gothic church St. Etiènne–du–Mont, the Rue Clovis and the enclosure of the surrounding streets bordering the open *place,* which is located to the east of the Jardin du Luxembourg on the highest ground of the left bank. The predominant blue expanse, with subdued inflections, is reminiscent of the skies in his earlier coast scenes, yet also foretells of the import of this color, in which Dufy reportedly painted his studio walls and which became a signature hue of his oeuvre.

S.K.

Thomas Eakins
American, 1844–1916

Music, 1904

Oil on canvas
39¾ x 49¾ (101 x 126.5)
George Cary, Edmund Hayes and James G. Forsyth Funds, 1955

Painted in 1904, *Music* exemplifies the sober, penetrating portrait style Eakins developed early in his career and represents one of his most personal contributions to the history of American art.

When Eakins lacked commissions, he often had friends, relatives and professional acquaintances pose for his portraits. The violinist in *Music* is Hedda van der Beemt, of the Philadelphia Orchestra, and the pianist is Samuel Myers. On the wall behind them, in tribute to past traditions, hangs a reproduction of J.M. Whistler's portrait of the celebrated Spanish violinist Sarasate. The two central figures, although self–absorbed and facing away from each other, are unified by the joint effort of making music and by the pyramidal design and homogeneity of dark, warm tones. Only the hands and face of the violinist are highlighted within the otherwise shadowy atmosphere of browns and black. The strongly evoked solemn, contemplative mood is a consistent 'one in Eakins' depictions of musical themes.

Although not previously noted in the literature on Eakins, it seems likely that the ideas underlying his music pictures derive in part from the work of Edgar Degas. There are remarkable compositional and expressive affinities, for example, between Eakins' *The Zither Player*, 1876 and *Professionals at Rehearsal*, c. 1883 and Degas' portrait of his father listening to Pagans play the guitar, the first version of which dates from the time of Eakins' sojourn in Paris. Similarly the *Mlle. Fiocre dans la Ballet 'La Source'* exhibited by Degas at the Salon of 1868, depicts the type of musical reverie found in several of Eakins' later works. It is also possible that Eakins knew and drew inspiration from Winslow Homer's *Amateur Musicians* of 1867.

S.N.

Born in Philadelphia, Thomas Eakins studied drawing at the Pennsylvania Academy and anatomy at Jefferson Medical School during the years 1861–66. In September 1866 he traveled to France, where he studied with Léon Gérôme at the Ecole des Beaux–Arts. He made trips to Italy and Germany and, in 1869, to Spain where he was particularly impressed by Jusepe de Ribera and Diego Velazquez. In 1870 he returned to Philadelphia, where he spent the rest of his life. His earliest works were genre scenes and portraits of friends but in 1875 he completed his large and important *Gross Clinic*, which surrounded his name with scandal. Eakins taught classes in anatomy at the Pennsylvania Academy from 1876 but resigned in 1886 to teach at the newly organized Philadelphia Art Students League. He joined the Society of American Artists in 1880 and was elected to the National Academy of Design in 1902. He experimented with photography and also did some sculpture. Eakins received a number of awards and honors but the full import of his powerfully realistic work was not recognized until after his death.

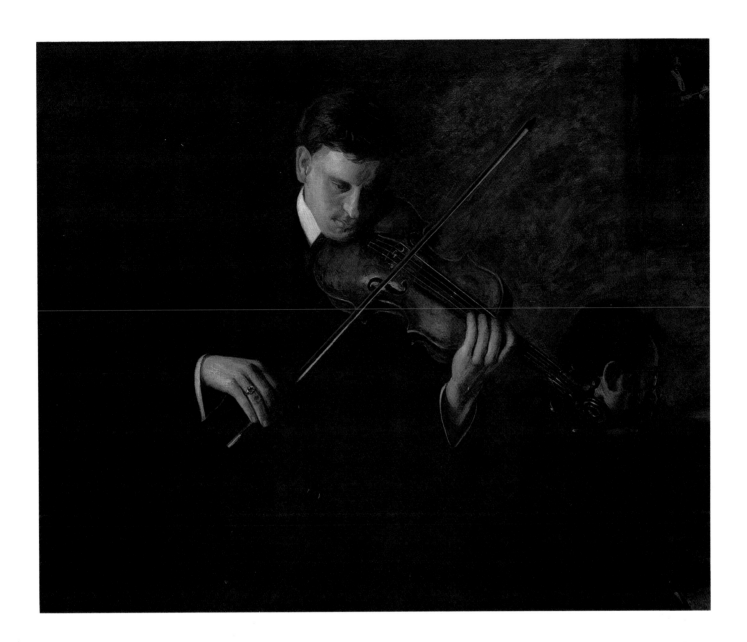

PABLO PICASSO
Spanish, 1881–1973

La Toilette, 1906

Oil on canvas
59½ x 39 (151 x 99)
Fellows for Life Fund, 1926

Picasso's enduring interest in classical art received its most complete early expression in works from his so–called "Rose Period," 1905–06. Influenced by Greek sculpture in the Louvre and the work of Cézanne and Puvis de Chavannes, as well perhaps by Jean Moréas' classical literary revival, he developed a classicizing style whose serenity and noble, sculpturesque forms countered the pathos and mannerism of his earlier "Blue Period." It reflected, as well, a new stability in his personal life and an intuitive understanding of the dignity of Greek art. This style culminated in Picasso's compositions produced during a three–month stay at Gosol in the Spanish Pyrenees in the summer of 1906, principal among which is *La Toilette*.

Seemingly part of some remote and timeless world, two statuesque figures stand in an empty, sun–warmed landscape performing the intimate ritual of a woman's daily toilet. Although hieratically placed, the figures are unified by the fitting together of their silhouettes, the paths of their vision and a pattern of balanced opposites: upward vs. downward gesture, movement vs. immobility, the naked vs. clothed body, warm pink vs. chill blue color and an open and alluring vs. introverted, chaste appearance.

Comparisons with Picasso's many portraits of his mistress and model, Fernande, indicate that it is she represented here in both of the figures. This suggests that Picasso intended to portray the dualistic components of Fernande's personality, her sensuous and extroverted side contrasted with her inward, impassive, more domestic side. *La Toilette* seems to comprise a type of vanitas lesson, celebrating sexuality while also exhorting self–examination and contemplation of the transience of beauty.

S.N.

PABLO RUIZ PICASSO was born in Malaga, Spain. His father was a drawing instructor, and as a youth Picasso showed precocious artistic talents. He studied at the Escuela de Bellas Artes of Barcelona, 1895–97, and then the Real Academia de Bellas Artes de San Fernande, Madrid. He visited Paris in 1900 and settled there in 1904 but returned frequently to Spain for summers. Progressing through various fin–de–siècle influences he arrived about 1902 at the moody, expressive style of his "Blue Period," to be followed in 1905 by his more classical "Rose Period." He was introduced in 1907 by Guillaume Apollinaire to Georges Braque, with whom, in close collaboration, he developed Cubism. He worked within the Cubist vocabulary for about ten years, applying it to both paintings and, 1912–14, to three–dimensional constructions. Between 1917 and 1924 Picasso designed costumes and decor for several Diaghilev ballets. The early twenties saw a return to a monumental Neo–classical manner, followed by a Surrealist period, c. 1925, into the thirties. His diagrammatic style of this decade climaxed with the celebrated *Guernica* of 1937, inspired by the bombing of the defenseless Spanish town of that name during the Spanish Civil War. Picasso refused for political reasons to return to Spain under the Franco military regime. He moved from Paris to the south of France in 1948 and remained enormously inventive in painting, sculpture, graphics and ceramics until his death.

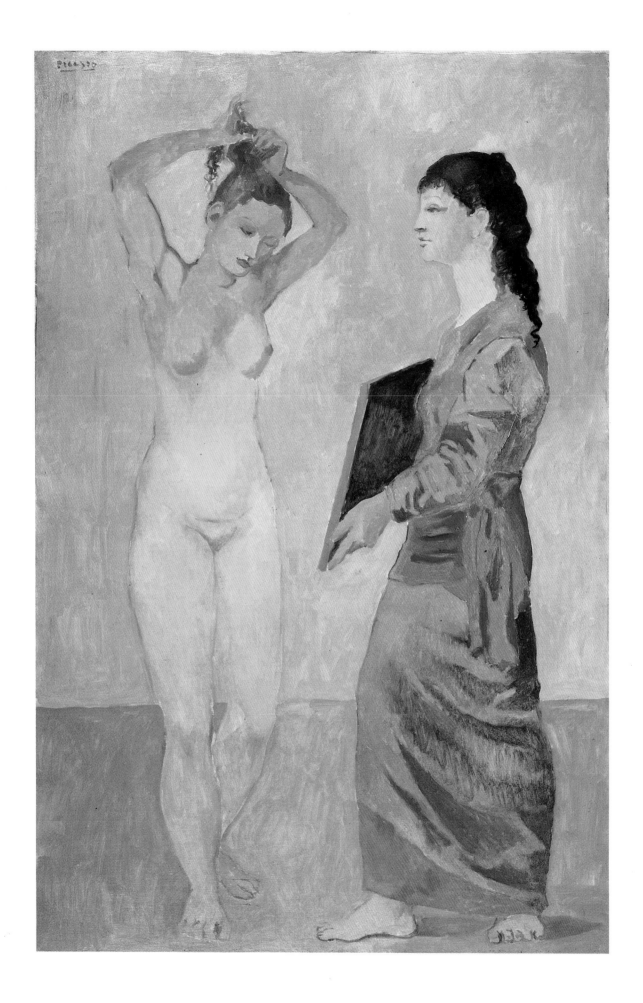

ANDRÉ DERAIN
French, 1880–1954

The Trees (Les Arbres), c. 1906

Oil on canvas
23⅜ x 28½ (59.5 x 73)
Gift of Seymour H. Knox in memory of Helen Northrup Knox, 1971

This brilliant light–filled landscape entered the Albright–Knox Art Gallery collection with an attributed date of 1904 but almost certainly derives from the period 1905–06 when Derain's Fauve style was at its height. A scarcity of reliable documentation from this period and the fact that Derain rarely dated his canvases make the tracing of his early chronology problematic. This painting, however, and two closely related compositions in the Zacks Collection of the Art Gallery of Ontario and San Francisco Museum of Art display the elongated, rectangular brushwork, the vivid color and movement and the free use of complementaries which typify Derain's style following his summer of work with Matisse at Collioure in 1905. It is likely that this canvas represents an intermediate state of development between the sketchier San Francisco *Landscape*, generally dated 1905–06 and the more concretely defined *Trois Arbres, L'Estaque* in Toronto, ascribed to 1906.

The basic composition of this work, with a row of undulating trees painted mostly in red against a brightly patterned landscape, reappears not just in Derain's work but became, in fact, a leitmotif treated by all the major Fauves, including Matisse, Maurice de Vlaminck and Georges Braque. It seems to have been popular as a theme which celebrated the joys of the warm southern landscape and allowed for personal improvisations of color and line. The Neo–Impressionist Henri–Edmond Cross had painted similar arabesques of trees in bright hues and the idea can be traced back even farther to the work of van Gogh and Gauguin, but only with the Fauves is the composition rendered with a chromatic brilliance completely liberated from the function of naturalistic description.

S.N.

Born at Chatou, France, the son of a well–to–do pastry cook, ANDRE DERAIN began painting c. 1895 and studied at the Académie Carrière in Paris, 1898–99. He met Vlaminck, with whom he shared a studio, and Matisse in 1900. His early, coloristically expressive work shows the influence of van Gogh, Cézanne and then Matisse. He attended classes at the Académie Julian in 1904 and in 1905 exhibited at the Salon d'Automne in the famous "Fauve" exhibition. His London series date from 1905 and 1906. Placed under contract by well–known gallery dealer Daniel–Henry Kahnweiler in 1907, he executed his first stone sculptures the same year. After the rather short–lived Fauve movement, his work passed through Cubist, naturalistic and classicizing phases. In 1919, he produced stage designs for Serge Diaghilev. Derain generally wintered in Paris and summered in the south of France.

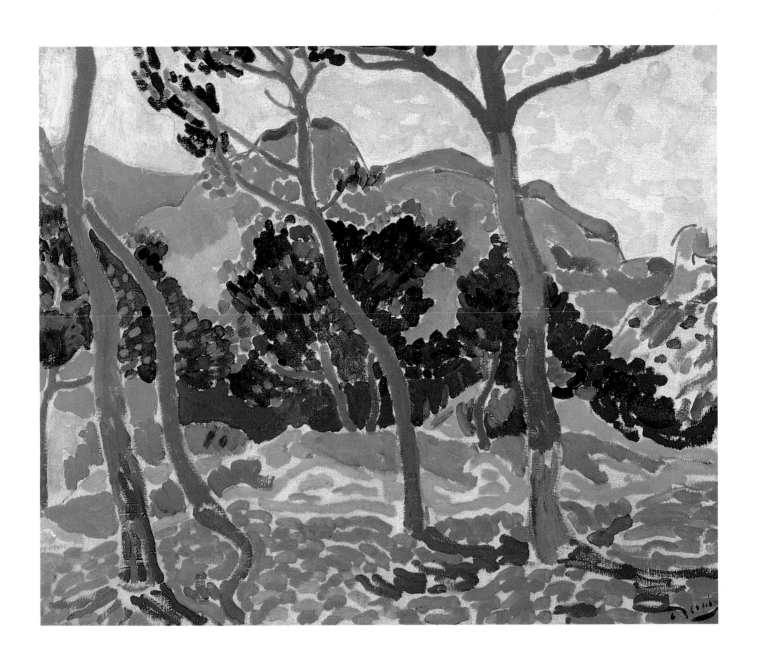

Henri Rousseau
French, 1844–1910

Flowers in a Vase (Nature morte), 1909

Oil on canvas
17⅞ x 12⅞ (45.4 x 32.7)
Room of Contemporary Art Fund, 1939

Although the majority of Rousseau's documented flower paintings date relatively late, he is thought to have worked in this genre throughout his career. Still lifes not only offered a pleasant diversion from more ambitious subject painting but also were saleable and of natural attraction for a colorist such as "Le Douanier." The strict frontality of his flower paintings, the superimposition of clear, solidly colored forms, one against the other, and the restricted, flattened space are all symptomatic of a vigorous, direct approach which seems to derive its abstractness from folk or "primitive" art. The overall unity of the image, however, and the tightly coordinated rhythms of line and shape bespeak a highly sophisticated natural talent. Thanks to Rousseau's careful rendering of each flower and leaf, the different varieties comprising the bouquet are all recognizable, including peonies, tulips, daisies, mimosa, acacia and forget–me–nots. The surface is smoothly and evenly brushed but is sometimes interrupted to allow the white preparatory ground to show through as a texturing element.

C.K.

Born in Laval in northwestern France, Henri Rousseau began law studies but while working as an attorney's apprentice, attempted a small perjury and sought refuge in the army. From 1871 to 1885 he occupied the post of a minor inspector at a toll station on the outskirts of Paris, giving rise to his nickname "Le Douanier" or "Customs Officer." After 1885 he devoted himself fully to painting. Almost entirely self–taught, he applied his naive or primitive style to portraits, still lifes, landscapes and scenes from the imagination, and is best known for his large and exotic jungle pictures. He first exhibited at the Salon des Indépendants in 1886 and participated regularly until 1910 (except in 1899 and 1900); he also showed at the Salon d'Automne in 1905, 1906 and 1907. In his later years Rousseau became associated with a group of younger progressive artists who admired him greatly. Immediately after his death a large retrospective was held at the Salon des Indépendants, conclusively establishing his reputation.

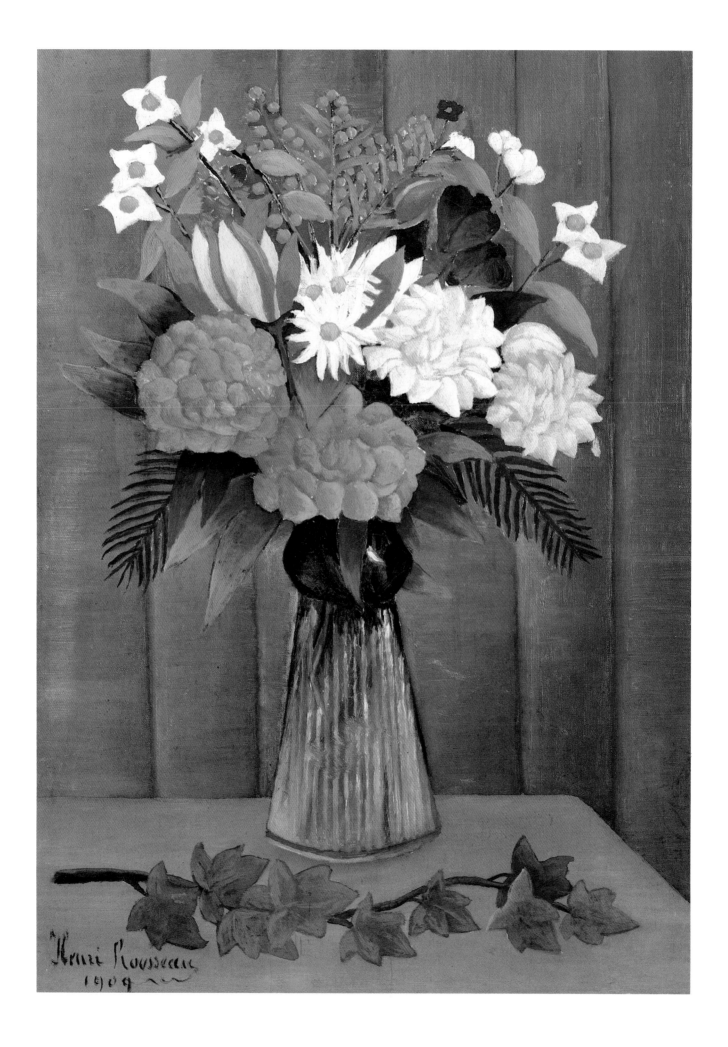

PABLO PICASSO
Spanish, 1881–1973

Nude Figure, 1909–10

Oil on canvas
39 x 30¾ (99.1 x 78.1)
General Purchase Funds, 1954

The pose of a standing female nude with upraised arm bent over her head is familiar in Greek art as well as 19th–century odalisque scenes and has been characterized by Max Kozloff as one of "voluptuous abandon." This figure appears with surprising frequency for a brief period in Picasso's work beginning about 1905. The pose is particularly marked in several early studies for the celebrated prostitutes of the *Demoiselles d'Avignon* of 1907 and continues through the Gallery's *Nude Figure*, providing a useful touchstone for the gradual articulation of his fully formulated Cubist style. This work appears to derive from a 1908 oil, *Bather*. A nude with drapery is placed in a barely suggested landscape with the horizon line cutting the composition at the level of the emphatically rounded buttocks. An echo of this line is preserved in the marked horizontal at the same level in this painting.

Although the painting is not dated, it is possible on stylistic grounds to place it chronologically in the winter of 1909–10. Two drawings of nudes with upraised arms and twisted torsos must be considered preparatory works, if not actual studies, for the final painting. The sober browns and greens characteristic of the preceding "Horta Period" (May–September 1909) are preserved along the left margin and in the lower right corner. The splintering of form is not nearly as advanced as in later 1910 portraits and figure studies; it is still possible, in fact, to decipher a number of anatomical details. A full-bodied, sculptural quality is retained, particularly in the jutting wedge–like torso, and some degree of spatial recession is suggested by the lightened vertical rectangle to the left. Yet the transparency of bleeding of planes, a technique derived from Cézanne, begins to create a flattened and ambiguous space. The lack of resolution at the head suggests that the painting is a transitional work, as Picasso moved away from the rounded and expressive forms of the years 1907–09, when the influence of African sculpture is often felt, toward the more abstract and intellectual statements of his fully realized Analytic Cubist style.

K.K.

PABLO RUIZ PICASSO was born in Malaga, Spain. His father was a drawing instructor, and as a youth Picasso showed precocious artistic talents. He studied at the Escuela de Bellas Artes of Barcelona, 1895–97, and then the Real Academia de Bellas Artes de San Fernande, Madrid. He visited Paris in 1900 and settled there in 1904 but returned frequently to Spain for summers. Progressing through various fin–de–siècle influences he arrived about 1902 at the moody, expressive style of his "Blue Period," to be followed in 1905 by his more classical "Rose Period." He was introduced in 1907 by Guillaume Apollinaire to Georges Braque, with whom, in close collaboration, he developed Cubism. He worked within the Cubist vocabulary for about ten years, applying it to both paintings and, 1912–14, to three–dimensional constructions. Between 1917 and 1924 Picasso designed costumes and decor for several Diaghilev ballets. The early twenties saw a return to a monumental Neo–classical manner, followed by a Surrealist period, c. 1925, into the thirties. His diagrammatic style of this decade climaxed with the celebrated *Guernica* of 1937, inspired by the bombing of the defenseless Spanish town of that name during the Spanish Civil War. Picasso refused for political reasons to return to Spain under the Franco military regime. He moved from Paris to the south of France in 1948 and remained enormously inventive in painting, sculpture, graphics and ceramics until his death.

S.N.

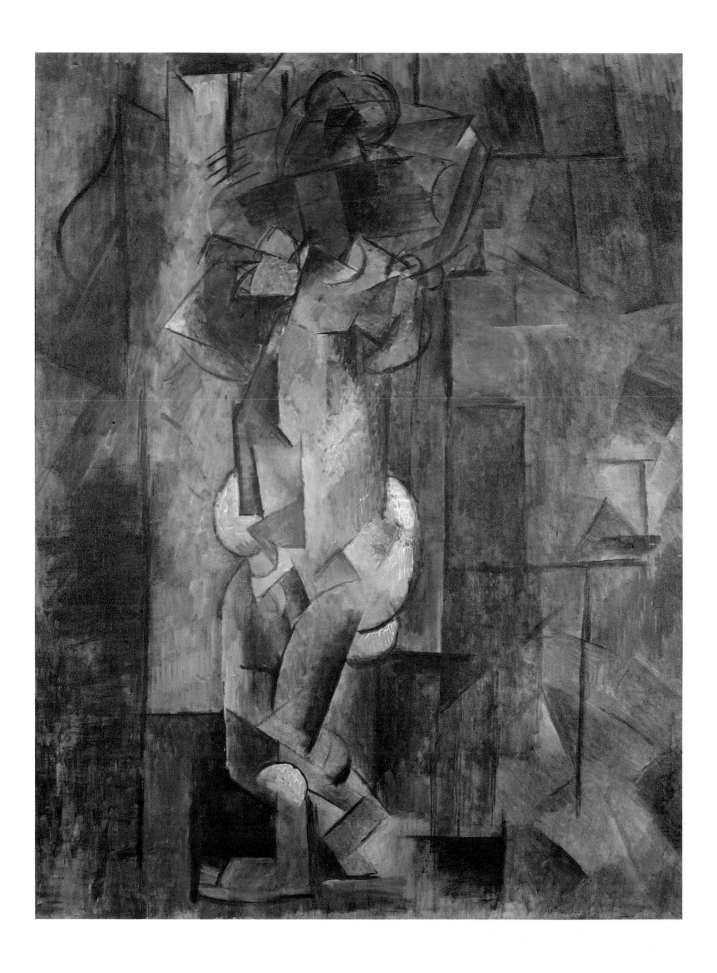

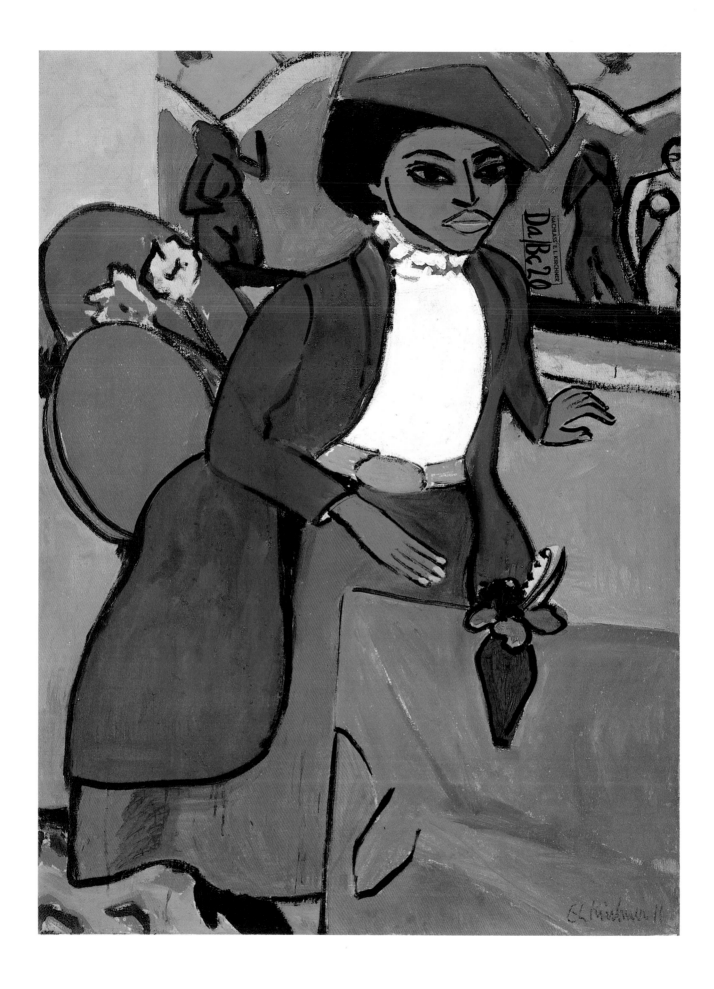

Ernst Ludwig Kirchner
German, 1880–1938

Portrait of a Woman (Frauenbildnis), 1911

Oil on canvas
46⅜ x 34⅝ (117.8 x 88)
General Purchase Funds, 1957

Born in Aschaffenburg, Germany, ERNST LUDWIG KIRCHNER was an architectural student in Dresden and Munich from 1901–04. He joined with Fritz Bleyl, Erich Heckel and Karl Schmidt–Rottluff to found "Die Brücke," a group active from 1905 to 1913. Kirchner's early style was primarily formed under the influence of Edvard Munch, the modern Viennese school and French post–Impressionism; it was given new dimensions by his interest in primitive art, leading to the development of a fervently expressionist manner, c. 1910–12. After the outbreak of World War I, he suffered a physical and nervous breakdown but continued to paint and make graphics even during treatment. In 1917, he entered a sanatorium in Davos and remained in Switzerland the rest of his life. The late twenties and early thirties witnessed his brief encounter with abstraction, derived mainly from Synthetic Cubism. Under the pressure of failing health and Nazi persecution—many of his works were confiscated from public collections in Germany and exhibited in the Munich Degenerate Art Exhibition in 1937—Kirchner committed suicide.

Portrait of a Woman, painted on the front of a double–faced canvas, is one of the major examples of Kirchner's later "Brücke style" (c. 1910–11), formed under the influence of Edvard Munch, the Fauves and primitive art, and bringing together rich surface decoration with strong psychological overtones. It is signed and dated 1911. Since however, both Kirchner and his wife Erna in their later years are known to have inscribed many early works with inaccurate dates, and since the signature on this work is in a thin, tentatively applied paint different from any other section of the canvas, the authenticity of the signature and the date of execution have been the subject of controversy.

The painting's ample forms, clear strong colors and solid outlines link it with works from the late Dresden period and support a dating to early 1911, before the move to Berlin and the ensuing shift toward more attenuated figures and more agitated contours and brushwork. D.E. Gordon notes correspondences between the Negress depicted here, with her squat proportions and pronounced buttocks, and Cameroon figure sculpture and also attributes the liberties taken with perspective to Kirchner's knowledge of Egyptian art. Negresses appear in several other works from 1910–11, as do also backdrops of African inspiration. The combination of motifs here gives particular cogency to Kirchner's primitivizing stylizations.

C.K. & S.N.

WILHELM LEHMBRUCK
German, 1881–1919

Kneeling Woman (Die Knieende), 1911

Cast stone
69¼ x 54½ x 27½ (176 x 138.5 x 70)
Charles Clifton Fund, 1938

Lehmbruck's *Kneeling Woman*, termed by the poet Theodor Daubler as "the preface to expressionism in sculpture," marks a radical departure from the classical influences which had previously predominated in his work. Its extreme attentuations of form and profound inwardness announce the stylistic path which Lehmbruck would continue to explore for the remainder of his life. A preparatory drawing for the *Kneeling Woman* shows that it was originally conceived in the more traditional stylistic idiom of the *Standing Female Figure* of 1910. It was only during work on the sculpture itself, which progressed fitfully during the summer and fall of 1911, that Lehmbruck's search for a modern spirituality in art led to the expressive distortions so prominent in the final figure. Inspiration for these changes, as often noted, derived possibly from medieval art or the sculpture of George Minne. Lehmbruck's new abstracting approach to the human form manifests itself not only in the elongated proportions but also in the emphasis on a flattened, lyrically outlined silhouette and the rhythmic linear patterns within that outline. The ethereal qualities evoked, together with the introverted gesture, bowed head and supplicating pose, all dramatize the figure's inner spiritual life and give to her a solemn, melancholic presence.

C.K.

Born in Meiderich, Germany, WILHELM LEHMBRUCK attended the School of Arts and Crafts in Dusseldorf from 1895 to 1899 and studied sculpture at the Dusseldorf Academy from 1901 to 1906. As a student he was awarded several prizes for his work executed in an academic, highly traditional vein. He lived in Paris from 1910–14, where he was befriended by Alexander Archipenko, Matisse, Amedeo Modigliani and Picasso and was particularly influenced by Aristide Maillol. He exhibited at the Salon de la Société Nationale des Beaux–Arts, Paris, 1907–11, the Salon d'Automne in 1910, 1911, and 1914, and the Armory Show of 1913. Under the influence of George Minne and northern medieval sculpture, Lehmbruck developed a style which expressed, through angular, attenuated figures, a sense of personal melancholy and spiritual uneasiness. He was also active as a painter and printmaker. At the outbreak of World War I, he moved to Berlin, though he lived in Zurich, 1917–18, to avoid military service. He returned to Berlin in 1919 and was admitted to the Berlin Academy the same year. Lehmbruck suffered a mental breakdown and died by suicide.

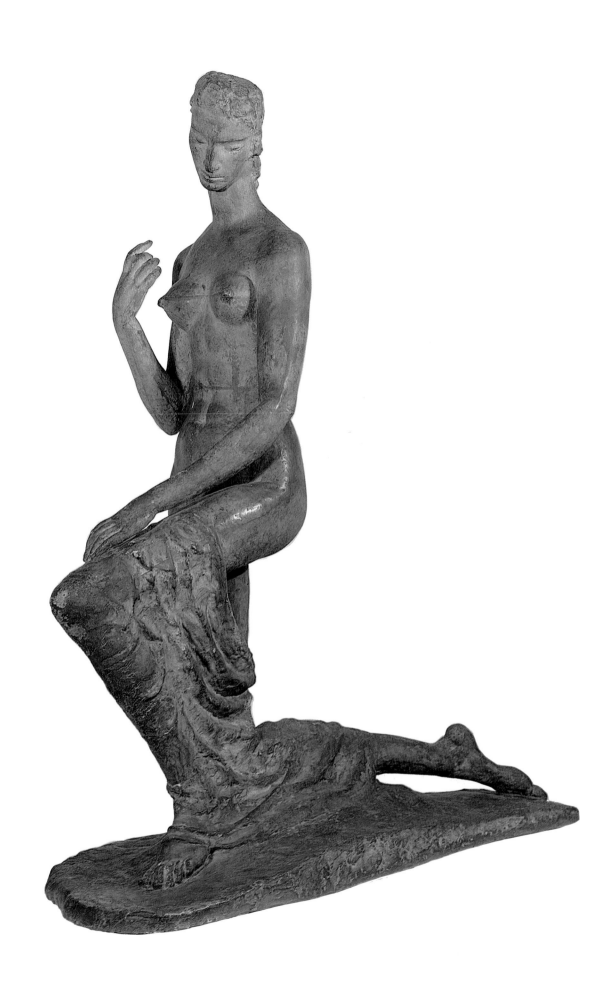

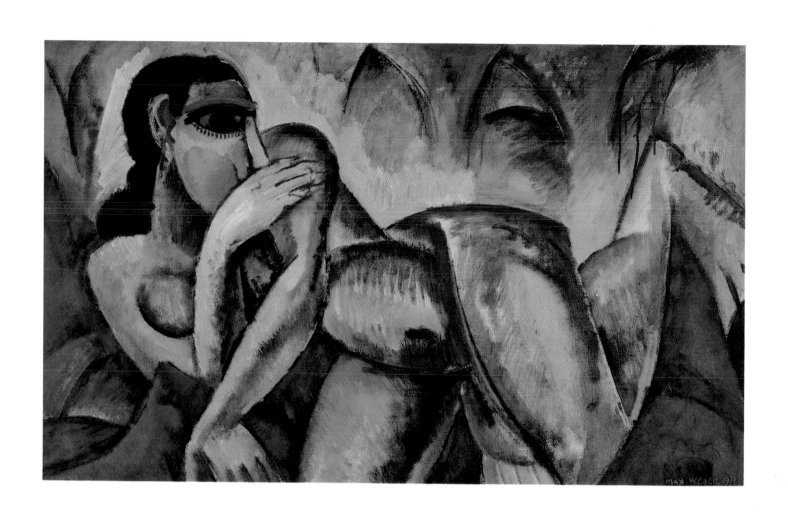

Figure Study, 1911

Oil on canvas
24 x 40¼ (61 x 102)
Charles W. Goodyear Fund, 1959

MAX WEBER was born in Bialystok, Russia to Orthodox Jewish parents. His family immigrated to America in 1891 and lived in Brooklyn in extreme poverty. After graduation from high school, Weber trained first at the Pratt Institute (1897–1900) under Arthur Wesley Dow and in 1905 he traveled to Paris where he studied at the Académie Julian and briefly in Matisse's art class. Weber's style at this point was mainly indebted to the structuralist ideas of Cézanne and Cubism, but also showed romantic overtones. He returned to the U.S. in 1909 and in 1911 was given a one–man show at Stieglitz's "291" gallery. In 1913 he exhibited at the Grafton group in London and had a one–man show at the Newark Museum, New Jersey. Probably more than any other American artist, his work outraged tradition–minded critics. During the twenties, Weber followed a trend back into representational art, often depicting Jewish themes in an expressionistic style.

Immediately following his return to the United States from Europe in January 1909, Max Weber concentrated on studies of massive and solemn cubistic nudes. These works, which help signal the beginnings of a truly modern American art, show the full impact of the lessons he had absorbed in Paris, while their formal and emotional strength prevents them from being pale echoes of European sources. The closest stylistic affinities lie with Picasso's nudes from his so–called Negro Period of 1907–08. Like Picasso, Weber admired the African sculpture he studied in ethnographic museums and derived from it inspiration for bold distortions, dark color and a general primitivizing approach. Attempting to recapture the psychological intensity they sensed in these works, both Picasso and Weber frequently endowed their figures with mask–like faces and brooding, self–confining gestures, as evidenced in *Figure Study*. The example of Picasso is also recalled here by the expressive modeling achieved through hatched strokes. In terms of anatomical distortions and the break–up of space, however, Weber never went as far as Picasso, perhaps due to the conditioning effect of a second stylistic influence, that of Matisse. In the Gallery's painting, the pose of the figure as well as the strong, accented rhythm of the contours specifically recall Matisse's *Blue Nude* of 1907 as well as his bronze *Reclining Nude I*. Weber, in fact, owned a ceramic tile by Matisse which depicts this particular sculpture. The concept of placing a nude in a forest landscape to express a harmony between man and nature had been used by both Picasso and Matisse and derives, of course, from the great bathing scenes of Cézanne.

S.N.

GIACOMO BALLA
Italian, 1871–1958

Dynamism of a Dog on a Leash, 1912

Oil on canvas
35⅜ x 43¼ (89.9 x 109.9)
Bequest of A. Conger Goodyear to George F. Goodyear, Life interest,
and the Gallery, 1964

Giacomo Balla painted this witty study of a skittering dachshund and the staccato steps of his mistress in May 1912 while visiting one of his students, the Contessa Nerazzini, at Montepulciano, near Siena. The light background with its vibrating contrasts of high–valued pink and green streaks is said to represent the white dust of the Tuscan countryside shimmering under the bright summer sun.

In 1910 Balla, though older and geographically removed from the group of Futurist painters organizing in Milan, signed the Technical Manifesto of Futurist painting. This document proclaimed that "universal dynamism must be rendered in painting as a dynamic sensation" and that "movement and light destroy the materiality of bodies...A profile is never motionless before our eyes, but it constantly appears and disappears."

Balla conveys this sense of palpable dynamism through a number of devices, none new to painting, but applied with appealing virtuosity. Even more systematically than the Impressionist cityscape or in Seurat's work, masses are overlaid with a welter of Divisionist dots which help imply a rapid, almost audible scurry. Balla was intuitively aware of the findings of Gestalt psychology which held that sensation of movement is most convincingly transmitted by a blurred image and broken outline. The paths of the vibrating links of the leash, for example, create what the Futurists would later call "lines of force," schematically rendering the direction and rhythm of movement.

Clear antecedents for these superimposed, successive images existed in photography, particularly in the work of the 19th–century French physiologist Etiènne–Jules Marey, who was certainly known by the Futurists. In 1911–12, a young Roman photographer, Anton Bragaglia, exhibited his work which he called "photodynamism" for its attempt to document the elusive trace of motion. Bragaglia once photographed Balla in front of this work; he obligingly moved and is recorded only as a shapeless blur.

K.K.

Born in Turin, GIACOMO BALLA worked for a commercial lithographer, took night classes in drawing and enrolled for a very brief period at the Accademia Albertina. In 1895 he went to Rome where he was soon established as a successful academic portrait painter. He traveled to Paris in 1900 for six months, was impressed by Seurat's work and returned to work in a Divisionist manner which he passed on to his students Umberto Boccioni and Gino Severini. In 1910, he signed the *Technical Manifesto of Futurist Painting* but remained aloof from the movement until 1912, when he began to be increasingly involved in Futurist activities, collaborating with Fortunato Depero on the manifesto, *Futurist Reconstruction of the Universe*, 1915, experimenting with Futurist cinema and working in interior decoration. In the late 1920s, he resumed conventional figure painting and virtually abandoned Futurism, although he continued to exert a strong influence on the course of Italian design in fashion, furniture and typography. He was named to the Accademia San Lucca in 1935.

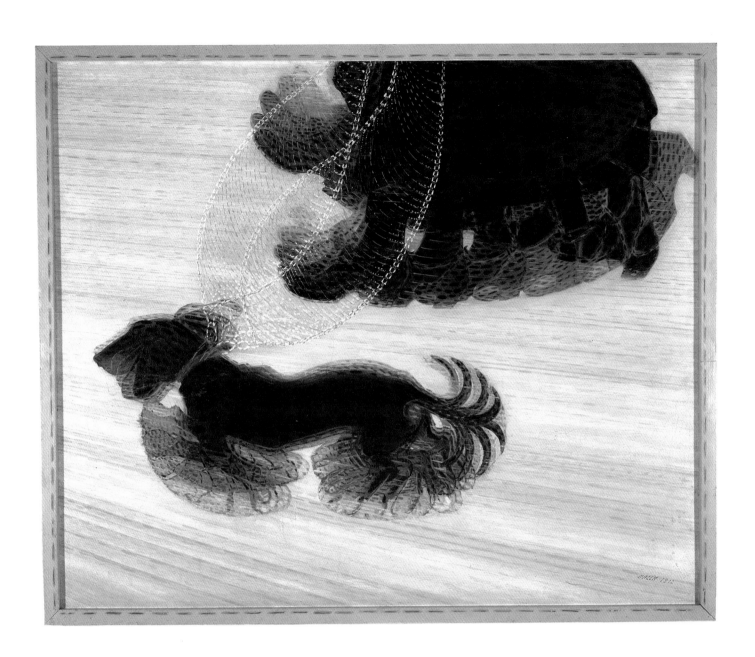

FERNAND LÉGER
French, 1881–1955

Smoke, 1912

Oil on canvas
36¼ x 28¾ (92 x 73)
Room of Contemporary Art Fund, 1940

Between 1910 and 1912, while he was formulating his theory of dynamic contrasts as the structural basis for modern art, Fernand Léger painted at least seven studies of the contrast between puffs of smoke and solid architectural forms. He wrote, "Contrast = dissonance, and hence a maximum expressive effect. I will take as an example a commonplace subject: the visual effect of curled and round puffs of smoke rising between houses. You want to convey their plastic value...Concentrate your curves with the greatest possible variety without breaking up their mass, frame them by means of the hard dry relationship of the surfaces of the houses, dead surfaces that will acquire movement by being colored in contrast to the central mass and being opposed by live forms; you will obtain a maximum effect."

It is not certain that Léger's remarks refer specifically to this painting, although the contrasts he enumerates are clearly evident. The rounded forms of an imposing vertical column of smoke divide an industrial cityscape composed of small, flat geometric shapes. Despite a subdued scheme of browns and greys, occasional planes of bright primary reds and blues activate the background on either side of the monochrome mass in the center. Representational roofs, windows and chimneys are juxtaposed against purely abstract shapes, while curved contours are played off against straight edges.

K.K.

Born in Argentan, Normandy, FERNAND LÉGER studied architecture in Caen, 1897–99. In 1900 he settled in Paris where he worked as an architectural draftsman and from 1903–06 studied at the Ecole des Beaux–Arts under Léon Gérôme and Gabriel Ferrier. He painted first in an Impressionist manner, though the Cézanne retrospective of 1907 led him to search for a more solid formal structure. He exhibited with the dealer Daniel–Henry Kahnweiler in 1910. Mobilized in 1914 into the Engineer Corps, he later attributed his interest in social themes and machine forms to his war experience. Following his discharge in 1917 he began to subject both figures and objects in his painting to a hard tubular treatment. He opened an art school with Amédée Ozenfant and collaborated on the first abstract film *Ballet méchanique*. After three visits in the 1930s, he settled in the United States for the duration of World War II. After his return to France, monumental art, mosaics, stained glass and murals became his major preoccupations. From 1949 he lived in Biot in southeastern France and worked in ceramic sculpture.

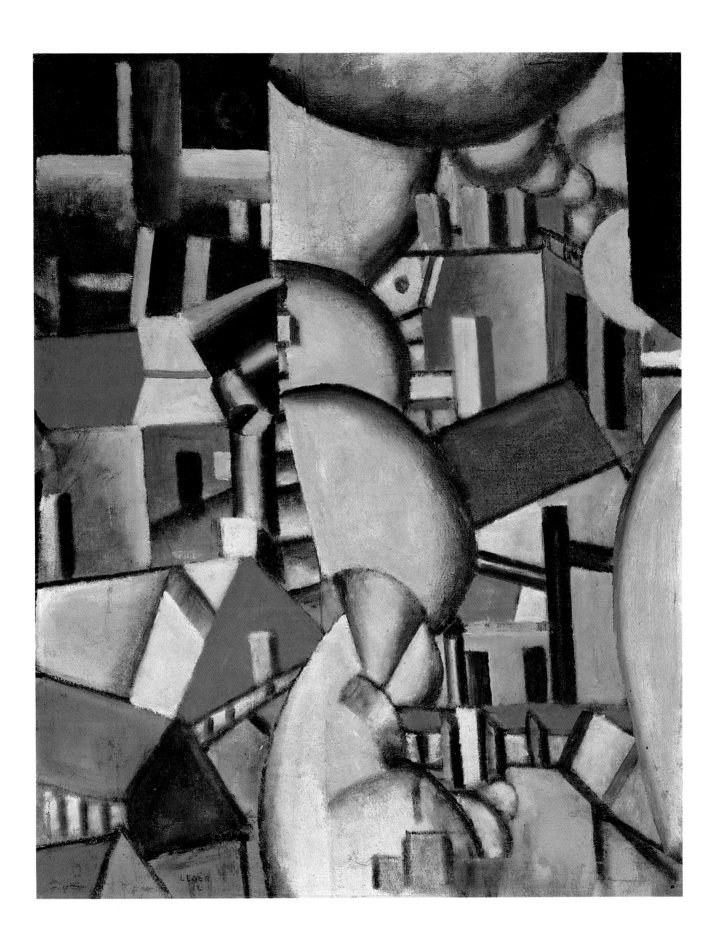

JEAN METZINGER
French, 1883–1956

Dancer in a Café (Danseuse au café), 1912

Oil on canvas
57½ x 45 (146 x 114.3)
General Purchase Funds, 1957

Never as concerned as the major Cubists with pursuing the pictorial implications of a break–up of form and space, Metzinger remained closer to a faithful representation of traditional genre subjects. In this interior café scene, four fashionable Parisians crowded around a small table at the left are being entertained by a tall, strutting dancer. The mood and tempo of pre–war café society are effectively conveyed by the rapid, shifting movement, the capturing of artifical light and the variety of specific colorful detail, seen in, for example, the elements of costume, table–top still life and the dancer's bouquet. The lack of a thorough–going redefinition of space, however, along with the arbitrary planes and the pointillist brushstroke characterize a style that is essentially decorative rather than intellectual and properly "Cubist."

It is clear from the subject matter as well as from the flat and stylized arabesques of the lighting fixtures that Metzinger was familiar with Seurat's *Le Chahut*. The painting also testifies to an awareness of the Italian Futurists, active and exhibiting in Paris in 1912. The impression of jerky staccato motion, new to Metzinger's work, clearly reflects Futurist theory and the work in particular of Gino Severini, many of whose dancers and café studies date from 1911 and 1912.

Katharine Kuh has stated that Metzinger may have exchanged this work with Albert Gleizes for the latter's *L'Homme au hamac*, also in the Albright–Knox Art Gallery, but documentation of the trade cannot now be traced.

K.K.

Born in Nantes, by the age of twenty JEAN METZINGER had decided to paint and settled in Paris. His early work was in a Neo–Impressionist manner derived from Seurat; about 1909 he was introduced to the circle of Picasso by the poet Max Jacob and adopted a more Cubist approach. In 1911 –12 he collaborated with Albert Gleizes on the theoretical treatise *Du Cubisme* and helped to organize the 1912 *Section d'Or* exhibition. His later work continued in a Synthetic Cubist vein until the late 1920s when the influence of the hard mechanical forms of Fernand Léger was felt. His paintings thereafter became increasingly academic.

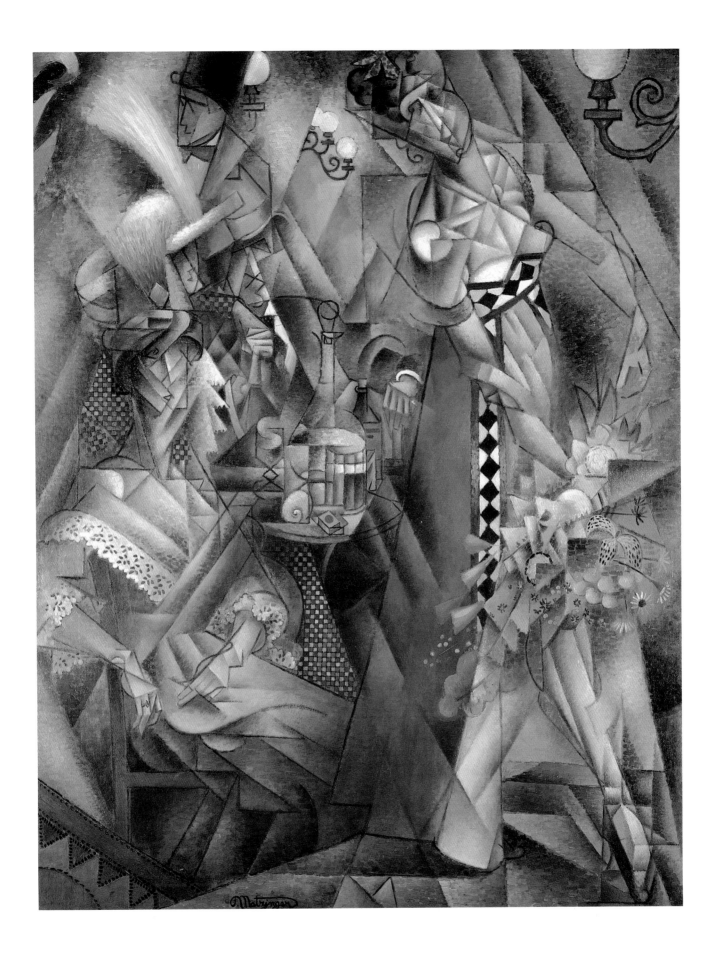

FRANCIS PICABIA
French, 1879–1953

Figure triste, 1912

Oil on canvas
46½ x 47 (118.1 x 119.4)
Gift of The Seymour H. Knox Foundation, Inc., 1968

Although this painting is not dated, it can be situated quite securely. In 1911, Picabia was painting colorful and expressive canvases in a Fauve vein; by the end of that year a new flattened and fragmented approach announced his awareness of contemporary Cubist work. Since *Figure triste* was shown publicly in October 1912, it must have been painted earlier that same year, as its similarities with two other works from this same period, the famous *Procession Seville* and *Dances at the Spring*, imply.

Picabia's title does not unmask for us the enigmatic content of the painting, since *Figure triste* can be understood to mean "sad fact," "sad figure," or even "metaphor for sadness." A pervasive melancholy is undeniable, resulting from the somber palette of lifeless black, grey and white, relieved only by cold blue, a hue traditionally associated with sadness and loss. In the center of the painting it is possible to detect a small seated figure viewed from the right side, its knees slightly drawn up, its right arm extended and resting on a curved form and its head leaning to the side supported by its bent left arm. This attitude, reminiscent of personifications of Melancholia in earlier art, seems consistent with the title. The figure is nestled among ample forms which could be construed as the lap and encompassing arms of a mother figure, whose dark upswept coiffure appears at the top. The psychological implications of such a grouping, though unverifiable, are of a young boy's idealization of the protective maternal relationship. It is perhaps pertinent that Picabia's mother died when he was only seven years old.

K.K. & S.N.

Born in Paris to a Spanish father and a French mother, FRANCIS PICABIA entered the Ecole des arts décoratifs in 1895 and four years later first showed at the Salon. He studied with Fernand Cormon but was converted to Impressionism in 1902 when he met Camille Pissarro's two sons. Despite his early success, he abruptly rejected Neo–Impressionism in 1909 for a freer, more experimental approach to form and color. In 1911, his friendship with Guillaume Apollinaire led to an association with the Puteaux artists, Marcel Duchamp, Jacques Villon and Albert Gleizes, and he showed in their Salon de la Section d'Or in 1912. The following year, he visited New York on the occasion of the Armory Show which included some of his work. He became close friends, as well, with Alfred Steiglitz who gave him a one–man show at his "291" gallery. His first machine paintings date from the summer of 1915. In 1918, Picabia was invited by Tristan Tzara to collaborate with the Dada group in Zurich, after which he proceeded to launch Dada in Paris. By 1923, his witty and irreverent machinist and abstract work was virtually terminated. He settled on the French Riviera in 1915 and devoted the rest of his life, with one brief exception, to figurative art.

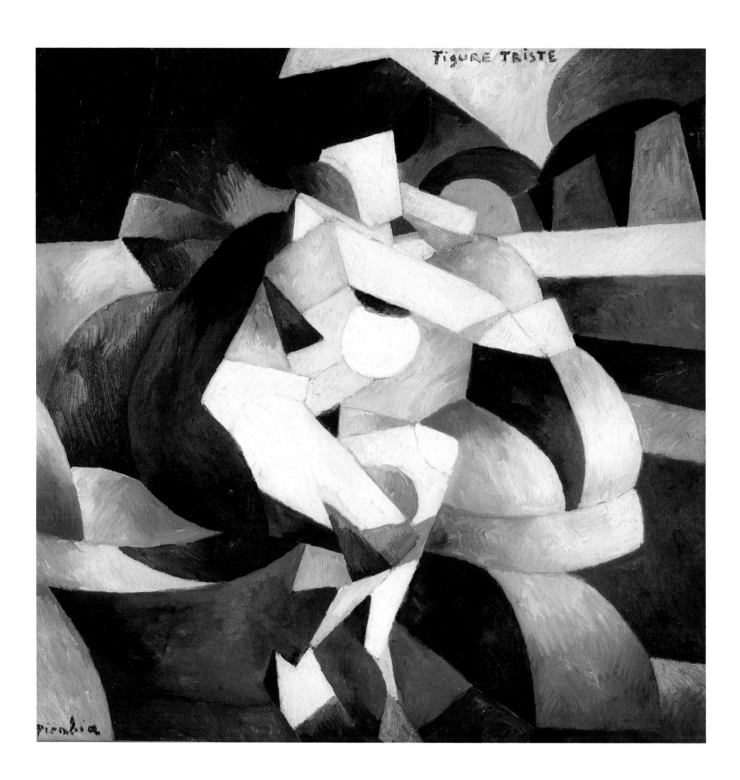

MAURICE UTRILLO

French, 1883–1955

Houses on the Isle of Ouessant, Brittany (Maisons à l'Ile d'Ouessant, Bretagne), 1912 (?)

Oil on canvas
23¾ x 32¼ (60.5 x 82)
Room of Contemporary Art Fund, 1939

Although undated, this work was probably painted during Utrillo's only documented trip to Brittany, from July to October 1912. Earlier that year he had been admitted to a sanitarium in Sannois, but his condition improved steadily and in July he received leave to travel under the care of his friend Richmond Chaudois. Ouessant is an island off the western coast of Brittany whose simple houses, churches and windmills Utrillo depicted in several works. This same trip yielded scenes of the resort and fishing village of Le Conquet on the Brittany coast, which this painting has sometimes been thought to represent. However, its sparse grouping of houses relates more to Utrillo's other depictions of Ouessant than to the street scenes and less severe architecture of Le Conquet. The composition is unusually simplified for Utrillo, the reduced geometric shapes and broad, flat areas of color showing his style at its most abstract. An overall buff tonality is used to diminish the intensity of the whites and to help unify the composition.

S.N.

MAURICE UTRILLO was born in Montmartre, the son of model and artist Suzanne Valadon and an unknown father. In 1891 he was given a legal surname by the Spanish writer Miguel Utrillo. His youth was troubled by an addiction to alcohol followed by periodic self–imposed sanitarium cures. He received no formal art training but was a pupil of his mother and was largely self–taught. He was painting by 1904, at first mainly scenes of Montmagny and later during his so–called "White Period" (c. 1908–14), scenes of Montmartre. He made trips to Brittany and Corsica in 1912 and 1913. In 1919 he received the Croix de la Légion d'honneur.

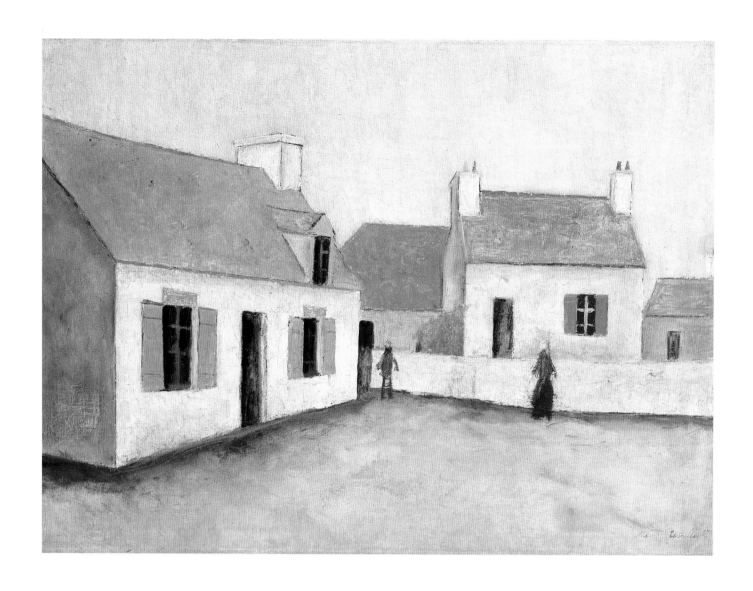

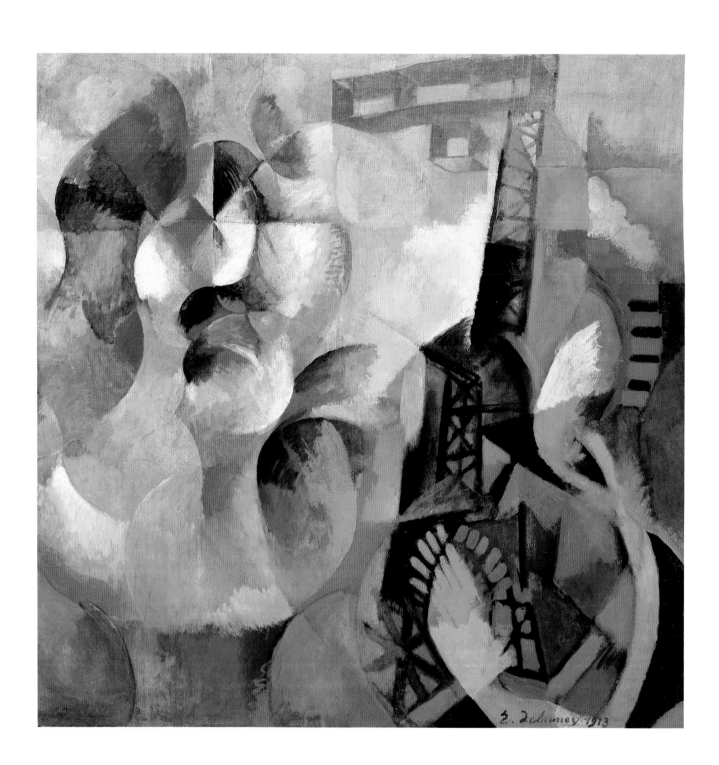

ROBERT DELAUNAY
French, 1885–1941

Sun, Tower, Airplane (Soleil, Tour, Aeroplane), 1913

Oil on canvas
52 x 51⅝ (132 x 131)
A. Conger Goodyear Fund, 1964

Born in Paris, ROBERT DELAUNAY was apprenticed to a theater set designer in 1902. From 1905–07 he painted in a Neo–Impressionist manner and came under the influence of Chevreul's 19th–century color theories. His studies of St. Severin, the city and the Eiffel Tower from 1909–10 mark the beginning of his preoccupation with the dynamics of color relationships. He was invited by Kandinsky to show in the first Blaue Reiter exhibition in 1911; in 1912 he painted his first "Disc" painting. In the same year he showed a large painting in the Salon des Indépendants which Guillaume Apollinaire praised as an example of color creating structure; this led Apollinaire to incorporate Delaunay into Orphism, his newly designated category of Cubism. During World War I, he lived in Spain and Portugal, returning to Paris in 1921. He continued to work in series of portraits and city studies and in 1930 began his plaster reliefs. He completed the decoration of the Railroad and Air Pavilions at the Paris International Exhibition in 1937.

In 1912 Robert Delaunay wrote of his satisfaction in having eliminated all descriptive anecdote from a series he called "Window Paintings," in which color relationships constituted the sole subject of his investigations. Yet the right half of this work, in which the Eiffel Tower, a biplane, and a ferris wheel are clearly recognizable, adheres quite closely to an actual photograph known to have been in the artist's possession. These three powerful symbols of technology triumphant, which appear in several other works from the same period, appealed to his enthusiasm for the excitement and dynamism of modern life. Defying gravity, they soar up into dematerialized space and the realm of pure light, the essence of which Delaunay considered the primary reality.

The left side of the painting, more brilliant and intense, reiterates in abstract terms the movement and dynamic rhythms implied on the right. As the title indicates, this painting is closely related to a series of works based on the sun and moon which Delaunay painted at Louveciennes, west of Paris, from April to November 1913. The disc constituted in the painter's eyes a symbolic equivalent for the universe, whose fundamental rhythms were expressed in the movement of light as revealed by color. The overlapping and intersecting circular forms are laid down in bright, high–valued tones whose juxtaposition produced the simultaneous contrasts described in the color theories of M.E. Chevreul.

K.K.

ALBERT GLEIZES
French, 1881–1953

Man in a Hammock (L'Homme au hamac), 1913

Oil on canvas
61⅜ x 51½ (155.9 x 130.9)
General Purchase Funds, 1957

Unlike the relatively small–scale, compact work being done by his contemporaries Georges Braque and Picasso, Gleizes favored large and complex scenes broken down into several planes hung on a linear grid in a manner inspired perhaps by the work of Juan Gris. Although the flattened foliage at the top of the canvas and the hammock strings attempt to bring background detail forward to the picture plane, the reclining figure is clearly readable in a landscape setting which recedes to the buildings in the center background. Unlike the Cubists' limited palette, Gleizes employs large areas of red, green, blue and ochre around the grisaille figure.

The Cubists frequently employed stencilled lettering to make an ironic comment on the flatness of the picture surface. The book title prominently displayed in the center foreground, however, has little function other than alluding to the work of the Socialist poet Alexandre Mercereau who later introduced Cubism to Eastern Europe through a series of exhibitions he arranged in Moscow and Prague. Since Gleizes was familiar with Mercereau's writing, having collaborated with him in founding the Abbaye de Créteil, it is quite possible, as Daniel Robbins believes, that the recumbent figure is a self–portrait.

K.K.

ALBERT GLEIZES was born in Courbevoie, a suburb of Paris. His father was a fabric designer in whose atelier Gleizes worked around 1900. He showed an early interest in painting and exhibited in Paris, 1902–03. Impressed by the ideals of democratic socialism, in 1906 he founded the short–lived Abbaye de Créteil, a communal society of artists, with the Socialist poet Mercereau and others. His early style was based on Impressionism, though he was introduced by Mercereau to Henri Le Fauconnier and Jean Metzinger whose theories and geometrizing approach greatly influenced his development. He showed in the 1911 Salon des Indépendants Cubist "Room 41" and in 1912 published with Metzinger *Du Cubisme*, the first theoretical study of Cubism. That year he also helped to organize the first Section d'or exhibition. He visited Spain in 1916 and New York in 1915 and 1917–19, where he experienced a religious conversion which reoriented his work. In 1927 he founded a second Utopian community of artisans, Moly–Sabata at Sablons near the Alps. In 1932 he published a study of form in various epochs of art history. He executed two murals for the Paris Exposition of 1937 and illustrated Pascal's *Pensées*, 1950–52.

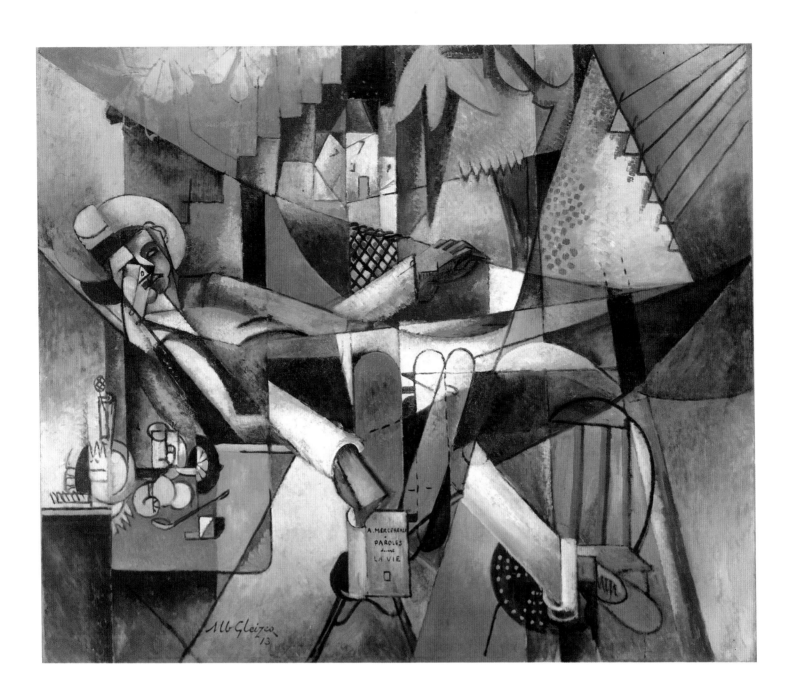

WASSILY KANDINSKY
Russian, 1866–1944

Fragment 2 for Composition VII, 1913

Oil on canvas
34½ x 39¼ (87.5 x 99.5)
Room of Contemporary Art Fund, 1947

In his *Concerning the Spiritual in Art* Kandinsky described three basic types of works: the Impression, the Improvisation and the Composition. The latter, involving "an expression of a slowly formed inner feeling, tested and worked over repeatedly, almost pedantically," is the most complex. Kandinsky painted only ten works of this type, the first seven before World War I.

Previously considered one of the artist's earliest major nonrepresentational statements, *Composition VII* has been shown to contain a formal vocabulary derived from the great eschatalogical themes which Kandinsky had been exploring since 1910. He frequently turned to the Book of Revelations with its mystical visions of a new era as an apt metaphorical vehicle for his ongoing search for a spiritual plane above surface appearances. It has been pointed out, for example, that the first oil study for *Composition VII* is quite close to a glass painting of the *Last Judgment* of 1911–12. Sixten Ringbom demonstrates that the next step in the development of *Composition VII* can be found in the so–called *First Abstract Watercolor*. This contains certain configurations which, when considered in conjunction with earlier, more representational paintings of The Deluge, All Saints, Resurrection and Last Judgment, can be deciphered as angels, apocalyptic horsemen, human figures, sea monsters, candles and other highly charged images, and which in turn shed light on the still further abstracted shapes in the Gallery study. Other elements, notably the central image, have remained totally enigmatic and personal, although Ringbom indicates that at one point Kandinsky considered using a hexagram, a theosophical symbol of the universe, in the central position.

E.W. & K.K.

Born in Moscow, WASSILY KANDINSKY moved with his family to Odessa in 1871. He studied law at Moscow University but in 1896 declined a professorship and went instead to Munich to study art. He worked first in the Azbé School, 1897–99, and then with Franz von Stuck at the Akademie der Bildenden Künste, 1900. In 1901, he founded the "Phalanx" group. Extensive travels from 1903–08 in Italy, France, and Tunisia brought him into contact with the latest developments in art, and he was particularly influenced by Fauvism. He returned to Munich in 1908 where he founded the "Neue Künstlervereinigung" and with Franz Marc in 1911 "Der Blaue Reiter" and produced his first abstract work about 1910. Kandinsky visited Russia in 1910 and 1912 and revisited there after the outbreak of World War I. He received various important cultural appointments but in 1921 returned to Germany where he taught at the Bauhaus, 1922–23. He moved to Paris when the Nazis closed the Bauhaus in 1933.

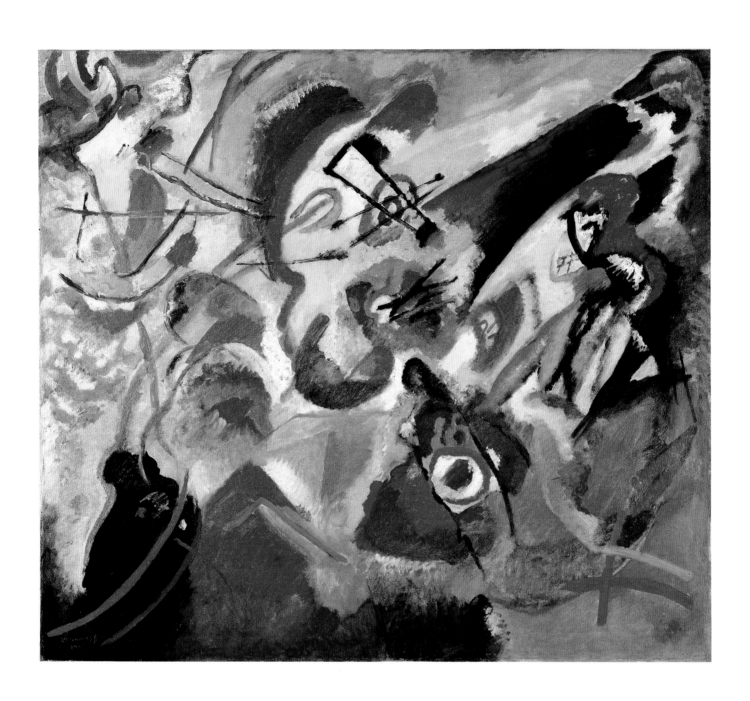

FRANZ MARC
German, 1880–1916

The Wolves (Balkan War) (Die Wolfe [Balkan Krieg]), 1913

Oil on canvas
27⅞ x 55 (70.8 x 139.7)
Charles Clifton, James G. Forsyth and Charles W. Goodyear Funds, 1951

Franz Marc's Nordic sensibility and attitude toward nature were at once mystical, romantic and symbolic. Natural laws and especially those of the animal world reinforced his belief in the basic ethical values of spontaneity, deep inner freedom and the unity of the individual with the entire universe.

Marc's animals, at first lyrical, at peace with their surroundings and painted in clear prismatic color, conveyed the artist's belief in a pervasive harmony in nature. But after 1912 his imagery substantially changed as though he sensed the impending cataclysm of world events. *The Wolves*, subtitled *Balkan War*, was painted during May of 1913 in Sildensdorf, Upper Bavaria, where Marc had settled permanently in 1909. It represents a personal allegory concerning the conflict between the Balkan Allies and Turkey on the Balkan peninsula in 1912–13. In this picture, nature is seen in a moment of violence and tumult; a pack of wolves charges forward with overwhelming power, brutally crushing everything in its path. By simplifying the forms and incorporating Cubist elements, Marc was able to merge the animals with the surrounding landscape while at the same time achieving a dynamism reminiscent of the works of the Futurists. The compositional structure of multiple horizontal volumes gives a strong sense of forward movement as well as recession into depth. Diagonals counter the massive horizontality of the central pictorial plane and are echoed in the background in the silhouette of the Balkan mountains. The colors are equally dramatic: the light clear hues of Marc's earlier paintings have disappeared, replaced by darker earth tones, purple, blue–green and flaming red. In the evolution of Marc's style, this painting represents an intermediate stage between the more static and serene works of 1912 and early 1913 and the increasingly complex and abstract pictures of late 1913 and 1914.

C.K.

Born in Munich, the son of a painter, FRANZ MARC abandoned plans to study theology to enroll in the Akademie der Bildenden Künste in 1900. During a sojourn in France in 1903 he came into contact with Impressionist painting and during a second trip in 1907 was deeply impressed by the art of van Gogh. In his early years, he painted mostly animal studies and landscapes in an academic manner and also executed numerous animal sculptural studies. About 1909 he met Wassily Kandinsky, Alexej Jawlensky and August Macke and his art came to assume its characteristic combination of intense color, dynamic design and symbolic meaning. Marc joined the "Neue Kunstlervereinigung" in Munich and after its dissolution in 1911 he, along with Kandinsky, founded "Der Blaue Reiter." A visit to Robert Delaunay's studio during his third trip to Paris in 1912 stimulated his interest in Orphic Cubism, whose influence as well as that of Futurism, soon became evident in his work. The gradual expulsion of representational elements in his paintings during 1913 culminated in almost complete abstraction by 1914. Marc was killed at Verdun.

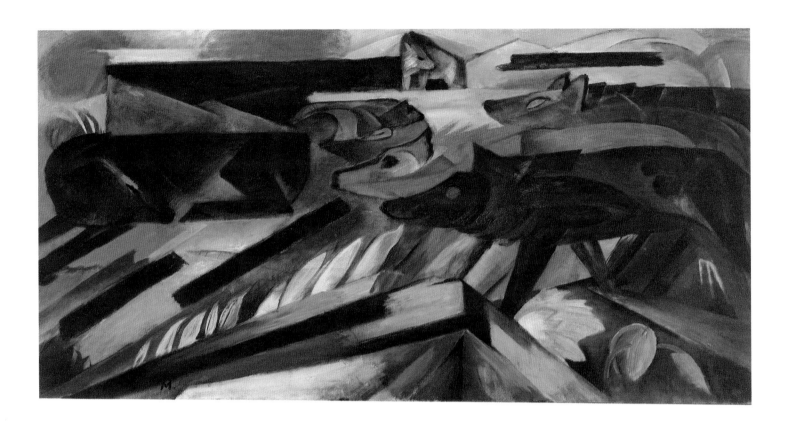

MORGAN RUSSELL
American, 1886–1953

Synchromy in Orange: To Form, 1913–14

Oil on canvas
11'3" x 10'1½" (3.43m x 3.08m)
Gift of Seymour H. Knox, 1958

Synchromy In Orange: To Form is generally regarded as the central work of the Synchromist style. It is the largest of Russell's known paintings and represents in the complexity and grand scale of its imagery a summation of the color experiments he had been pursuing. Although often referred to as a non–objective composition, numerous preparatory studies for this work make it clear that the central formal configurations, as in other of Russell's "abstract" paintings, relate to the human figure and, more specifically, to studies after Michelangelo's Dying Slave. The principal spiral rhythm in the composition derives from the contraposto pose of the Slave, while the interpenetrating wedge–like shapes seem to originate in studies after Cubist paintings such as Picasso's Three Women of 1908, known to Russell from the Stein collection.

The color organization of Synchromy in Orange: To Form shows the influence on Russell's ideas of Ogden Rood's Modern Chromatics of 1879, in which it is suggested that color harmony can be obtained through the use of triads of colors located within areas divided by 120° on the color wheel. As the title of the painting indicates, the principal color is orange and it therefore follows that the dominant triad is red–orange–yellow. Russell's aim was to explore the harmonic relationships of pure color and the rhythm, movement and space generating powers of the chromatic scale. Here the color volumes are all gradated both in tone and brushstroke, increasing the overall sense of dynamism. An outer spatial plane is established by the large block of yellow near the center, whose size and brilliance project it farthest outward. The other colors are placed to give not only a lateral balance but also a balance in depth within the limits set by the strong yellows and the recessive dark blues. The painted frame serves as a transition between the dense color patterns of the canvas and the surrounding space, a device for which there are numerous precedents in late 19th– and early 20th–century art.

S.N.

Born in New York, the son of an architect, MORGAN RUSSELL studied architecture as a youth and then painting under Robert Henri and sculpture under James Earle Fraser at the Pennsylvania Academy, 1906–09. He received the patronage of Gertrude Vanderbilt Whitney, 1908–13, allowing him to move to Paris in 1909. There he worked at first in sculpture in a Rodin–inspired mode, but by 1911 he had turned to painting, adopting a coloristic Fauve style. The same year he met Stanton Macdonald–Wright; together, and under the influence of modern color theorists, they developed the luminous, semi–abstract style known as Synchromism. Joint exhibitions of their work followed at the Neuekunstsalon in Munich in June 1913, the Galerie Bernheim–Jeune, Paris in October, and in 1914 at the Carroll Galleries, New York. Russell isolated himself from 1920 at Aigues–Mortes, France, first producing variations on his earlier themes but then moving back to representation. He returned to the United States in 1946.

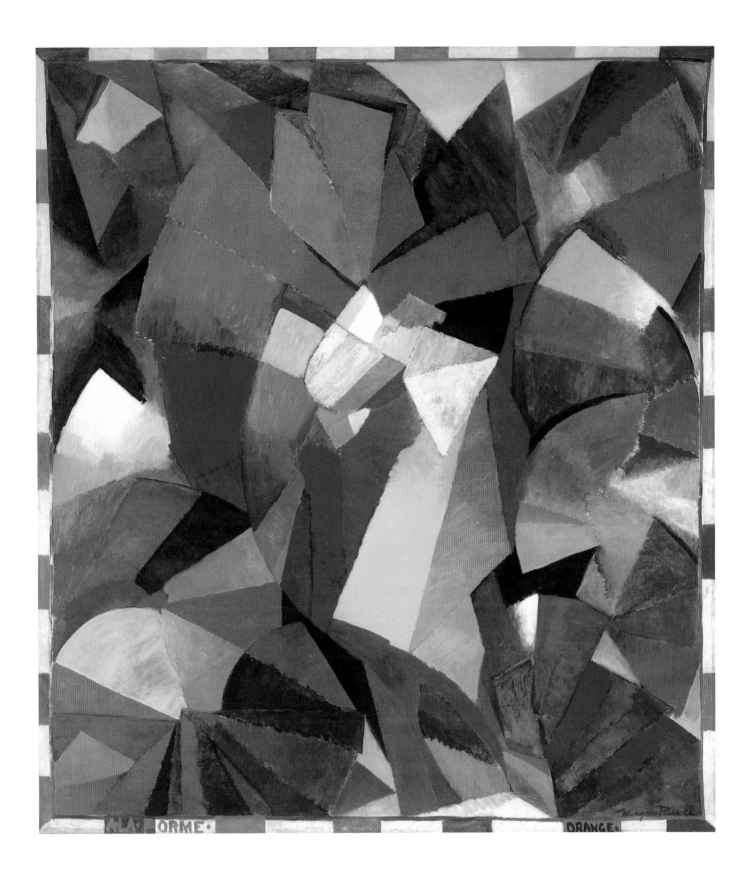

ALA ORME. ORANGE.

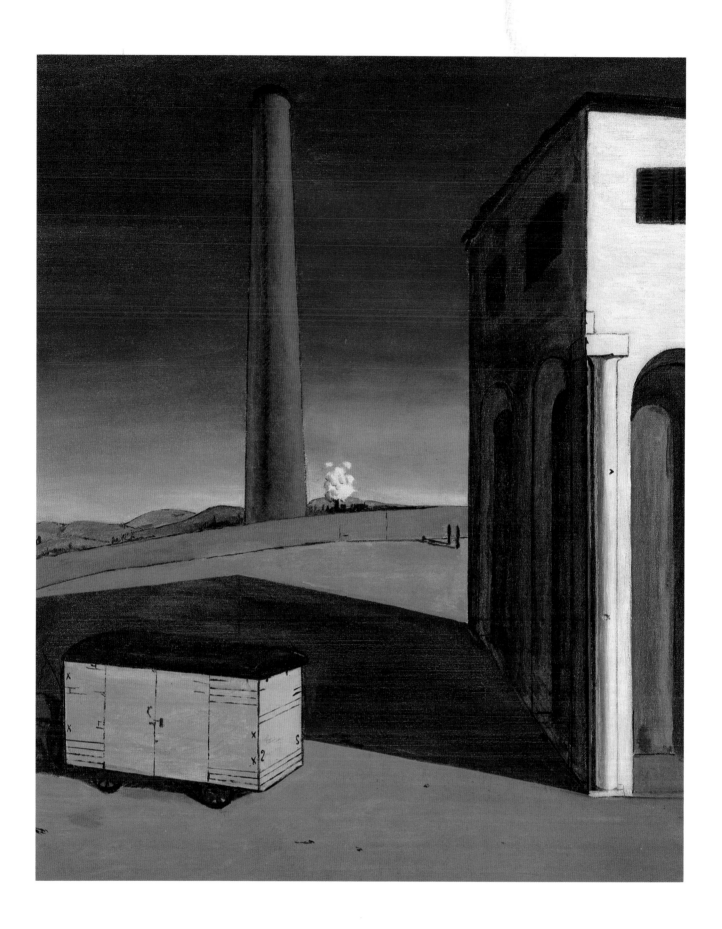

GIORGIO DE CHIRICO
Italian, 1888–1978

The Anguish of Departure, 1914

Oil on canvas
33½ x 27¼ (85.1 x 69.2)
Room of Contemporary Art Fund, 1939

Born in Volos, Greece to Italian parents, GIORGIO DE CHIRICO spent his youth in Athens where he entered the Polytechnic Institute at the age of twelve. In 1905 he traveled through Italy and settled for several years in Munich, studying at the Akademie der Bildenden Künste where he admired the fin–de–siècle art of Arnold Böcklin and Max Klinger. After returning to Italy, c. 1909–10, he painted the first of his celebrated city squares; he joined his brother in Paris in 1911. Here he met Guillaume Apollinaire, Picasso and others of the avant–garde art world. He exhibited at the Salon d'Automne and Salon des Indépendants in 1913 and 1914, but returned to Italy with the outbreak of war. About 1917 he met Carlo Carrà with whom he founded the "scuola metafisica," a short–lived informal group dedicated to revealing the fantasy and mystery underlying surface reality. About 1918 he moved to Rome, where the influence of Italian High Renaissance and Baroque art would soon effect a radical change in his style. He returned to Paris from 1925–40 at the height of Surrealist activity there, but disavowed his early work. He continued to paint in a florid and academic style, only returning to imitate his early manner at a much later date.

Giorgio de Chirico's early works were enthusiastically endorsed by the Surrealists who appreciated, if they did not necessarily imitate, his subversion of Renaissance order to create a world of mystery and enigma. His limpid otherworldly light casts shadows endowed with an independent existence and his sharp–edged detail records images not of the eye but from the hidden recesses of the mind.

This work is composed of several of de Chirico's familiar and highly individual motifs: a wide but enclosed public space, a large industrial tower, a distant train, a pseudo–Classical building, looming geometric shadows, two tiny isolated figures and a mysterious horse–drawn van, which possibly provides a key to the picture's mystery. The symbolism is often autobiographical in de Chirico's works from this period and the vehicle, whether carnival wagon or moving van, clearly represents transience in the midst of permanence. It may be germane, therefore, that after the death of his father in 1905, de Chirico abandoned the familiar sites of his childhood and embarked on the peripatetic wanderings which would lead him in less than ten years to Florence, Munich, Milan, Paris and Ferrara. The tower and arcade in his art have long been recognized as male and female symbols respectively. Given the generally acknowledged latent sexuality of his other contemporaneous paintings, it is possible to sense the artist expressing anxieties occasioned by the loss of his father, which may be seen in the threateningly large male symbol that is segregated behind a barrier.

The building, an architectural pastiche deriving in part from Mediterranean domestic dwellings, seems in its impossibly elongated arcades to be conceived through the hallucinatory or dream perspective of a small child. Such details as the side corner column which is merely sketched in and the unidentified specks littering the ground further insist on enigma as the touchstone of de Chirico's quiet but disquieting vision.

K.K.

103

Marsden Hartley

American, 1877–1943

Painting No. 46, 1914–15

Oil on canvas
39¼ x 32 (99.5 x 81.3)
Philip Kirwen Fund, 1956

Following a year in Paris and a close association with the avant–garde circle of Gertrude Stein, Hartley established himself by June of 1913 in Berlin. Except for a brief visit to the United States, he lived in Berlin until December 1915 and there produced his long series of military "abstractions," fusing the romanticism inherent in his outlook with ideas from Cubism and the German Expressionists. These works depict paraphernalia from the German army—insignias and medals, banners and flags, epaulets and numerals—in kaleidoscopic array, with a strong emphasis on the German Imperial colors of white, red and black. They show a curious fascination with the German military aristocracy and their sense of pageantry exemplifies interests about which Hartley had written to Gertrude Stein soon after his arrival in Berlin. The shallow space in Hartley's paintings from this period and the thin layering of shapes follow the lead of Synthetic Cubism, although there is never a thoroughgoing Cubist fragmentation of form. The boldness of color and movement, as well as the general impetus toward an art of pure color and shape, owe much to the example of Wassily Kandinsky. Within Hartley's military series, *Painting No. 46* is one of the works freest from specific symbols and, therefore, closest to pure abstraction.

S.N.

Born in Lewiston, Maine, Marsden Hartley moved with his parents to Cleveland in 1892, where he attended classes at the Cleveland Art Institute. After settling in New York in 1898, he studied under William Merritt Chase and later at the National Academy of Design, but his style was most greatly affected by Albert Pinkham Ryder and the Impressionist Giovanni Segantini. He had his first one–man show at Stieglitz's "291" gallery in 1909. Through "291," he was introduced to the art of Cézanne and Picasso, whose ideas on structure he readily absorbed. While living abroad in Paris and Berlin from 1912 to 1915, his style was redirected toward abstraction by the influence of Kandinsky, Franz Marc and the Fauves. He worked in Provincetown, Maine, New Mexico, California and New York before returning to Europe in 1921. By 1920 Hartley's painting had become increasingly representational. His later landscapes, endowed with a rustic power, express a strong romantic attachment to his native land. He returned to America in 1930 and traveled extensively while working mostly in Maine. In addition to painting, Hartley also composed poetry and wrote on modern art.

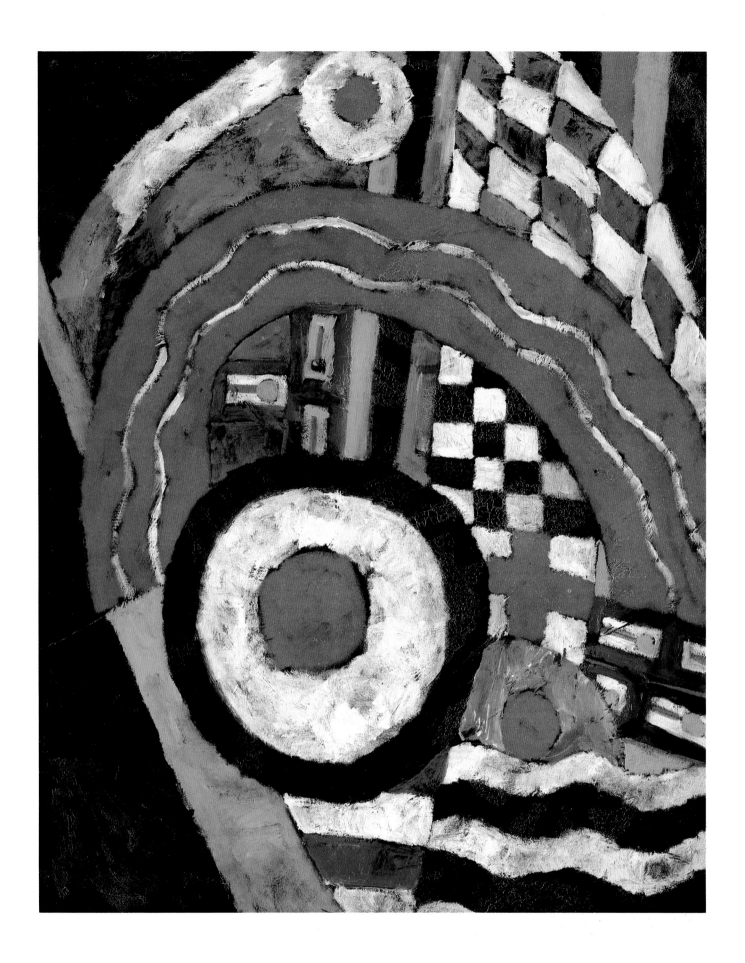

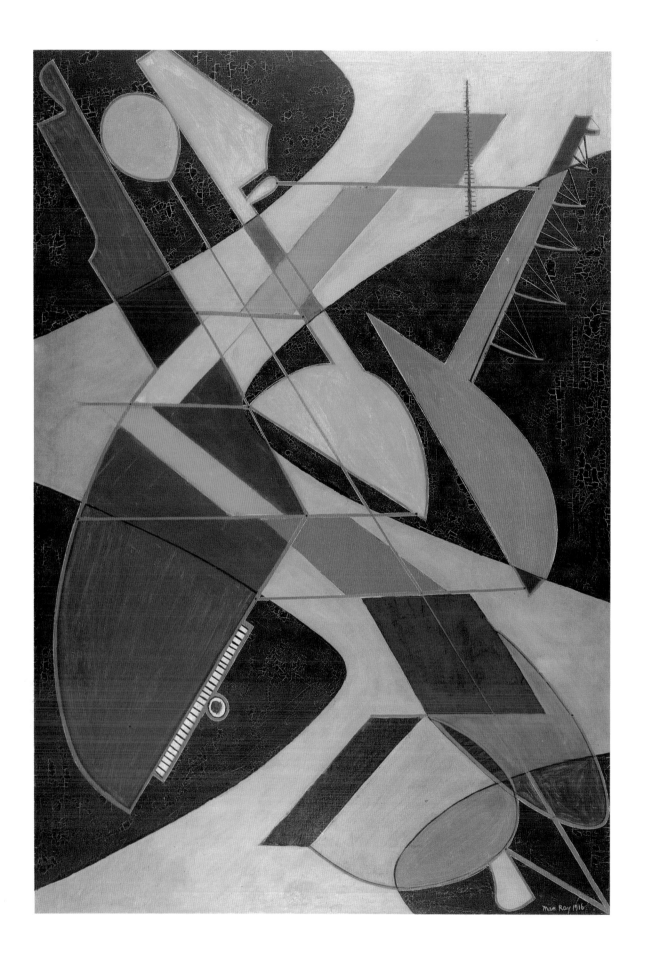

MAN RAY
American, 1890–1976

Symphony Orchestra, 1916

Oil on canvas
52 x 36 (132 x 91.5)
George B. and Jenny R. Mathews Fund, 1970

Born Emmanuel Radenski in Philadelphia, MAN RAY moved in 1908 to New York, where he worked in an architectural drafting firm and attended classes at the National Academy of Design and the Art Students League. He studied under George Bellows and Robert Henri at the Ferrar Center from 1912. Familiar with modernist developments through Alfred Stieglitz' "291" gallery and the Armory Show, he worked first in styles influenced by Fauvism and Cubism. From 1913 to 1915, Ray lived in a community of artists, writers and intellectuals outside Ridgefield, New Jersey. In 1915 in New York he formed a life–long friendship with Marcel Duchamp, who would profoundly influence his development. He played a leading role in the New York Dada group and when he moved abroad in 1921 was welcomed by the Dadists in Paris. His first "aerograph" spray paintings date from 1918. He worked in photography and in 1921 invented the "rayograph." He published a single edition of New York Dada with Duchamp in 1921 and participated in the first Surrealist exhibition in Paris in 1925. He lived most of his life in France and continued to produce enigmatic, highly evocative art objects.

Man Ray's *Symphony Orchestra* develops ideas and motifs present in a more simplified collage composition entitled *Orchestra* from the "Revolving Doors" series of 1916–17. Although essentially an abstraction, it retains certain representational elements relating to its orchestral theme. The keyboard–like design at the lower left, together with the contiguous curved shape, suggests a grand piano. The horizontal lines spaced upward across the composition may relate to a musical staff. At the upper right, the triangular clusters of lines along a long neck suggest a stringed instrument, while other of the shapes seem also to derive from musical instruments and notes. To further enliven the design of intersecting arcs and straight edges, a wide variety of hues are introduced, including red, yellow, green, blue, orange and silver. By placing this design against a simplified background, consisting of a large silver field flowing through a black one, Man Ray seems to suggest the relationship between a large, visually diverse orchestra and its single, unifying musical expression.

The artist's experimental, somewhat cavalier attitude toward technique is reflected here in the incising of many of the contours, the use of both brush and palette knife and an unorthodox layering of paints, one of which is an aluminum type, leading to considerable crackle from drying. The witty suture–like design painted over a repair at the upper right presumably is the work of the artist himself.

S.N.

Amedeo Modigliani
Italian, 1884–1920

The Servant Girl (La jeune bonne), c. 1918

Oil on canvas
60 x 24 (152.5 x 61)
Room of Contemporary Art Fund, 1939

According to Arthur Pfannstiel the subject of this portrait is Marie Feret, a young country girl from Cagnes in the south of France. Nothing further is known of her, nor is the date of the painting certain. It unquestionably derives from Modigliani's later so–called "classical" period, when a tendency toward angularity and elisions in the drawing of the figure gave way to greater smoothness of line. It is perhaps germane that Modigliani sojourned in Cagnes from April, 1918 through the spring of the next year.

Modigliani's portrait iconography, embracing a world of artists, poets and acquaintances on the fringe of society had included servants before. In this respect he shared an important common interest with Chaim Soutine. Like Soutine, he responded sympathetically to the subject, and despite his severe stylizations of the figure, inspired partly by African art and partly by fifteenth–century Italian masters, he nevertheless managed to preserve the individuality of his sitters. Here the girl's blank eyes, her meek expression, the somewhat nervous clasping of her hands and the sense of encumbrance evoked by the heavy dress all portray a timid country girl who accepts her confining status with unquestioning resignation.

Characteristically, the elongated figure, described by a series of rhythmic elliptical curves, completely fills the vertical format. A tendency toward flatness of design seen in the collapsed perspective of the corner and the emphasis on linearity is countered by full naturalistic modeling in the face and neck. Similarly, the composition exploits a contrast between delicate drawing in the features and surrounding passages of vigorous, open brushwork.

S.N.

Amedeo Modigliani was born in Leghorn, Italy, the fourth child of Jewish parents. At age eleven, he contracted pleurisy, which would plague him the rest of his life and eventually cause his death. He studied art briefly under Guglielmo Micheli and from 1902 to 1905 at the Florentine Academy and the Instituto di Belle Arti, Venice. He moved to Paris in January, 1906 and lived in Montmartre and then the Cité Falguière with Soutine, Moïse Kisling and other artists under increasingly destitute conditions. He first exhibited at the Salon des Indépendants in 1908. Between 1909 and 1915 Modigliani concentrated on sculpture, working under the influence of Constantin Brancusi and African carvings. He gave up sculpture due to the harmful effect of dust on his lungs and turned again to painting, producing between 1915 and 1920 a great many portraits and nudes in his primitivizing signature style. A one–man show at the Galerie Berthe Weill in 1917 ended in public uproar. He lived on the Riviera for much of 1918–19.

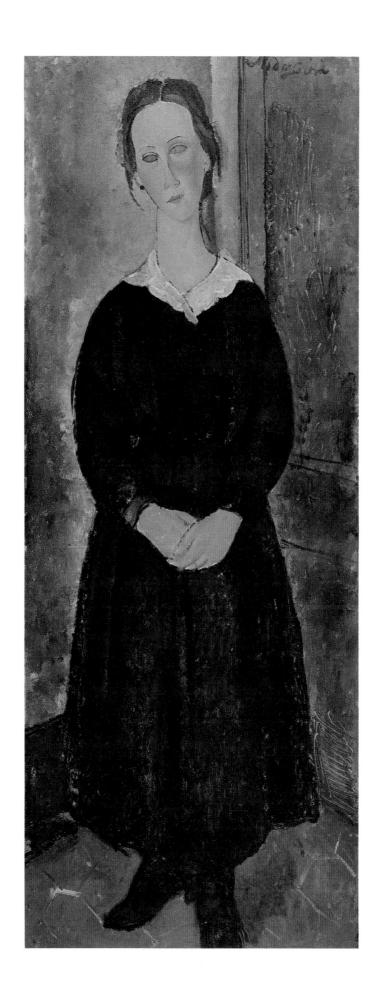

Georgia O'Keeffe

American, 1887–1986

Black Spot No. 3, 1919

Oil on canvas
24 x 16 (61·x 40.5)
George B. and Jenny R. Mathews and Charles Clifton Funds, 1973

Black Spot No. 3, painted in 1919, is among the earliest of Georgia O'Keeffe's abstract oils. Working primarily with drawings and watercolors and influenced perhaps by the landscape abstractions of Arthur Dove, about 1915 she began to produce abstract pictorial "equivalents" of natural forces and form, works which constitute one of the most original contributions to the development of American modernism. Despite its high degree of abstraction, which would continue until the introduction of a more representational approach in the early 1920s, her imagery was always rooted in nature and lived experience, translated with a clarity and deep sensuousness that remained one of the hallmarks of her style. The lightly tinted, curving folds seem related to O'Keeffe's floral imagery, although since there is a generally acknowledged sexual undercurrent in much of her art, the solid angular block here held in the midst of soft curving forms may well involve an invocation of the male and female principles. The artist has, however, generally rejected attempts to interpret meanings from her abstract images.

S.N.

Born near Sun Prairie, Wisconsin, GEORGIA O'KEEFFE began drawing lessons at the age of ten. From 1905 to 1906, she studied at the Art Institute of Chicago under John Vandepoel, and 1907–08, at the Art Students League in New York with William Merritt Chase. Disillusioned with academic art, she gave up painting in 1908 and went to Chicago where she worked as a commercial artist. Her visit in 1912 to an art class at the University of Virginia taught by Alon Bement, a pupil of Arthur Dow, renewed her interest in painting; she then studied under Dow at Columbia University, New York, 1914–15. A friend showed her drawings and watercolors to Alfred Stieglitz, who exhibited them at his "291" gallery in May 1916. without her knowledge. The close relationship which ensued led to their marriage in 1924. She had a one–artist show at "291" in 1917 and made her first trip to New Mexico the same year. From 1918–28 she lived and worked in New York with frequent trips to Lake George and Maine. She shared an interest in the romantic abstraction of nature with such artists as Marsden Hartley, Arthur Dove and John Marin, all of the Stieglitz circle. From 1929, she spent summers around Taos, New Mexico, and in 1949 after the death of Stieglitz, moved to Abiquiu.

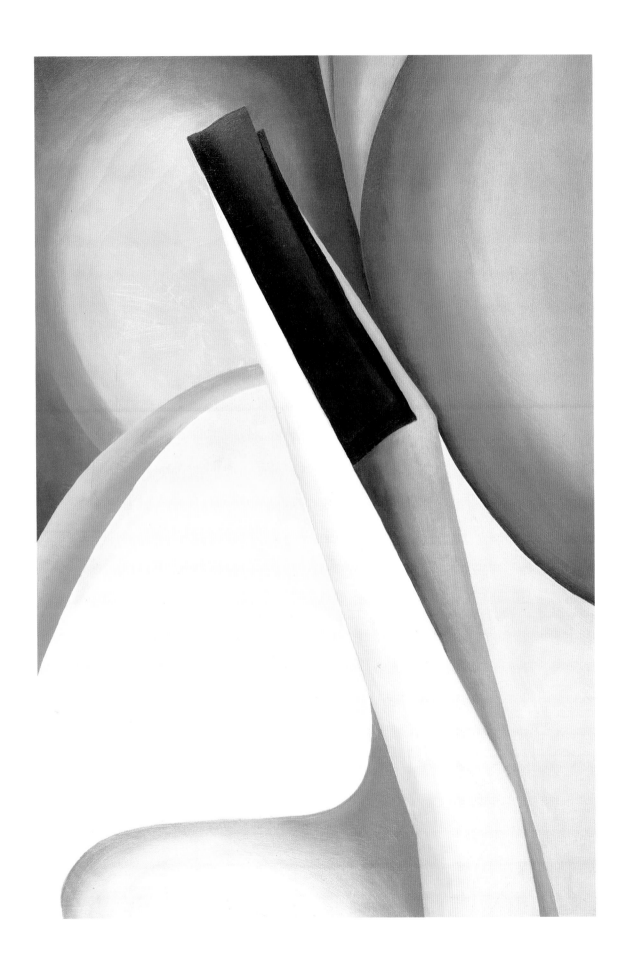

GEORGE BELLOWS
American, 1882–1925

Elinor, Jean and Anna, 1920

Oil on canvas
59 x 66 (150 x 167.5)
Charles Clifton Fund, 1923

George Bellows painted this portrait of his aunt Elinor, his daughter Jean, and his mother, Anna in September 1920 at Woodstock, New York, where he and his family were summering. He had previously made portraits of each of the sitters, but had never before attempted such an ambitious, monumental family grouping. Soon after the completion, *Elinor, Jean and Anna* was exhibited in the New Society of American Artists show. The response was overwhelmingly enthusiastic, and during the following years the painting was widely reproduced in art journals; it was also awarded the Beck Medal at the 1921 Pennsylvania Academy annual exhibition and first prize at the Carnegie International of 1922. In 1923 the Albright Art Gallery bought it for $7500, at that time an exceptionally high price for a living American artist.

The sober, almost puritanical handling and mood of the picture characterize Bellows' late work and his development away from painterly brilliance toward a more reasoned and calculated art. The sitters are arranged in a balanced geometric design comprised of three triangles in a single plane set against a backdrop that divides the canvas vertically into equal halves. Sharp divisions of light and dark heighten both the compositional structure and the painting's most striking feature, the contrast between youth and old age. With a gesture and solemnity reminiscent of religious presentation scenes, the aunt motions toward her grandniece, emblematic of youth, the future and life renewed. There is a human warmth to Bellows' depiction of his family, as well as an insight into character and a formal strength that make the work one of his highest achievements.

S.N.

George Bellows was born in Columbus, Ohio. He attended Ohio State University in that city, 1901–04, but left in his senior year to attend art school in New York, where he studied with Robert Henri for three years in the New York School of Art. In 1906 he opened his own studio. Although not officially a member of the so-called Ashcan School, his work strongly reflects its influence. He was made an Associate Member of the National Academy of Design in 1907 and in 1913 became the youngest artist ever to be made a Full Member. From 1910–11 he taught at the Art Students League and from 1912–18 at the Ferrar School with Henri; in 1916 he began doing lithographs. He helped organize the Society of Independent Artists, the New Society of Painters and the Armory Show of 1913. Bellows lived and worked in New York and spent most summers with his family in various places in New England and in Woodstock where he built a summer home in 1922. He died in New York at the age of forty–two as a result of an appendicitis attack.

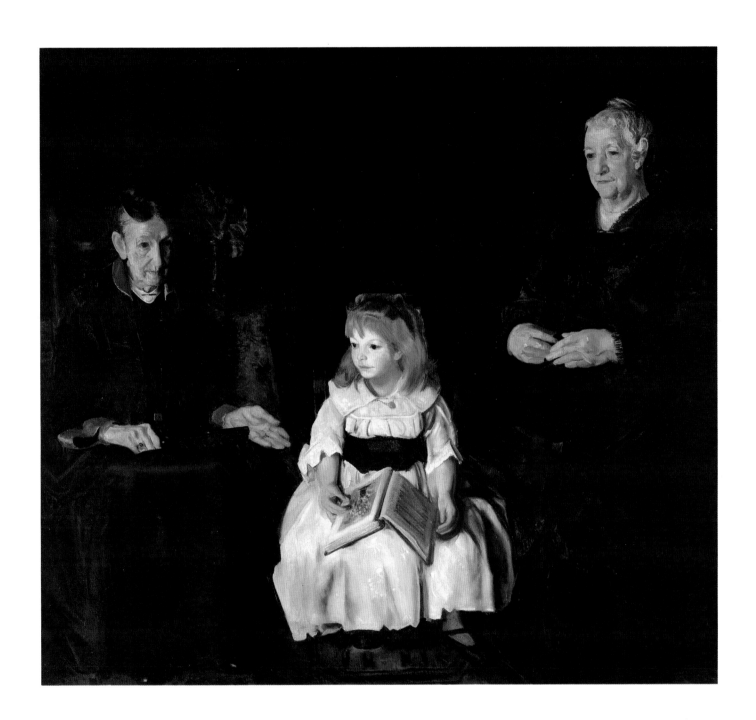

CONSTANTIN BRANCUSI
French, born Romania, 1876–1957

Mlle. Pogany II, 1920

Polished bronze
17¼ x 7 x 10 (43.7 x 17.5 x 25.5)
Charlotte A. Watson Fund, 1927

Brancusi modeled the original clay studies for *Mlle. Pogany* in Paris in December 1910 and January 1911. His inspiration was Margit Pogany, a young Hungarian painter who was studying in Paris and whose sharp, petite features, observed by Brancusi at a pension where he often dined, had captured his interest. After their initial meeting, Margit saw a good deal more of Brancusi and his work and persuaded him to do her portrait.

As with other of his serial sculptures, Brancusi returned to the *Mlle. Pogany* several times over a period of twenty–three years, reworking and purifying its forms and transferring it into different materials. The first version of *Mlle. Pogany* develops the concept of a simplified ovoid head with arched eyes and long curving neck first found in the *Narcissus* and *Danaide* but, like the *Muse* of 1912, introduces a new complication of form through the addition of hands. The sense of portraiture in this version is still strong, with the large eyes, mouth, hands, hair and chignon all well–defined. In the Albright–Knox Art Gallery *Mlle. Pogany II*, the earliest of three known bronzes, a further rationalization of the portrait has rendered it still more abstract. The hands are simplified into one elongated cone, the eyes are reduced to geometric crescents, the mouth is eliminated, the chignon becomes a fan of movement. This movement, along with the asymmetry of the work and its changing profiles, invites inspection from all angles and provides a different aspect from each point of view. In *Mlle. Pogany III*, made twelve years later, Brancusi clarified still more the changes made in the second version, managing to preserve a hint of the original human presence while verging on pure abstraction.

S.N.

Born in Hobitza, Romania, CONSTANTIN BRANCUSI studied in the Craiova School of Arts and Crafts and the Bucharest School of Fine Arts. He departed for Paris on foot in 1903 and there attended the Ecole des Beaux–Arts, 1905–07, and worked for a short period in the atelier of Rodin. He exhibited at the Salon d'Automne in 1906 and in 1907 received a commission for a funerary monument in Romania. He was friends with Fernand Léger and Marcel Duchamp. Five sculptures by Brancusi were included in the Armory Show of 1913 and in 1914 he was given his first one–man exhibition at the Gallery of the Photo–Secession in New York. His *Princess X* and its withdrawal from the 1921 Salon des Indépendants brought him notoriety; soon thereafter he began receiving favorable critical attention in international journals. The famous trial concerning the customs status of *Bird in Space* occurred in 1927. Brancusi traveled widely throughout Europe and to the United States. His sculpture of purified, essential forms became recognized during his lifetime as one of the major developments in 20th–century art and has been honored in many publications and exhibitions.

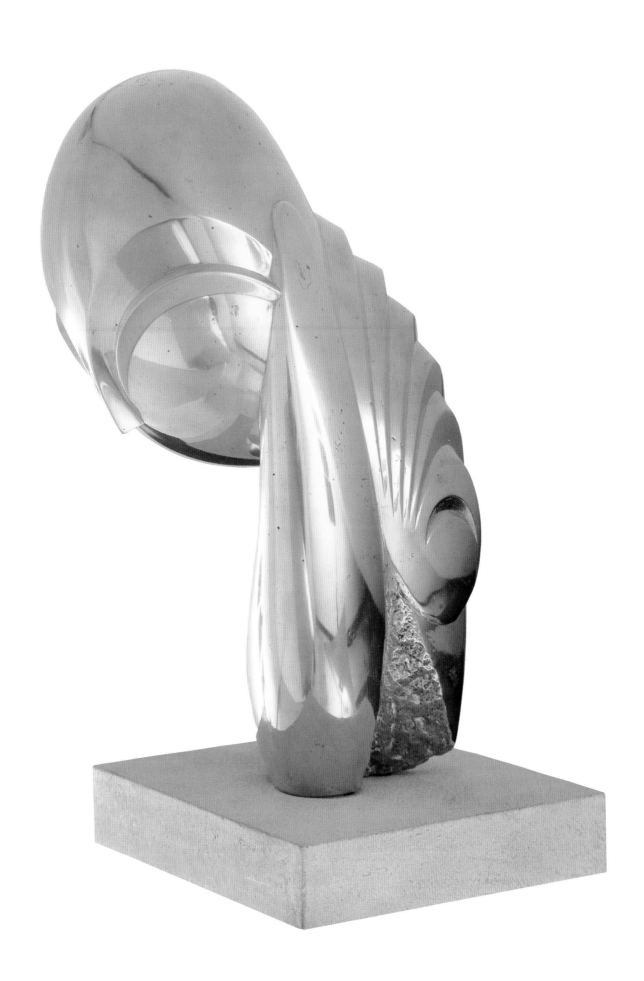

Frantisek Kupka

French, born Bohemia, 1871–1957

Lines, Planes, Depth (Traits, plans, profondeur), c. 1920–22

Oil on canvas
31½ x 28½ (80 x 72.5)
Charles Clifton and George B. and Jenny R. Mathews Funds, 1977

As František Kupka's abstractionist vocabulary expanded and developed, one of the themes that concerned him most consistently was the dynamic radiation of arcs and colors out of a single, stable nucleus. This idea was explored directly in two separate but related series of works entitled "Around a Point" and "Lines, Planes, Depth." With the aim of finding a new pictorial means for the representation of movement, energy and growth, Kupka began as early as 1908 to make drawings of figures broken into intersecting, spiraling arcs, in a manner anticipating the Italian Futurists. Out of these studies developed pure color abstractions introducing more complex problems of color relationships in depth. Kupka produced at least five paintings on this theme. A version in the Musée national d'art moderne in Paris is possibly the earliest surviving example. A second version, probably from the same period, is in the Národní Galerie, Prague. In contrast to these rather heavily worked canvases, the two other versions (Národní Galerie, Prague and private collection, New York), and that of the Gallery, are more thinly painted and more transparent in color. Margit Rowell has described the earliest painting as emphasizing a biological inspiration, and notes that the later ones recall light shifting through panes of glass. Kupka is known to have kept in his studio a wooden panel carved out and glazed with a floral pattern and placed against a blue backdrop.

S.N.

Born in Opocno, Eastern Bohemia, the son of a notarial clerk, František Kupka studied at the Prague Academy 1889–92. At the age of fifteen, he supported himself as a medium; his involvement with mysticism and the occult would continue to be a driving force throughout his life and work. In 1892 he moved to Vienna and enrolled at the Academy there. Kupka settled in Paris in 1896, attended the Académie Julian and studied with J.P. Laurens. During his early years there he did numerous fashion illustrations and drawings for books and newspapers. In 1906 he moved to Puteaux where his neighbors were Jacques Villon and Raymond Duchamp–Villon and with whom he would participate in the "Section d'or" group meetings. Around 1910 Kupka's concept that painting should concentrate on color, light and shadow and lines and planes as synesthetic signs of natural and spiritual phenomena culminated in his first abstract works, marking one of the earliest contributions in this field. *La Création dans les arts plastiques*, Kupka's book outlining his theories of the function of painting was published in Prague in 1923. During Kupka's lifetime his works were exhibited frequently at all the Paris Salons; major retrospectives were held at the Národní Galerie in Prague in 1946 and at the Guggenheim Museum in New York in 1975. He died in Puteaux in 1957.

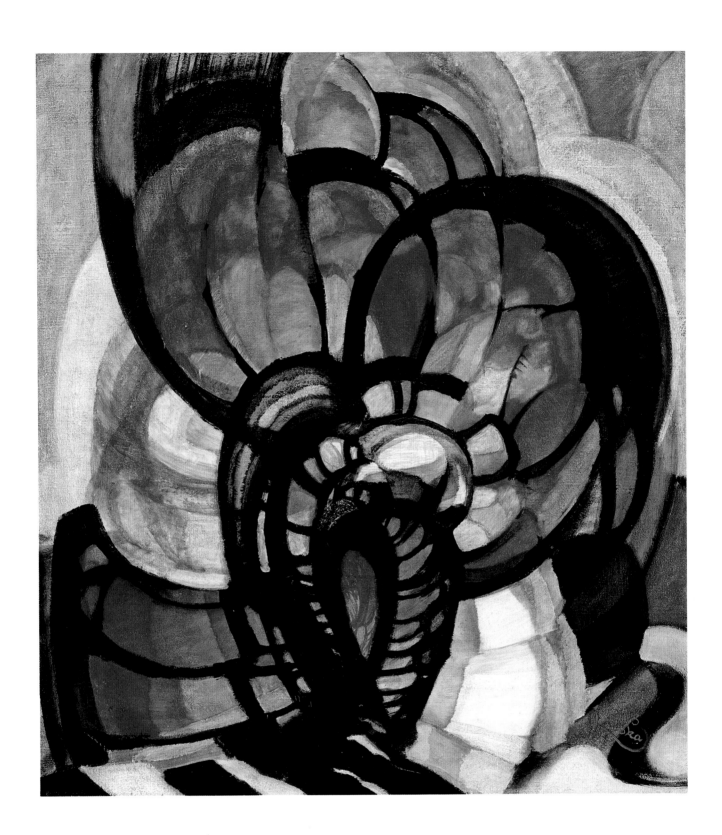

JUAN GRIS
Spanish, 1887–1927

Le Canigou, 1921

Oil on canvas
25½ x 39½ (64.8 x 100)
Room of Contemporary Art Fund, 1947

To avoid the rigors of winter in Paris, Gris spent from late October 1921 to April 1922 in Céret, a small town at the eastern end of the French Pyrenees. The window of his hotel room looked out onto the mountains, of which the Canigou was the highest peak.

The problem of unifying a landscape viewed through an open window with a still life placed before it was not new to Gris' work. In his 1915 *Place Ravignan*, for example, now in the Philadelphia Museum of Art, he wove together a vista through his studio window and the boxes, bottles and papers placed on a table in front of it. Gris accomplished the integration of objects widely separated in distance, size and identity through careful analogies of form which establish sparse geometric accords on the picture surface. The peaks and sweeps of the mountain range are repeated in the upper triangular corner of the table, the lower contour of the guitar and the draped tablecloth at the bottom of the picture. Additional duplications of forms confound the identification of objects and their placement in space: the tilted ovoids of sound hole and goblet, the decorous upper curve of guitar and the identical contour below and to the right and the centerfold of the book, which appears to extend for the entire height of the canvas.

Although Gris did not consider himself primarily a colorist, here he constructs elegant harmonies from a greatly restricted palette. Sober browns and greys, familiar Cubist tones, are modified by a chill and biting blue. This icy hue and the stark whites convey almost tangibly the crispness and clarity of a winter atmosphere and reaffirm the cold of which Gris continually complained in his letters.

K.K.

José Gonzalez, later called JUAN GRIS was born in Madrid, where he studied engineering briefly at the Escuela de Artes y Manufacturas. After leaving school in 1904, he painted under J.M. Carbonero in an Art Nouveau manner and worked as a comic illustrator. He moved to Paris in 1906; here he lived in the Bateau Lavoir next to Picasso, through whom he met Max Jacob, Georges Braque and Guillaume Apollinaire and supported himself by furnishing illustrations for newspapers. Influenced by the Cubist movement, he began serious work in 1910–11, first in watercolor and colored crayon. He exhibited at the 1912 Salon des Indépendants. He traveled with Picasso to Céret in 1913 and with Matisse and Albert Marquet to Collioure, 1914, and spent the war years in Paris. His first "open window" painting dates from 1915. In 1920 Gris suffered his first attack in an extended period of ill health. In 1923, he designed costumes and sets for Serge Diaghilev's Russian Ballet. He died four years later of uremia.

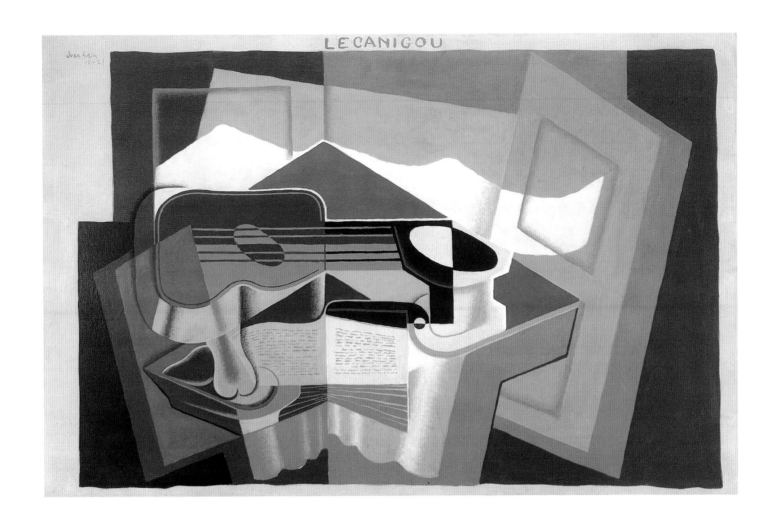

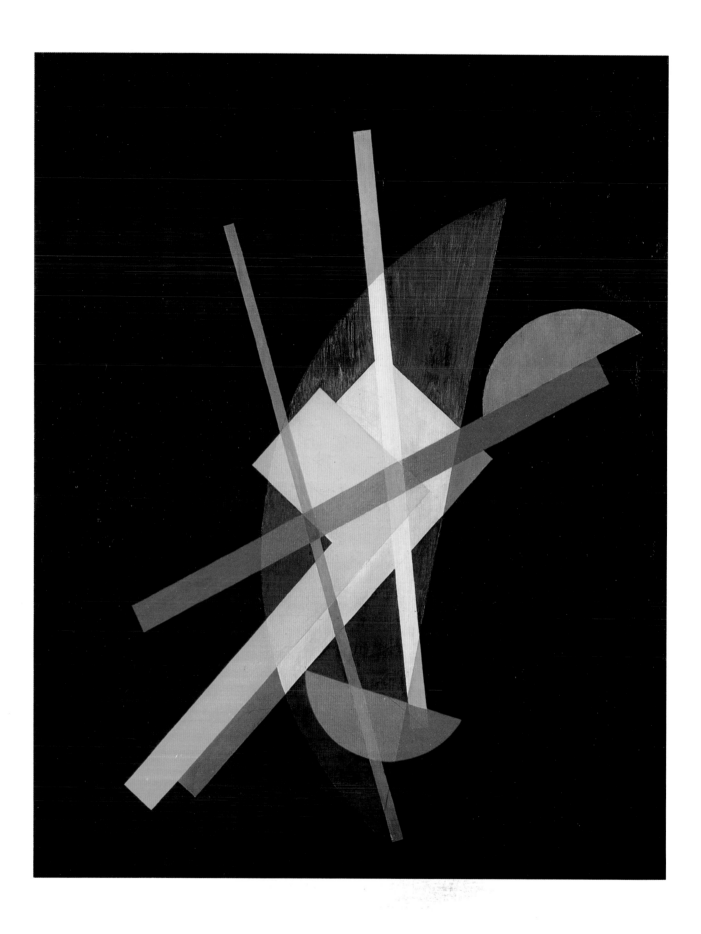

D IV, 1922

Oil on canvas
37 x 29½ (94 x 75)
George B. and Jenny R. Mathews Fund, 1973

Born in Bacsbarsod, Hungary, LÁSZLÓ MOHOLY–NAGY studied law at the University of Budapest from 1914–17, until interrupted by World War I. While recuperating from war wounds he became interested in art. His early work was in an expressionistic vein. In 1917 he joined Lajos Kassák in the activist art group "MA" (Today) and co–founded the literary review *Jelenkor*. The influence of Russian avant–garde art, especially the work of Malevich and Lissitzky, became evident in his work c. 1919. He became a member of "MA" in Vienna in the fall of 1919 and moved to Berlin in 1920 where he became acquainted with the Berlin Dadaists. He joined the staff of the Bauhaus in Weimar in 1923 as head of the metal workshop and also taught the foundation course, photography, typography and layout. He resigned from the Dessau Bauhaus in 1928, returning to Berlin where he had a successful career in stage design, working for the Krollopera and the Piscator Theater until 1933. He moved to Amsterdam in 1934 and to London the following year. In 1937 he accepted the Directorship of the New Bauhaus in Chicago and, when that failed financially, opened his own School of Design. He continued to work and teach in Chicago until his death.

Although such works from 1920 as the *Large Railway Picture* and the Dadaist *Large Emotion Meter* still utilized recognizable imagery, by 1921 Moholy–Nagy had become absorbed in the purely abstract pictorial problems of color, transparency and resulting spatial relationships. This led to experiments with painted transparent sheets and, subsequently, to his use of a variety of unorthodox materials, new synthetics such as gallaith and bakelite, aluminum and later, plexiglass. His interest in color and light took him beyond painting to find expression in his spacelight modulator, film and color photography. Although still a conventional easel painting, *D IV* (by 1920 Moholy had begun to title his work by impersonal letters and numbers) already moves out of the tradition of pictorial architectonics which was Moholy's inheritance from the Russian Constructivist inspired "MA" group. Moholy felt that the simplified geometric forms he learned from Kasimir Malevich and El Lissitzky freed him to concentrate on heightening color relationships.

In *D IV* he achieved a brilliance approaching that of projected light by means of transparent planes of luminous color superimposed against a black background. Moholy's palette was initially inspired by the bright hues of Hungarian folk art but by 1922 had a sophistication undoubtedly resulting from the artist's new fascination with urban technology, especially artificial illumination. His respect for technology is evident also in the smooth and painstakingly finished surface. Here this smoothness is interrupted only by the matte black of the central shape, which adds a contrast of texture and also lighting.

E.W.

121

Joan Miró
Spanish, 1893–1983

Carnival of Harlequin (Le Carnaval d'Arlequin), 1924–25

Oil on canvas
26 x 36⅝ (66 x 93)
Room of Contemporary Art Fund, 1940

Carnival of Harlequin is one of the most familiar and appealing of Surrealist paintings. It was painted in Paris during the winter of 1924–25, the climactic work in a series in which the landscape and color of Miró's native Catalonia were supplanted as primary influences by the painter's private fantasies.

Though several other of the painter's contemporaneous works have recently been shown to have been based on specific texts by the Surrealist poets whose company Miró frequently sought, no such source can be identified for *Carnival of Harlequin*. The title, however, may provide a clue to the meaning of this welter of whimsical detail. The character of Harlequin is familiar from the *Commedia dell' arte*, in which he plays a foolish clown, perpetually and almost always unsuccessfully, in love. Despite Miró's own identification of the two cats with Harlequin, the bearded and mustachio–ed gentleman at the left in the painting sports Harlequin's traditional mask, rounded "admiral's" hat and diamond–patterned tunic. Carnival, in its strictest sense, refers to the merrymaking and revelry which precede the enforced abstinence of Lent. The prominent hole in Harlequin's middle suggests that his fasting has begun prematurely. The Harlequin as self–portrait of the artist is a long-established artistic tradition which Miró certainly knew, for example, from the work of Picasso.

This painting is bisected vertically by a peculiar guitar–wielding female. It teems with symbols which have been shown to have explicit sexual reference for Miró. The large winged insect–like creature with a flamelike stem at the right is one of many female silhouettes which Miró derived from the contours of a kerosene lamp. Harlequin's woeful expression ironically belies the general riotous gaiety; he appears to suffer simultaneously from the pangs of unrequited hunger and the temptations of suggestive apparitions which flit cheerfully but tantalizingly just out of reach.

The canvas is very thinly painted and beneath the surface can be discerned traces of a broad linear grid which served to situate the major forms and provides some degree of systematic organization for the wealth of detail. Unity is also achieved through the astutely distributed areas of bright blue, a symbolic color which Miró particularly associated with the space and freedom of the dream.

K.K.

Joan Miró was born in Barcelona, the son of a goldsmith. He drew at a very early age and studied at the School of Fine Arts at La Lonja, where he was particularly influenced by Modesto Urgel and José Pascó. In 1912, after two years as a business clerk, Miró committed himself to art and entered Francisco Gali's Escola d'Art. After his first one–man show in 1918 he traveled to Paris in 1919, where he met his countryman Picasso. From 1920 he regularly wintered in Paris, returning to his family farm near Barcelona for the summer. He met Tristan Tzara, Pierre Réverdy and Max Jacob and was tangentially associated with the Dada movement, though beginning in 1922, his friendship with André Masson and a circle of avant–garde poets led him toward the nascent Surrealist group. 1923 marked a turning point in his development toward his characteristic mode of hallucinatory fantasy. A new source of inspiration from music culminated in the first of the "Constellation" series in 1940. With the German invasion of 1940, Miró left France for Spain where, four years later, he first collaborated with J.L. Artigas on the ceramics which would henceforth constitute a major segment of his oeuvre. In 1947, he visited the United States for the first time. He settled in a new studio designed by J.L. Sert in Palma da Mallorca in 1956. A prolific artist, Miró lived there until his death in 1983.

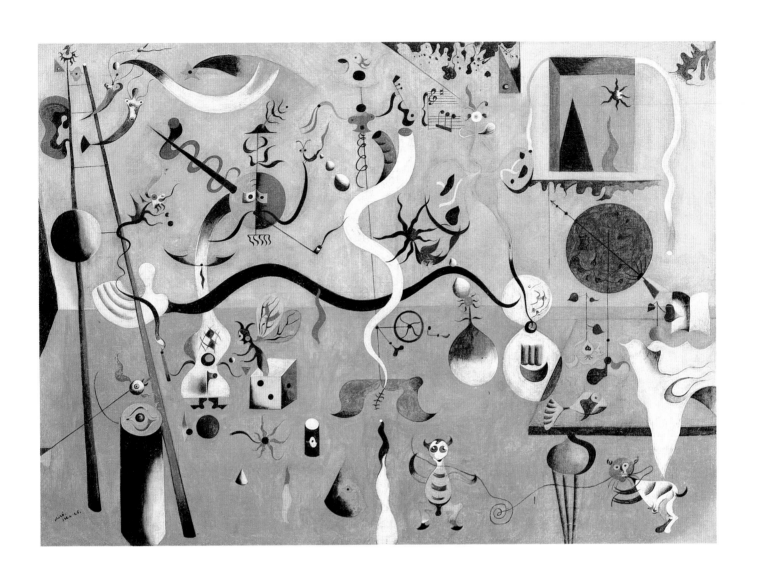

Marc Chagall
French, born Russia, 1887–1985

Peasant Life (La Vie paysanne), 1925

Oil on canvas
39⅜ x 31½ (100 x 80)
Room of Contemporary Art Fund, 1941

In 1911, not long after his move from Russia to Paris, Chagall painted the first version of *I and the Village* (The Museum of Modern Art, New York), a happy reminiscence of life in the Ukraine. After he returned to France, having spent 1914–23 in Vitebsk, Moscow and Berlin, he settled in the village of Montchauvet. There in 1925 he gave new expression to this theme in *Peasant Life*, also known as *Russian Village*, and in several replicas of *I and the Village*. Both compositions are based on a free association of images drawn from legends, memories and the imagination, pieced together in a dream—like atmosphere. *Peasant Life* repeats the basic compositional structure of the 1911 painting, with crossed diagonals and circles, but is freer and less schematic. The principal motif remains a young man and a horse, suggestive of the unifying, symbiotic qualities of nature embracing both man and beast. The circular background, recalling the shape of the earth, reinforces this idea of natural coexistence. At the left a family sits at a table in a building with a plaque inscribed with the Russian letters "LV," which probably are short for LAVKA ("little store" or "shop"), referring most likely to Chagall's mother's grocery store. The optimistic tone of the painting continues in the scenes of a carriage ride and dancing figures. Around the man and horse revolve various hues of red, green and yellow, the vividness of which surpasses that of earlier peasant scenes and reflects the happy and settled atmosphere of his life at Montchauvet. Although there has been considerable confusion over the title of this painting, Chagall indicated in 1976 that *Peasant Life* is correct.

C.K.

Born in Vitebsk, Russia, into a deeply religious Jewish family, Marc Chagall received his first artistic training there under Jehuda Penn; from 1907–10, he studied at the Imperial School for the Protection of Fine Arts in St. Petersburg. He later studied with Leon Bakst and became interested in the expressive power of color and distorted line. In Paris from 1910–14, Chagall was exposed to Cubism and Orphism, which had a marked influence on his art but did not dispel his love of poetic fantasy or his interest in universal human themes. His first one—man show was at the Galerie Der Sturm in Berlin in 1914. During his visit to Russia in 1914, World War I was declared; Chagall remained there and after the October Revolution, was appointed Fine Arts Commissar for the province of Vitebsk. He moved to Moscow in 1920 where he designed sets and murals for the Kamerny State Jewish Theater. In 1922, he left Russia for Berlin, settling permanently in France in 1923. He was given a retrospective exhibition in Paris in 1924. A prolific painter, Chagall executed as well numerous book illustrations, stained glass windows, murals and stage sets. He fled France ahead of the Nazi occupation and lived in the United States between 1941 and 1948; until his death in 1985 he lived in Paris and St. Paul—de—Vence.

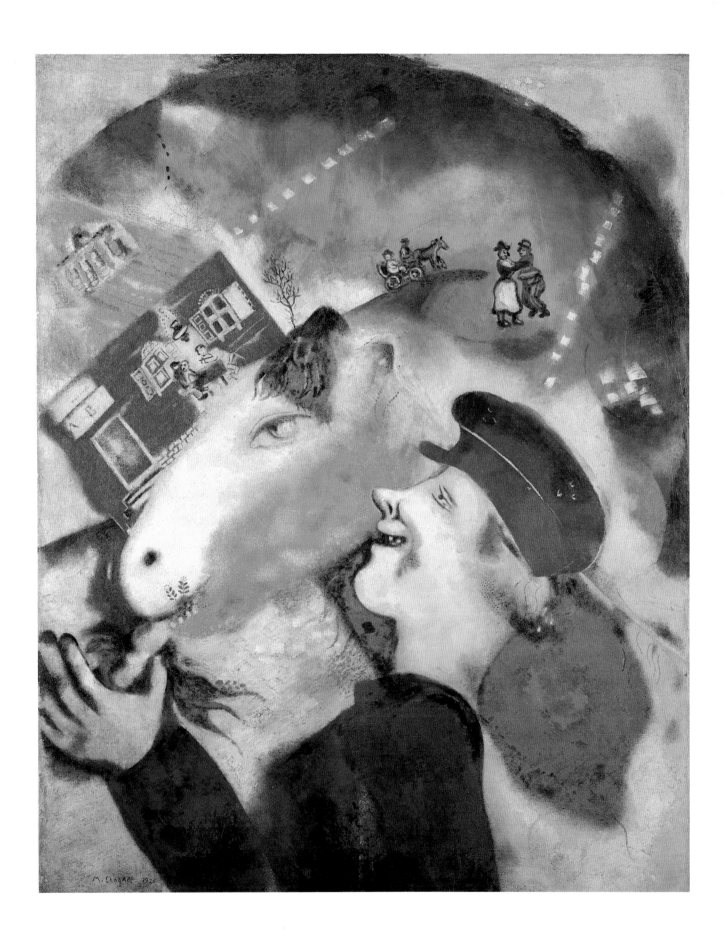

Max Ernst
German, 1891–1976

Age of Forests (Epoque des forêts), 1926

Oil on canvas
36⅛ x 23½ (91.8 x 59.5)
A. Conger Goodyear Fund, 1964

Max Ernst's forest paintings, spanning four decades from 1925 to the sixties, form an imposing thematic series exploring the mystery and symbolic associations of dark forest interiors. Ernst has related that at the age of three he was taken by his father on an outing to the forest surrounding Brühl, an experience which left a profound impression and helps explain the lasting hold this subject had on his imagination. He felt "...delight and oppression and what Romantics called 'emotion in the face of Nature.' The wonderful joy of breathing freely in an open space, but at the same time distress at being hemmed in on all sides by hostile trees. Inside and outside, free and captive, at one and the same time." The forest became for Ernst a symbol of night and darkness, of timeless nature, of freedom and imprisonment, hope and hopelessness combined. The paintings on this theme are generally similar in composition. A curtain of truncated, strangely textured "trees" rises up—mysterious vegetation in a primordial landscape. The forests vary in density and are sometimes elaborated with birds or celestial forms. Ernst's palette also varies, from dark browns to lighter, less sinister colors such as the blue–greens of this painting. The trees are produced in Ernst's so–called "grattage" technique, whereby the wet canvas is laid over wood or some textured object and the surface scraped so as to pick up the underlying pattern. Several applications may be combined. In this painting, the surface layers are applied over an earlier design, the circular forms of which remain visible in the center of the picture and seem to have been purposefully exploited by Ernst as a variant, disorienting texture.

C.K. & S.N.

Max Ernst was born in Brühl, Germany, near Cologne, son of the teacher and painter Philipp Ernst. Introduced by his father to art at an early age, Ernst received no formal training. In 1908 or 1909 he enrolled at the University of Bonn to study philosophy. A visit to an asylum spurred his interest in art of the mentally ill. He was friendly with August Macke and deeply influenced by the art of van Gogh, Cézanne, Picasso and other moderns seen at the Sonderbund exhibition in Cologne. During World War I, he served in the German army and was given an exhibition at Galerie Der Sturm in Berlin, 1916. With Jean Arp and Johannes Theodor Baargeld (pseudonym for Alfred Grünewald) he founded the Cologne branch of the Dada movement in 1919. In 1922, Ernst moved to Paris where he collaborated in the founding of Surrealism. Within these movements he cultivated an art of the irrational, symbolic and whimsical and gave expression to a fertile inventiveness that resulted in such devices of automatism as "frottage" and "decalcomania." Although he worked primarily in painting and collage, he also produced assemblages and in 1934, turned to sculpture. In 1937 he published *Au delà de la Peinture*. He escaped internment in France and entered the United States in 1941, spending time in California and Arizona. He married Peggy Guggenheim and then the American painter Dorothea Tanning. He returned to France in 1952.

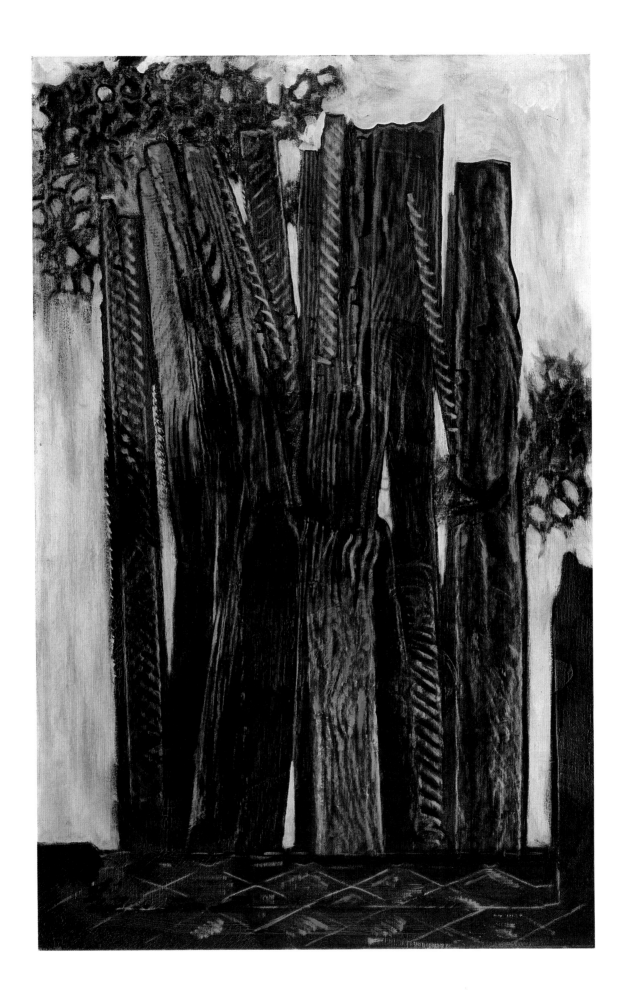

OSKAR KOKOSCHKA

British, born Austria, 1886–1980

London, Large Thames View I, 1926

Oil on canvas
35¼ x 51¼ (89.5 x 130.2)
Room of Contemporary Art Fund, 1941

*L*ondon, *Large Thames View I* is among the most celebrated of Kokoschka's many cityscapes. The artist visited London first in 1925, from which period only one painting has survived. During his second visit in 1926, which lasted several months, he executed a total of eleven pictures, mostly views of the Thames. In his autobiography he records how he was overpowered by the majesty of the city and the river:

> This river has always caught my imagination...My Thames! Those were the days when the merchandise of the whole world was still shipped up this river, when London was still a mother–city...It was the metropolis of the world trade, the founder of colonies on all five continents...I tried again and again to capture the Thames in a painting— that artery of life flowing from century to century, the river beside which multitudes gathered to form a community with a style of its own, bringing the most diverse races together...I was particularly attached to one painting of a bend in the river, visible from the window of my hotel room, looking down over the Egyptian obelisk known as Cleopatra's Needle...

With its exuberant brushwork and color and its baroque concentration of activity, this painting records the dynamism of the city at its fullest. The view is taken from high up over Victoria Embankment and shows Cleopatra's Needle and the Waterloo, Charing Cross and Westminster Bridges. Monet had painted from nearly the same point but from down close to the riverbank and had chosen to exclude Cleopatra's Needle to avoid dividing his composition. Kokoschka overcame this problem through the selection of a bird's–eye view. He painted a second, closely–related version of this scene in 1954, now in the Tate Gallery, London.

C.K.

Born in Pochlarn on the Danube of Czech and Austrian parentage, OSKAR KOKOSCHKA studied at the Wiener Kunstgewerbeschule in Vienna from 1905–08 and was strongly influenced by Egon Schiele, Gustav Klimt and Aubrey Beardsley. Prior to World War I, he concentrated on portraiture and executed a series of lithographs and wrote several plays. From 1910–14, he worked for the review *Der Sturm* in Berlin where he came in contact with German Expressionism and took part in the important expressionist show at the Galerie Der Sturm in 1912. Seriously wounded in the war, he suffered extreme psychological instability for several years. In 1919 he was appointed professor at the Dresdner Akademie but left abruptly in 1924 to travel until 1931. These were highly productive years in which he brought his expressionist style to its full culmination. After a brief stay in Vienna, Kokoschka moved to Prague in 1934 but fled to London ahead of the Nazi occupation in 1938. He became a British subject in 1947 and resided in Villeneuve, Switzerland, from 1953 until his death in 1980.

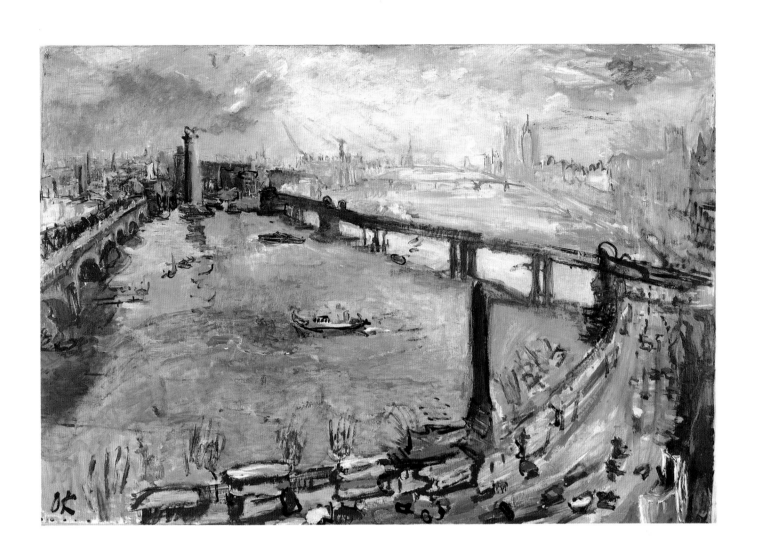

CHAIM SOUTINE

French, born Lithuania, 1893–1943

Page Boy at Maxim's, c. 1927

Oil on canvas
51 x 26 (129.5 x 66)
Edmund Hayes Fund, 1953

Soutine's interest in uniformed figures as subject matter arose simultaneously with his interest in animal still lifes, but unlike his paintings of the latter, generally excited and calligraphic in treatment, the figure paintings take the form of simplified compositions with large, flat areas of concentrated color. He dwelt with obvious delight on the reds of the page boy and choir boy, the whites of cooks, and the blues and greens of valets. He seems also to have been deeply drawn to pathetic figures whose identity is lost in service to others and in the anonymity of uniforms. In this painting, the gawky, loose–jointed youth, his features twisted in an expression of suffering, opens his hand in what is at once a commonplace request for a tip and a more moving gesture of resignation.

S.N.

Born in Smilovitchi, near Minsk, in Lithuanian Russia, the tenth of eleven children of an impoverished Jewish tailor, CHAIM SOUTINE left home to study art in Minsk and in 1910 was admitted to the art school in Vilna. He traveled to Paris in 1913, where he studied under Fernand Cormon at the Ecole des Beaux–Arts and established himself in the artists' quarter known as La Ruche with Marc Chagall, Moïse Kisling, Fernand Léger and Amedeo Modigliani as his neighbors. Modigliani became a close friend and introduced him to his future patron and dealer Leopold Zborowski. During this period Soutine lived in extreme poverty. In 1918 he paid his first visit to Cagnes and in 1919 his first to Céret, where he worked for the greater part of the next three years. In 1923 he sold a large number of paintings to Albert Barnes, finally achieving a measure of financial security. More or less in isolation, Soutine continued to work in the tradition of French painterly expressionism, enriched by his knowledge of Rembrandt, van Gogh and Gustave Courbet. The German Occupation forced him to leave Paris and he settled in 1941 at Champigny–sur–Veuldre.

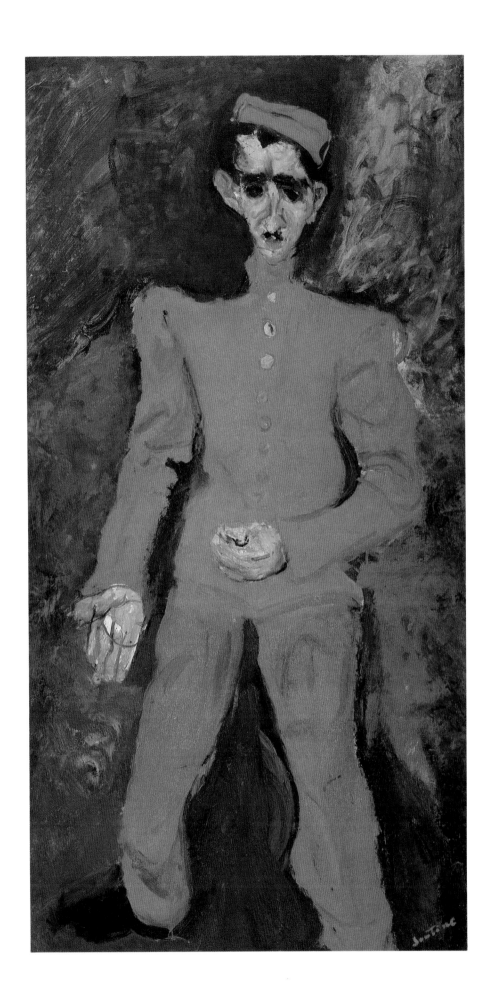

RENÉ MAGRITTE
Belgian, 1898–1967

The Voice of Space (La Voix des airs), 1928

Oil on canvas
25½ x 19½ (64.8 x 49.5)
Albert H. Tracy Fund by exchange; George B. and Jenny R. Mathews Fund, 1976

Magritte stated that one of his conscious intentions in this painting was to find a new feeling of space. As with much of his hermetic discourse it is difficult to know exactly what he meant. Quite certainly he was not referring to a new type of pictorial space; unlike the Cubists, Magritte's approach was consistently traditional in the depiction of a deep illusionistic space. We do know from Magritte himself that the cleft spheres which figure so powerfully here and recur throughout his iconography derive from the large metal bells hung on horses' collars. The bell has traditionally defined and articulated the space through which its sound waves scatter. In the history of art the sphere has often symbolized the perfect geometric materialization of volume, as well as the universe or infinity. Whether Magritte intended to defy the restrictions of the two–dimensional image by conveying in a palpable way the vastness of infinity or to suggest space travel when such a notion had just begun to enter the public fantasy, his image is peculiarly haunting and mysterious.

The motif of the bell is central to an understanding of Magritte's art, for no other image reappears so consistently. From the suggestive *Maître du plaisir* of 1926, in which a hairy, licentious bell is personified as the Master of the Revels, to drawings made shortly before Magritte's death, it recurs with startling frequency in many different contexts. In considering the origins of the imposing sphere as a device in Magritte's work, it is instructive to recall Giorgio de Chirico's *Song of Love*, 1913–14, a painting which Magritte considered a critical catalyst in his artistic development and which groups an antique head, a glove and a large foreground ball. René Passeron has described Magritte's bell as a kind of silent bell, matrix and money box, spatial device and maternal symbol. This sphere, opened to reveal its hollowness, becomes a metaphor for what is revealed and what is contained, a fitting emblem of the mystery which Magritte felt underlies all human experience.

K.K.

RENÉ MAGRITTE was born in Lessines, Belgium in 1898. He began to paint and draw at the age of twelve and from 1916–18 studied at the Academy of Fine Arts, Brussels. His youthful work derived from early Cubism and Futurism, and was frequently tempered with a personal eroticism. In the early twenties he collaborated with a number of avant–garde poets and painters on several short–lived periodicals. Paul Le Comte in particular proved an important catalyst by introducing Magritte to the early paintings of de Chirico. From then on he would continue to fix his attention on the familiar object, variously isolated and altered in scale or otherwise wrenched out of its normal context in an appeal to areas of feeling beyond the realm of reason. From 1927–30 he lived in the suburbs of Paris, associating tangentially with the French Surrealists, then at the height of their activities. He returned to Brussels, where he was active in the Belgian Surrealist group, while at the same time living a quiet and unpretentious life. His style never evolved, though the nature of the metaphysical issues he investigated became more complex. He died after increasing international success and several important large–scale mural commissions in Belgium.

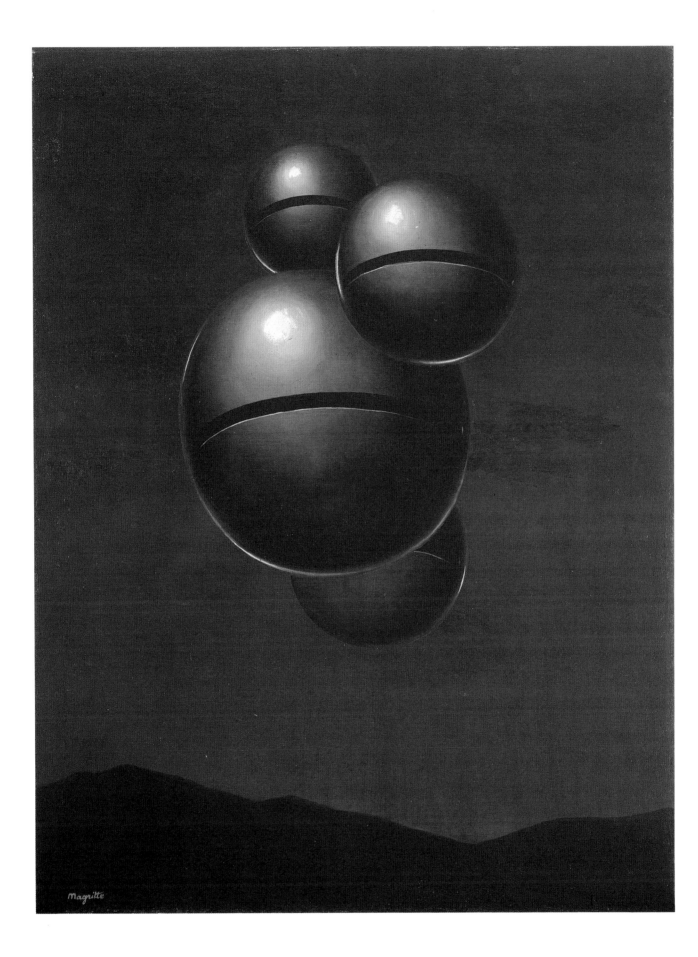

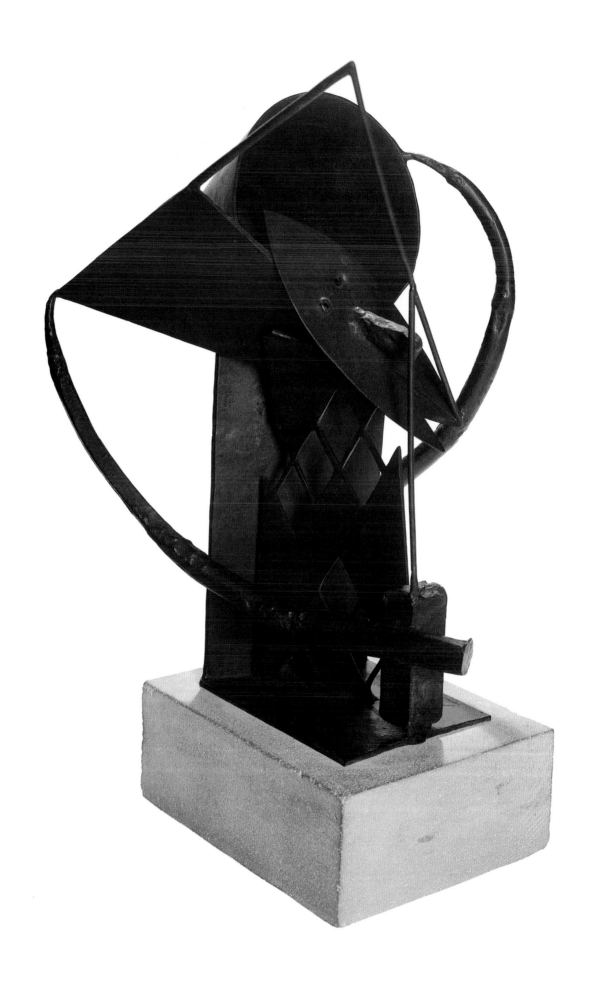

JULIO GONZALEZ
Spanish, 1876–1942

Harlequin, c. 1930

Bronze
16½ x 12 x 11 (42 x 30.5 x 28)
George B. and Jenny R. Mathews Fund, 1972

Born in Barcelona, JULIO GONZALEZ learned metalsmithing from his father and also studied painting at the School of Fine Arts. In 1900 his family moved to Paris. He developed a close friendship with Picasso and worked at the time mostly in painting but also made his first metal mask. In 1908 Gonzalez's brother died, and the deep sense of loss he felt caused him to withdraw from his friends and abandon his art. He did not not resume working until about 1926, and after a period of self–doubt he began to concentrate on sculpture, particularly welded masks and figures. Starting in 1928 he assisted Picasso for several years in the execution of his welded iron sculptures and began himself to make more complex and abstract works. In 1932 he joined the group Cercle et Carré. His *Montserrat* was exhibited in the Spanish Pavilion at the 1937 World Exposition. During the war he turned more to drawing and modeling in plaster. Gonzalez died in Arcueil outside of Paris leaving a legacy of work that has continued to influence greatly the history of welded sculpture.

Harlequin, executed probably c. 1930, was by far the most ambitious and complex structure Gonzalez had made to date. His earlier work consisted for the most part of masks and head and figure reliefs with a basically frontal, two–dimensional, collage–like orientation. The *Harlequin*, in constrast, manifests an increased involvement of space (the "drawing and projecting in space" that Gonzalez would later acknowledge as a guiding principle behind his sculpture) and a freer and more inventive approach to composition. It announces, moreover, the style of witty, dynamic configurations that would characterize this artist's mature work. Given the close collaboration that existed between Gonzalez and Picasso from 1928 to 1931, with Gonzalez supplying the technical expertise for realizing Picasso's formal ideas but also gradually developing as a self–confident, mature sculptor in his own right, it is very likely that inspiration for the bold departures in the *Harlequin* came from Gonzalez's Spanish compatriot. Gonzalez undoubtedly was familiar with certain of Picasso's paintings and drawings of open, geometric figures from the preceding years, and there exist particularly close correspondences, both in details and overall syntax of composition, between the *Harlequin* and Picasso's *Figure* of March 16, 1930. Certainly the *Harlequin* must count in its parentage not only Lipchitz's "transparencies" of 1926–27 and works from Picasso's late Cubist style such as the *Three Musicians*, but even more importantly, the sculptural ideas advanced by Picasso in his *Construction* and *Painted Iron Head* of 1928.

S.N.

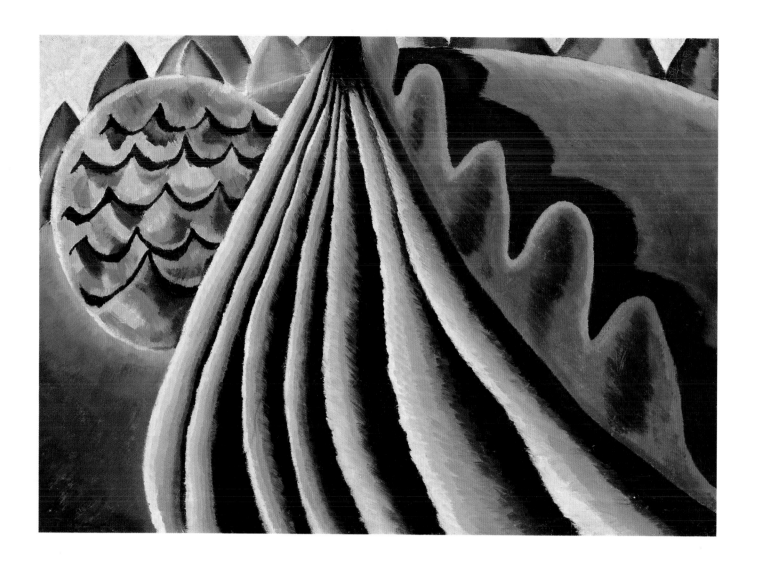

Fields of Grain as Seen from Train, 1931

Oil on canvas
24 x 34⅛ (61 x 86.8)
Gift of Seymour H. Knox, 1958

Born in Canandaigua, New York, ARTHUR DOVE spent most of his childhood in Geneva, New York, where his father was a contractor. He attended Hobart College in Geneva and then Cornell University in Ithaca. He later moved to New York City in 1904 to work as a free–lance illustrator. In France from 1907 to c. 1909, he met Alfred Maurer and Arthur B. Carles and came under the influence of Matisse and Cézanne. Dove's first abstractions, derived clearly from nature, date from 1910. Living in Westport, Connecticut he attempted· to support his family by farming but stayed in contact with the Stieglitz circle in New York. His first one–man exhibition at Stieglitz's "291" gallery was in 1912. He lived on a boat in Long Island Sound, 1920–27, then at Halesite, Long Island. About 1924 he began making assemblages. He moved back to Geneva in 1922 and returned to Long Island in 1938, settling in Centerport. Late in life he was weakened by a heart attack and kidney disorder.

Dove's contribution to early avant–garde 20th–century American painting lies in his development of a pictorial language in which simplified, semi–abstract forms and earthen colors express the essence of natural forces and structure. *Fields of Grain as Seen from Train*, painted in 1931, is a celebration of the generative power of fertile farmlands. Dove himself had farmed as a young man and speaks here from the vantage point of long attachment to the land. Symbolic patterns, suggested by waves of grain blowing in the wind or furrows in newly plowed fields, are extracted from nature and joined as if viewed successively from a rushing train. The light is that of a warm late summer afternoon. A strong movement animates all elements of the composition, revealing Dove's own empathetic response to the rhythms of nature. In its rounded heaviness, the central funneling shape alludes to organic ripeness, as do the other swelling forms, all of which share in the restricted but warm palette of browns, deep green and yellow and are tied together by Dove's uniformly sketchy brushstroke.

This painting was among those found in a warehouse by the artist's family several years after his death and later obtained by the Downtown Gallery, where they were first shown as a group in 1956.

S.N.

ALBERTO GIACOMETTI
Swiss, 1901–1966

Invisible Object (Hands Holding the Void) (L'Objet invisible [Mains tenant le vide]), 1934

Bronze
60⅝ x 12¾ x 11 (154 x 32.5 x 28)
Edmund Hayes Fund, 1961

Invisible Object (Hands Holding the Void) illustrates, in the totemic, mythic quality of the figure, the incorporation of space into the design and the play of figure against abstract geometry, expressive and formal ideas which had been central to Giacometti's Surrealist investigations. Consistent with the purposefully enigmatic quality of his art, however, the sources and metaphorical content of the figure remain elusive. André Breton, with typical Surrealist subjectivity, interpreted it as an emanation of the desire to love and be loved, in quest of its true human object and in all the agony of this quest. He also credited a metal mask that Giacometti found at the flea market with helping to inspire the figure's forms. Reinhold Hohl has suggested as a source a Polynesian statue of a deceased woman which Giacometti knew from the Ethnological Museum in Basel. He further points out that the bird in the first casts, kindred to the skeletal bird flying aloft in Giacometti's *Palace at 4 a.m.*, 1932–33 may relate to the birdlike demons of death found in Polynesian art, and also suggests that the figure's gesture derives from an Egyptian statue of Queen Karomama carrying before her an invisible idol sacred to Isis, of which Giacometti made a drawing. Strong affinities in pose and gesture between Giacometti's figure and Georg Kolbe's *Assunta* of 1921 signal yet another possible source.

S.N.

Born in Borgonovo (Grissons), Switzerland, into a family of artists, ALBERTO GIACOMETTI moved with his family to the nearby town of Stampa in 1906. He worked as a youth in his father's studio and enrolled in the Academy of Fine Arts and Crafts in Geneva. He traveled in Italy, 1920–21, and in January of 1922, settled in Paris. Intermittently for five years he attended Bourdelle's sculpture class at the Académie de la Grande Chaumière and first showed in the Salon des Tuileries in 1925. In 1927 he moved into a small studio with his brother Diego, where he would live and work until his death. Giacometti's close association with the Surrealist artists and writers dates from 1929. After early sculptures showing both Cubist and primitivist tendencies and adherence to the Surrealist creed of "interior models," he began to work again from the model and quickly evolved the elongated, eroded figures of his mature style. He continued all the while to paint and draw. His first retrospective exhibition occurred in 1955.

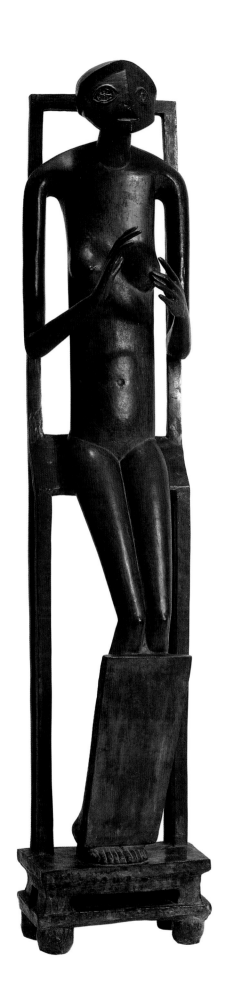

PAUL KLEE
Swiss, 1879–1940

Child Consecrated to Suffering (Wehgeweihtes Kind), 1935

Oil and watercolor on paper mounted on white board
6¼ x 9¼ (16 x 23.5)
Room of Contemporary Art Fund, 1940

Although drawn with humor and a deceptive child–like simplicity, this small head mingles with its innocence an underlying sense of foreboding. Crowding the boundaries of the picture, the face pushes outward with a quiet and solemn insistence, evoking the painful vulnerability of childhood and perhaps as well the inevitability of sorrow in a world then plunging toward war. The rough eroded surface hints at an ancient and, therefore, timeless meaning. A verbal–visual pun is formed by the worried furrow forming a W on the child's forehead echoing the inscription ("W = geweihtes Kind"), since in German the letter W and the word "weh" or "suffering" are pronounced alike.

The device of a close–up expressive face or mask is familiar in Klee's art, but in this case the motif seems to have been inspired by pre–Columbian sculpture, demonstrating the artist's interest in non–European traditions. Particularly close parallels exist with certain classic Teotihuacan stone figures. The criss–crossing linear ornament of the headdress relates to similar markings commonly found on pre–Columbian sculptures and had appeared in the earlier *Black Prince* of 1927 (Kunstsammlung Nordrhein–Westfalen). Indicative of Klee's imaginative approach to technique, the pigment here is brushed on thickly to create a rich, scumbled texture and to suggest other materials, such as rough stone or burlap. The primitive aspect of the image is accentuated by dull earthen tones of red, brown and green.

S.N.

Born in Munchenbuchsee near Bern, the son of a German musician, PAUL KLEE went to Munich 1898–1900 to study painting. He worked first under Heinrich Knirr and then at the Akademie der Bildenden Künste under Franz von Stuck. He visited Italy in 1901 with the sculptor Hermann Haller and in 1906 married and settled in Munich where he lived until 1920. Klee at first considered himself primarily a graphic artist and concentrated on etching, avoiding the problems of color. His first one–man show was in 1910. In 1912 he exhibited with "Der Blaue Reiter." Visits to Robert Delaunay's studio in Paris in 1912 and to Tunis in 1914 helped awaken his strong color sense and shift his interest to painting. In 1920 he accepted an invitation by Walter Gropius to teach at the Weimar Bauhaus and moved with the Bauhaus to Dessau in 1926. A trip to Egypt in 1928 brought about a change of style, leading him to submit his magical painted visions to greater simplification and abstraction. He served as Professor at the Kunstakademie Düsseldorf from 1931 until 1933 when he was dismissed by the Nazis. He settled in Bern and died in 1940 after a prolonged illness at Muralto–Locarno.

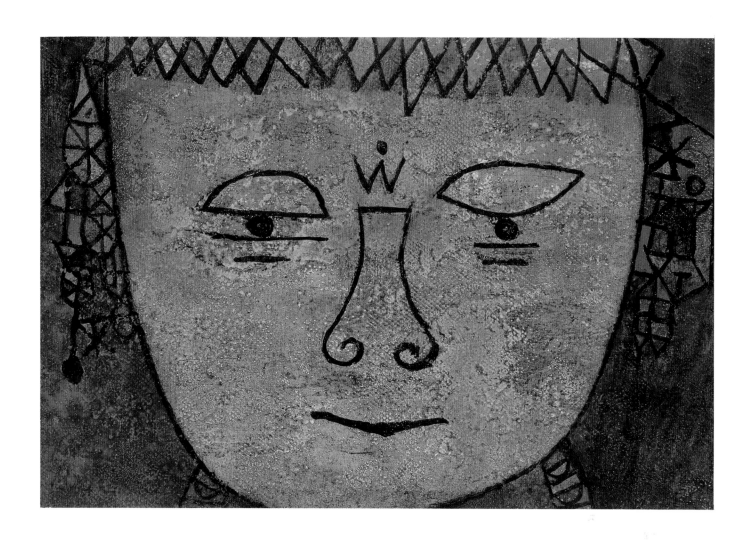

HENRY MOORE
British, 1898–1986

Reclining Figure, 1935–36

Elmwood
h. 19; 1. 35; d. 15 (48.3; 89; 38)
Room of Contemporary Art Fund, 1939

Reclining Figure is the earliest of Moore's wooden reclining figures and was the first sculpture by this artist purchased by an American museum. In the summer of 1939 Gordon Washburn, Director of the Gallery at that time, visited Moore's studio in Hampstead and there negotiated to buy this work from among the studio contents. Although it is sometimes dated 1935 or 1936, Moore himself confirmed in a letter to the Gallery, 1975, that he began work on the sculpture in 1935 and did not complete it until 1936.

The reclining female figure has been the single most enduring theme in Moore's art, providing a context for his continuous exploration of the underlying forms and rhythms of nature. The earliest figures, carved in stone in 1926–27, and another important group in stone from 1929–30 have a bulkiness and archaic quality bespeaking the influence of pre–Columbian art such as the Mayan *Chac Mool.* The Buffalo figure and related ones from 1936, 1938 and 1939 with their swelling contours, opened–out forms and abstracted anatomy evidence the stylistic freedom that resulted from the highly abstract phase Moore's art passed through in the early 1930s. Working in wood, he was able to carve more deeply than ever before into the forms and to heighten the flow of contour with grain patterns. In this figure the torso is completely tunneled through, uniting front and back surfaces. The legs and upper limbs merge smoothly without interruption, and the head, shoulders and breasts are locked in a tight undulation of curves. A psychological tension in the reclining figures, deriving from the alert, propped–up poses and odd expressions, as well as overt sexual references, such as the deep hollows and the use of a slash for faces, betray certain surviving affinities with Surrealism.

S.N.

HENRY MOORE was born at Castleford, Yorkshire, the son of a coal miner. Following service in France during World War I, he studied for two years at the Leeds School of Art, 1919–21, and then won a scholarship for study at the Royal College of Art in London. He began carving in stone in 1922. His early influences included Jacob Epstein and Henri Gaudier–Brzeska as well as Egyptian, African, Etruscan and Mexican art. Moore was appointed instructor at the Royal College of Art in 1924 and exhibited for the first time in a group show at St. George's Gallery, London, 1926. He moved to a studio at Hampstead in 1929. A primitivizing trend in Moore's early sculpture gave way in the 1930s to the open and organic qualities that characterize his mature work. He was a member of the 7 & 5 Society and Unit One and a founding member of the Surrealist group in England. During World War II he concentrated mostly on shelter and mining drawings. He moved in 1940 to Much Hadham, Hertfordshire, where he lived until his death in 1986. A recipient of numerous public commissions and honors, Moore also wrote perceptively on modern art.

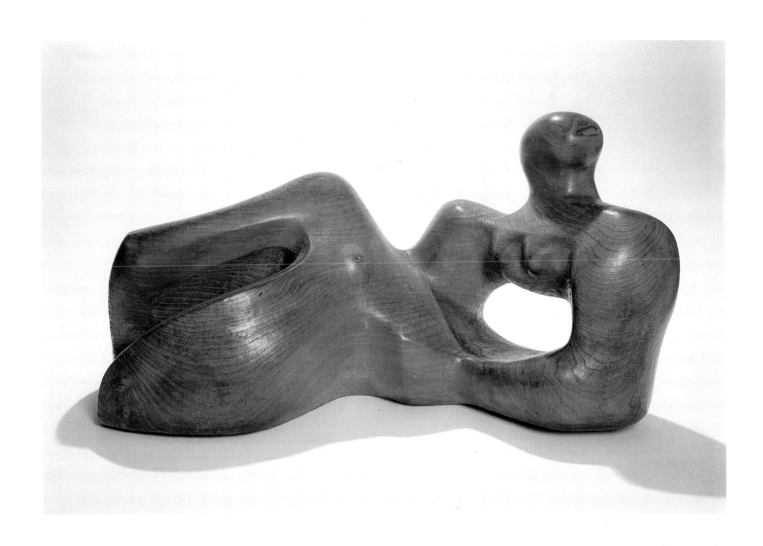

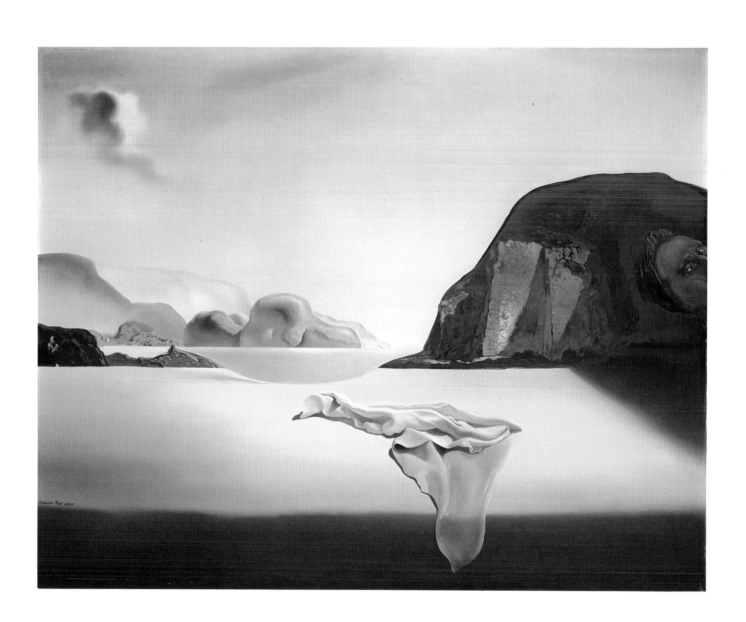

SALVADOR DALI

Spanish, born 1904

The Transparent Simulacrum of the Feigned Image, 1938

Oil on canvas

28½ x 36¼ (72.5 x 92)

Bequest of A. Conger Goodyear, 1966

SALVADOR DALI Y DOMENECH was born in Figueras, Catalonia, Spain, the son of a notary public. He enrolled at the Real Academia de Bellas Artes de San Fernande in Madrid in 1921 and after a stormy student career was finally dismissed in 1926. An early appreciation for such 19th–century genre painters as Mariano Fortuny and Ernest Meissonier would have a lasting influence on his technique. His first one–man show was in Barcelona, 1922. He visited Paris in 1927 and 1928, where he met Picasso, Miró and the Surrealists. Dali's early interest in Impressionism and Cubism was overshadowed by the more crucial influences of Yves Tanguy, Max Ernst and Giorgio de Chirico, and by the time he joined with the Surrealists in 1929–30, he had formulated his own Surrealist style in which he recorded the most subjective visions and fantasies as objective visual fact. He collaborated with Luis Buñuel on such films as *Un Chien andalou*, 1928 and *L'Age d'or*, 1930 and his activities extended to other media as well, including sculpture–jewelry, graphics and contributions to many Surrealist publications. In 1934 he was expelled from the Surrealist group by André Breton but continued to exhibit with them. He lived in exile in the United States during World War II. Dali's later work, often incorporating Renaissance and Baroque forms, became increasingly ponderous and eclectic. He lives in New York, Paris and Port Lligat, Spain.

Dali emerged about 1930 as the artistic leader of the Surrealists and throughout the decade that followed, he continued to examine within a consistent stylistic framework the psychological themes and motifs introduced by his paintings of 1928–29. His ambition, as he described it, was to materialize images of concrete irrationality with the most imperialist fury of precision. One of the central techniques in what he called his "paranoiac–critical" method was the projection of hallucinatory double images into commonplace surroundings and subjects.

In his *Transparent Simulacrum of the Feigned Image*, the title of which alerts us to equivocal visual illusions, what can be taken as a sandy landscape with a cove in the middleground can also be seen as a tabletop still life comprised of a crumpled cloth and, at the rear, a bowl of pears. Along the right margin floats an apparition of the head of Dali's wife Gala, who is continuously invested in Dali's paintings with mythical connotations and is credited here in the double signature for her inspirational role. The contrast of open spaces and smooth, malleable shapes with the rugged profiles of rock gives to the picture a visual drama that complements its ambiguous but tense psychological overtones.

S.N.

STUART DAVIS
American, 1894–1964

New York Waterfront, 1938

Oil on canvas
22 x 30¼ (56 x 77)
Room of Contemporary Art Fund, 1943

Although Davis was involved with WPA mural projects from 1934 to 1939, he continued to produce easel paintings, developing on a small scale new stylistic ideas that fed directly into the murals. His canvases from the preceding years had been essentially planar arrangements of geometric shapes, much under the influence of Synthetic Cubism. About 1933, however, his works began to show a greater complication of space, with heavy lines, fragmented forms and irregular color shapes interlocked in dense, pulsating compositions which recreated in semi–abstract language the dynamism and excitement that Davis found so stimulating in the American scene. One of his most frequent themes was the waterfront, of both New York City and New England ports. About *New York Waterfront* Davis wrote: "(This) is not an image seen from an East River pier with the eyes alone. It is a negation of the optically familiar in Nature. It calls on the memory and the imagination to make what the eye sees alive again." As part of the process of abstraction from nature, the colors here are arbitrarily restricted to blue, red, white and black, all set off against a light brown background. In the reduced shapes and strong contrasts, the influence of Fernand Léger is particularly discernible, while the thick, smooth paint surface is a reminder of Davis' early painterly stylistic development. The inclusion of letters and fragments of words, which function as both a dynamic part of the formal design and as a reference to everyday reality, had been a common device of Davis' since his Cubist experiments of the 1920s.

S.N.

STUART DAVIS was born in Philadelphia where his father was art director of the Philadelphia Press. He moved with his family to East Orange, New Jersey in 1901, and at age sixteen left school to study with Robert Henri in New York where he executed drawings for *The Masses* and *Harper's Weekly*. He exhibited five watercolors in the Armory Show of 1913 and in 1910 and 1917 exhibited with the Independents. He summered in Provincetown and Gloucester, Massachusetts. During World War I, Davis served as an Army cartographer. His early work was influenced by "The Eight" and by such European artists as van Gogh and the Fauves but by about 1920 he had turned to non–objective art, working at first in a Cubist–derived mode and then evolving an expressive treatment of distinctly American subject matter. He traveled to Paris, 1928–29, and returned to teach at the Art Students League, New York, 1931–32. In 1933 he enrolled in the Federal Art Project. He was active with the Artists' Union and, after 1935, with the Artists' Congress. He produced three murals under the WPA. From 1940 to 1950 he taught at The New School.

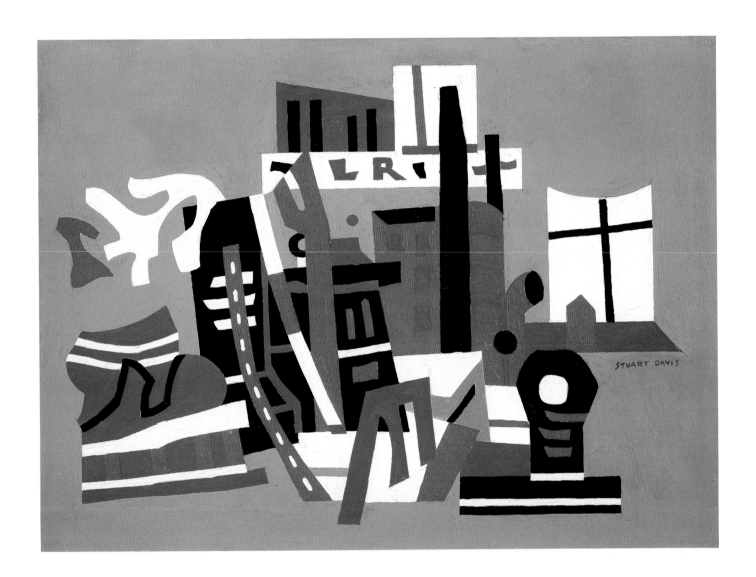

YASUO KUNIYOSHI
American, born Japan, 1889–1953

I Think So, 1938

Oil on canvas
38 x 30½ (96.5 x 77.5)
Room of Contemporary Art Fund, 1939

This is one of the numerous paintings produced by Kuniyoshi from 1930 to the early forties in which solitary women are caught in a mood of contemplation, reverie or fatigue. Generally shown seated and partially undressed, they often hold a cigarette as they stare up from a newspaper or magazine that no longer holds their interest. Titles such as *I'm Tired*, *Quiet Thought*, and *All Alone* emphasize Kuniyoshi's moody themes. Looking back over these works in 1948, the artist is recorded as saying, "All seem very lonely, all sort of lost, deserted, thinking. Hold newspaper, but don't read—sit in chair, just thinking." Viewed in context, this note of self–absorbed isolation can be seen as a common feature in works by other American urban realists, such as Edward Hopper, Kenneth Hayes Miller, the Soyers and Reginald Marsh, and seems to relate an uneasy loneliness they all sensed in the urban experience.

Kuniyoshi's technique, reminiscent of Jules Pascin in its combination of thin outlining and glazes of pale color, has a delicacy befitting his subject matter. In *I Think So*, the figure is painted in greyish tones against a background loosely brushed in pink and salmon tints. Although the artist kept a rather detailed record book, there is no specific information in it on this particular painting.

S.N.

Born in Okayama, Japan in 1889 and not 1893 as frequently stated, YASUO KUNIYOSHI came to the United States alone in 1906 and worked at odd jobs in Seattle and Spokane before entering the Los Angeles School of Art and Design. He went to New York in the fall of 1910 where he studied briefly at the National Academy of Design with Robert Henri, from 1914 to 1916 at the Independent School and from 1916 to 1920 under Miller at the Art Students League. He exhibited first at the Society of Independent Artists in 1917; his first one–man show was at the Daniel Gallery in 1922. Kuniyoshi traveled to Europe in 1925 and again in 1928, living for several months in Paris where he became friends with Pascin. He summered in Woodstock, New York from 1929. Kuniyoshi remained a figurative artist throughout his career, changing his style in the late 1920s from a somewhat primitivizing approach to a more direct naturalism. He taught at the Art Students League from 1933, at The New School from 1936 and worked on the WPA Art Project, 1936–38.

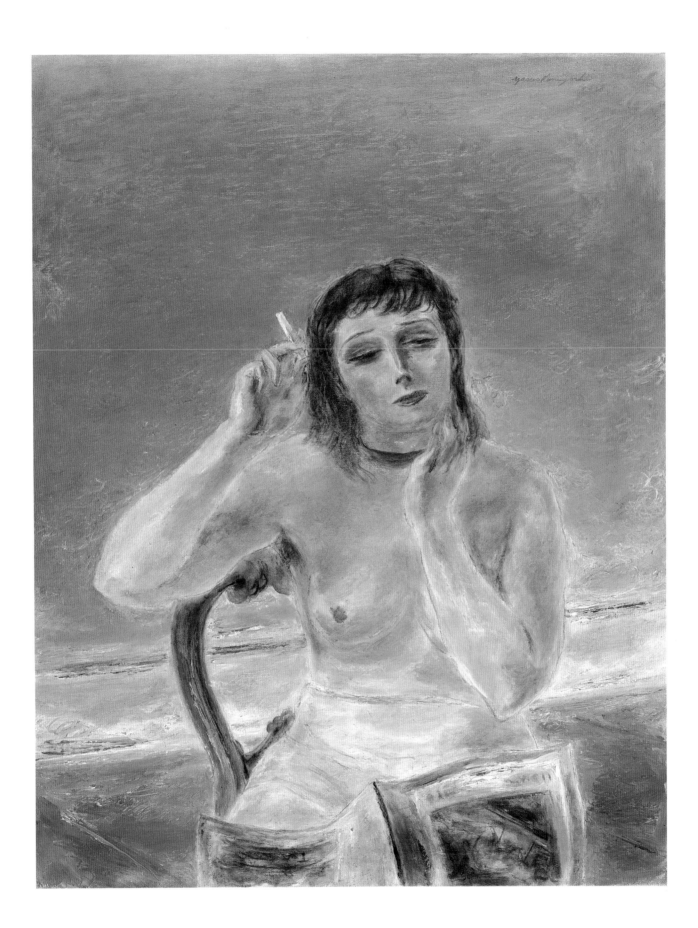

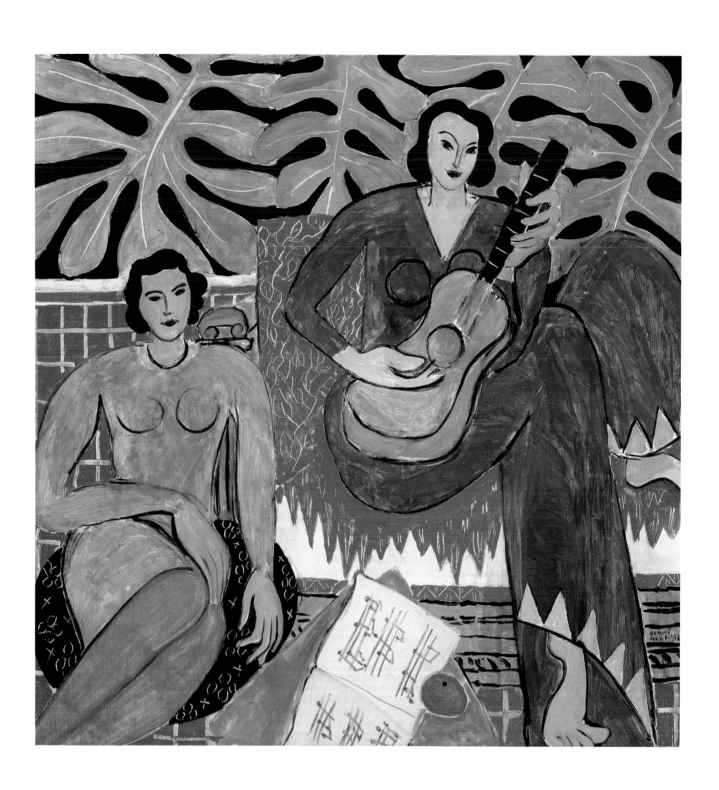

La Musique, 1939

Oil on canvas
45⅜ x 45⅜ (115.2 x 115.2)
Room of Contemporary Art Fund, 1940

Born at Le Cateau–Cambresis, HENRI MATISSE studied law in Paris from 1887 to 1888; in 1889, however, he decided upon an art career and joined the drawing class at the Ecole Quentin–Latour. He also received training from William Bouguereau at the Académie Julian. In 1892, he began work in the studio of Gustave Moreau; soon after, he met Albert Marquet and Georges Rouault, exhibited at the Salon de la Société Nationale des·Beaux–Arts in 1894 and was elected an associate in 1896. The next year, he met Camille Pissarro and came under the influence of Impressionism. Together with André Derain and Maurice de Vlaminck, Matisse led the group dubbed "Les Fauves" at the 1905 Salon d'Automne and developed an art of extreme color intensity. He took up sculpture and printmaking and received a great deal of support for his early work from Ambroise Vollard, the Steins and S.I. Shchukin. Matisse often worked at Collioure in the south of France and visited Spain, Moscow and Tangier; from 1916 on, he generally wintered in Nice. In 1920, he designed costumes and sets for Serge Diaghilev's ballet Le Rossignol. He also provided illustrations for numerous publications and in 1930–33, designed decorations for the Barnes Foundation in Merion, Pennsylvania. His late works include many large and colorful collages and decorations for the Chapel of the Rosary at Vence.

Painted in Nice in March and April of 1939, La Musique exemplifies Matisse's grand decorative style of the 1930s, in which he turned away from the intimate, deftly modeled interiors of the twenties and revived, on a large scale, the more flat, linear and abstract mode of such earlier works as the Young Sailor II, 1906 and the Dance, 1910. The themes of music and of two seated females in complementary poses recur frequently in Matisse's work and are here combined in a composition underscoring the artist's ability to orchestrate an abundance of ornamental pattern and pure tones while still maintaining clarity, balance and strong visual impact. That Matisse had difficulties with the composition, however, is documented by a series of eighteen photographs taken of the canvas between March 17 and April 8, 1939, at various stages of progress. The main difficulty involved harmonizing the shapes of the two quite differently clad figures. In early stages the figure at the right dominated, her great curved volumes overshadowing and conflicting with the more angular figure at the left. Similarly, the background was divided by a floral motif and a frame into two contrasting areas. Only after numerous intermediate steps did Matisse turn the figure at the left and soften her pose to rhyme with and balance that of her companion. He then extended the floral frieze across the full width of the background, tying the composition together and clarifying its geometric structure. The result is an image on the hand elegant and rich and on the other, classical and hieratic.

S.N.

151

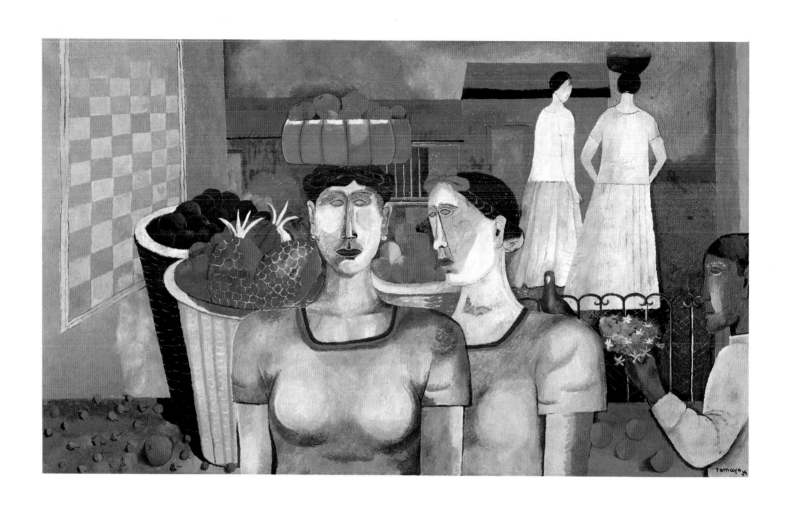

Women of Tehuantepec (Mujeres de Tehuantepec), 1939

Oil on canvas
35⅞ x 57⅛ (86 x 145)
Room of Contemporary Art Fund, 1941

RUFINO TAMAYO was born in Oaxaca, Mexico, to Zapotec Indian parents. His parents died when he was eight and he moved to Mexico City to live with an aunt. In 1915–16 he took evening art classes in Mexico City and in 1917 studied at the San Carlos Academy. In 1921 he became Head of the Department of Ethnographic Drawing at the National Museum of Archeology. He was given his first one–man shows in Mexico City and New York in 1926. Throughout his career Tamayo rejected the strict nationalism of the famous Mexican muralists in favor of a more independent expression, stemming from native Mexican art but incorporating European influences. He executed murals in the National School of Music, Washington, D.C., (1933), the Hillyer Art Library at Smith College, Northampton, Massachusetts, (1943), the National Palace of Fine Arts in Mexico City (1953) and UNESCO Headquarters in Paris (1958), among others. He taught at the Dalton School in New York in 1938 and the Brooklyn Museum Art School in 1946. He resides in Mexico City.

The fruit market is a theme which recurs with constant variations as Tamayo's style developed over the years. It is undoubtedly significant that from 1907 Tamayo lived with an aunt who was a fruit and fuel vendor in the local market place. The Gallery painting represents the market in Tehuantepec, a city whose women are famous throughout Mexico for their beauty and colorful costumes. On the shoulder of one of the women sits a small bird while a boy enters from the right offering a bouquet of flowers, two details which, along with the bright reds, greens and yellows of the painting, enhance the general sense of rich abundance.

The geometric structure of the painting, in which perspective is flattened and distance is established by overlappings and rapid shifts of scale, owes much to Tamayo's early knowledge of Cubism. The influence of Matisse is apparent in the flat color shapes as well, but these models are absorbed into a style which is highly expressive of Tamayo's own cultural tradition and which has made him one of the leaders of 20th–century Mexican art. Particularly important in his development was his native pre–Columbian sculpture, which he came to know at the National Archaeological Museum. Its influence is evident here in the mask–like faces of the women and the general archaizing stylizations.

C.K.

PIET MONDRIAN
Dutch, 1872–1944

Composition London, 1940–42

Oil on canvas
32½ x 28 (82.5 x 71.1)
Room of Contemporary Art Fund, 1944

From the moment of his encounter with Cubism in 1911, Mondrian dedicated himself to a systematic purification of all particular and non–essential elements from his art. By 1913, he had arrived at the balance of horizontal and vertical elements that characterized his entire later production. And by 1918, he had devised a format of colored rectangles bounded by black lines from which he deviated only in his last few paintings completed in New York. In 1942, he wrote: "To create pure reality plastically, it is necessary to reduce natural forms to the constant elements of form and natural color to primary color. The aim is not to create other particular forms and colors with all their limitations, but to work toward abolishing them in the interest of a larger unity."

Composition London, 1940–42, is a transitional work between the Paris paintings of the late 1930s and those done in New York. Though begun in London, the small red square at the middle of the left edge, unbounded by black, undoubtedly was added in New York, since it predicts his last paintings, in which black was eliminated. The division of space in the composition is related to several drawings made in London, and the concentration of vertical lines at the right reappeared in several canvases left unfinished at his death.

E.M.ed.

PIETER CORNELIS MONDRIAAN was born in 1872, in Amersfort, the Netherlands. He received early instruction from his father, an amateur draftsman, and his uncle, Frits Mondriaan, a painter. He moved to Amsterdam in 1892, where he studied painting and drawing at the Academy of Fine Arts until 1896. Mondrian remained in Amsterdam, painting and occasionally exhibiting in group shows until 1908, when he settled in Zeeland. In 1909, he joined a theosophic organization whose philosophy acknowledged a dualism between physical matter and its supersensible essence. The development of Mondrian's desire to push abstraction toward its ultimate goal, "the expression of pure reality," was significantly influenced by this group.

In 1910, he helped Conrad Kikkert to found Moderne Kunstkring; the following year they organized an exhibition of French avant–garde painting. Impressed especially by the Cubist work of Picasso and Braque, he moved to Paris in 1912. In 1915 he met Theo van Doesburg, with whom he organized the de Stijl group in 1916–17. For the next ten years, they worked and exhibited together and wrote in defense of Neo-plasticism, an art based on straight lines, right angles and primary colors that would integrate the fine arts, architecture and design.

Mondrian exhibited with the Cercle et Carré group in 1930 and joined Abstraction–Création, founded in 1931 by Auguste Herbin and Georges Vantongerloo. In 1938, he settled in London, but was soon forced by wartime conditions to emigrate to the United States. Arriving in New York in October 1940, he set up a studio and, two years later, received his first one–man show. In 1944, Mondrian died in New York.

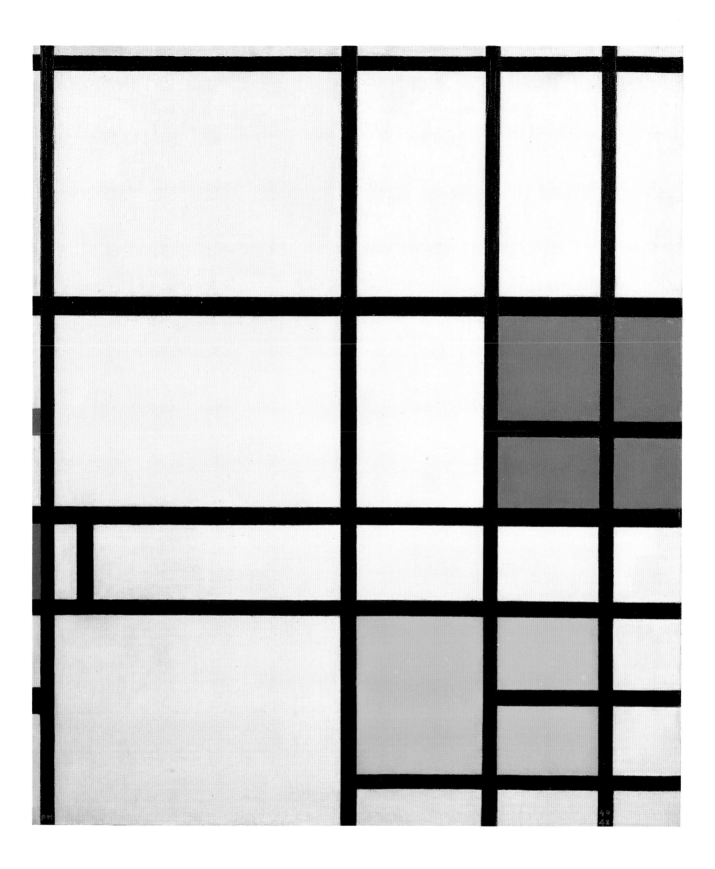

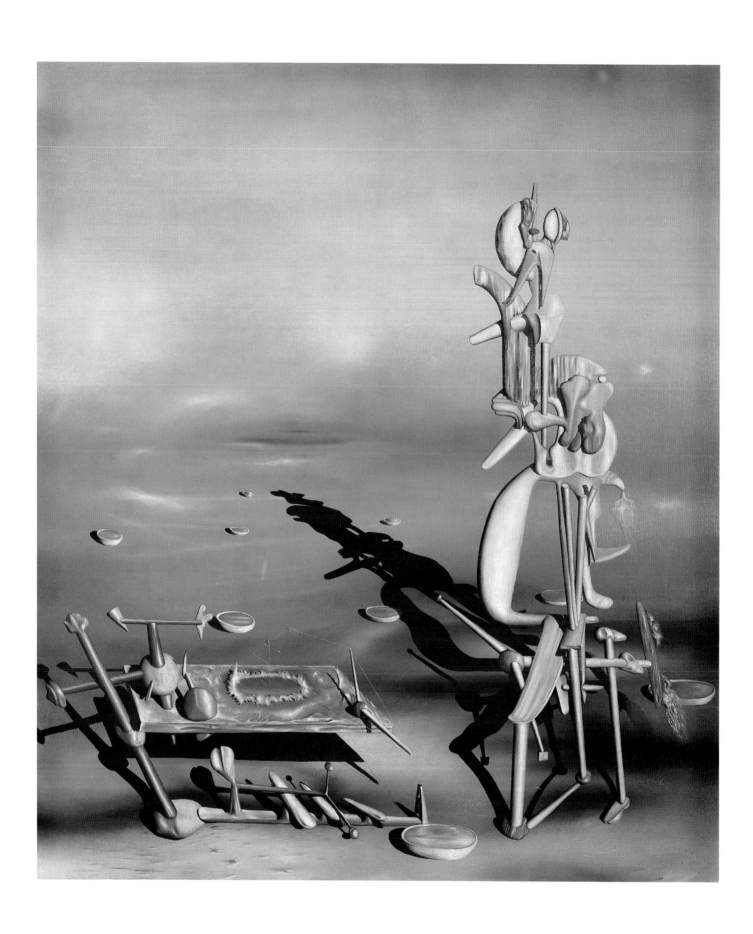

Indefinite Divisibility, 1942

Oil on canvas
40 x 35 (101.6 x 88.9)
Room of Contemporary Art Fund, 1945

RAYMOND GEORGES YVES TANGUY was born in Paris in 1900, the son of a retired sea captain. According to the artist, he was born in a bed that had belonged to Gustave Courbet, the 19th–century painter whose dedication to realism is in complete contrast to Tanguy's unreal objects in an equally unreal space. As a boy, he was a schoolmate of Pierre Matisse, son of the painter, who became his lifelong friend and dealer. He spent his childhood vacations at Locronan, in Brittany, where the landscape and prehistoric stone monuments undoubtedly influenced the images in his later paintings.

From 1918 to 1920 Tanguy followed the family tradition and became an apprentice officer on cargo boats traveling to Africa and South America. In 1920, he was drafted into the army, where he met Jacques Prévert, later a poet and filmmaker, who remained a close friend during the next years in Paris. Undecided on a career, Tanguy concluded that he would become a painter one day in 1923 when he saw an early metaphysical painting by Giorgio de Chirico in a gallery window. In 1925, he met André Breton, the leader and chief theoretician of the Surrealist group, which he soon joined. In 1927, Tanguy, self–taught as an artist, began to develop his particular version of a limitless space where strange objects rest or float in a stark light, and this remained, with many variations, his subject matter throughout his lifetime.

Tanguy emigrated to the United States in 1939, married the American Surrealist painter Kay Sage, and lived in Woodbury, Connecticut, until his death in 1955.

Indefinite Divisibility, 1942, is one of several similar works that Tanguy painted after his arrival in the United States in which his characteristic forms have increased in size and dominate the foreground. These bizarre constructions, neither animal nor machine, seem to tower over a vast plain, the depth of which is indicated by a series of flat bowls shown in perspective. Tanguy's palette, previously cool and restrained, has become more abrasive, with metallic blue, red, green, and deep yellow highlighting the over–all grey. Paint has been applied with a painstaking meticulousness reminiscent of the early Flemish painters whom Tanguy admired. In his craftsmanship, he differed from those Surrealists who advocated uncontrolled and spontaneous processes directed by the subconscious. Nevertheless, except for a brief period when he made preparatory drawings on the canvas, he followed them in working intuitively, allowing one form to dictate another as the painting progressed. Tanguy said: "I found that if I planned a picture beforehand, it never surprised me, and surprises are my pleasure in painting."

E.M.ed.

ARSHILE GORKY

American, born Russia, 1904–1948

The Liver is the Cock's Comb, 1944

Oil on canvas
73¼ x 98 (186 x 249)
Gift of Seymour H. Knox, 1956

The Liver is the Cock's Comb, 1944, was recognized at an early date as a key work in the development of Gorky's style. André Breton wrote on seeing the work in 1945: *"The Liver is the Cock's Comb should be considered the great open door to the analogy world. Easy–going amateurs will come here for their meager rewards: in spite of all warning to the contrary, they will insist on seeing in these compositions a still life, a landscape, or a figure instead of daring to face the hybrid forms in which all human emotion is precipitated....Here is an art entirely new."*

The primary of the hybrid forms to which Breton refers is the spongy reddish mass in the lower right, simultaneously liver and cock's comb, opened to reveal a variety of fleshy viscera. According to Julien Levy, Gorky's close friend and dealer, the Greeks considered the liver to be the seat of the soul. It is here..."seen erect, proudly touched by rays of the rising sun as the cock crows. A rich assortment of other suggestive shapes—genitalia, sacs, tumors, organs, and tendrils against a warm earth–brown background—all convey the sense of a ravenous optimistic virility, a paean to human and animal fecundity.

Despite the orthodox Surrealist insistence on spontaneous expression and the appearance of impulsive application of paint and forms, Gorky carefully plotted every aspect of the composition, as a preparatory drawing for the painting reveals.

E.M.ed.

Born Vosdaning Adoian in 1905 in Turkish Armenia, ARSHILE GORKY emigrated to the United States in 1920, settling in New England. He studied art for brief periods in Providence and Boston, but was largely self–taught. In 1925 he moved to New York, where he studied and later taught at the Grand Central School of Art. About 1930 he took the name Gorky after the Russian writer (in Russian, Gorky means "the bitter one") and Arshile, perhaps after the mythical Achilles.

In 1927 he began to imitate Synthetic Cubism as formulated by Picasso, Georges Braque, and Juan Gris. In the late thirties, he added an element of dark fantasy based on freely rendered, symbolic organic shapes, inspired by Miró.

The arrival of the refugee Surrealists brought Gorky face–to–face with a living European tradition, and he was encouraged to give freer rein to his subconscious. Even more important, his marriage in 1941 coincided with a new era of stability after years of poverty and neglect. Beginning in 1942, he spent considerable time in the country, particularly Virginia and Connecticut, where the scrutiny of natural forms contributed to his use of highly personal symbols that evoked specific incidents from his childhood and expressed the sexuality that he saw as the fundamental undercurrent of nature.

The period of Gorky's mature and original production was tragically short–lived. A succession of disasters, a studio fire, cancer, a disabling auto accident, and a broken marriage led him to commit suicide in 1948, at the age of forty–three.

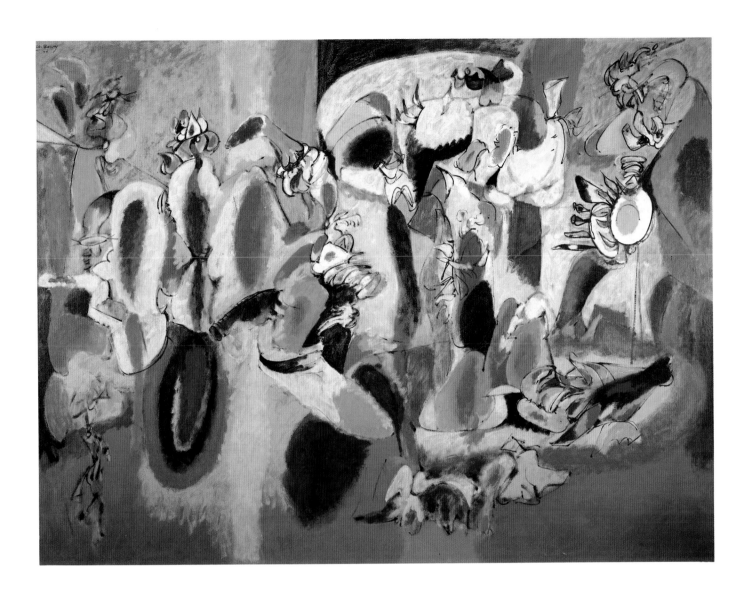

Joan Miró
Spanish, 1893–1983

Woman and Bird in the Night (Femme et oiseau dans la nuit), 1945

Oil on canvas
51 x 64 (129.5 x 162.5)
Gift of Seymour H. Knox, 1958

Woman and Bird in the Night, 1945, contains particularly poetic and romantic themes that recur frequently in Miró's work of the 1940s. Painted after he had completed the exacting, structurally intricate series of gouaches known as the "Constellations" in 1941, it appears, in contrast, particularly free and spontaneous, containing rough brush marks, splashes and drips. The bright colors are subordinated to the linear character of the work, which is emphasized by Miró's use of a white ground. At the time, he frequently used the device of capitalizing on an accidental, unconscious mark or splash, carefully calculating and directing in the second stage the development of his images. The resulting balance between spontaneity and control is central to *Woman and Bird in the Night*, where the graceful arabesque of the central form contrasts with the "brutal" brush marks and the precisely delineated rhythmic signs. Miró's imagery— stylized eyes, stars, sexual symbols—evolved into a form of personal shorthand with which he was able to express human content in vivid terms, for it was not in his nature to be satisfied with the purely abstract exploration of formal values.

E.M.ed.

Joan Miró was born in Barcelona, the son of a goldsmith. He drew at a very early age and studied at the School of Fine Arts at La Lonja, where he was particularly influenced by Modesto Urgel and José Pascó. In 1912, after two years as a business clerk, Miró committed himself to art and entered Francisco Gali's Escola d'Art. After his first one–man show in 1918 he traveled to Paris in 1919, where he met his countryman Picasso. From 1920 he regularly wintered in Paris, returning to his family farm near Barcelona for the summer. He met Tristan Tzara, Pierre Réverdy and Max Jacob and was tangentially associated with the Dada movement, though beginning in 1922, his friendship with André Masson and a circle of avant–garde poets led him toward the nascent Surrealist group. 1923 marked a turning point in his development toward his charactistic mode of hallucinatory fantasy. A new source of inspiration from music culminated in the first of the "Constellation" series in 1940. With the German invasion of 1940, Miró left France for Spain where, four years later, he first collaborated with J.L. Artigas on the ceramics which would henceforth constitute a major segment of his oeuvre. In 1947, he visited the United States for the first time. He settled in a new studio designed by J.L. Sert in Palma da Mallorca in 1956. A prolific artist, Miró lived there until his death in 1983.

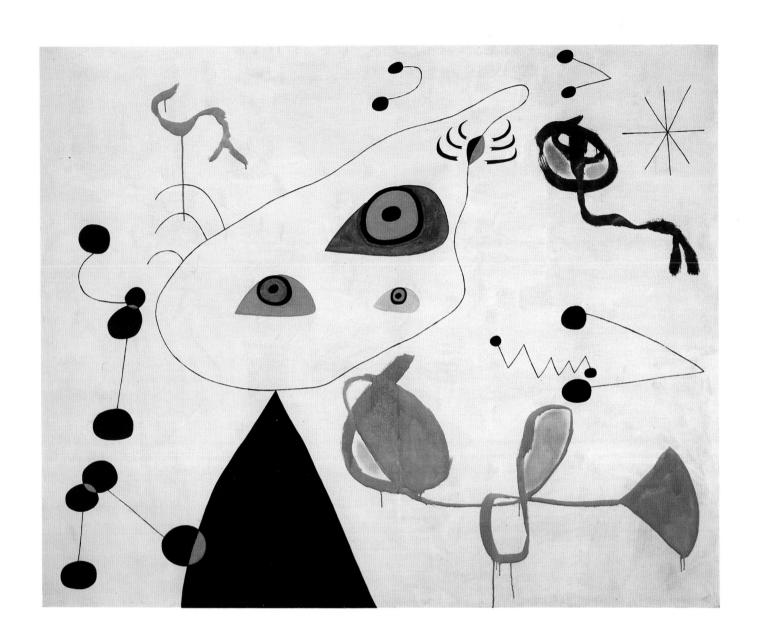

CLYFFORD STILL
American, 1904–1980

July 1945–R, 1945

Oil on canvas
69 x 32 (175.3 x 81.3)
Gift of the artist, 1964

Considered one of the original masters of Abstract Expressionism, Clyfford Still maintained an uneasy and often hostile relationship with the other practitioners and the tenets of that tradition. Although aware of the work of his contemporaries, Still disclaimed any outside influence on the development of his style, and after settling in New York twice—first from 1945 to 1946, then from 1950 to 1960—he ultimately rejected art politics of that city and retreated to a farm in Maryland. Nevertheless, Still's rough, uncompromising abstractions had a pronounced impact on others. Kenneth Sawyer wrote in *Portfolio and Art News Annual* in 1960 of the unsettling effect of Still's one–artist exhibition at the California Palace of the Legion of Honor, San Francisco in 1947: "His works were marked by a violence, a rawness, which few of us ... were prepared to recognize as art...The School of Paris had died quite suddenly for us; something new, something that most of us could not yet define had occurred."

According to Still's own account, during the late 1930s, he "worked through the idiomatic means to which my culture had subjected me, until the way became clear." By 1941, he reported, "space and figure in my canvases had been resolved into a total psychic entity, freeing me from the limitations of each, yet fusing into an instrument bounded only by the limits of my energy and intuition." Removing these early works, *July 1945–R* sets a precedent for pictorial, expressive techniques that Still expanded in later paintings. The browns, greys and blacks, pricked by two dots of red, are typical of his paintings during the mid–1940s to mid–1950s. At that time, he wished to avoid appealing colors, like those of the Fauves, in order to skirt conventional decorative or symbolic interpretations. His goal was not to please but to depict only "himself." For him, dark colors seemed "warm and generative" rather than indicative of death or despondency. Most significant, however, is the thread–like white line that slithers down the center of *July 1945–R*. Fragile, yet carrying the energy of a streak of lightning or earthquake fissure, it splits the raspy impasto of somber color. This device appeared again in Still's subsequent work, most strikingly in a large black painting *1951–52 (PH–246)* now in the collection of the Art Institute of Chicago.

H.R.

CLYFFORD STILL was born November 30, 1904, in Grandin, North Dakota. Shortly after his birth, the family moved to Spokane, Washington and, in 1910, homesteaded in Alberta, Canada. After graduating from Spokane University in 1933, he went to Washington State University in Pullman, receiving an M.A. degree in 1935 and remaining to teach, 1935–41. From the fall of 1941 until the summer of 1943, Still worked in the war industries—aircraft and shipbuilding—in Oakland, California, and later in San Francisco. He lived in New York, 1945–46, where he exhibited at Peggy Guggenheim's Art of This Century Gallery. In 1946, he returned to San Francisco to teach at the California School of Fine Arts. In 1950 Still again moved to New York. From 1960 until his death in 1980, he lived and worked in Maryland. In 1964, Still donated thirty–one of his works to the Albright–Knox Art Gallery, making it the largest repository of his work in the world.

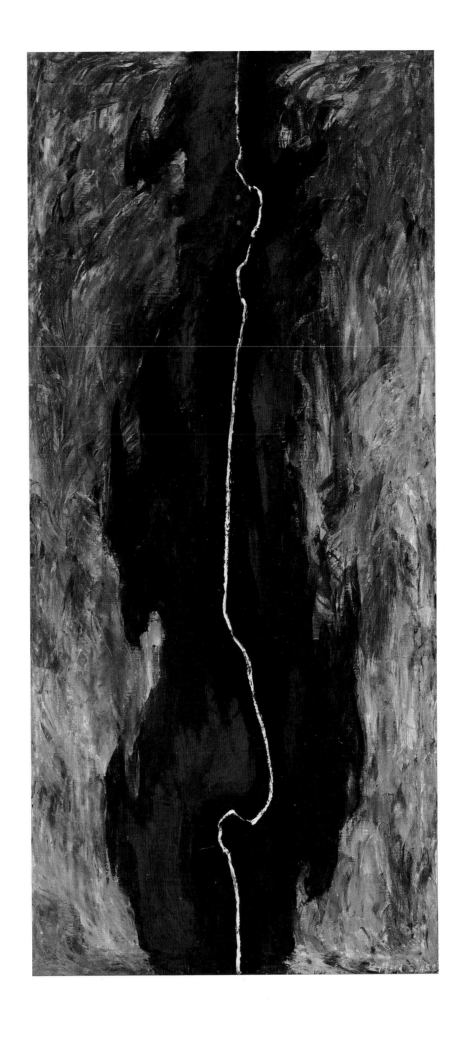

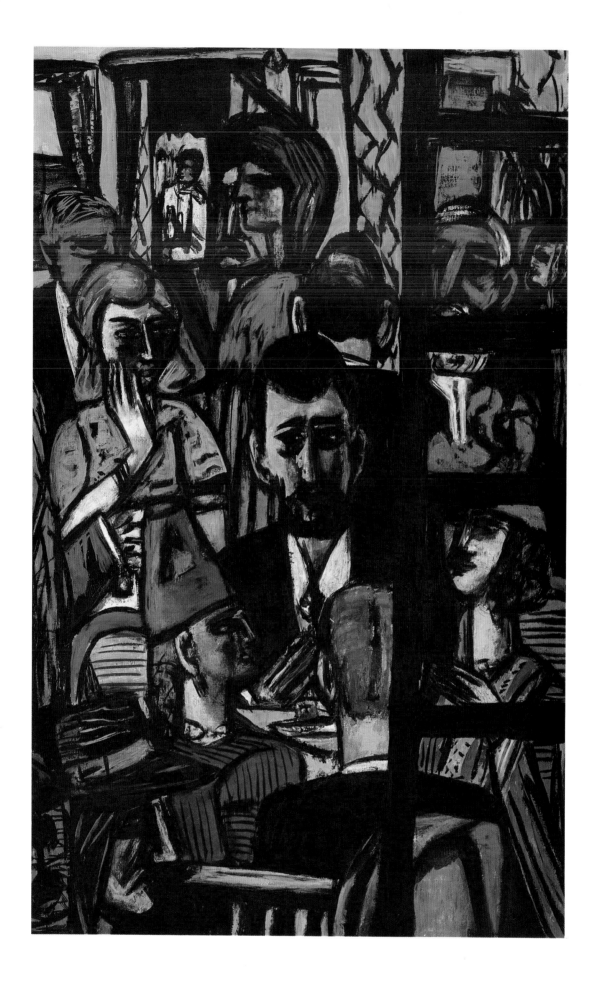

Hotel Lobby, 1950

Oil on canvas
56 x 35 (142.2 x 88.9)
Room of Contemporary Art Fund, 1950

MAX BECKMANN was born in Leipzig, Germany, in 1884. He studied at the Weimar Academy of Art, 1900–03 and moved to Berlin late in 1904, where he became a member of the Secession group, 1906–11. He was successful as a young painter, working in a style influenced by German Expressionism, French Impressionism, and Verism; he studied the works of the old masters in Paris and Florence as well. In 1914, he enlisted in the army as a medical corpsman, serving near the front line in Belgium and the Netherlands. Wounded in 1915, he was confined for a prolonged period in a hospital in Frankfurt–am–Main. After his release, he remained in Frankfurt, teaching at the art school. The war had a profound effect on Beckmann, and his mature work became characterized by violent subject matter and distortion. Slashing, brutal paint strokes, hard contours defined by heavy black lines, highly personal symbols, and sharply contracted space replaced his earlier, more academic style, resulting in a new balance between emotional content and structural elements.

A prominent German painter, Beckmann was labeled a "degenerate artist" by the Nazis. His work was removed from the national museums, and he was dismissed from his teaching post. By 1937, he had fled to Amsterdam, where he lived during the war years; he came to the United States in 1947 to teach at Washington University, in St. Louis, for two years. In 1950, he moved to New York, where he taught briefly at the Brooklyn Museum School of Art before his death in December of that year.

Hotel Lobby, 1950, is a straightforward depiction of a familiar and commonplace scene. During the last three years of Beckmann's life, when he lived in the United States, he frequently painted his immediate surroundings—in contrast to his numerous allegorical, monumental, and often violent canvases of the 1940s, filled with a highly personal and enigmatic symbolism. A perceptive observer who had experienced two World Wars, he was particularly sensitive to suffering and tragedy, conveyed in this painting by the tense and somber facial expressions. Although the figures are crowded together in a constricted space, they appear indifferent to each other, isolated and lonely. The man at the center, the only figure shown full–face, appears to be the principal observer of the scene, possibly identifiable with the artist. The ladderlike form at the right, a design device Beckmann used repeatedly, serves both as a unifying structural element in the painting and as a barrier that separates the viewer from the scene.

The emotional impact of the painting is amplified by the broad and expressionistic brushstrokes that create flat patterns of deep color, with heavy black outlines. The faces are garishly highlighted by artificial light. By using colors of equal value for the foreground and the background figures, and by repeating designs such as the stripes in various parts of the canvas, Beckmann has maintained an essentially flattened perspective—a dominant characteristic of his paintings.

E.M.ed.

AUGUSTE HERBIN
French, 1882–1960

Life No. 1 (Vie no. 1), 1950

Oil on canvas
57 x 38 (144.8 x 96.5)
Gift of The Seymour H. Knox Foundation, Inc., 1966

Influenced by the examples of Malevich, Mondrian and de Stijl painting in general, Herbin often used primary colors and a vocabulary of rectangular shapes as well as circles, semi–circles and triangles. Through the use of simple, two–dimensional forms and intense colors, he realized his aim of creating an art that evolved solely from the mind and eschewed the "impurities" of the material world.

Herbin's persistent efforts to refine his precise formal grammar and the theories on which it was based culminated in his treatise *Art non–figuratif, non–objectif* published in 1949. In this, he set forth his ideas concerning the spiritual significance of color, including his "Plastic Alphabet" in which specific colors are associated with each letter of the alphabet, with various geometric forms and with the notes of the musical scale. Frequently he would execute a series of paintings—variations on a theme—based on a single word.

Vie no. 1 is the first of a series in which the letters v–i–e (life) determine the color scheme: black, the color related to v, is appropriate for all forms and notes; orange is associated with spherical and triangular forms and the sonority of ré; red is identified with e, a spherical shape and the tone of do. While these three colors comprise the dominant theme of all the paintings in the "Vie" series, the background colors differ and thus impart a different nuance of meaning to each work. The compositions, always tautly structured and balanced, also vary. *Vie no. 1*, for example, has a vertically oriented structure, whereas *Vié no. 2* (The Museum of Modern Art, New York), is more asymmetrically arranged. Herbin's "Plastic Alphabet" paintings are widely acknowledged as important precursors of the hard–edge and Op art painting of the 1960s, exemplified by the works of such artists as Vasarely and Agam.

H.R.

AUGUSTE HERBIN was born in Quiévy, near Cambrai, France, in 1882. After attending the Ecole des Beaux–Arts in Lille, 1900–01, he went to Paris, where his early paintings were in the Impressionist and Fauve styles. In 1909, he took a studio in the Bateau Lavoir, where, influenced by Picasso, Georges Braque, and Juan Gris, he began to work in a Cubist manner. As his style evolved, he ceased to use the object as inspiration and turned increasingly to the relationships of color and form. After a return to figurative painting, 1922–25, followed by another period of abstract painting, 1925–39, he devoted himself for the rest of his life to non–objective abstract composition, developing his "plastic alphabet" of geometric forms and colors. He painted various series of works on such themes as Life, Evil, Bird, Christ, Christmas, Rose, and Wheat, in which his aim was to express the particular qualities of the word and idea through plastic means. Herbin died in Paris in 1960.

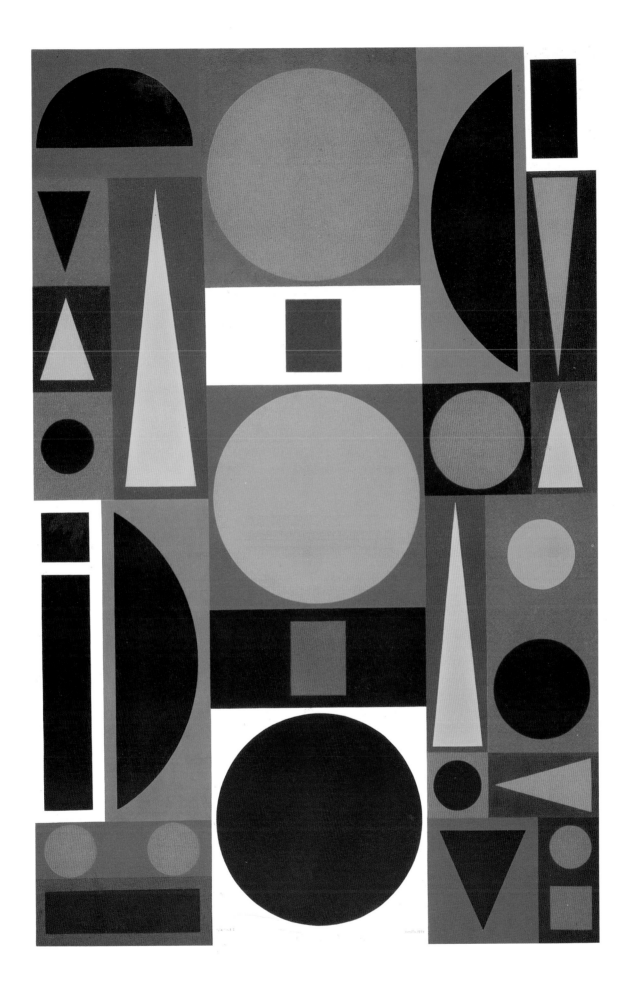

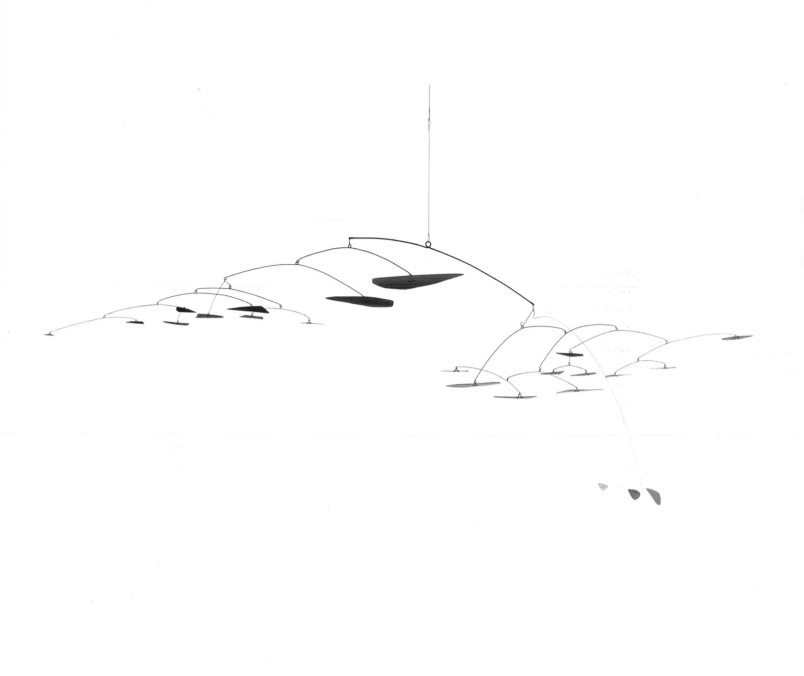

Conger, c. 1950

Iron and wire
43 x 69 x 38 (109.2 x 175.2 x 96)
Gift of A. Conger Goodyear Trust, 1965

ALEXANDER CALDER was born in 1898 in Lawnton, Pennsylvania, to a family of well–known artists. Although his childhood was spent in an atmosphere of art, Calder graduated as a mechanical engineer from Stevens Institute of Technology in Hoboken, New Jersey, in 1919. After a number of engineering jobs, he began to study at the Art Students League in New York, 1923–26, working part–time as a freelance illustrator for the *National Police Gazette*.

In 1926, he went to Paris where he produced works based on the circus. The *Circus* introduced Calder to many of the artists in Paris who were to be influential to his career, and it served also as a laboratory in which he developed ideas and techniques used in his later work.

After a visit to Mondrian's studio in the early 1930s, Calder abandoned representational sculpture in favor of abstract, geometric constructions, which Jean Arp labeled "stabiles." He gradually began to add movement (another factor of the *Circus*) to the sculptures, and these became known as "mobiles," named by Marcel Duchamp. The first of these were motorized or operated by hand cranks, which Calder soon found too repetitive and predictable; he then began to create works which were dependent on air currents for motion. By 1934, he had arrived at the basic concepts of the "mobiles" and "stabiles," which constituted the major portion of his work. Calder also designed sets and props, textiles, book covers, jewelry and posters. In 1976 he was honored with a large retrospective, *Calder's Universe*, at the Whitney Museum of American Art in New York; he died shortly thereafter.

Alexander Calder virtually invented mobile sculpture in the early 1930s. Some precedents existed—moving sculptures by Marcel Duchamp and Naum Gabo, for example—but such experiments were not reported by these artists, nor were they widely known. He conceived the idea independently during his visit to Mondrian's studio in Paris, when he suggested that Mondrian's rectangles "should vibrate and oscillate." Although this proposal did not appeal to Mondrian, Calder pursued it.

Conger, like most of Calder's mobiles, is made of steel wire and aluminum, painted in his favorite color scheme of red, yellow, blue and black. Constructed around 1950, it was a gift of the architect Edward Durrell Stone to Anson Conger Goodyear. (The title, given by the artist in 1974, refers to the former owner). A native of Buffalo, Goodyear moved to New York in the late twenties and in the mid–thirties commissioned Stone to design a house for him in Old Westbury, Long Island. The Goodyear house is known as one of Stone's most striking accomplishments in residential design, and it is there that *Conger* was displayed until Goodyear's death in 1964. Goodyear, a collector, patron of the arts and one of the founders of the Museum of Modern Art in New York, first became interested in modern art when he served on the Board of Directors of the Buffalo Fine Arts Academy. He bequeathed the bulk of his collection to the Albright–Knox Art Gallery.

H.R.

FERNAND LÉGER
French, 1881–1955

The Walking Flower (La Fleur qui marche), 1951

Ceramic
26½ x 20½ x 15 (67.3 x 52 x 38)
Gift of Seymour H. Knox, 1969

*T*he *Walking Flower* was executed in 1951, shortly after Léger started to make ceramics at Biot in southern France. He was primarily interested in the integration of architecture, painting, and sculpture, and his deep ceramic reliefs were designed as murals. He made only a few free-standing sculptures. *The Walking Flower* appears with little modification in a large composition of 1951–52, *Projet monumental polychrome*, in which a variety of flower motifs are depicted, a subject he used frequently. A similar flower was included in a large sculptural composition, *Kindergarten*, which was completed five years after Léger's death in 1955.

On *The Walking Flower*, Léger used lustrous glazes for the colors, combined with a dull, off-white glaze. On the reverse, the basic design is repeated in high-glaze black on white. Although small in scale, the sculpture suggests monumentality.

E.M.ed.

Born in Argentan, Normandy, FERNAND LÉGER studied architecture in Caen, 1897–99. In 1900 he settled in Paris where he worked as an architectural draftsman and from 1903–06 studied at the Ecole des Beaux-Arts under Léon Gérôme and Gabriel Ferrier. He painted first in an Impressionist manner, though the Cézanne retrospective of 1907 led him to search for a more solid formal structure. He exhibited with the dealer Daniel-Henry Kahnweiler in 1910. Mobilized in 1914 into the Engineer Corps, he later attributed his interest in social themes and machine forms to his war experience. Following his discharge in 1917 he began to subject both figures and objects in his painting to a hard tubular treatment. He opened an art school with Amédée Ozenfant and collaborated on the first abstract film *Ballet méchanique*. After three visits in the 1930s, he settled in the United States for the duration of World War II. After his return to France, monumental art, mosaics, stained glass and murals became his major preoccupations. From 1949 he lived in Biot in southeastern France and worked in ceramic sculpture.

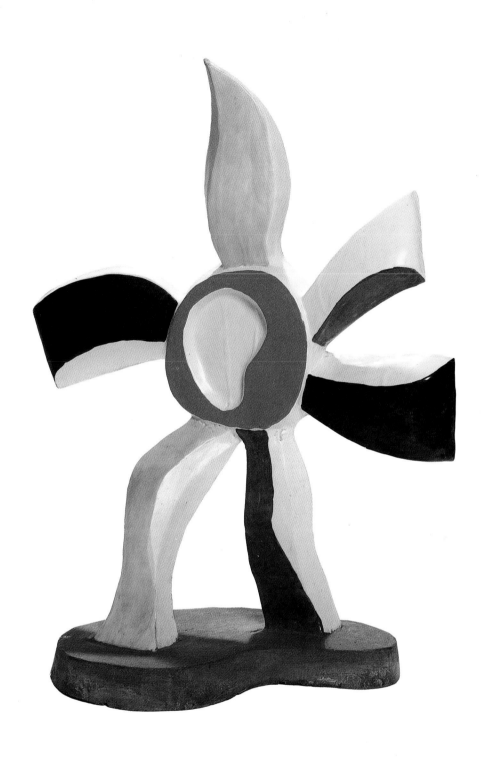

BEN NICHOLSON
British, 1894–1982

Tableform, 1952

Oil and pencil on canvas
62½ x 43¾ (158.8 x 111.1)
Gift of Seymour H. Knox, 1956

At once classical and lyrical, Ben Nicholson's paintings display a refined, highly individualized interpretation of Synthetic Cubism. Although he kept a collection of jugs and cups in his studio from which he could select a pleasing profile or contour line, ultimately the identity of an object was of far less importance to him than even to his Cubist counterparts, who reveled in creating ambiguous relationships between representational and abstract forms. Basically, still life served as a point of departure for his exploration of the expressive potential of Cubism, which he found in the harmonious architectural structuring of overlapping planes and in the romantic overtones inherent in muted color combinations and delicate linear rhythms. Nicholson also often compared the architectural structuring of these expressive elements to musical relationships. One of his most abstract still lifes, *Tableform* epitomizes his careful orchestration of complementary qualities: open and closed forms, advancing and receding planes, opaque and transparent areas of color, angular and curving lines.

Tableform is representative of the monumental still lifes that Nicholson produced during the 1950s; in comparison to his earlier work, his paintings of this period are more atmospheric in handling and contain more open forms. The still–life objects themselves, reduced to razor–sharp outlines, become intangible and the line more fragile and graceful. Nevertheless, this linear purity and the superimposition of silhouettes derive from the style of draftsmanship that he had already established in his drawings from nature: the overlapped, rectangular planes found in these still lifes owe a debt to his abstract reliefs, begun in the 1930s. *Tableform* also may be linked to Nicholson's still life and open window theme of the late 1940s, since the dark, undulating line in the upper right portion of the canvas recalls the contour of softly rolling hills, while the airy expanse of the blue above it suggests the sky. Here, however, still life, landscape and architecture merge completely into an abstract, poetic statement.

H.R.

BEN NICHOLSON was born in 1894 in Denham, Buckingham, England, son of the painters Sir William Nicholson and Mabel Pryde. He attended the Slade School of Art in London, 1910–11, followed by several years of travel, primarily in Europe. During his frequent trips to Paris, he was attracted to Synthetic Cubism and developed his semi–abstract still lifes. He met his second wife, the sculptor Barbara Hepworth, in 1931 and, probably influenced by her direct carving, began his carved geometric reliefs, often painted white, shortly thereafter. In the early 1930s Nicholson became interested in the work of Arp and Mondrian and was particularly impressed by a visit to Mondrian's Paris studio in 1934 which had a marked effect on his work of subsequent years. He was a member of the 7 and 5 group, 1925–36, of Unit One, 1933, and Abstraction–Création in Paris, 1933–35. In 1937, he was coeditor with J.L. Martin and Naum Gabo of the book *Circle: International Survey of Constructive Art*, published when Gabo and Mondrian were his neighbors in Hampstead. From 1940 to 1956, he lived in St. Ives, Cornwall, and from 1958 until his death, resided in Ticino, Switzerland.

JACKSON POLLOCK
American, 1912–1956

Convergence, 1952

Oil on canvas
93½ x 155 (237.7 x 393.7)
Gift of Seymour H. Knox, 1956

Prior to painting *Convergence* in 1952, Jackson Pollock had begun to rely less on his drip technique, to reintroduce suggestions of mythic shapes in his paintings, and to limit his palette to black and white. In *Convergence*, he added the primary colors, red, yellow and blue, and—unlike his earlier drip paintings in which a space existed between the painted area and the canvas edge—he extended the loops and spots of paint over the entire surface, creating an intense activity and virtually eliminating any sense of depth.

Convergence demonstrates Pollock's revolutionary and influential approach to the act of painting. He was one of the first to use line as an independent image rather than to define forms or planes, and to distribute paint equally over the picture surface. This lack of central focus and the related monumental scale of his canvases particularly impressed younger painters. Of equal significance is the importance given to process: the painting constitutes an instantaneous record of the particular creative act, the encounter between painter, his subconscious, pigment and chance. The uniform and high–keyed color of this painting has been especially influential on later Color Field painting.

E.M.ed.

JACKSON POLLOCK was born in Cody, Wyoming, in 1912 and grew up in Arizona and California. He first studied painting in high school in Los Angeles, but followed an older brother to New York in 1929 to study with the regionalist painter Thomas Hart Benton at the Art Students League, 1930–32. Pollock was employed, with occasional interruptions, on the WPA Federal Art Project from 1935 to 1943. Though his early paintings, dark and dramatic genre scenes from the thirties and primitive totemic images of the early forties, demonstrate great expressionistic individuality, it was not until 1947 that he arrived at his drip and spatter technique. It has been conjectured that Pollock's experience in 1936 of working in the New York studio of the Mexican muralist David Alfaro Siqueiros, who was using spray guns, air brushes, and other unusual methods of spontaneous paint application, proved fruitful to Pollock's later development. Placing his canvas on the floor, then moving around it and occasionally onto it, Pollock flung skeins of heavy pigment from brushes, sticks, and trowels, using the energy generated by his entire body to give free expression to his subconscious. This controlled frenzy, derived from Surrealism's interest in automatism, defined the gestural branch of Abstract Expressionism and proved enormously influential to subsequent painting. Pollock was killed in an automobile accident in 1956.

AD REINHARDT
American, 1913–1967

No. 15, 1952, 1952

Oil on canvas
108 x 40 (274.2 x 101.5)
Gift of Seymour H. Knox, 1958

A tireless polemicist against excess, hypocrisy, and superficiality in painting, Ad Reinhardt conducted a lifelong crusade for an art purified of gesture, pictorial incident and color. From the beginning, he committed himself to the logical pursuit of a stripped–down geometry of regular flat forms placed along increasingly strict vertical and horizontal axes. In *No. 15, 1952*, against a deep–blue field, flat brick shapes of close–valued greens and brown appear to vibrate, intensifying the blue background and setting up an illusory shifting in depth. The implied space of these floating rectangles is deliberately contradicted, however, since the high–keyed greens that tend to come forward are, with only one exception, overlapped and fixed in space by the deeper, normally receding tones. The asymmetrically placed rectangles appear to be gravitating toward a central vertical axis, drawing attention to the imposing height of the canvas.

Reinhardt carried this rigid geometry progressively further. In 1953 he renounced color and by 1960 had devised his final paintings of nearly–black trisected squares. With this ultimate rejection of all but the minimum pictorial means, Reinhardt believed he had painted the last possible painting. Indeed, this format would be repeated with only minor tonal variations until his death.

E.M.ed.

Born in Buffalo, New York, in 1913, AD REINHARDT showed a marked and precocious interest in art—drawing, copying, and cartooning prolifically. After graduating from Columbia University, New York, in 1936, he studied painting with Carl Holty, Francis Criss and Karl Anderson. From 1937 to 1941 he worked on the WPA Easel Painting Project. The only New York School painter to begin and end his career as an abstract artist, he was a member of the American Abstract Artists from 1937, a year after the organization of the group, until 1942. During 1946–50, he continued the study of art history, concentrating on Far Eastern art. He died in New York in 1967.

FRANZ KLINE
American, 1910–1962

New York, N.Y., 1953

Oil on canvas
79 x 51 (200.6 x 129.5)
Gift of Seymour H. Knox, 1956

Originally interested in cartooning and commercial illustration, Franz Kline developed a facility with pen and ink which, during his student days in London, led him to describe himself as a "black and white man. The drawings of his early years reveal his ability to create a dynamic composition in a few concise lines, a talent learned from cartooning. They also demonstrate his tendency to render naturalistic subjects in roughly geometric forms. These qualities grew more pronounced as Kline moved toward complete abstraction and fully blossomed in his paintings of the 1950s, such as New York, N.Y.

Around 1949, Kline saw the image of one of his drawings enlarged by a Bell–Opticon projector in the studio of his friend Willem de Kooning. Although the story of Kline's instant conversion to painting large black and white abstractions has become a legend, it would be incorrect to overlook the evolution of his previous work, which led to his embracing the possibilities implied by the blown-up drawing. During the 1940s, he had broadened his drawing technique, moved away from anecdotal compositions to a more generalized treatment of appearances and increased the scale on which he worked. De Kooning's black and white paintings had already had an impact on Kline's experiments with abstraction as had Bradley Walker Tomlin's thick, textured brushstrokes. Kline assimilated and transmuted these influences in his distinctive, architectonic paintings, but his work differed from his contemporaries' in that its link with Surrealism was tenuous. His inspiration lay largely in the objective world—the figure and the city of rural landscape—which he interpreted in intuitive, non–objective terms.

New York, N.Y. typifies Kline's urban abstractions; its angular shapes and structure aptly convey the energy of the city in which the artist made his home for over twenty years. In such works he succeeds in melding drawing and painting into a single powerful image as did Jackson Pollock. Unlike Pollock's skeins and drips of paint, however, Kline's lines are not positive forms interacting with the blank canvas. The "negative" white areas in his paintings are, in many places, painted over the black and, in essence, give the black lines their form. Thus the black and white, both heavily worked, came to carry equal weight in his compositions.

H.R.

FRANZ KLINE was born in Wilkes–Barre, Pennsylvania, in 1910. He studied painting at Boston University, 1931–35, and at Heatherly's Art School in London, 1937–38. When he returned to the United States in 1938, he settled in New York and soon became interested in the work of the artists who were to become the Abstract Expressionists. His own painting during the thirties and forties, however, consisted of melancholy portraits, landscapes, and city scenes in which, as with his later work, line plays an important role. The conversion to his mature style dates from around 1949; this approach required new tools and Kline soon replaced artists' brushes and pigments with wide housepainters' brushes and quick–flowing enamel. Kline first came to public attention when these early black–and–white abstractions were shown in New York in 1950. Although he subsequently reintroduced color toward the end of the fifties, black and white remained his characteristic idiom. After a long illness, he died in New York in 1962.

E.M.ed.

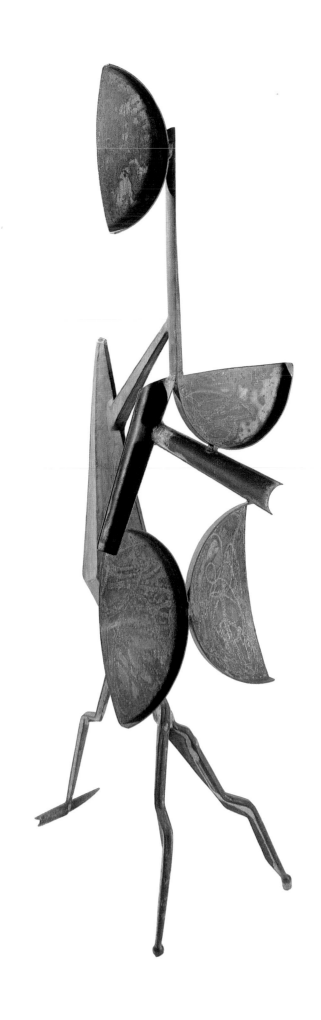

Tank Totem IV, 1953

Steel
92⅝ x 29 x 34 (235.6 x 73.6 x 86.3)
Gift of Seymour H. Knox, 1957

DAVID SMITH was born in Decatur, Indiana, in 1906. He studied art by correspondence at the Cleveland Art School, 1923, attended Ohio University, Athens, 1924–25, and studied briefly at Notre Dame University, South Bend, Indiana, in 1925. During the summer of 1925, he worked as a welder and riveter at the Studebaker plant in South Bend. After a brief stay in Washington, D.C., he moved to New York in 1926, where he studied painting at the Art Students League from 1927 to 1932. Although he continued to paint and draw throughout his life, in 1932 Smith turned to sculpture as his dominant interest after he saw reproductions of the welded metal constructions of Picasso and Gonzalez. By 1934, he had rented working space at the Terminal Iron Works in Brooklyn where, using the practical experience gained at the Studebaker plant, he began to make metal constructions. In 1940, he moved his studio to his farm at Bolton Landing, New York.

After two years during World War II (1942–44) of working as a welder making army tanks, he began to develop his symbolic works, employing both easily identifiable images and those which had a personal and private meaning. By around 1952, these relatively small–scale sculptures were replaced by larger and less subjective works, often anthropomorphic, and frequently produced in series. During the early 1960s, Smith began to use stainless steel and reintroduced color in some of his sculptures.

In the remaining years before his death, Smith produced two major series, the celebrated "Cubis" and the polychromed "Zig" sculptures. Smith was killed in an automobile accident near Bennington, Vermont, in 1965.

Tank Totem IV, 1953, is one of ten sculptures David Smith produced between 1952 and 1960 that have the same title, referring to the ends of steel boiler tanks incorporated in the works. Smith's use of industrial materials and working methods increased during the last decade of his career as his work became more monumental and prolific. In *Tank Totem IV*, two tank ends were cut in half to become component parts of an anthromorphic structure. The half–circles are joined by narrow metal strips; a kite–shaped section at the middle is visible from the sides. The figure, poised on three curving legs, is roughly finished and the surfaces of the tank ends were incised with a calligraphic pattern.

E.M.ed.

ROBERT MOTHERWELL
American, born 1915

Elegy to the Spanish Republic #34, 1953–54

Oil on canvas
80 x 100 (202.5 x 253.3)
Gift of Seymour H. Knox, 1957

Robert Motherwell undertook what would become known subsequently as the "Elegy to the Spanish Republic" series in 1948 after he came upon the dominant motif while decorating a page of poetry by Harold Rosenberg. Though the series now numbers over one hundred, each painting contains the same stark black and white forms alternated in a ponderous funereal rhythm. The earliest "Elegies" exercised a considerable impact on black and white painting that flourished in New York about 1950.

Elegy #34 of 1953–54 is smaller than some of the mural–sized paintings in the series. Nevertheless, it has an imposing monumentality because of the relatively enlarged scale of the black verticals and ovoids. More important than any attempt to make the evident sexuality of the major configurations specific is the tension that exists between colors and shapes and the forces they symbolically represent. The pressures and points of tangency between ovoids and verticals and the contrast of black and white refer to life and death or, in terms of the existential philosophy that interests Motherwell, between the freedom that allows self–definition and the removal of choice that constitutes self–destruction. In a letter to the Gallery, October 18, 1968, Motherwell wrote,

> #34 is certainly one of the half–dozen most realized of the Spanish Elegy series, though saying this reminds me that when it was first exhibited Hans Hofmann told me that it was a great picture, but five or ten percent unfinished. I knew what he meant, that it could have had a more 'finished' aspect, but I chose to stop at the moment that I thought the expression of feeling was wholly complete, and I do not regret it. It differs from many of the elegies in having more color in it (relatively speaking), though there are some even more colorful ones in the 1960's.

E.M.ed.

Born in 1915 in Aberdeen, Washington, ROBERT MOTHERWELL spent his first twenty–five years on the West coast, primarily in San Francisco. At Stanford University in Palo Alto, California, 1932–36, he began to develop his lifelong interests in philosophy, psychoanalytic theory, and aesthetics, which he pursued in graduate school at Harvard University, Cambridge, Massachusetts, 1937–38, and Columbia University, New York, 1940. In 1941, he decided to devote himself professionally to painting. Motherwell soon became intimate with the exiled European artists in New York, particularly the Surrealists with whom he shared a deep interest in the processes of the unconscious. One of the most intellectual figures of the New York School, Motherwell has written prolifically, recording the history and defending the cause of the avant–garde.

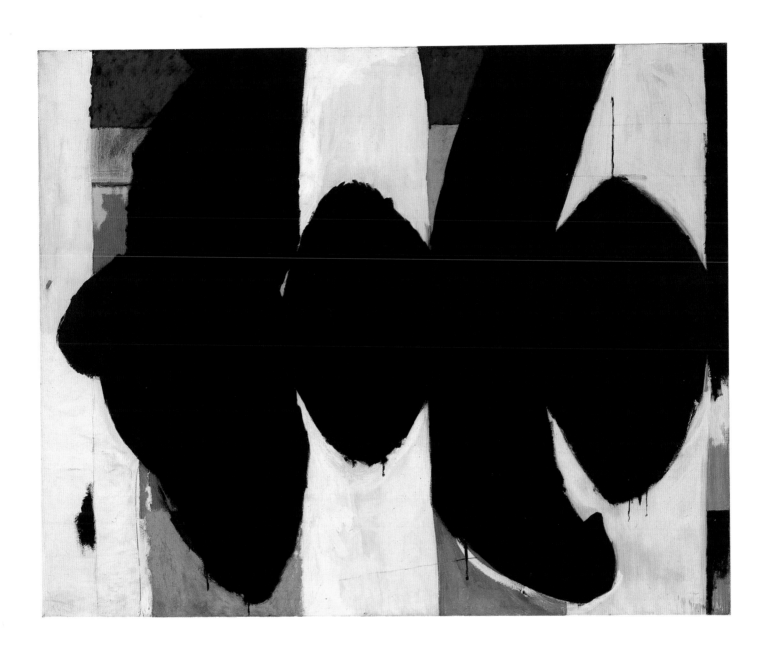

HANS HOFMANN
American, born Germany, 1880–1966

Exuberance, 1955

Oil on canvas
50¼ x 40 (127.6 x 101.6)
Gift of Seymour H. Knox, 1955

During the mid–1930s, Hofmann's landscapes and interiors had attempted to combine brilliant Matisse–inspired color with Cubist structure. Under the impact of Surrealism, his work became freer and his imagery more fantastic and increasingly schematic until finally, about 1944, he developed a new, totally abstract approach.

The title of *Exuberance*, 1955, seems to describe the expressionistic manner of the painting's execution, rather than the subject. Hofmann always maintained that he based his pictures on nature and, indeed, one can discern references to a studio interior behind the active surface. His characteristically vivid colors—blue, green, orange, and yellow—are applied in long, slashing strokes, the disintegrated edges of his Cubist–inspired planes.

Hofmann's charged surfaces and active, inventive paint application (he dripped and spattered paint several years before Pollock) had an important impact on the first and second generations of American Abstract Expressionists. His celebrated "push and pull" theory, which acknowledges the overwhelming significance of the picture surface, and his selection of the rectangle or plane as the configuration best adjusted to the overall shape of the canvas and the framing edge proved influential to the ideas of a younger generation.

E.M.ed.

Born in Weissenburg, Germany, HANS HOFMANN left home at sixteen to become assistant to the Director of Public Works of the State of Bavaria. By 1898, he had abandoned his interest in technology to enroll at Moritz Heymann's art school in Munich. Hofmann moved to Paris in 1904, studying at the Académie Colarossi and the Ecole de la Grande Chaumière. There he met fellow student Henri Matisse, who became an important influence. During this period, he became acquainted with the leading figures in French and German art, exhibited with the Neue Sezession in Berlin in 1909, and had his first one–artist exhibition at Galerie Paul Cassirer in Berlin.

Hofmann's Schule für Moderne Kunst opened in 1915 in Schwabing, a suburb near Munich, and attracted in its later years many students from abroad, including Louise Nevelson, Alfred Jensen, Ludwig Sander and Carl Holty. From 1930 to 1931 Hofmann taught at the University of California, Berkeley, and at the Chouinard School of Art, Los Angeles.

In the face of growing hostility to modern art, Hofmann closed his school in Germany in 1932, and two years later opened the Hans Hofmann School of Fine Arts in New York. Through his teaching, and such essays as *Search for the Real*, published in 1948, Hofmann shaped the views of a generation of younger American painters, as well as those of prominent critics such as Clement Greenberg and Harold Rosenberg. Growing recognition of Hofmann's painting allowed him to close his school in 1958 and turn his full efforts to painting. It was during this period that Hofmann made a startling breakthrough to a highly influential late style. In 1970, the University Art Museum, University of California at Berkeley, opened a wing dedicated to Hofmann with a permanent collection of forty–five of the artist's works.

R.E.

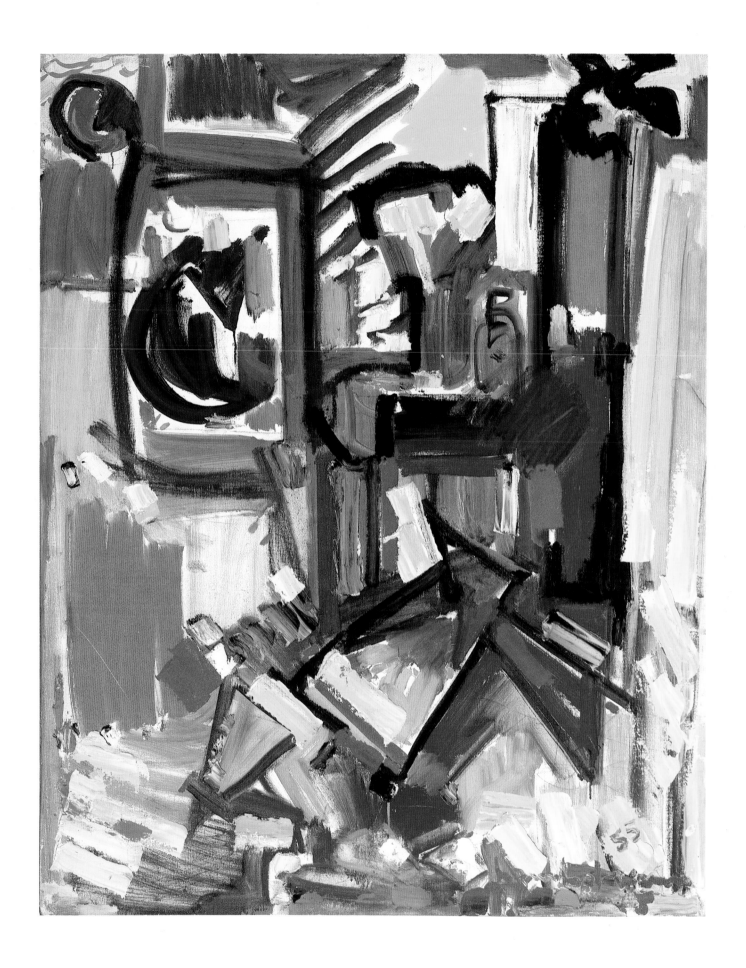

WILLEM DE KOONING
American, born The Netherlands, 1904

Gotham News, 1955

Oil on canvas
69 x 79 (175.2 x 200.6)
Gift of Seymour H. Knox, 1955

Painted in 1955, *Gotham News* is one of de Kooning's several abstract landscapes in which fragments of the female form from his immediately preceding "Women" series can occasionally be discerned. Thomas Hess wrote that in the spring of 1955, de Kooning "moved into a new series of abstractions that relate to earlier black–and–white pictures in the complication of their shapes and to the Women in their heavy, rasping colors and textures...There is a proliferation of images, a piling of ambiguity on top of ambiguity. Sometimes the paint is pushed into wrinkles and folds, like dead flesh. It is as if all the despair in *Woman, I* (The Museum of Modern Art, New York) and in the black–and–white pictures was heaped together in a gesture of defiant exaltation."

The newspapers that de Kooning laid directly onto the wet pigment to hasten the drying process have left traces of printed words and images along the edges of the painting. These subtle disjunctures in depth, scale, and reference, together with the crowded confusion of brushstrokes, convey the dizzying disorientation of the contemporary city, as the title discreetly implies.

A tension is generated by the conflict between de Kooning's approach and traditional painting and drawing. Line occasionally models and defines edges and yet, in an ambiguous manner, loses touch with form. Color areas move back and forth so that spatial relationships are never clarified.

E.M.ed.

WILLEM DE KOONING was born in 1904 in Rotterdam. He left school at twelve and was apprenticed to a commercial art company, where his precocious talent was recognized and he was encouraged to attend evening classes at the Academie voor Beeldende Kunsten en Technische Wetenschappen, 1916–24. After brief periods of study in Antwerp and Brussels, he immigrated to the United States in 1926, settling first in Hoboken, New Jersey, where he supported himself as a housepainter. A year later he established his studio in New York and worked as a commercial artist until 1935, when a year with the WPA Federal Art Project allowed him to concentrate full–time on painting.

Throughout his career, de Kooning's dominant interest has been to portray either a figure against a ground or an abstraction composed of fragmented lines and planes. His abstractions from the late twenties and thirties gradually gave way to figure studies in the early forties. These in turn were supplanted by the bold black–and–white enamel abstractions that constituted his influential first one–man show in 1948. In 1950 he began working on his "Women" series; together with the abstract landscapes, they have continued to occupy him up to the present.

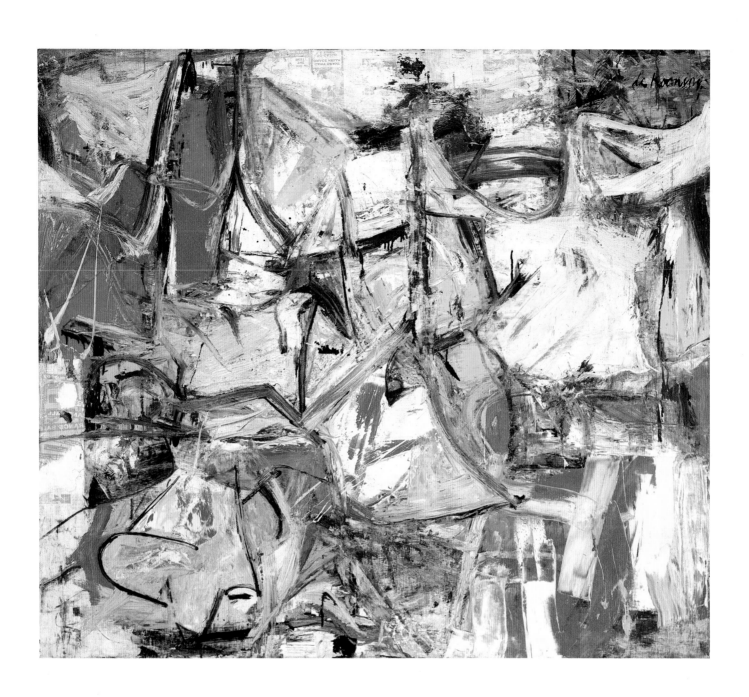

LEE KRASNER

American, 1908–1984

Milkweed, 1955

Oil and collage on canvas
83⅜ x 57¾ (209.2 x 146.7)
Gift of Seymour H. Knox, 1976

Lee Krasner's series of canvas collages, to which *Milkweed* belongs, were made between 1953 and 1955, and are, in part, a fuller development of ideas contained in the earlier black and white paper collages done in 1951.

A highly self–critical artist given to a regular, periodic editing of her work, Krasner began in 1952–53 to destroy a group of paintings that she wished to reject. The process of unstretching, and slashing or cutting up the canvas suggested the idea for a series of collages made from the resulting fragments. It seems likely that the canvas support for *Milkweed* came from a group of works intended for destruction. Krasner had painted works consisting largely of vertical bands of color, such as one sees in the background of *Milkweed*, as early as 1951, and the fragments of canvas and paper attached to that painting's surface may also have been salvaged from earlier works.

In *Milkweed*, the fragments of canvas and paper are torn in a manner that particularizes their edges, which are jagged and frayed, sharp and incisive. A lightly brushed arabesque unites the fragments at the top of the image in a circular rhythm that contrasts with the vertical movement of thin white strips rising from below. Krasner titled her paintings once they had been finished, and after careful study. *Milkweed* may have been chosen for the suggestion of a rounded form atop a vertical one or, in a more general fashion, for the plantlike, germinative sensation of rising, swelling and splitting produced by the forms themselves. Krasner's color also follows the same dramatic structure. The slow movement of black against a background of brown and olive is suddenly arrested by a patch of orange–gold of such intensity that it appears to be illuminated from within.

R.E.

LEE KRASNER (née Lenore Krassner) was born in Brooklyn into a Russian–Jewish immigrant family from Odessa. In 1926 she entered the Women's Art School of the Cooper Union, New York, and, after graduating, was admitted to the National Academy of Design.

From 1934 to 1942, Krasner supported herself by working on the Public Works of Art Project of the WPA. During the late 1930s, she took an increasing interest in the work of Picasso and Matisse, and attended the night classes of Hans Hofmann (from 1937–40). Among her friends of this period were Arshile Gorky and John Graham, in whose theories on the unconscious she took a special interest.

In 1942, Krasner began a close association with Jackson Pollock. The two were married in 1945 and moved from New York to The Springs, a rural community in East Hampton. During the next four years Krasner, influenced by Pollock, experimented with methods opposed to the tenets of Cubism and similarly arrived at the kind of "all–over" composition that is one of the distinct inventions of Abstract Expressionism.

Until her death in 1984, Krasner's work underwent numerous significant changes. Experiments with collage between 1951 and 1955 were followed by a long period of working in a gestural mode. In later years she also adopted a flatter, more geometric style and returned to collage again in 1976.

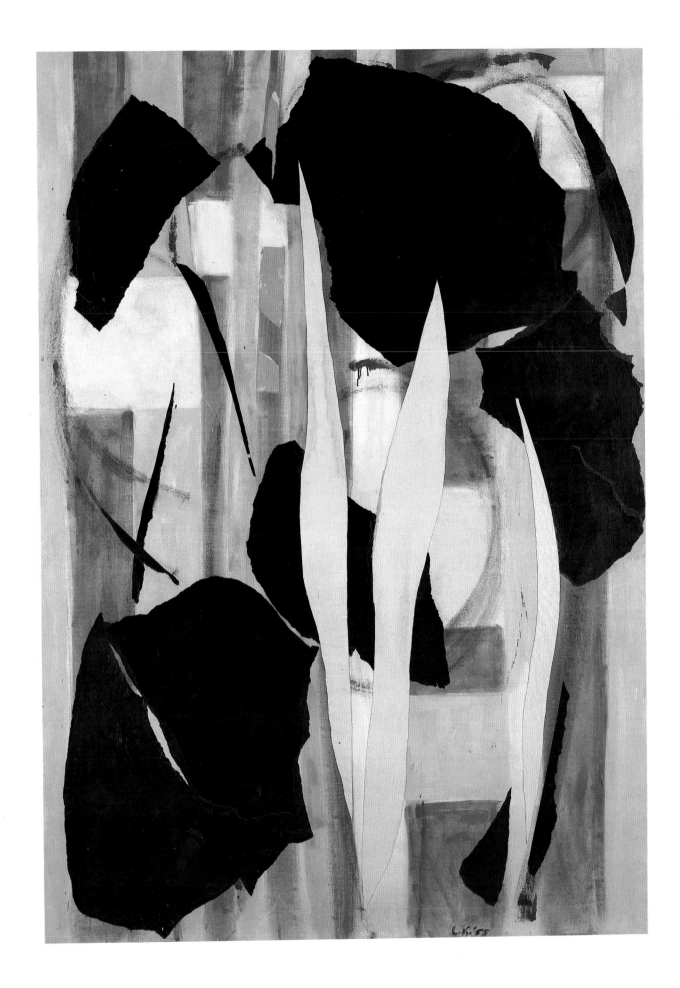

MARK ROTHKO
American, born Russia, 1903–1970

Orange and Yellow, 1956

Oil on canvas
91 x 71 (231.2 x 180.3)
Gift of Seymour H. Knox, 1956

Orange and Yellow, 1956, is representative of Rothko's work from the mid–fifties, not only in the vibrant buoyancy of the two colors, but also in their selection from closely adjacent points on the spectrum. Oil paint is thinly diffused to leave no trace of the brush or hand of the painter and to avoid any explicit edge or boundary between the various color zones. The imposing size and intensely saturated color provide the viewer with a sensory experience and invite a meditative state of mind. Space and the relationship between the rectangles and the framing edges are left deliberately ambiguous. Faint halations of light appearing to emanate from beneath the surface suggest an awesome and mysterious presence. By the 1960s, Rothko's palette and mood had darkened and his earlier light–filled canvases were replaced by somber and austere paintings.

E.M.ed.

Born in Dvinsk, Russia in 1903, at the age of ten MARK ROTHKO (born Marcus Rothkowitz) emigrated with his family to Portland, Oregon. He attended Yale University, New Haven, Connecticut from 1921–23 but abandoned his liberal arts studies to go to New York. There he was exposed to art classes by a friend; a brief period of study under George Bridgman and Max Weber at the Art Students League constituted his entire formal art training.

In 1935, along with Adolph Gottlieb, Ilya Bolotowsky, Louis Schanker and others, Rothko founded "The Ten," a loose association of artists that met in each other's studios and exhibited together regularly until 1940. Like most of his contemporaries, Rothko worked on the WPA Federal Art Project, 1936–37. In 1938, he became an American citizen and by 1940, had adopted the name Mark Rothko. A one–man exhibition in New York in 1945 at Peggy Guggenheim's Art of This Century gallery brought him to public attention.

During the forties, Rothko's imagery, like that of most of the New York School painters, relied on Surrealist–inspired myth and fantasy. By the fifties, he had simplified his approach to exclude all line and movement in a new monumentality consisting of soft–edged horizontal rectangles superimposed on a vertical ground.

Rothko taught during the summers of 1946 and 1947 at the California School of Fine Arts in San Francisco and later at the Subjects of the Artists School in New York, which he co–founded in 1948 with Robert Motherwell and William Baziotes. Rothko committed suicide in New York in 1970.

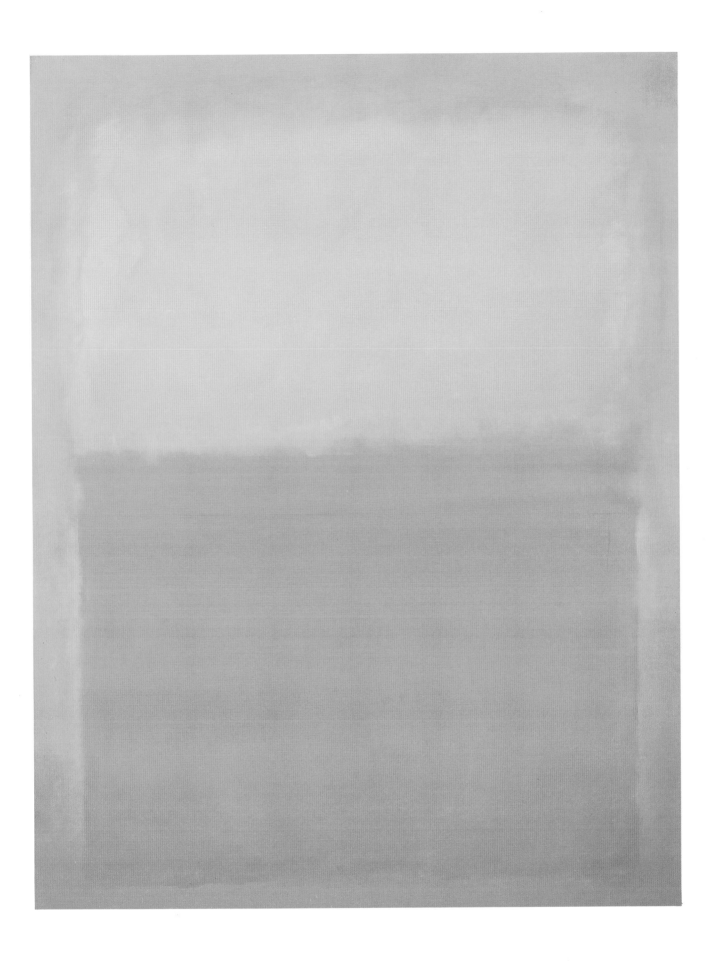

SAM FRANCIS
American, born 1923

The Whiteness of the Whale, 1957

Oil on canvas
104½ x 85½ (265.4 x 218.2)
Gift of Seymour H. Knox, 1959

The Whiteness of the Whale, 1957-58, is a key painting in Sam Francis' concern for the tension between white and the opposing forces of color. The title is taken verbatim from a chapter in Herman Melville's *Moby Dick* that consists entirely of a disquisition on the "elusive something in the innermost idea of this hue (white) which strokes more panic to the soul than the redness which affrights in blood." The white field, far from being empty and uninflected, is composed of a richly textured welter of daubs and appears a subtle yet powerful counterforce to the stream of brilliantly colored cells.

In some of Francis' later work, the white fields that Melville had equated with "the heartless voids and immensities of the universe," have continued to expand, relegating the vestiges of color to the farthest extremes of the edges.

E.M.ed.

Born in San Mateo, California, in 1923, SAM FRANCIS studied medicine and psychology at the University of California at Berkeley. A severe spinal injury incurred in 1943 during an air force mission resulted in an extended period of hospitalization during which Francis began painting in watercolors. After leaving the hospital, he studied briefly at the California School of Fine Arts in San Francisco and enrolled again in 1948 at Berkeley, where he received an M.A. degree in 1950.

In 1950 he went to Paris and immediately became acquainted with a small group of North American expatriate painters, particularly the Canadian Jean–Paul Riopelle. Francis remained in Paris, with few interruptions, until 1957, when he undertook a lengthy journey around the world, stopping for several months in Japan, where the culture and artistic tradition impressed him profoundly. After a second tour in 1959, he returned to Paris and began to make lithographs, which have since constituted an important part of his production. Since 1962 he has lived in Santa Monica, California; he also has studios in Japan, France and Switzerland. Francis works not only in painting and lithography but also in watercolor and ceramics.

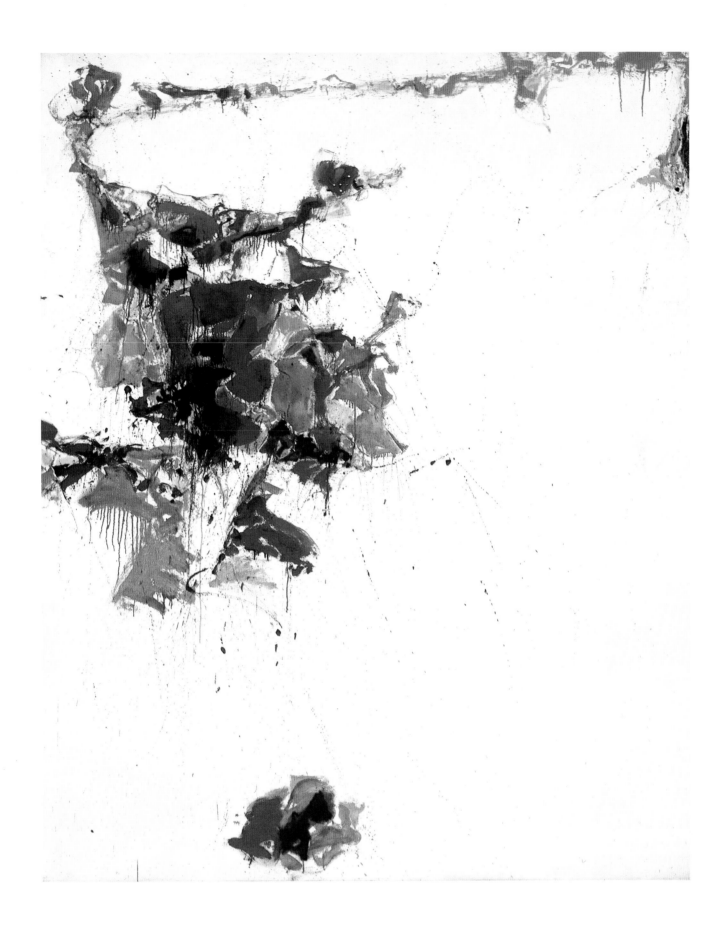

HELEN FRANKENTHALER
American, born 1928

Round Trip, 1957

Oil on canvas
70¼ x 70¼ (178.5 x 178.5)
Gift of James I. Merrill, 1958

Although the title of *Round Trip*, 1957, makes no explicit reference, one senses, as with most of Frankenthaler's paintings from this period, an abstract landscape, derived not so much from the memory of a specific moment or location as from the nature of her technique. The canvas, both the unpainted areas and those reflecting through the thin color stains, conveys an atmospheric luminosity. Working on the floor from all four sides, and making decisions by cutting away at edges rather than proceeding according to a preconceived plan, she carefully manipulates analogous colors and forms to complete the composition. In 1963 she began to use acrylic paints that permitted her to achieve more opaque and intense color fields, often covering larger areas, which have characterized her more recent work.

E.M.ed.

Born in New York in 1928, HELEN FRANKENTHALER first studied with Rufino Tamayo at the Dalton School. At Bennington College, Vermont, 1945–49, she received a disciplined grounding in Cubism from Paul Feeley, though her own instincts lay closer to the linear freedom of Arshile Gorky and the color improvisations of Wassily Kandinsky's early work.

In 1950 the critic Clement Greenberg introduced her to contemporary painting. During that summer, she studied with Hans Hofmann in Provincetown, Massachusetts. In 1951 Adolph Gottlieb selected her for an important *New Talent* exhibition, and she had her first one–person show in New York later that year.

The work of Jackson Pollock proved the decisive catalyst to the development of her style. Immediately appreciating the potential, not fully developed by Pollock, of pouring paint directly onto raw unprimed canvas, she thinned her paint with turpentine to allow the diluted color to penetrate quickly into the fabric, rather than build up on the surface. This revolutionary soak–stain approach not only permitted the spontaneous generation of complex forms but also made any separation of figure from background impossible since the two became virtually fused—a technique that was an important influence on the work of other painters, particularly Morris Louis and Kenneth Noland.

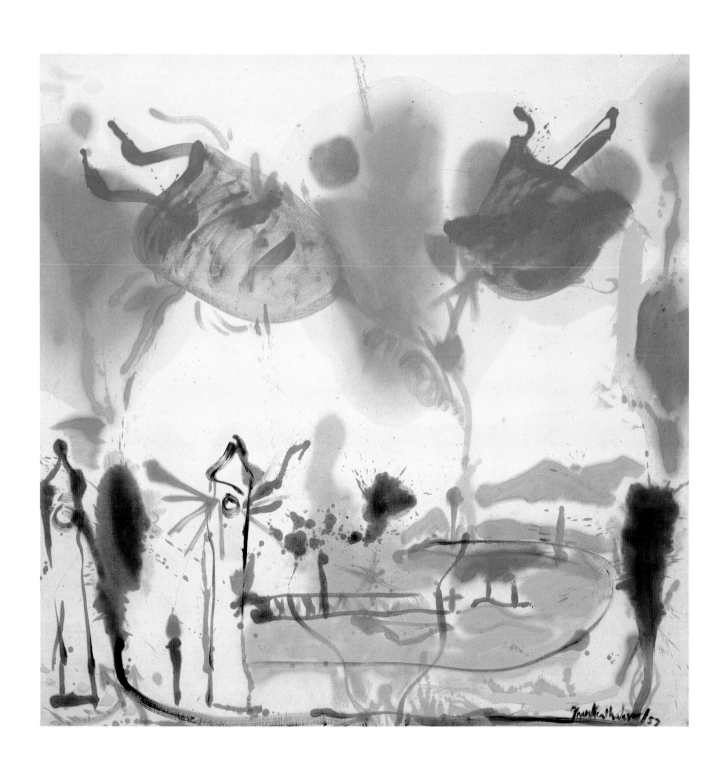

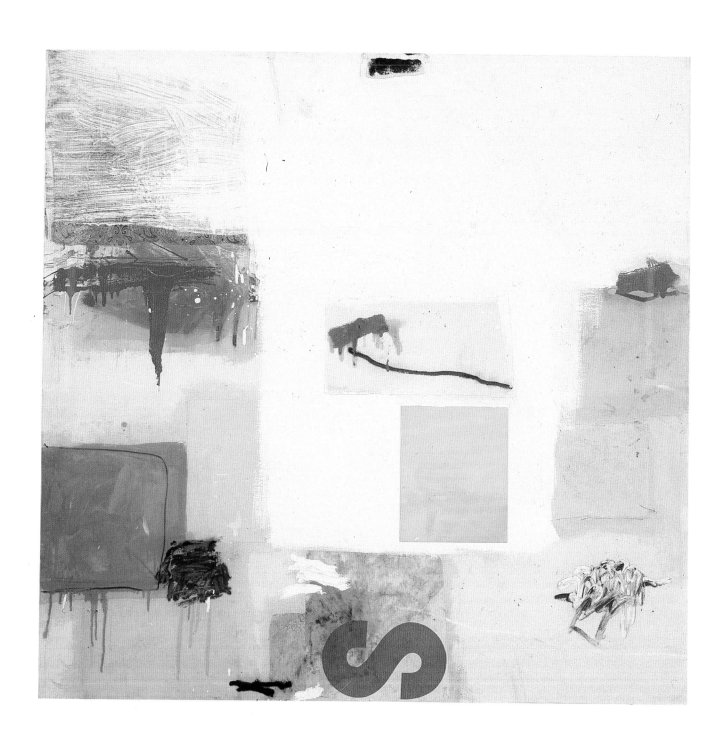

Painting with Red Letter S, 1957

Oil and collage on canvas
51 x 52 (129.5 x 132)
Gift of Seymour H. Knox, 1959

Born in 1925 in Port Arthur, Texas, ROBERT RAUSCHENBERG studied briefly at the Kansas City Art Institute and the Académie Julian in Paris. Dissatisfied with his inability to break away from the colorful and sensual qualities of pigment, he returned to the United States in 1948 to study under Josef Albers at the avant–garde Black Mountain College in North Carolina. During the next two critical years, he began what was to be a continuing involvement with photography, music and modern dance.

In 1949, Rauschenberg settled in New York, where he studied for a year at the Art Students League. In the early fifties, he designed sets and costumes for the Merce Cunningham Dance Company and worked closely with the composer John Cage and the painter Jasper Johns. During this period, he developed his "combines," bringing together on canvas freely brushed areas and increasingly assertive three–dimensional objects. By the late fifties, Rauschenberg became interested in a number of graphic techniques—rubbing, silkscreen, lithography—that have continued to influence his work to the present.

Rauschenberg established his permanent home and studio on Captiva Island, Florida in 1971; he also maintains a residence in New York. Since that time, he has produced several major series, for example, the "Cardboards," "Jammers," "Spreads," "Scales," "Cloisters," and "Signals." In 1982, after a trip to China, Rauschenberg formulated plans for the *Rauschenberg Overseas Culture Interchange* (R.O.C.I.), a monumental traveling exhibition that would show works he had made in different countries with local craftsmen and artists. In 1985, R.O.C.I. toured in Mexico, Chile, Venezuela, China and Tibet.

During the mid–1950s, Robert Rauschenberg and Jasper Johns resided in the same building on Pearl Street in New York, where they became close friends. Together, they were largely responsible for introducing common objects and images, presented in an impersonal manner, into an art milieu dominated by the idealism and individualism of Abstract Expressionism. Both employed the expressionists' gestural stroke for non–expressive purposes. Nevertheless, the underlying concerns of the two men's art differ significantly; as the critic Lawrence Alloway has so aptly noted, the predominant characteristic of Johns' painting is ambiguity, while the distinguishing trait in Rauschenberg's art is heterogeneity.

Rauschenberg studied with Josef Albers at Black Mountain College in North Carolina in 1949. However, he found himself unsympathetic to his teacher's rigid theories and rebelled against the authoritarianism he perceived in the subordination of component parts of a work of art to a unifying principle. More responsive to the inclusive, non–hierarchical approach of the composer John Cage, Rauschenberg determined to operate "in the gap between art and life." In the latter half of the 1950s, he began making collages and also "combine paintings," the latter which contained three–dimensional objects, collage and painting. Drawing on materials and images produced by an urban, "throw–away" culture, he put them together in a fashion best described as free association.

The first Rauschenberg painting to enter the collection of an American museum, *Painting with Red Letter S* demonstrates the artist's use of collage and painterly gesture. It is the first of a group of works—culminating in *Ace*—in which he combines the two techniques in an abstract manner and includes letters from the alphabet. Although *Painting with Red Letter S* is abstract and contains gestural strokes, it is yet dissimilar to Abstract Expressionism: Rauschenberg limits the evidence of his presence as much as possible and instead emphasizes the materials and the element of chance. In regard to his collaborative approach to materials, he has explained, "Making a work is an unpredictable dialogue with the substance, the technique and the artist, preferably mute...materials have a reserve of possibilities built into them."

H.R.

CLYFFORD STILL
American, 1904–1980

1957–D, No. 1, 1957

Oil on canvas
113 x 159 (288.2 x 403.8)
Gift of Seymour H. Knox, 1959

Clyfford Still claimed to paint solely for himself, without concern for public acceptance. Notorious for his distrust of art writers, whom he felt invariably misrepresented him, and of art institutions, which he believed were generally opportunistic and corrupt, Still hoarded his paintings and sold only to those he deemed worthy. Seymour H. Knox and Gordon Smith, then director of the Gallery, won Still's trust by demonstrating a sincere admiration and understanding of his work. In the late 1950s, Mr. Knox purchased *1957–D, No. 1* and another painting, *1954*, for the museum, and in 1959, the Gallery gave Still a retrospective exhibition. These acts stood as a vote of confidence in Still and moved the artist to donate thirty–one of his paintings to the Albright–Knox Art Gallery in 1964. Extremely concerned with the presentation of his work, Still preferred that his canvases be seen in groups spanning the production of a number of years; he conceived each painting as part of an organic whole, properly understood only in the context of the overall evolution of his work.

A particularly dramatic work, with its sharp contrasts of yellow and black, *1957–D, No. 1* exemplified Still's characteristic rugged shapes that appear at once like areas brutally rent in the painted field and as integral parts of a single interlocking composition. The illusion of advancing and receding shapes seems to cause the paintings to breathe, while the gritty texture and irregular forms further contribute to the "organic" quality of Still's works. Many critics have compared the paintings to landscape, bark, rock formations and other natural objects, often likening the canvases to the vast plains where Still grew up. Still always resolutely denied these analogies and insisted that the subject was himself, not nature. He explained, "each painting is an episode in a personal history, an entry in a journal." Carrying the metaphor a step further, he spoke of his titles as headings to journal entries that simply designate order but do not impinge on the meaning of the content. If he had wished to refer to phenomena in the material world, he noted, he would have given his paintings descriptive titles.

H.R.

CLYFFORD STILL was born November 30, 1904, in Grandin, North Dakota. Shortly after his birth, the family moved to Spokane, Washington and, in 1910, homesteaded in Alberta, Canada. After graduating from Spokane University in 1933, he went to Washington State University in Pullman, receiving an M.A. degree in 1935 and remaining to teach, 1935–41. From the fall of 1941 until the summer of 1943, Still worked in the war industries—aircraft and shipbuilding—in Oakland, California, and later in San Francisco. He lived in New York, 1945–46, where he exhibited at Peggy Guggenheim's Art of This Century Gallery. In 1946, he returned to San Francisco to teach at the California School of Fine Arts. In 1950 Still again moved to New York. From 1960 until his death in 1980, he lived and worked in Maryland. In 1964, Still donated thirty–one of his works to the Albright–Knox Art Gallery, making it the largest repository of his work in the world.

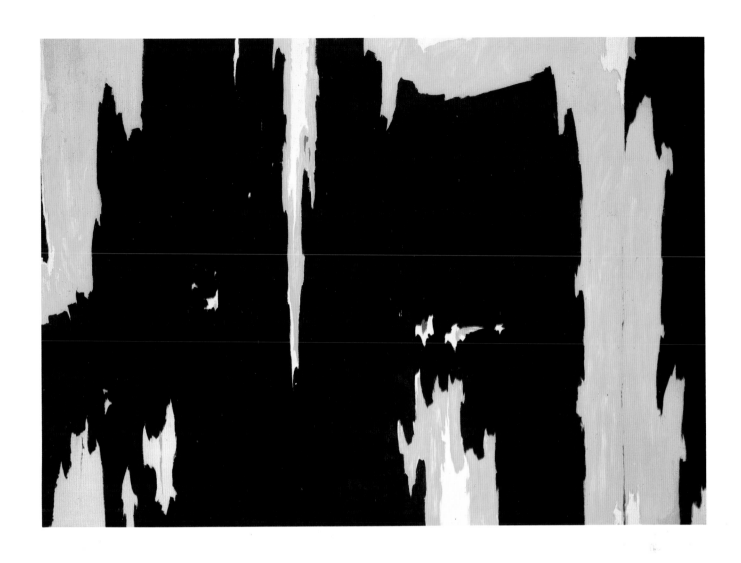

LOUISE NEVELSON
American, born Russia, 1900

Sky Cathedral, 1958

Wood, painted black
115 x 135 x 20 (298.4 x 342.9 x 50.8)
George B. and Jenny R. Mathews Fund, 1970

Sky Cathedral, 1958, consists of thirty—eight boxes of different sizes, arranged in a careful balance of symmetry and asymmetry, the whole painted matte black. The individual found objects (sometimes not "found" but made to order for the artist) are arranged in a seemingly endless variety of combinations. The oblong boxes vary in size, and the content of each has a completely different character and is sufficiently complex to exist as a separate entity. In some cases, the objects are openly revealed; other boxes are closed or partially closed, the contents remaining concealed.

The construction has a strongly architectural aspect and exists less as a sculpture than as a whole environment of a particularly poetic character. The multitude of objects are arranged in a carefully controlled "disorder," and a strong tension is created between the various elements. *Sky Cathedral* is more starkly expressionistic and less romantic than many of the artist's constructions of the period.

E.M.ed.

LOUISE NEVELSON was born in Kiev, Russia, in 1900. Her family moved to Rockland, Maine, in 1905. In 1920, she went to New York, where she studied music, acting, and philosophy before attending the Art Students League, 1929–30. She was a student of Hans Hofmann in Germany the following year, and after returning to New York she worked as a mural assistant to Diego Rivera.

During the fifties, she developed her wooden constructions, largely composed of found objects, the first of which were painted matte black, followed by a series in metallic gold paint, and another in white. She has made sculptures in metal also, and during the late sixties she completed a number of plexiglass constructions.

Basically Constructivist, Nevelson's work is also poetic and has elements of Surrealism. Within the various boxes that are component parts of most of her sculptures, she usually arranges a variety of objects of different shapes and sizes. The individual boxes are then placed to create a tension and design within the finished work and are unified by a single color.

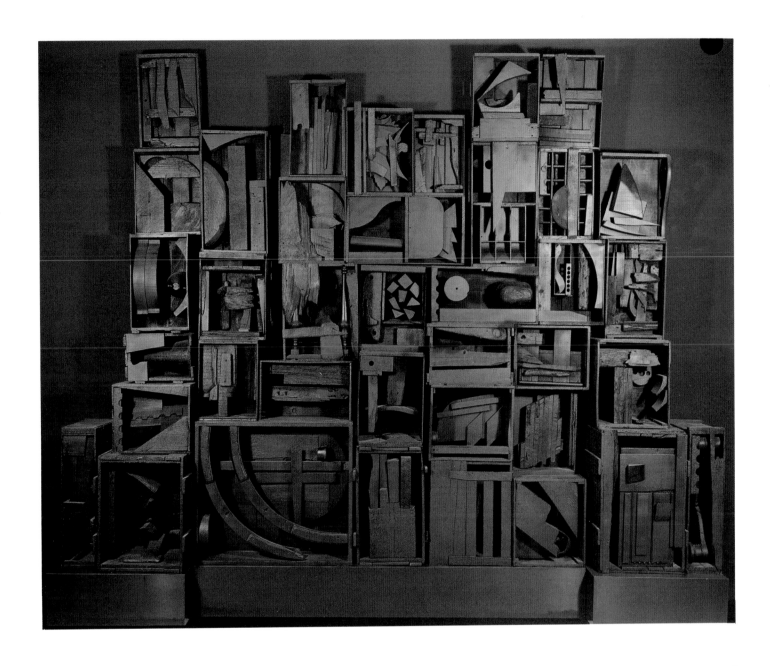

JASPER JOHNS
American, born 1939

Numbers in Color, 1959

Encaustic and newspaper on canvas
66½ x 49½ (168.9 x 125.7)
Gift of Seymour H. Knox, 1959

Jasper Johns' "Number" paintings of the mid– to late fifties, like the "Flag" and "Target" paintings that preceded them, startled the art world when they first appeared. With his impersonal presentation of identifiable symbols, Johns seemed to repudiate the subjective Abstract Expressionist style that was then predominant. Nevertheless, Johns' comments indicate that his intentions were not directed toward shocking the public, but rather toward finding a neutral image on which to hang independent ideas. He said that using the design of the American flag, for instance, "took care of a great deal for me because I didn't have to design it. So I went on to similar things... things the mind already knows. That gave me room to work on other levels." Presented out of context, common symbols and objects become disassociated from their usual meaning or use. For example, one would normally associate numerals with such processes as mathematical or statistical computation. Yet in Johns' painting, the immediate impulses to focus on and make sense of the numbers are frustrated. Embedded in an all–over network of uniform brushstrokes, the figures seem to appear and disappear like camouflaged animals. Although they are arranged neatly in a grid and march across the canvas from left to right in a repetitive sequence, the numbers serve no purpose beyond that of a design element.

Numbers differ from targets or flags in that numbers refer only to ideas and have no concrete existence in the material world. Deprived of their symbolic function, they become pure abstractions, recognizable but without meaning. Thus, the subject of Numbers in Color is abstraction itself. Forced to confront Johns' painting on this basis, one becomes aware of the role the mind plays in the act of visual perception.

It is a natural tendency to seek familiar things first when one is trying to interpret new information. Johns encourages this tendency by providing enough visual clues in Numbers in Color to allow the viewer to pick out the numbers from the field and to infer a numerical system. However, he then foils the viewer's attempts to impose this kind of visual or intellectual order on his painting by camouflaging the numbers and denying their logical function. By doing so, Johns causes us to question our mental and visual habits.

H.R.

Born in Augusta, Georgia in 1939, JASPER JOHNS grew up in South Carolina and attended the state university for a year and a half. After service in the army, he went to New York in 1952 where friendships with the avant–garde composer John Cage and the painter Robert Rauschenberg, with whom he shared a studio, were influential to his development as an artist. At that time, Abstract Expressionism dominated the New York art world, although Geometric Abstraction and American Realism were also in evidence. From each of these opposing movements, Johns chose certain elements that he shaped to his own uses. He elected to employ real and commonplace subject matter, pre–existing and inherently flat motifs such as the American flag, targets, maps, letters of the alphabet, and numbers which he placed in carefully ordered compositions, retaining the flat surface, and rendered with painterly brushwork akin to that of the action painters.

Johns has produced sculpture as well and is a particularly distinguished printmaker, his innovations and sensibility marking him as one of the most accomplished and influential of contemporary American artists.

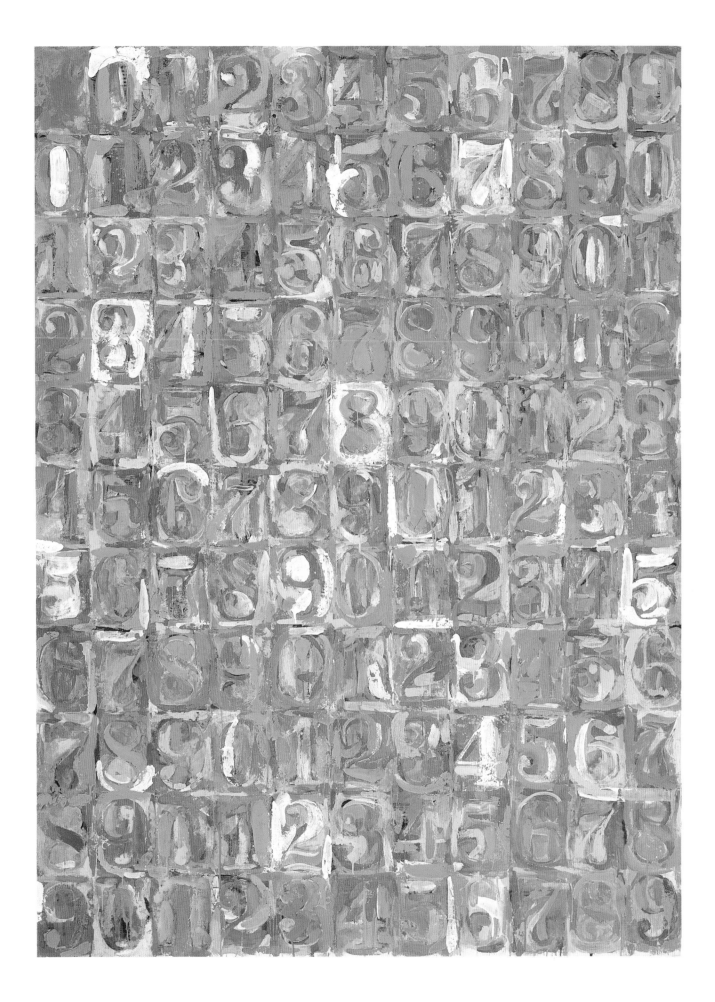

Frank Stella
American, born 1936

Jill, 1959

Enamel on canvas
90¾ x 78¼ (230.5 x 200)
Gift of Seymour H. Knox, 1962

Eliminating color to concentrate on structure, Stella stressed a pictorial organization deduced from the shape of the canvas. The resulting paintings were large emblematic designs composed of parallel bands of black enamel and then "breathing" spaces of raw canvas. They divide roughly into two groups: in the first, the bands are rectilinear and parallel the framing edge; in the second, to which Jill belongs, the bands run parallel to the diagonal axes of the picture field. When first exhibited publicly, the "Black" paintings appeared particularly mute, inert, even nihilistic.

Jill, 1959, in keeping with the downbeat titles of the "Black" pictures, was named after a girl involved with black, deviate nightclubs. It is one of the simplest compositions in which concentric bands echo the central diamond shape, and the modular repetition implies an extension beyond the picture's edge. It demonstrates Stella's holistic approach to painting and recalls his goal to "see the whole idea without any confusion." Like the other "Black" pictures, Jill was painted freehand and reveals the irregular edges and personal paint handling absent from most geometric painting, and modified in Stella's later work.

E.M.ed.

Born in Malden, Massachusetts, in 1936, FRANK STELLA attended Phillips Academy, Andover, 1950–54, and Princeton University 1954–58, where he majored in history and studied painting under William Seitz and Stephen Greene. After exploring the then–dominant Abstract Expressionist style while at Princeton, Stella moved in 1958 to New York, where he produced a series of "transitional" paintings influenced by Jasper Johns' flags and targets. In the winter of that year, he began the "Black" series, three of which were selected by Dorothy Miller to appear in the Sixteen Americans exhibition at the Museum of Modern Art in December 1959.

Stella's approach to pictorial problems has been systematic, rigorously formal, and radically innovative. Early in 1960 he pioneered the shaped canvas with his "Aluminum" series by cutting notches in the canvases to eliminate "leftover spaces" in the design. In 1961 he began his first color series, still continuing, however, with the monochrome canvas. Not until the winter of 1962–63 did he begin to paint multicolored canvases—the "Concentric Squares" and "Mitered Mazes." With the "Irregular Polygons" of 1965, Stella moved away from the self–imposed restriction of stripes to large geometric areas of unbroken color. In 1967, curvilinear designs were introduced for the first time in the monumental "Protractor" series. Stella originally experimented with reliefs in 1970, and has increasingly expanded the three–dimensionality, color and gestural nature of his works. Now usually made of painted honeycomb aluminum, some of his dynamic "paintings" project as much as six feet from the wall. One of the most prolific of contemporary artists, Stella lives and works in New York.

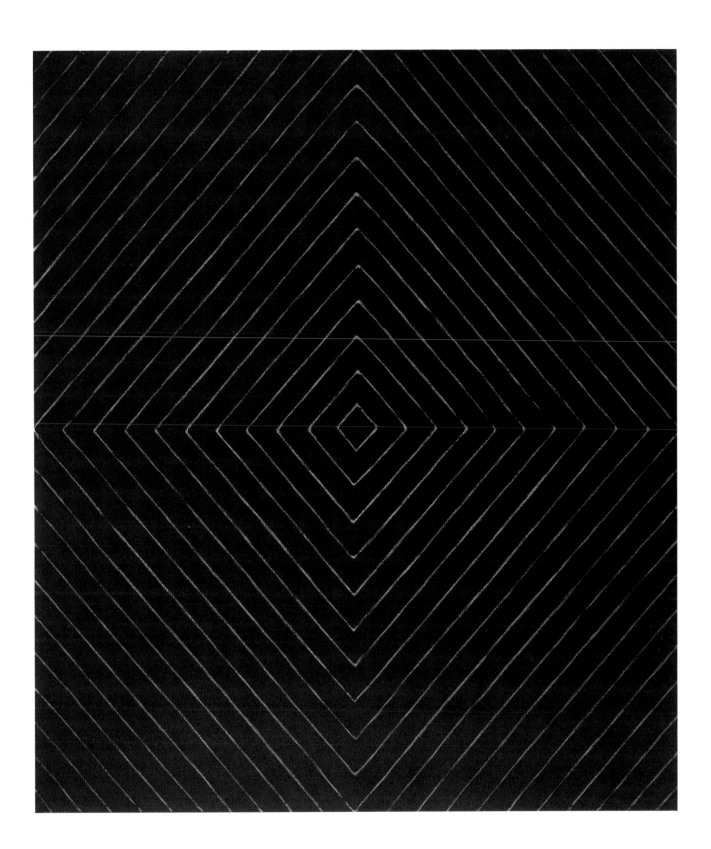

REUBEN NAKIAN
American, born 1897

Mars and Venus, 1959–60

Welded steel, painted black
7′ x 15′ x 6′ (213.5 x 482.8 x 182.9)
A. Conger Goodyear Fund, 1968

About *Mars and Venus*, Nakian wrote: "...the medium one uses should dictate its style—the steel sheets demanded a contour of shapes, without the help of modeling. My large bronze abstractions are modeled in plaster; I think my steel pieces and my modeled ones related to each other. I usually begin my work from naturalistic drawings, and then work them up to abstractions."

This sculpture of 1959–60 was constructed shortly after Nakian's work had undergone a transition from figurative to abstract. Composed of rods and sheets of welded steel, it is an open structure in which portions are raised from the base within the framework of an overall space that is suggested but not fully rendered. During the late 1950s, Nakian made a series of spontaneous drawings; *Mars and Venus* has the lightness and grace of such a drawing transferred into a three–dimensional sculptural concept and realized on an enormous scale. The visually floating, interpenetrating planes project upward and outward in a number of directions simultaneously. The ancient and engaging mythological theme, executed in contemporary materials, results in a powerfully suggestive abstraction.

E.M.ed.

REUBEN NAKIAN was born of Armenian–American parents in College Point, New York, in 1897, and as a child lived in New York City and several communities in New Jersey. He began drawing at an early age and, at sixteen, started to earn his living in New York at advertising agencies. He attended the Independent Art School and the Beaux–Arts Academy; in 1916, he began studying with Paul Manship and his chief assistant, Gaston Lachaise. When Manship left for Europe in 1920, Lachaise and Nakian shared a studio until 1923. Deeply influenced by these two figurative artists, Nakian's work remained realistic until the mid–1930s, when he began a reevaluation of his style that was accelerated during the 1940s. At that time, he became acquainted with the Abstract Expressionists, particularly Willem de Kooning, Franz Kline and Philip Guston; his sculpture as a consequence became abstract and large–scale. He also made many drawings and a number of works in terra–cotta.

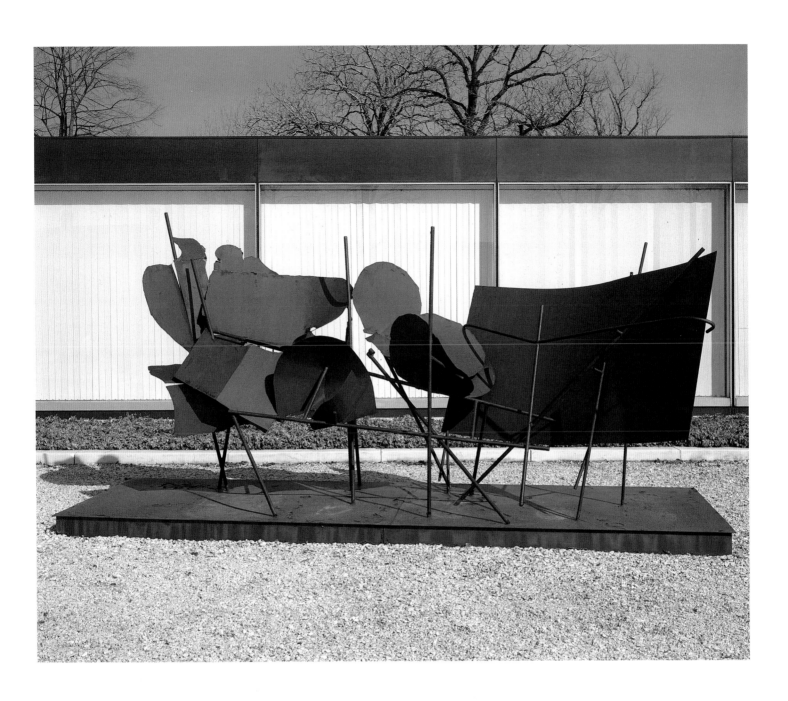

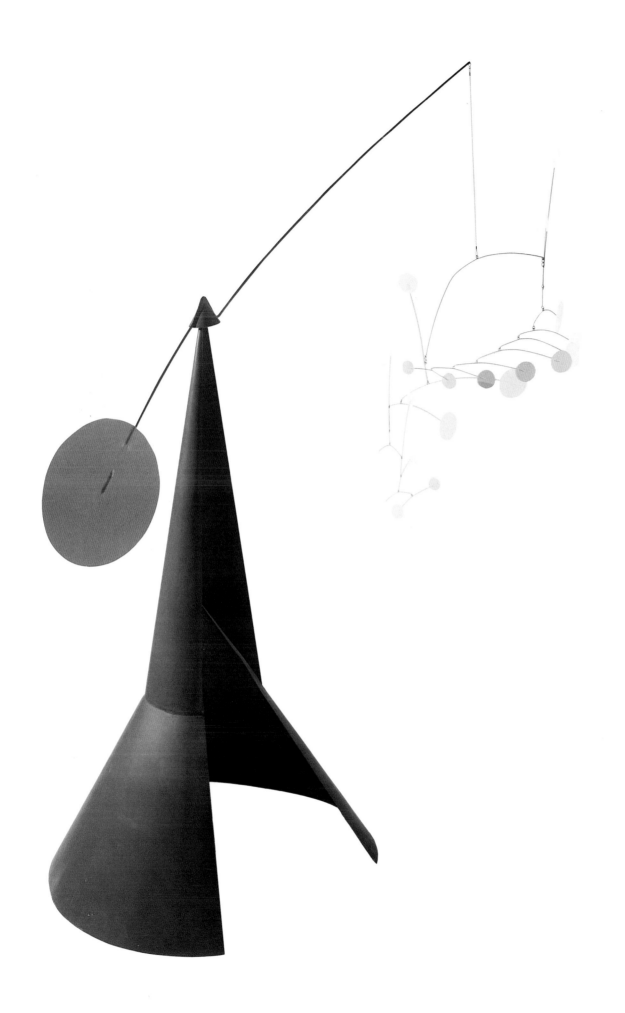

The Cone, 1960

Steel and aluminum
100 x 110 x 65 (254 x 279.4 x 165.1)
Gift of Seymour H. Knox, 1961

ALEXANDER CALDER was born in 1898 in Lawnton, Pennsylvania, to a family of well–known artists. Although his childhood was spent in an atmosphere of art, Calder graduated as a mechanical engineer from Stevens Institute of Technology in Hoboken, New Jersey, in 1919. After a number of engineering jobs, he began to study at the Art Students League in New York, 1923–26, working part–time as a freelance illustrator for the *National Police Gazette*.

In 1926, he went to Paris where he produced works based on the circus. The *Circus* introduced Calder to many of the artists in Paris who were to be influential to his career, and it served also as a laboratory in which he developed ideas and techniques used in his later work.

After a visit to Mondrian's studio in the early 1930s, Calder abandoned representational sculpture in favor of abstract, geometric constructions, which Jean Arp labeled "stabiles." He gradually began to add movement (another factor of the *Circus*) to the sculptures, and these became known as "mobiles," named by Marcel Duchamp. The first of these were motorized or operated by hand cranks, which Calder soon found too repetitive and predictable; he then began to create works which were dependent on air currents for motion. By 1934, he had arrived at the basic concepts of the "mobiles" and "stabiles," which constituted the major portion of his work. Calder also designed sets and props, textiles, book covers, jewelry and posters. In 1976 he was honored with a large retrospective, *Calder's Universe*, at the Whitney Museum of American Art in New York; he died shortly thereafter.

In *The Cone*, 1960, Alexander Calder combined a stabile and a mobile in a single work. The stabile section consists of two black cone shapes, one placed asymmetrically over the over, each of which was cut to form a triangular void. The mobile portion is formed by a rigid rod with a large red circle attached at one end and balanced by a freely moving arrangement of white circles suspended from the other. The connecting rod was welded to a separate small cone which rests on the apex of the stabile, pivoting freely and presenting an ever–changing composition. The white discs react to the slightest air movement, bouncing and swaying in an intricate pattern.

E.M.ed.

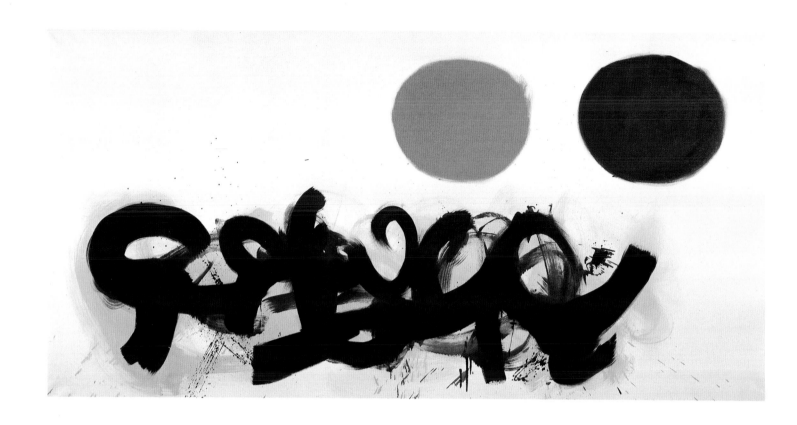

Dialogue I, 1960

Oil on canvas
66 x 132 (167.6 x 335.2)
Gift of Seymour H. Knox, 1961

Born in 1903 in New York, ADOLPH GOTTLIEB studied with Robert Henri and John Sloan, prominent figures in the Ashcan School, at the Art Students League, 1920. In 1921 he went to Europe, studying briefly in Paris and visiting museums in Germany. Back in New York in 1923, he was a founding member with Rothko of "The Ten," a pioneer organization dedicated to the encouragement of abstract painting. He worked for a short time on the WPA Federal Art Project and in 1937 moved to Arizona for two years.

Gottlieb's work can be classified into three phases. His "Pictographs," 1941–51, divided the canvas into unequal rectangular compartments, each containing an image derived from primitive myths or the subconscious. The "Imaginary Landscapes" begun in 1951, such as *Frozen Sounds II*, separated stylizations of sky and earth by a sharp horizon line. In the "Bursts," begun in 1957 and evolving from the landscapes, large floating discs appear above loosely brushed areas in the lower portions of the canvases.

Although Gottlieb's palette frequently included delicate and sensitive colors, *Dialogue I*, 1960, is restricted to a severe and almost classical palette of red and black on white and retains the horizontal division of sky and earth seen in landscapes. Unlike his earlier impasto, the paint is thinned with turpentine so that the swift and slashing brush leaves an instantaneous record of its passage in the drips, drags and spatters. Faint turpentine halos cause the disks to appear to shift quietly in space.

Gottlieb's underlying concern is the dualism within the universe that man must resolve. Of that concern, Martin Friedman wrote: "A radiant astral disc hovering over a seething earth mass is a statement of radical opposition, and these forms—one calm, defined, and tightly contained, the other undisciplined, in flux—suggest interpretations ranging from the actual to the metaphysical: male and female, sun and earth, order and chaos, creation and destruction, reason and emotion—positive and negative entities essential to one another that interact across the charged field of the canvas."

E.M.ed.

MORRIS LOUIS
American, 1912–1962

Alpha, 1960

Acrylic resin paint on canvas
105½ x 145½ (268.3 x 369.8)
Gift of Seymour H. Knox, 1964

Between the summer of 1960 and the middle of the following winter, Morris Louis produced a series of over 120 "Unfurled" paintings, including *Alpha*. Characterized by a broad, untouched field framed by diagonal colored bands, they were, according to the artist's own estimation, the greatest achievement of his career. By 1960, he had begun to receive considerable critical attention and to improve his financial status through increased sales; finally he could afford to purchase large quantities of art supplies. His access to greater amounts of canvas and paint and his use of the new, more fluid acrylic paint that his friend, Leonard Bocour, had developed for him at that time contributed to the evolution of the "Unfurleds."

Louis attained the effect he desired in the "Unfurleds" by making channels out of folds in the canvas and by shifting the orientation of the mobile stretcher on which he worked in order to direct the rivulets of pigment. Despite his control of his "draftsmanship" in this manner, the nature of the process allowed room for chance in the way the paint flowed.

In Louis' earlier works, different aspects of his style—forceful composition, lush coloring and graceful draftsmanship—seemed to vie for dominance, with one often gaining precedence over the others. The "Unfurleds" bring all these elements into balance: divided into three interlocking areas, the composition of two wedges of color stripes framing an inverted triangle of unpainted canvas causes figure and field to become inseparable. Similarly, color and line are synonymous in these paintings. Yet, they remain dynamic in their equilibrium, as the colors appear at once to squeeze the central area and to pull away from it, creating the illusion of expansion.

Due to the monumental scale of these works, few galleries or museums during the 1960s were equipped to show them. Only two paintings from the "Unfurled" series were ever exhibited during Louis' lifetime. Clement Greenberg, a prominent critic and the artist's close friend, selected *Alpha* and another "Unfurled," *Delta*, to be included in an exhibition at Bennington College in Vermont in October, 1960. Louis did not attend the show and thus never saw any of his "Unfurled" paintings properly stretched and hung.

H.R.

MORRIS LOUIS was born Louis Bernstein in Baltimore, Maryland, in 1912. He moved to the Washington, D.C. area in 1947. In 1952, while an instructor at the Washington Workship Center, he became friends with fellow teacher Kenneth Noland. In April 1953, Louis and Noland, together with critic Clement Greenberg, visited the New York studio of Helen Frankenthaler, where they saw her recently completed *Mountains and Sea*, a painting utilizing the poured–stain technique. This greatly impressed both artists. For Louis, it proved to be the turning point in his career. He said later of Frankenthaler, "She was a bridge between Pollock and what was possible."

Borrowing from Pollock a greater freedom in paint handling and an enlarged format, Louis explored the possibilities of the stain technique by soaking thin veils of pure color into unprimed cotton duck canvas. The resulting series of softly overlapping color configurations with sensuous, evocative outlines came to be known as the "Veil" paintings. Louis was not concerned with gesture, with the artist's "handwriting" that was so important to the Abstract Expressionists. Instead of impasto and emphasis on paint quality, he employed color that, soaked into the raw canvas, became a part of the fabric.

In 1959 Louis had his second one–man show in New York, and a succession of exhibitions followed in the next three years. During this period he painted the series known as "Florals," the "Unfurleds," and the "Stripe" paintings. Although he received some critical acclaim before his death in 1962, extensive public recognition has come to him posthumously.

E.M.ed.

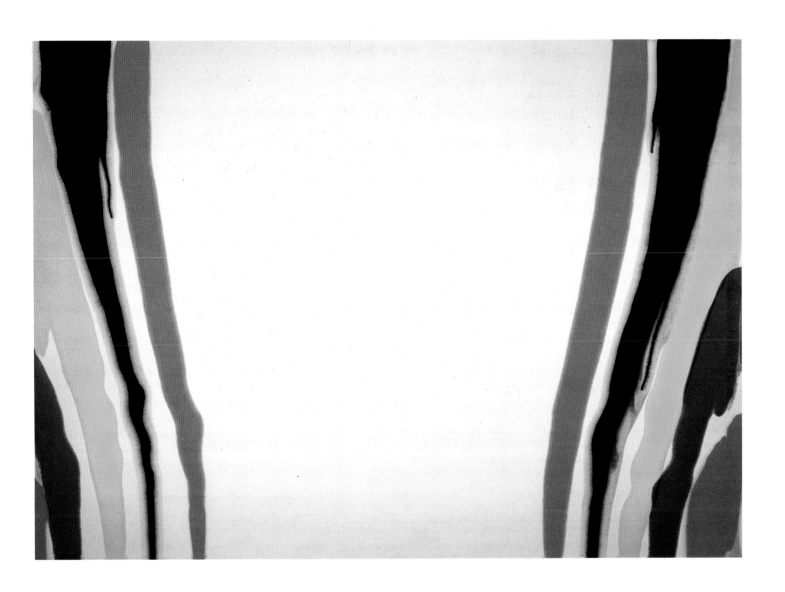

ROBERT INDIANA
American, born 1928

Year of Meteors, 1961

Oil on canvas
90 x 84 (228.5 x 213.3)
Gift of Seymour H. Knox, 1962

The title *Year of Meteors*, 1961, is also that of a poem by Walt Whitman, dated 1859–60, from the "Birds of Passage" section in *Leaves of Grass*:

> Nor forget I to sing of the wonder, the ship as she swam up my bay,
> Well–shaped and stately the Great Eastern swam up my bay, she was six hundred feet long,
> Her moving swiftly surrounded by myriads of small craft I forget not to sing;
> Nor the comet that came unannounced out of the north flaring in heaven,
> Nor the strange huge meteor–procession dazzling and clear shooting over our heads,
> (A moment, a moment long it sail'd its balls of unearthly light over our heads,
> Then departed, dropt in the night, and was gone;)...

Indiana's interest in American literature and history, combined with the location of his studio near Coenties Slip, by which the Great Eastern probably sailed into New York, contributed to the inspiration for this painting. His designs and colors recall street signs and hex signs; the lettering within circles suggests commemorative medals. In *Year of Meteors*, the colors are the blue and green of water and the white of cresting waves. The eight–pointed motif lends itself to a multiplicity of interpretations: points of the compass, a ship's wheel, a star, or—simply—an emblematic device to relate the two circles.

<div align="right">E.M.ed.</div>

ROBERT INDIANA (born Robert Clark) adopted Indiana as his surname in tribute to his home state, where he was born in New Castle in 1928. He studied at the John Herron Art Institute in Indianapolis, 1945–46; Munson–Williams–Proctor Institute, Utica, New York, 1947–48; Art Institute of Chicago, 1949–53; and in Great Britain at Edinburgh College of Art, 1953–54, and London University, 1954. In 1956, he moved to New York, where he rented a loft on Coenties Slip on the lower east side, a locale that was to play a major role in his work. Dating from the time when New York was Nieuw Amsterdam, Coenties is the oldest, largest, and busiest of the slips and is constructed in the form of a Y, a shape that also appears in the leaves of nearby ginkgo trees and which Indiana frequently employed as a design motif. He has stated that his use of lettering derives from several sources: the thickly lettered wall of a neighboring building; letters and numbers on passing boats, ships, and trucks in the area; and his discovery of old commercial stencils that he put to new use in his work.

He developed a hard–edge style during 1957–59 and made considerable use of the circle and variations on the circle after 1960. During 1960 he created a number of three–dimensional constructions, returning to painting the following year. Although related to Pop art, Indiana's work is more literary, poetic, and non–objective than that of most artists associated with the movement.

Head—Red and Yellow, 1962

Oil on canvas
48 x 48 (121.9 x 121.9)
Gift of Seymour H. Knox, 1962

Born in New York, ROY LICHTENSTEIN first studied at the Art Students League with Reginald Marsh in 1939. He later attended Ohio State University, Columbus, from 1940–43 and served in the military during the war years, returning to Ohio State in 1946. After receiving his M.F.A. in 1949, he taught for a year, but in 1951 moved to Cleveland, where he worked as a graphic artist and engineering draftsman. In the same year, he had his first one–artist exhibition at the Carlebach Gallery, New York.

Lichtenstein's early work was generally influenced by European painting, but changed over the decade as he absorbed elements of Abstract Expressionism into his style. Unlike the New York painters of this period, however, he took an interest in such subject matter as "cowboys, Indians, treaty signings, a sort of Official Western art" that foretells his later adoption of the popular imagery of comic books and advertising.

Lichtenstein returned to teaching in 1957. In 1961, he broke through to the hard-edged, flat representational style and sentimental subject matter derived from comic books and advertising. A one–artist exhibition at Leo Castelli gallery, New York, which also showed work by Andy Warhol, Jasper Johns and Claes Oldenburg, brought increased recognition to Lichtenstein and the movement of Pop art.

During the 1970s, Lichtenstein broadened his subject matter to include mirrors, Art Deco, architectural decoration and numerous other subjects typical of mass industrial culture. A series of still–lifes and interiors initiated a long phase, lasting until the present, in which he addressed many of the movements of modern art, including Cubism, Purism, Surrealism and Expressionism.

In the mid–1950s, critics predicted the imminent arrival of a new humanism in art as the natural outgrowth of Abstract Expressionism. Instead, an irreverent wit emerged in the work of Pop artists, so-called because they culled their images—comic book characters, glamour girls, appliances, processed foods and the like—from popular sources. American Pop artists, raised on a plethora of commercial imagery, emphasized the quotidian blandness of the objects they painted. Although based on commercial art techniques, the graphic, emblematic style characteristic of much Pop also paralleled contemporaneous abstract styles such as hard–edge, Color Field painting. Clearly recognizable and rapidly absorbed, Pop imagery precludes the vague connotations of Abstract Expressionism, and allows the artist to concentrate on composing without concern for subjective interpretations.

Roy Lichtenstein, one of the most prominent Pop artists, is widely known for his large renditions of comic strip frames, selected from adventure or romance comics. Although at first glance his paintings appear to be no more than exact enlargements of the original comics, upon closer scrutiny, it becomes apparent that they differ subtly from their sources. Specific portions of an image may be isolated and brought closer to the foreground, and distracting details or words are often eliminated.

Head, Red and Yellow for example, derives from a vacation ad in a newspaper that pictured a girl tossing a beachball. Lichtenstein has disposed of all but the girl's head and has blown it up to an enormous size. Not only has he copied the head, however, but he has applied the paint through a screen to simulate the mechanical printing technique used in the newspaper and has emphasized the heavy outlines and patterned highlights common to commercial illustration. By taking the image out of context and monumentalizing it, Lichtenstein exposes the artificiality and clichéd quality of commercial art. The purpose of the ad and the naturalism used to convey its message are no longer of consequence; only the image itself and the unnaturalistic formal techniques used to create it interest the artist. In effect, the content of Lichtenstein's art is style itself.

H.R.

Ace, 1962

Oil, wood, metal, cardboard on canvas
108 x 240 (274.3 x 609.6)
Gift of Seymour H. Knox, 1964

Born in 1925 in Port Arthur, Texas, ROBERT RAUSCHENBERG studied briefly at the Kansas City Art Institute and the Académie Julian in Paris. Dissatisfied with his inability to break away from the colorful and sensual qualities of pigment, he returned to the United States in 1948 to study under Josef Albers at the avant–garde Black Mountain College in North Carolina. During the next two critical years, he began what was to be a continuing involvement with photography, music and modern dance.

In 1949, Rauschenberg settled in New York, where he studied for a year at the Art Students League. In the early fifties, he designed sets and costumes for the Merce Cunningham Dance Company and worked closely with the composer John Cage and the painter Jasper Johns. During this period, he developed his "combines," bringing together on canvas freely brushed areas and increasingly assertive three–dimensional objects. By the late fifties, Rauschenberg became interested in a number of graphic techniques—rubbing, silkscreen, lithography—that have continued to influence his work to the present.

Rauschenberg established his permanent home and studio on Captiva Island, Florida in 1971; he also maintains a residence in New York. Since that time, he has produced several major series, for example, the "Cardboards," "Jammers," "Spreads," "Scales," "Cloisters," and "Signals." In 1982, after a trip to China, Rauschenberg formulated plans for the *Rauschenberg Overseas Culture Interchange* (R.O.C.I.), a monumental traveling exhibition that would show works he had made in different countries with local craftsmen and artists. In 1985, R.O.C.I. toured in Mexico, Chile, Venezuela, China and Tibet.

Robert Rauschenberg's *Ace*, 1962, is composed of five separate panels originally intended for another work, a sound collage with radio loudspeakers behind the canvas, operated by remote control. Though electronic problems caused the project to be abandoned, the piece retains a high level of complexity. As the artist stated, "5 is the first complicated number; it's not two pairs, three or a couple."

With the exception of the crumpled metal at the center, and a small suspended can, the attached objects were already either entirely flat—the cardboard, paper and umbrella fragment, for example—or perceptually flattened by the bold two–dimensionality of the letters and the arrow. The separation of flat surface and appendage (and the hint of an illusion of depth created by the gradations in value at the far left) is significant in Rauschenberg's later work. Henceforth, the complex texture and rhythm of contemporary life, as well as the sudden shifts in subject and focus, would be conveyed entirely through floating and overlapping silkscreened images or transferred photographs, moving from the particular object to the abstracted picture of it.

E.M.ed.

ANDY WARHOL
American, born 1928

100 Cans, 1962

Oil on canvas
72 x 52 (182.9 x 132.1)
Gift of Seymour H. Knox, 1963

When questioned as to why he chose to paint soup cans, Warhol said, "Because I used to drink it. I used to have the same lunch every day for twenty years, I guess, the same thing over and over again." Between 1962 and 1967, Warhol depicted the cans in every condition: pristine, opened, crushed, individually placed and in stacks, portrayed sketchily or precisely rendered, enlarged to varying degrees, presented in both realistic and fanciful colors, and in different media.

100 Cans, 1962, is one of the last works Warhol painted by hand before he turned to using silkscreen methods. Pencil lines are discernible beneath the thin oil paint; the red is somewhat lighter than in the standard label and the "gold" seal has become a yellow circle. The word "Campbell's" is usually carefully lettered in script while the lettering of the other words varies in preciseness. The fleur–de–lis are often randomly placed and the cans in the painting are almost double actual size. The multiple presentation, interrupted at the lower part of the canvas by partial cans, suggests endless stacks of cans, of which only a small portion is made visible to the viewer.

E.M.ed.

ANDY WARHOL was born Andrew Warhola in 1928 in McKeesport, Pennsylvania. His parents were emigrants from Czechoslovakia, his father a laborer. Warhol attended the Carnegie Institute of Technology, Pittsburgh from 1945–49 and after receiving his B.F.A. moved to New York. He worked as an illustrator for *Glamour* magazine from 1949–50, then had a highly successful career as a free–lance illustrator for the next seven years, during which he worked for I. Miller, Bergdorf Goodman, *Vogue* and Columbia Records among others. Warhol soon began painting images gleaned from advertising and, by 1960, from comic strips. After experimenting with tracings from slide projections, Warhol started in 1962 to use photographic silkscreens to render his mundane images of popular consumer culture—the now–famous Campbell's soup cans, boxes of Brillo, repeated visions of Marilyn Monroe and Troy Donahue that catapulted him to widespread notoriety with the advent of Pop Art. Warhol has since furthered his enigmatic cult persona which, along with overt commercialism, has become an important component of his art. After an attempt on his life in 1968, Warhol curtailed his underground activities and in 1969 started his fashionable magazine, *Andy Warhol's Interview*. He has since painted numerous portraits and series of paintings based on mythic popular heroes and, of late, on historical paintings. Warhol lives and works in New York.

S.K.

Naum Gabo
Russian, 1890–1977

Linear No. 2, Variation, 1962–65

Stainless steel coil on plastic
46 x 16 x 25 (117 x 40.6 x 63.5)
Gift of The Seymour H. Knox Foundation, Inc., 1965

With his brother, Antoine Pevsner, Naum Gabo wrote in the *Realistic Manifesto* of 1920: "The realization of our perceptions of the world in the forms of space and time is the only aim of our pictorial and plastic art." His training in engineering, physics and philosophy likely predisposed Gabo toward an art whose "spiritual expression" drew on contemporary materials, methods of construction and philosophical ideas concerning the continuum of time and space. More "real" to him than a sculptural imitation of a natural object, his elegant creations resulted from an unusual blend of mathematical and intuitive thought.

Linear No. 2, Variation, composed of steel wires stretched over clear plastic planes, demonstrates the concept of time through the visual motion engendered by the curving contours of the planes and the complex interweaving of the wires. Transparent yet luminous, the web–like structure catches the light and seems to describe volumes of space, forever twisting and turning in upon themselves.

Gabo's use of unorthodox materials and his emphasis on space instead of mass represented a revolutionary approach to sculpture in the early 20th century. Although these ideas, shared by a number of his contemporaries, were central to the development of Constructivist art, Gabo refused to accept the political, utilitarian strictures that came to be associated with Russian Constructivism. For him, art remained apolitical, a manifestation of the human spirit.

Linear No. 2, Variation is a variant of *Linear Construction in Space No. 2*, one of Gabo's favorite pieces. Originally derived from a model for a large sculpture commissioned in 1949 (but never executed) for the Esso Building in New York, *Linear Construction in Space No. 2* (The Solomon R. Guggenheim Museum, New York) is made of plexiglass and nylon monofilament.

Gabo repeated it many times in different sizes and materials, some versions standing and others hanging. The version here differs from the original not only in its materials and dimensions but in its structure as well. The starry image in the center of *Linear No. 2, Variation* is entirely unique.

H.R.

Naum Gabo was born Naum Neemia Pevsner in Briansk, Russia, in 1890. In 1910 he went to the University of Munich, where he studied medicine for a year, then transferred to the natural sciences and, in 1912, to engineering studies. Gabo visited his older brother Antoine in Paris, 1913–14; at the outbreak of World War I, he went to Scandinavia with his younger brother Alexei, where he formulated his theoretical theses and created his first constructions, signed with the name Gabo. In 1917 he returned to Russia, and in 1920 he and his brother Antoine published the *Realistic Manifesto*, setting forth the essentials of Constructivism, a new aesthetic in which time and space were redefined and volume and mass were given new values, as were line and color. Static rhythm was replaced by kinetic rhythm, which resulted in Gabo's first motorized constructions in 1920. In 1922 he left Russia and lived until 1932 in Berlin, where he designed sets and costumes for Diaghilev's ballet *La Chatte* in 1926. In 1929 he proposed a *Fête Lumière*, one of the earliest electric–light shows, which was to be in the center of the city, focusing on the Brandenburg Gate. During the Berlin stay, Gabo designed several large–scale monuments that were not realized; his first large construction was completed in 1957 at the Bijenkorf Shopping Center in Rotterdam. In 1932 Gabo went to Paris, where he lived until 1935, and became a member of the Abstraction–Création group. He lived in England, 1935–46, and in 1937 co–edited a book with J.L. Martin and Ben Nicholson, *Circle: International Survey of Constructive Art*. Gabo immigrated to the United States in 1946, becoming a United States citizen in 1952. He lived in Middlebury, Connecticut, until his death in 1977.

E.M.ed.

James Rosenquist
American, born 1933

Nomad, 1963

Oil on canvas, plastic and wood
90 x 141 (228.5 x 358)
Gift of Seymour H. Knox, 1963

This 1963 painting dates from the period when Rosenquist had begun to attach three–dimensional objects to his canvases. In the upper left corner, a plastic bag with drips of pigments that it presumably once contained is suspended directly over a fragile wood–and–metal construction on the floor upon which paint has been dripped and spattered. The unusual collection of commonplace images in the painting is related by repeated design motifs—the x of the Oxydol label, the legs of the ballet dancer, and those of the picnic table and bench; the O of the label and the bulbous forms of meatballs, olives, and a light bulb.

The effect of the painting is that of a composite billboard, providing no central focal point; the eye of the viewer tends to wander over the surface, attracted first to one area and then another, like the nomad of the title.

E.M.ed.

JAMES ROSENQUIST was born in Grand Forks, North Dakota, in 1933. He attended the University of Minnesota, Minneapolis, 1953–55, where he studied painting and art history with Cameron Booth. During this time, he became interested in the Mexican muralists José Orozco and Diego Rivera, whose large–scale works and flattened images were adapted by Rosenquist in his later paintings. In 1955, he won a scholarship to the Art Students League in New York, where he studied until 1958. At the age of nineteen, Rosenquist began working as a commercial painter and he continued to earn a living at this trade in New York, where he painted billboards, later transferring that technique to his own paintings. During the late fifties, he was influenced by Abstract Expressionism, but he soon developed his own version of Pop art in enormous, collage–like paintings in which portions of commonplace objects are depicted, often in distorted size and in unexpected combinations.

Cinema, 1963

Plaster, illuminated plexiglass, metal
118 x 96 x 30 (299.7 x 243.8 x 99)
Gift of Seymour H. Knox,-1964

Born in 1924, GEORGE SEGAL lived in New York until 1940, then moved with his family to South Brunswick, New Jersey, where he currently lives. He studied painting in New York at Cooper Union and at New York University, where he received a B.A. in Art Education in 1949. In 1963, he received an M.F.A. from Rutgers University in New Brunswick. While teaching at Rutgers in the late fifties, he met Allan Kaprow, several of whose early Happenings took place on Segal's chicken farm. Like Kaprow, Segal became aware of the incompatibility between painting and his own concerns for plasticity and a totality of experience. By 1958 he had begun to experiment with life–size sculptured figures of plaster and burlap over chicken–wire armatures, making a complete break with painting in 1961. In 1970, Segal received an honorary Ph.D. from Rutgers. Most recently, he has been casting sculptures in white bronze and has renewed his work in drawing and print-making.

E.M.ed.

George Segal came to artistic maturity in the early 1960s, a turbulent period of transition when artists were striking out in new directions following the denouement of Abstract Expressionism. Although Segal had great respect for the masters of Abstract Expressionism and admired the passionate ideals embodied in their art, he wished to express the inner life of humankind through figuration rather than abstraction. He shared with the Pop artists a desire to reunite art and everyday life after the long banishment of representation from the realm of serious art. A participant in a number of "Happenings" organized by his friend Alan Kaprow, Segal pursued a similar goal of creating a sense of art as an all–encompassing experience by placing plaster casts of people in environments containing "real" props: actual furniture, signs, walls, doors, windows, etc.

Nevertheless, though cast from live models and inhabiting "real" environments, his ghostly white or garishly monochromatic figures are distanced from reality. They appear simultaneously life–like and removed, immediate in their candid poses but timeless in their frozen reverie. His naturalistic, empathetic portrayals of people also differ from Pop renditions of the figure that are based on highly stylized techniques of commercial illustration. Segal's prime interest lies in capturing a posture or gesture revelatory of an aspect of the human psyche that is both individual and universal.

One of his most successful sculptures, *Cinema* reveals the grace and dignity inherent in a simple act, as well as the isolation of existential existence. He has expertly conveyed the impression of a fleeting scene he once witnessed while driving home from New York late one night; as he has recounted, he noticed "...a fellow reaching up to pluck off the last letter from an illuminated sign and it was like seeing an exalted moment. It was like seeing an epiphany.... I remembered...the man's body silhouetted against a wall of emanating light which appeared to dissolve his edges." *Cinema* is the first sculpture in which Segal employed electric light and the only one in which it is such an integral part of the composition.

H.R.

DAVID SMITH
American, 1906–1965

Cubi XVI, 1963

Stainless steel
11′ x 5′ x 33″ (335.3 x 152.4 x 83.8)
Gift of The Seymour H. Knox Foundation, Inc., 1968

DAVID SMITH was born in Decatur, Indiana, in 1906. He studied art by correspondence at the Cleveland Art School, 1923, attended Ohio University, Athens, 1924–25, and studied briefly at Notre Dame University, South Bend, Indiana, in 1925. During the summer of 1925, he worked as a welder and riveter at the Studebaker plant in South Bend. After a brief stay in Washington, D.C., he moved to New York in 1926, where he studied painting at the Art Students League from 1927 to 1932. Although he continued to paint and draw throughout his life, in 1932 Smith turned to sculpture as his dominant interest after he saw reproductions of the welded metal constructions of Picasso and Gonzalez. By 1934, he had rented working space at the Terminal Iron Works in Brooklyn where, using the practical experience gained at the Studebaker plant, he began to make metal constructions. In 1940, he moved his studio to his farm at Bolton Landing, New York.

After two years during World War II (1942–44) of working as a welder making army tanks, he began to develop his symbolic works, employing both easily identifiable images and those which had a personal and private meaning. By around 1952, these relatively small–scale sculptures were replaced by larger and less subjective works, often anthropomorphic, and frequently produced in series. During the early 1960s, Smith began to use stainless steel and reintroduced color in some of his sculptures.

In the remaining years before his death, Smith produced two major series, the celebrated "Cubis" and the polychromed "Zig" sculptures. Smith was killed in an automobile accident near Bennington, Vermont, in 1965.

The twenty–eight monumental sculptures of the "Cubi" series, dated 1961–65, constitute Smith's most important work as a sculptor. In each of the "Cubis," he attempted to solve a separate sculptural problem for which a sequence of works was often required in order to reach a solution, resulting in an extraordinary variety within the series. As a whole, he developed within the group the final versions of ideas he had been exploring for twenty years.

The material Smith chose for the sculptures, stainless steel with the surfaces polished in a pattern, was of primary importance. He wrote, "I like outdoor sculpture, and the most practical thing for outdoor sculpture is stainless steel, and I made them and I polished them in such a way that on a dull day they take on the dull blue, or the color of the sky in the late afternoon sun, the glow, golden like the rays, the colors of nature. And in a particular sense, I have fused atmosphere in a reflective way on the surface. They are colored by the sky and surroundings, the green or blue of water. They reflect the colors. They are designed for outdoors."

In *Cubi XVI* the steel was formed into hollow boxes, square and rectangular and organized into a Cubist frontal plane. The structure embodies the artist's personal reevaluation of the Cubist–Constructivist tradition as a major organizational principle of sculptural parts in space.

E.M.ed.

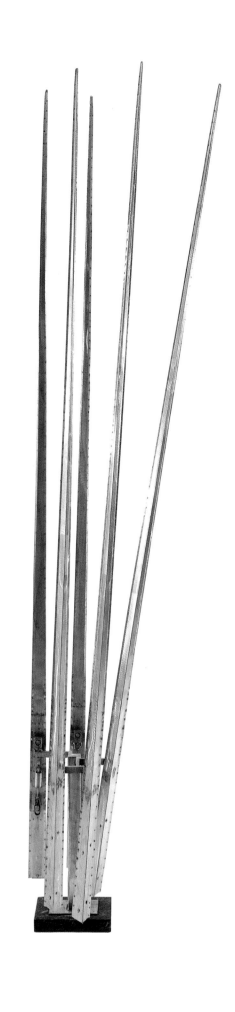

GEORGE RICKEY

American, born 1907

Peristyle: Five Lines, 1963–64

Stainless steel
100 x 10 x 13 (254 x 25.4 x 33)
A. Conger Goodyear Fund, 1965

GEORGE RICKEY was born in South Bend, Indiana, in 1907, but in 1913 moved with his family to Scotland where he attended Trinity College, Glenalmond, 1921–26. He received a B.A. degree in modern history from Balliol·College, Oxford, in 1929 and an M.A. in 1931. He studied also at the Ruskin School of Drawing, Oxford, 1928–29, and with André Lhote and at the Académie Moderne in Paris, 1933–34, and in New York, 1934–37; taught painting at colleges in Michigan, Illinois, and Pennsylvania, 1937–41; and served in the air force, 1942–45.

In addition to his sculpture, Rickey is an eminent critic and writer; he published *Constructivism: Origins and Evolution* in 1967 and is the author of a number of articles on kinetic sculpture. Since 1960, he has lived and worked in East Chatham, New York.

E.M.ed.

George Rickey made his first moving sculpture while he was serving in the air force during World War II. An historian who also studied art history and ultimately devoted himself to sculpture, Rickey at first built upon his knowledge of Constructivism in the development of his own art. His three–dimensional polychromed works of the 1950s often resembled paintings by such modern masters as Paul Klee, Piet Mondrian and El Lissitzky. By the early 1960s, however, he began to eliminate color and pare down his forms, eventually reducing his structures—sometimes suggesting flowers or leafy plants—to spare sculptures composed of basic geometric shapes. One of the most important contributors to the field of kinetic (moving) art since Alexander Calder, he has always differed in approach from Calder: the shapes of the components in Rickey's works tend to have a more mechanical appearance and are of less importance to him than is the behavior of movement itself.

In 1961, he began experimenting with vertical, oscillating blades using heavy, planar elements as counterweights. Soon, however, he eliminated the planar portions and placed the counterweights inside slender, welded–steel casings that tapered, as in *Peristyle: Five Lines*. The wide end of the hollow spears are attached to a fulcrum, which allows them to swing in a wide arc when mobilized by wind. Rickey's extreme simplification of form in these works minimizes the tangible aspect of his sculpture so that the movement of the blades and their interaction with air and light becomes more noticable. He refers to the blades as lines and wrote to the Gallery in 1968: "I was aware of the precedent of a tapered line in engraving and pen strokes. I often thought of my moving lines as a finite, but indeterminate, drawing in space."

Its title referring to a Greek colannade, *Peristyle: Five Lines* originally belonged to a group of six similar pieces which together made up one sculpture. Since they were later sold separately, he executed a second set, with ten–foot lines, for himself and a third for a private collector. A fourth set, with three–foot blades, belongs to the Corcoran Gallery in Washington, D.C.

H.R.

JEAN ARP
French, born Germany, 1887–1966

Figure classique, 1964

Marble
96 x 14 x 16 (243.9 x 35.6 x 40.7)
A. Conger Goodyear Fund, 1965

In the fifties, Jean Arp made two visits to Greece, and classical references appeared subsequently in his titles and his forms, particularly in his renewed interest in the human torso, which is related less to the organic forms of his earlier "concretions" than to the grace and harmony of proportion of the classical models. In 1960 he created a *Sculpture classique* in both bronze and marble, a smaller version of the monumental, over–life *Figure classique* of 1964. In this piece the erect female form has been reduced to gentle curves and rhythms which mark the points of articulation of the human form— shoulders, hips, and knees—with suggestions of the torsion and contraposto of classical figures. In contrast to some of Arp's sculptures which have no base, or a base of contrasting materials, *Figure classique* is one piece with its pedestal, emphasizing its "statue" quality. The sculpture in the Albright–Knox Art Gallery collection is the unique marble version, created after the bronze, of which five casts were made.

E.M.ed.

JEAN ARP was born in 1887 in Strassburg, then in German territory. By the age of fifteen, he had begun writing poetry modeled on that of the German romantic poets. He studied at the School of Applied Art in Strassburg, 1904; at the Weimar Art School, 1905–07; and at the Académie Julian in Paris, 1908. Returning to Switzerland, he settled with his family in Weggis, where he was a co–founder of the Moderne Bund groups, which first exhibited advanced art of the period in 1911. In the same year, he met Wassily Kandinsky, Paul Klee, and other artists in the "Blaue Reiter" group in Munich and exhibited with them in 1912. He went to Paris in 1914, where he knew Max Jacob, Amedeo Modigliani, Picasso and Robert and Sonia Delaunay. After he moved to Zurich in 1915 he met and married Sophie Taeuber, an artist and dancer, with whom he collaborated on collages, fabrics and tapestries until her death in 1943. In 1916–19 Arp was a co–founder and leading activist in the Dada movement in Zurich and participated in the Cabaret Voltaire. By 1925 he became involved with the Surrealists in Paris and took part in their first exhibition in that year. He settled in Meudon, outside Paris, in 1927. In 1932 he was a member of the French "Abstraction–Création" group. In addition to creating reliefs, collages, and paintings, Arp began modeling sculpture "in the round" in 1930–31. His writing has been widely published. Arp lived and worked in Soldino, Switzerland, before his death in Basel in 1966.

232

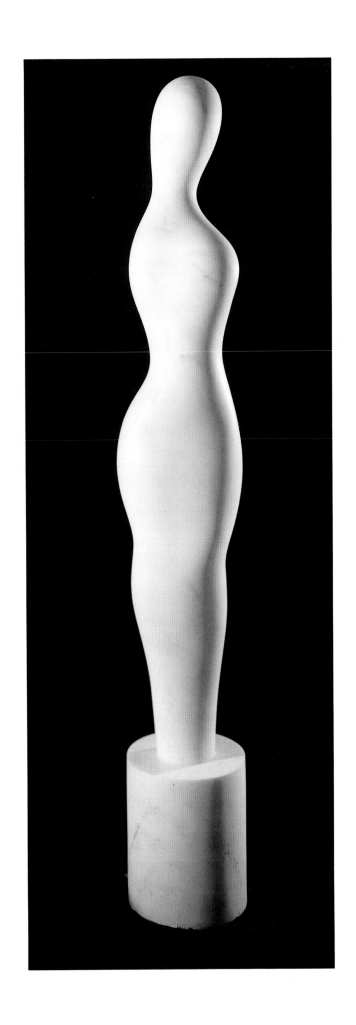

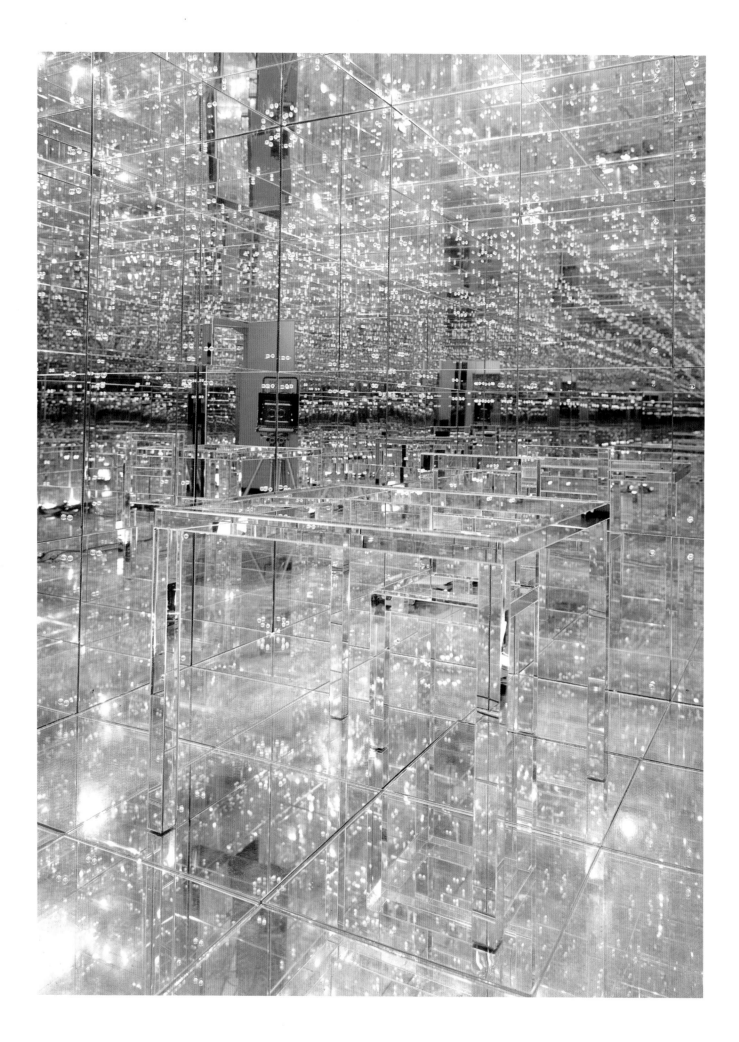

Mirrored Room, 1966

Mirrors on wooden frame
8' x 8' x 10' (243.9 x 243.9 x 304.8)
Gift of Seymour H. Knox, 1966

Born in Kastoria, Macedonia, Greece, LUCAS SAMARAS came to the United States in 1948 when his family settled in West New York, New Jersey. From 1955 to 1959, he attended Rutgers University, New Brunswick, New Jersey, where he met Allan Kaprow, George Segal and Robert Whitman. At that time, he began experimenting with unusual materials such as glass, tin foil and silver paint; this presaged his later use of mirrors, tacks, colored yarn, fake gems and other unorthodox substances in his constructions. Samaras' fascination with colorful, glittering materials and threatening objects reflects his childhood memories of violent, war–torn Greece, jewel-like Byzantine church interiors, and his mother's flamboyant taste.

Between 1959 and 1962, while Samaras studied art history with Meyer Schapiro at Columbia University in New York, he also performed in Happenings at the Reuben Gallery, where he met Claes Oldenburg, Jim Dine and Red Grooms, among others. In 1959 he had his first one–person show at the Reuben Gallery and completed *Pythia*, the first in a series of bizarre, erotic-psychological stories.

Samaras taught briefly at Yale University, New Haven, Connecticut in 1969 and at Brooklyn College, New York from 1971 to 1972. The Whitney Museum of American Art in New York organized a retrospective of his work in 1972. Most recently, he has turned to drawing pastel self–portraits, photographing art–world celebrities in the nude, and making small bronze figurative sculptures.

H.R.

Lucas Samaras' box constructions were of modest dimensions until he recreated his bedroom, *Room No. 1,* in 1964. *Room No. 2,* later retitled *Mirrored Room,* was built in 1966. According to the artist, "The idea for a completely mirror–covered cube room occurred to me around 1963 when I incorporated the idea in a short story, *Killman.* The reason I used a cube rather than any other geometric shape was to minimize the number of planes that would reflect the space enclosed within them but still give a convincing illusion of perpendicular extension in every direction. The mirror room which is in a way a box (I had covered the inside of two boxes with mirror in 1960–61 but had also glued down tacks on the mirror partly to produce a pattern, partly to transform mirror into something else, and I also thought about the possibility of covering a box inside and outside with mirror but didn't do anything about it) is a continuation of the idea of enlargement or gigantism. I was primarily dealing with small carryable works and it wasn't until 1964 when I did the bedroom at the Green Gallery that I entered the territory of largeness. Also, since that bedroom had been a real, autobiographical room, I was searching for an idea to create some other kind of room, an abstract, geometric or theoretical room. As it developed, the *Mirrored Room* was such a thing. I included a table and chair, two important objects that can be found in a room, as a three–dimensional drawing you might say, a skeleton, a sculptural outline. A table and chair for someone to sit down and imagine or think or discover. In terms of my other work, mirror as a surface is related to silver paint and tin foil that I was using in the late 1950s."

The *Mirrored Room* is composed of 24–inch square mirrors, attached to a plywood frame with screws which are covered by glass balls. No interior lighting is incorporated; the single source of light is the open door.

E.M.ed.

KENNETH NOLAND
American, born 1924

Wild Indigo, 1967

Acrylic on canvas
89 x 207 (226 x 527.7)
Charles Clifton Fund, 1972

Wild Indigo, 1967, is an early painting from Noland's initial "horizontal stripe" series which was characterized by attenuated bands of many intense hues, stretching tautly across a canvas of monumental dimensions. The horizontal extension of the bands allows maximum surface contact between colors, resulting in an intense optical quality. This is tempered by Noland's sensitive articulation of twenty–nine different hues, which enables the painting to maintain unity. The "breathing spaces" of raw canvas permit the colors to expand and appear to come forward and suffuse the space between the canvas and the spectator. These paintings determine the distance from which they are most successfully viewed by the relationship of the parts to the whole: in order to distinguish the individual stripes of color, the viewer is drawn close to the painting; to perceive it as a whole, however, one must see it from a considerable distance. The overall patterning of directional lines does not allow the eye to rest, but forces it to constantly scan back and forth over the image. As was the case with many paintings of the sixties, the execution is impersonal and mechanistic, the artist being responsible primarily for the conception of the work and remaining relatively detached from the actual painting process.

E.M.ed.

KENNETH NOLAND was born in 1924 in Asheville, North Carolina. He studied at Black Mountain College, North Carolina, 1946–48, with Ilya Bolotowsky, and with Ossip Zadkine in Paris in 1940. He returned to the United States in 1959 to teach at the Institute of Contemporary Art in Washington, D.C. and at the Washington Workshop Center, where he became friends with Morris Louis. After a visit to the New York studio of Helen Frankenthaler in 1953, Noland and Louis spent weeks working together, attempting to overcome their preconceived assumptions about painting by eliminating recognizable structure, and experimenting with new techniques such as the poured–stain method deriving originally from Jackson Pollock.

In 1957–58 Noland first utilized the center of the canvas as a structuring device. In the resulting paintings, pinwheels and concentric color bands, the depicted forms related to the shape of the canvas through a shared central axis. Such a schematic arrangement, which automatically excluded the possibility of involvement in arbitrary formal decisions (he called them self–canceling structures), freed Noland's use of color. In 1963–64 he developed the chevron motif and by 1967 had reduced the format of his painting to horizontal color stripes, often on canvases of monumental proportions.

Noland moved to New York in 1961. He taught at Bennington College, Vermont, from 1967–68 and has been honored with numerous one–artist exhibitions.

236

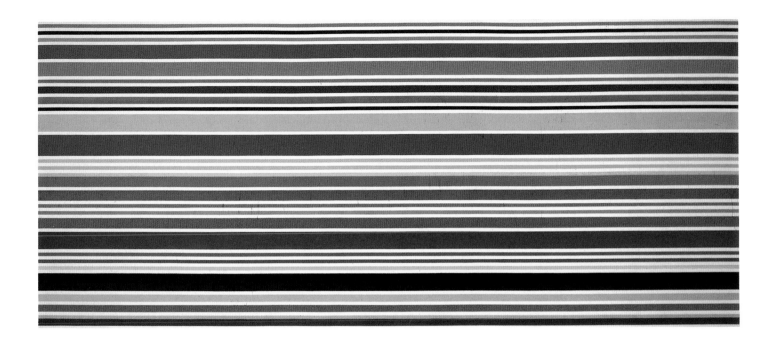

DONALD JUDD

American, born 1928

Untitled, 1969

Galvanized iron and plexiglass
10′ x 27 1/8″ x 24″ (304.8 x 68.9 x 61)
Edmund Hayes Fund, 1972

DONALD JUDD was born in Excelsior Springs, Missouri in 1928 and spent his childhood in the Midwest, Philadelphia and New Jersey. After a year in the army in Korea, he attended the Art Students League in New York, 1947–53, the College of William and Mary, Williamsburg, Virginia, 1948–49, and Columbia University, New York from which he received a B.S. degree in philosophy, 1953, and an M.A. in art history,1962. From 1959 to 1965, his writings in several major art periodicals exercised considerable influence on the direction of both criticism and avant–garde painting and sculpture.

Judd was originally a painter of dark, flat abstractions, but his desire to avoid even the slightest degree of illusionism in his work inevitably led him to sculpture. His first reliefs were exhibited in New York in 1963. His subsequent free–standing boxes and objects constituted a rejection of the additive and assembled approach to sculpture—as practiced by Picasso, Julio Gonzalez, and David Smith—which has characterized much modern sculpture of the twentieth century.

Donald Judd's *Untitled* consists of ten boxes cantilevered from a wall; the identical units are separated by intervals exactly equal to their height of six inches in a predetermined and totally symmetrical scheme. This "stack" configuration has recurred frequently in Judd's work since the mid–sixties, in a variety of different materials, color and dimensions.

Judd has consistently sought to avoid a traditional European hierarchical composition of balanced individual parts in favor of a structure apprehended as a single integrated experience. He said: "I don't like sculpture with a handled look, just as I don't like the evidence of brushwork in painting. All of that implies expressionism, implies that the artist is involved with the work as he goes along. It's a particular attitude that comes out of the European tradition. I want the material to be material when you look at it." Since 1964, his pieces have been manufactured industrially according to his specifications, giving them the meticulous anonymity he favors.

The absence of any visible means of attachment, the exaggerated extent of projection, and the use of translucent orange plexiglass within the galvanized iron bands create an impact far greater than the simple materials would imply.

E.M.ed.

239

FRANK STELLA

American, born 1936

Lac Laronge III, 1969

Polymer paint on canvas
9' x 13½' (274.3 x 411.4)
Gift of Seymour H. Knox, 1970

Born in Malden, Massachusetts, in 1936, FRANK STELLA attended Phillips Academy, Andover, 1950–54, and Princeton University 1954–58, where he majored in history and studied painting under William Seitz and Stephen Greene. After exploring the then–dominant Abstract Expressionist style while at Princeton, Stella moved in 1958 to New York, where he produced a series of "transitional" paintings influenced by Jasper Johns' flags and targets. In the winter of that year, he began the "Black" series, three of which were selected by Dorothy Miller to appear in the *Sixteen Americans* exhibition at the Museum of Modern Art in December 1959.

Stella's approach to pictorial problems has been systematic, rigorously formal, and radically innovative. Early in 1960 he pioneered the shaped canvas with his "Aluminum" series by cutting notches in the canvases to eliminate "leftover spaces" in the design. In 1961 he began his first color series, still continuing, however, with the monochrome canvas. Not until the winter of 1962–63 did he begin to paint multicolored canvases—the "Concentric Squares" and "Mitered Mazes." With the "Irregular Polygons" of 1965, Stella moved away from the self–imposed restriction of stripes to large geometric areas of unbroken color. In 1967, curvilinear designs were introduced for the first time in the monumental "Protractor" series. Stella originally experimented with reliefs in 1970, and has increasingly expanded the three–dimensionality, color and gestural nature of his works. Now usually made of painted honeycomb aluminum, some of his dynamic "paintings" project as much as six feet from the wall. One of the most prolific of contemporary artists, Stella lives and works in New York.

Lac Laronge III, 1969, is part of the "Saskatchewan" series that Frank Stella started in the summer of 1967 in Canada; unable to obtain shaped canvases there, he adapted his "Protractor" series to a rectangular format. It is related to the schema *Gur*, one of the twenty–seven variations planned by Stella for the "Protractor" series, and the internal design is that of the interlaced protractor shapes (as opposed to the rainbow and fan motifs). A significant departure for Stella is the introduction of a figure–ground relationship, absent in earlier "Protractor" paintings where the depicted shape was identified with the shape of the canvas. While the strong color and curvilinear surface patterning induces a powerful kinesthesia, this effect is kept in check by Stella's use of a strict and pervasive geometry.

E.M.ed.

VICTOR VASARELY

Hungarian, born 1908

Vega–Nor, 1969

Oil on canvas
78¾ x 78¾ (200 x 200)
Gift of Seymour H. Knox, 1969

Victor Vasarely, perhaps more than any other artist, encouraged the use of optical phenomena for artistic purposes, a practice that gained great popularity in the 1960s. Op art, as it came to be called, took various forms, with some artists focusing on color images and others on patterning, black and white contrasts or visually complex reliefs and constructions. All ascribed to at least some of the same principles: Op artists employed simple abstract forms—circles, squares, triangles or lines—to avoid distracting references to representation. They generally applied color in flat areas where boundaries were defined with razor–edge precision to cause an optical snap when colors or values of equal intensity abutted. Overall patterns of dots or stripes or strictly symmetrical compositions enhanced the active perceptual effects. Inspired by scientific research in perception and psychology and by contemporary technology, Vasarely and his followers explored the mysterious act of perception that takes place between the retina and the brain. In an era of moving pictures and photo–mechanical reproduction, they sought a visual art that was kinetic, at least in an optical sense, and which could become widely accessible.

Vasarely himself was profoundly dedicated to a populist art. A prolific theorist, he promoted the concept of the artist as the creator not of unique objects, affordable only to the wealthy, but as a "communitarian plastician": one who develops a collective art, produced and distributed with the aid of advanced technology.

Despite or perhaps due to his determination to incorporate scientific methods and findings into his art, Vasarely ultimately found inspiration in nature, claiming, "It is only to the extent to which we have the revelation of discovering an identity between ourselves and the inner structure of the universe that one becomes a creator." Hence, his "Vega" series begun in 1956 relates to constellations. In a letter to the Albright–Knox Art Gallery in 1972, Vasarely wrote:

> "VEGA" is a distant star well–known by everyone This composition expresses the extension, the expansion of the Universe: the extreme of the great infinities of Nature most of my "expanding" compositions have been called "VEGA," but in order to differentiate them—aside from numbering—I add a small word such as: "VEGA–NOR". . . .

H.R.

VICTOR VASARELY was born in Pecs, Hungary, in 1908. He studied medicine for two years before enrolling for a year at the Mühely Academy, a version of the Bauhaus that had been started in Budapest by Alexander Bortnyik. In 1930, he went to Paris where he earned a living for several years as a commercial artist. In 1945, he began to paint in a Surrealist style, turning to abstract art in 1947. Since that time, he has developed an optical art based on a pattern of geometric units, modified by variations in shape and color—works that present, simultaneously, a strong surface design and an impression of images actively moving in space. Vasarely has worked both in brilliant colors and with a palette limited to black and white. His production includes three–dimensional constructions, in addition to paintings and graphics. In recent years, he has confined himself to planning his works, which are then executed by assistants.

A prolific writer as well, Vasarely has had a wide influence on younger artists. He has established several museums and foundations as study centers to promote the integration of all the arts, among them, The Vasarely Center in New York, The Vasarely Foundation in Aix–en–Provence and the Vasarely Museum in the Zichy Castle in Budapest.

E.M.ed.

ANTONI TÀPIES

Spanish, born 1923

Triptych with Footprints, 1970

Mixed media on canvas
57½ x 133½ (146.1 x 339.1)
Gift of Mr. and Mrs. David K. Anderson to The Martha Jackson Collection, 1977

Triptych with Footprints was begun in the weeks following the death of Martha Jackson, a life–long friend of the artist and owner of the gallery that introduced Tàpies' work to America. Upon receiving the telegram announcing her death, Tàpies, profoundly moved, nailed it to the wall of his studio. Later, Tàpies placed the nail in the center panel of *Triptych*. The imprint of a chain in the right hand panel also commemorates Martha Jackson, for it resembles the large beaded necklaces she usually wore.

The subject of *Triptych* is, as Tàpies stated, "the passage of a person" whose traces in the work's sandy ground are signs denoting the passage of time. This sense of passage is also evoked by the mysterious writing—with its legible "-B," in the upper left hand corner—that crosses a line dividing the panel and becomes a stream of checkmarks dwindling into empty space.

In addition to the motif of time, there is another, drawn from a Christian archetype. The nail so prominently displayed in the center panel is an ordinary object with a private association for the artist; but in the context of the triptych, a form belonging to a historical tradition of altar decoration, it recalls the Crucifixion, the scene generally placed in the central panel. The whip–like lacerations of the surface in the right–most panel may allude to the scourging of Christ, although the road to the horizon (also a "t," the artist's monogram) is uncrowded and ends in empty space. Thus, while *Triptych* may have a religious tenor, its imagery is used in such a way that refutes a religious interpretation. Tàpies' painting gains much power through such ambiguities and, by resisting interpretation, defers to what the artist has called "the liberty of the viewer to read."

R.E.

The Catalan painter and sculptor ANTONI TÀPIES was born in Barcelona to a family long involved with the political and cultural life of the city. Tàpies studied law at the University of Barcelona, but abandoned it to become a painter. He attended the Valls Academy, a drawing school, for only two months and his early works in a Surrealist style owe little to any formal training.

In 1948, Tàpies joined with a group of writers and artists to publish *Dau al Set* (Seven–faced dice), a journal concerned with the themes of modernism and Catalan identity. Through the influential collector Joan Prats, Tàpies met Miró, with whom he formed a close and lasting friendship. In 1950, the French government awarded Tàpies a fellowship that allowed him to travel in Europe and exhibit in Paris.

Around 1952, Tàpies began painting works characterized by heavily textured surfaces, scribbled and incised lines and seemingly chance arrangements often evocative of doors, windows and scarred walls. His use of humble materials and his incorporation of everyday objects into the language of painting strongly influenced post–war European art. In 1971 Tàpies published *La Practica de l'art*, a collection of his essays in Catalan. Often considered the most accomplished Spanish painter since Picasso and Miró, Tàpies has also been recognized for his commitment to intellectual freedom during the years of Franco's reign.

ELLSWORTH KELLY
American, born 1923

Chatham #11, Blue/Yellow, 1971

Oil on canvas
90 x 77 (230 x 190)
Gift of Seymour H. Knox, 1972

Chatham #11, Blue/Yellow belongs to a group of fourteen works Kelly painted in 1971 which were exhibited together for the first time at the Albright–Knox Art Gallery in 1972. Painted in brilliant spectral hues and utterly simple in design, the "Chatham" paintings exemplify Kelly's uniquely pragmatic, classicizing style. Each work in the series is composed of two panels, separately painted and joined at right angles. Although the arrangement is not symmetrical, the works possess a balance and stability that seems architectural, like the joining of column and architrave.

Although these forms are abstract and rarely present any identifiable image, they in fact derive from the artist's own experience of colors and shapes noticed in such things as the curve of a hill, the space enclosed by a window frame, or the pattern of light and shadow cast by buildings and objects. The source for the format of the "Chatham" paintings was the profile of the *Winged Victory of Samothrace*, which Kelly knew from his frequent trips to the Louvre during the early 1950s. The famous Greek statue of a tall Victory figure with her wings thrust out, parallel to the ground below, has qualities akin to Kelly's own work, but his transformation of the source is complete. His procedure is to "erase all 'meaning' of the thing seen" in order to allow the formal qualities of a visual discovery to come to the fore. This process is one that Kelly associates with honesty, a quality to be maintained by a strict fidelity to one's perception of those things presented to the senses.

R.E.

Born in Newburgh, New York, ELLSWORTH KELLY studied art at the Pratt Institute, Brooklyn, 1941–42, and at the Boston Museum School, 1946–48. Kelly left for Paris in 1948, and settled there for six years. During the first two years, he attended classes at the Ecole des Beaux–Arts, but the most important influence on his development was his contact with the abstract artists he met; while there, he visited the studios of Arp, Vantongerloo, Taeuber–Arp, Brancusi and others, an experience that confirmed his own predilection for spare and unpretentious abstraction. Particularly important for him were Arp's reliefs, whose influence may be observed in Kelly's paintings of flat biomorphic forms done in the fifties. Although he continued to paint figurative works, by 1949 Kelly had already begun to experiment with pure abstraction in paintings and reliefs.

Kelly returned to New York in 1954 and rented a studio at Coenties Slip. Residing in the same neighborhood were Agnes Martin, Jack Youngerman, a close friend, and Robert Indiana, all artists who shared with Kelly an interest in flat, reductive abstraction at a time when American art was dominated by Abstract Expressionism. In 1959, Kelly began working in sculpture; he also produced the austere outline drawings of plant and fruit that have been an important part of his activity. Although his work developed from his own experience of European abstract art, it was influential during the 1960s when it provided an example to the "Minimalist" artists. In addition to painting and sculpture, Kelly also works extensively in color lithography. In 1970, Kelly moved to Chatham, New York, where he currently lives and works.

JOAN MITCHELL
American, born 1926

Blue Territory, 1972

Oil on canvas
102⅜ x 70⅞ (260 x 180)
Gift of Seymour H. Knox, 1972

In a work such as *Blue Territory*, 1972, Joan Mitchell divided her canvas into rectangular areas of color reminiscent of the work of Hans Hofmann; but, unlike Hofmann's primarily plastic paintings, *Blue Territory* remains essentially a landscape. Displaying mastery of a style originally derived from Abstract Expressionism, Mitchell builds up areas of sumptuous color, some applied in a lustrous impasto, others dissolving in thin veils and drips of pigment. In spite of the richness of her brushwork, the gravitational pull of the drips lends the painting a stable, rather serene air. This painting, one of the "Fields" series of 1971–72, was inspired directly by the French landscape of Vetheuil, where Claude Monet painted in the late 1870s.

E.M.ed.

JOAN MITCHELL attended Smith College in Northampton, Massachusetts from 1942 until 1944, when she transferred to the School of the Art Institute of Chicago in her hometown. During the summers, from 1943 to 1946, she resided in Mexico where she was influenced by Orozco. She received her B.F.A. from the Art Institute in 1947 and was awarded a traveling fellowship which enabled her to visit France, Italy and Spain between 1948 and 1949.

By 1949, Mitchell had begun to move away from her academic training to a freer style inspired by Cézanne, van Gogh and Kandinsky. It was not until 1950, however, when she settled in New York, that she abandoned representation entirely and turned to painting abstractions based on her response to landscape. Gorky's and de Kooning's works were important examples for her at that time, but perhaps most significant was her introduction to the paintings of Kline in 1950. In that year, she also received an M.F.A. from the Art Institute.

Although Mitchell quickly gained recognition and exhibited regularly throughout the fifties, she remained somewhat detached from the mainstream; this independence was more emphatically asserted when she went to France with Canadian-born French painter Jean–Paul Riopelle in 1955 and began dividing her time between Paris and New York. Mitchell obtained a studio on the rue Frémicourt in Paris in 1959, which she retained until 1969 when she moved to Vetheuil, outside of the city. She continues to live and paint there in a house connected to one in which Monet lived from 1878 to 1881.

H.R.

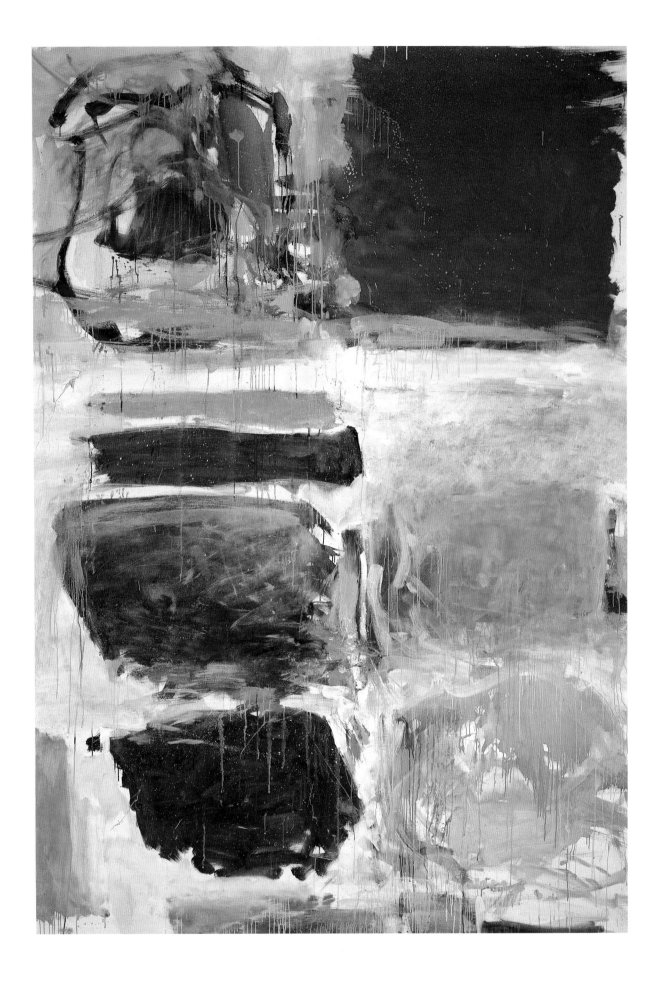

RICHARD DIEBENKORN

American, born 1922

Ocean Park No. 66, 1973

Oil on canvas
93 x 81 (236.2 x 203.2)
Gift of Seymour H. Knox, 1974

Begun in 1967, the "Ocean Park" paintings heralded Richard Diebenkorn's return to abstraction after eleven years of working in a representational mode. This was prompted, in part, by his move from northern California, where he was in close contact with a group of representational painters, to southern California. On his own in new surroundings, he was struck by the different light and color of the Los Angeles area. Titled after the beachfront section of Santa Monica where he lives, these paintings reflect the even, hazy sunshine and languid colors found there. Throughout his career, abstracted elements of the landscape, whether color or form, have appeared in his work, and he once said, "tempermentally, I have always been a landscape painter." Yet it would be a mistake to interpret his work as only abstract landscape, for it represents a response to aesthetic challenges as much as a receptiveness to environment.

Ocean Park No. 66, like the others in the series done during the late sixties and seventies, has a spare, vertical format. The bottom area, as is often the case in these paintings, is expansive and untraversed by lines except for a vertical division near the edge and some horizontal lines, partially or completely brushed over; most of the activity takes place in approximately the top quarter of the painting where diagonal lines occasionally interrupt horizontal bands. The network of lines accentuates the planarity of the canvas and as numerous critics have commented, pentimenti—lines that have been drawn or painted over—contribute a sense of temporality to the work by emphasizing the progression of the creative process. Diebenkorn's relaxed, unconcealed brushwork also enhances one's awareness of duration. Built up in layers, the diaphanous scrim of color effects the impression of amorphous space, which gently plays against the pronounced materiality and linearity of the work.

H.R.

Born in Portland, Oregon, RICHARD DIEBENKORN was raised in the San Francisco area of California. He attended Stanford University in Palo Alto but in 1943 enlisted in the marines and was transferred to the University of California at Berkeley, where he received a B.A. Stationed at the Officer Candidate School in Quantico, Virginia in 1944, he had the opportunity to frequent The Phillips Collection in Washington, D.C. There, he saw the works of Picasso, Braque and Bonnard and was particularly struck by the paintings of Matisse, which were to have an enduring influence on his artistic development. Later that year he went to Hawaii to train as a war artist.

Discharged from the marines in 1945, he returned to California and in 1946 attended the California School of Fine Arts in San Francisco, studying with Elmer Bischoff, David Park and Hassel Smith. From 1950–51 he lived in Albuquerque, and earned an M.F.A. at the University of New Mexico. After accepting a teaching position at the University of Illinois in Champaign–Urbana in 1952, he continued to perfect his distinctive brand of Abstract Expressionism.

In 1953, he began his "Berkeley" series, on which he worked until 1955 when he began painting figuratively, a practice he continued for eleven years. Of prime importance during the period was his trip in 1964 to Leningrad, where he visited the Schuhkin and Hermitage collections. From 1966–73, he was Professor of Art at the University of California at Los Angeles. His "Ocean Park" series, which he began in 1967, continues to occupy his efforts.

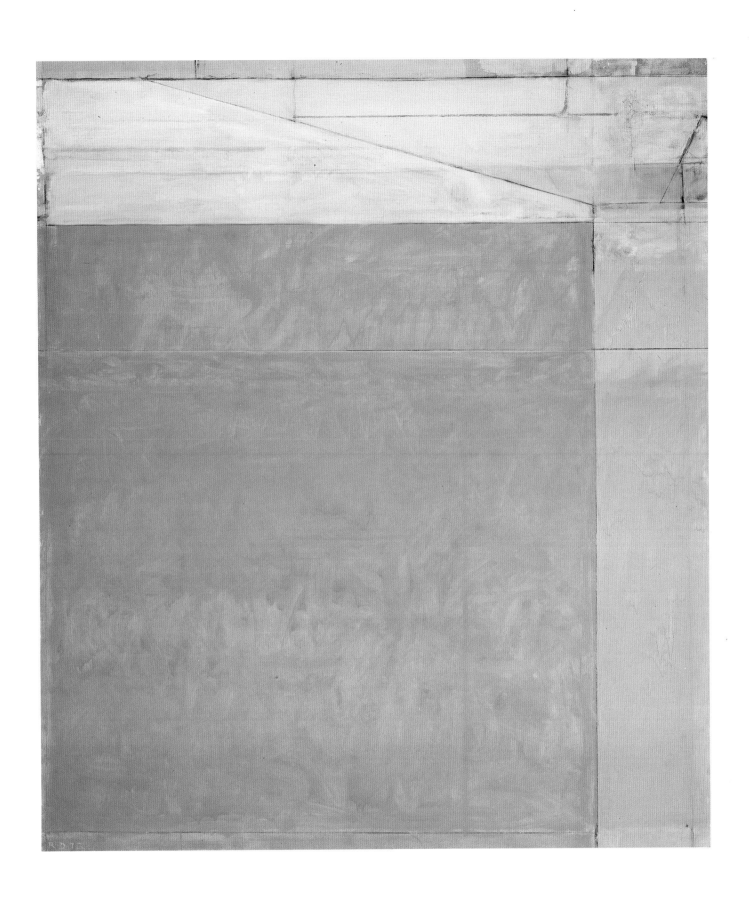

JEAN DUBUFFET
French, 1901–1985

The Loud One (Le Vociférant), 1973

Painted sheet metal
98¾ x 51 x 30½ (251 x 129.5 x 77.5)
Gift of Seymour H. Knox, 1973

Le Vociférant is one of a number of metal sculptures that reproduces a costume Dubuffet designed for the spectacle *Coucou Bazar (Bal de l'Hourloupe)*, his last major project in the "Hourloupe" style. First performed at the Solomon R. Guggenheim Museum, New York, in 1972, *Coucou Bazar* was intended to be unlike any normal theatrical production. In Dubuffet's theater, actors disguised as various fictive personnages were directed to move silently at a nearly imperceptible pace through a fantastic and grotesque "Hourloupe" environment, accompanied by a musical score that alternated loud noises, disordered voices and sudden interruptions of silence. By mingling figures and objects in an indeterminate and continuous field of shapes and lines, Dubuffet aimed to abolish orderly processes of perception and substitute instead a kind of visual cacophony. This state, like the "delirium" advocated by the Surrealists, rests on the inversion of the normal relation between fantasy and reality. Although sculpture, *Le Vociférant* is governed strictly by graphic principles. The various portions of the original costume were devised by drawing on paper stiffened with wire, without any predetermined idea of the work's final appearance, and only later assembled. Furthermore, with its flat space, its frontal orientation and its skeleton of lines, *Le Vociférant* might be paradoxically described not as a sculpture, but as a special kind of free–standing collage.

R.E.

JEAN DUBUFFET was born into a prosperous family of wine merchants in Le Havre, where he first studied art at the Ecole des Beaux–Arts. Twice he gave up painting to enter the wine trade, which he finally abandoned in 1942.

Dubuffet's extensive study of the untutored art of primitive societies, naives, and the insane—for which he coined the collective term *Art brut*—strongly influenced his early, graffiti–like style of painting and his experiments with unorthodox materials such as earth, straw and sand. His 1949 essay, "L'Art brut preféré aux arts culturelles," announced his "anticultural" stance and his antipathy toward the dominant School of Paris. Dubuffet's second exhibition in 1946 at the Galerie René Drouin, Paris, created a public scandal; it was followed in later decades by numerous exhibitions in Europe and the United States.

In 1962, Dubuffet began a new cycle of paintings and sculptures characterized by many small, interlocking shapes with irregular contours. The series culminated in the theatrical spectacle *Coucou Bazar* of 1972, first performed at the Solomon R. Guggenheim Museum, New York. In that same year Dubuffet donated his large collection of *Art brut* to the Musée de l'art brut in Lausanne, Switzerland, which had been established primarily as a repository for that collection. Dubuffet had been occupied as well with a series of large collages titled "Théâtres de Memoire" and "Psychosites." He worked at his studio in Perigny–sur–Yerres, near Paris until his death.

SUSAN ROTHENBERG
American, born 1945

Two–Tone, 1975

Acrylic and tempera on canvas
69 x 113 (175.2 x 287)
Gift of Mr. and Mrs. Armand J. Castellani, 1977

Susan Rothenberg's paintings of horses, made between 1973 and 1979, constitute an imposing and exceptionally coherent contribution to the revival of the image in recent painting. For all its naturalistic connotations, Rothenberg's image—the horse—is conceived in the most essential terms. These could only be arrived at by a certain simplification: a shortening of the neck, a rounding out of the head, a cropping of the ears, and a general reduction of the body to its outlines. The line formed down the center of the painting, where the two areas of color meet, is a structural device which Rothenberg used in the first painting of the series and which serves several functions. First, it breaks the image in half and in doing so prevents the illusionistic reading of the horse's form. It also introduces an explicit symmetry into the work by marking the point of balance between two differently shaped halves. Finally, the division of the painting into two equal halves carries with it the implicit strength and simplicity of abstract design.

Of the artists who sought to reconcile a new interest in imagery with the vocabulary of abstraction, Rothenberg has been particularly admired for the sense of authenticity her paintings communicate. Her works, in fact, project an almost palpable sense of the difficulty of the task, as if form could be wrestled from painting only by great effort. As in a heavily worked drawing, the contours seem to have been drawn slowly and thoughtfully, with many revisions; moreover, in their tenuousness, they set up a tension between the form and the surrounding space.

R.E.

Born in Buffalo, SUSAN ROTHENBERG attended Cornell University, Ithaca, New York from 1962–65 and from 1966–67, with a year of travel to Greece in between. After a brief period of graduate study at the Corcoran Museum School, in Washington, D.C. she again went abroad, traveling in Europe and Israel. After her return, she settled in New York. Originally trained as a sculptor, Rothenberg at first worked on process pieces consisting of arrangements of wire and plastics reminiscent of the work of Eva Hesse. Gradually, she turned to using canvas, and eventually turned to painting. Her early abstract paintings of geometric patterns were superseded, around 1973, by her first representational ones, in which she used the image of a horse. This initiated a long series of paintings with that image, on which she worked through 1979.

Rothenberg currently lives and works in New York and Long Island.

254

Acrylic on canvas
96¼ x 143⅞ (244.4 x 364.4)
Gift of Seymour H. Knox, 1982

Born in Brooklyn, New York, AL HELD studied at the Art Students League in New York. In 1950, he went to Paris under the G.I. Bill to study at the Académie de la Grande Chaumière. There he became part of an American expatriate community that included, among others, Ellsworth Kelly, Sam Francis, Kenneth Noland and Jules Olitski.

During the 1950s, Held painted thickly encrusted canvases in an Abstract Expressionist mode, but by the early 1960s had turned to painting large, flat letters and geometric shapes in a hard–edge, Minimal style. Held's work in this vein reached its peak between 1966 and 1967. Although he subsequently eliminated color from his paintings, he introduced more complex compositional devices such as multiple points of perspective and overlapping forms, which created a spatial disequilibrium. In 1978, he resumed the use of color and thus added yet another element to confound the eye, as the optical effects of advancing and receding hues contradict the apparent linear perspectives.

Held has influenced a generation of young artists during his tenure as a professor at Yale University in New Haven since 1962. He received the Logan Medal from the Art Institute of Chicago in 1964 and a John Simon Guggenheim Foundation Fellowship in 1966. The Whitney Museum of American Art in New York gave Held a retrospective in 1974.

No earthly environment ever resembled the world of Al Held's *Piero's Piazza* yet an observer might well feel it almost possible to step into the vista that seems to stretch forth within this monumental canvas. Held goes through a painstaking process to create this trompe l'oeil effect. He begins by making marks on a large canvas and proceeds to compose intuitively; with the help of assistants he continually "reshuffles" the imagery until he is satisfied with the results. After further adjustment of the color and scale, the clarified composition is copied exactly onto the final canvas. Colors and shapes may go through some additional changes until the whole "gets terribly clear," and the surface is sanded. One can assess the extent of Held's perfectionism from the extensive color notations left on the tape lining the sides of the canvas. Finally, he completes each painting by trimming every line with a razor blade.

Piero's Piazza was painted following Held's residency at the American Academy in Rome in 1982. A "poetic allusion" to the great fifteenth–century artist Piero della Francesca, the title places Held's painting at the summit of a long history of perspectival experimentation. Piero was one of the original leaders in the refinement of single point perspective. His paintings of ideally–proportioned figures and the lucid, geometric plan of the architecture that often surrounds them bear the stamp of a mind for whom space is intimately linked to its mathematical definition. Held's paintings are far removed from those of Piero, but they continue in the same tradition of calculating a mathematically conceived, ideal space.

H.R.

BRYAN HUNT
American, born 1947

Charioteer, 1982

Bronze
Sculpture 112 x 61 x 45 (284.5 x 154.9 x 114.3)
Limestone base 9 x 56 x 40 (22.9 x 142.2 x 101.6)
George B. and Jenny R. Mathews Fund, 1984

Reference to figure and landscape, solid and liquid, positive space and negative space converge in Bryan Hunt's towering bronze *Charioteer*. Over nine feet tall, this monumental sculpture flairs, twists and arches backward like a headless Nike. From one "shoulder," a slender extension or "arm" of bronze stretches toward the viewer, bends and drops to the base. Interpreted differently, the fluid curves of the sculpture seem to succumb gracefully to the forces of gravity in a manner reminiscent of falling water, a recurrent image in Hunt's work. The space defined by *Charioteer*'s forms can be imagined as invisible cliffs over which the bronze cataracts cascade thereby reversing the usual relationship of positive and negative space. Even the mottled green patina can be read variously as a color of nature—of water reflecting the forest vegetation—or as the color of a bronze sculpture weathered by age.

Two of Hunt's major interests are the reexamination and adaptation of forms used in classical Greek architecture and sculpture, and the exploration of the relationship between figure and landscape. Inspired by the famous 5th century B.C. sculpture of the same name, *Charioteer* shares the dominating presence and imposing columnar stance of its venerable precursor; while Hunt's *Charioteer* is more animated in bearing and treatment, its agitated surface recalls the undulating folds of drapery clothing the representational figure. Another factor that attracted Hunt to the original *Charioteer* was the precarious balance of the figure's solid, draped body resting upon delicate feet and ankles. Since working at the Kennedy Space Center, Hunt has been concerned with creating an awareness of gravity, in part by defying it, as he does in his "airships" and in the unsupported liquid forms of *Charioteer*.

H.R.

BRYAN HUNT was born in 1947 in Terre Haute, Indiana, and moved with his family to Tampa, Florida in 1957. In 1967, he enrolled in architecture and engineering drawing courses at the University of South Florida, Tampa and began working at the Kennedy Space Center, where he held a variety of jobs through 1969. His fascination with space exploration later materialized in the hull–shaped wood and silk–paper "airships" that he began constructing in the early seventies. Although Hunt was originally influenced by the Minimalist emphasis on formal reduction, his references to Minimal construction became increasingly oblique, as in his cast bronze lakes and quarries that Hunt considers a challenge to the severity of Carl Andre's planar grid sculptures.

Between 1967 and 1968, Hunt traveled extensively in the United States and Europe. During these trips, he found inspiration in such diverse sources as the waterfalls in Yosemite National Park and the Parthenon in Greece. Another visit to Europe in 1970 and a tour around the world in 1980 likewise affected the form and content of his art.

Hunt attended Otis Art Institute of Los Angeles County from 1969 to 1971, when he received a B.F.A. In 1972 he participated in the Whitney Museum of American Art Independent Study Program in New York. His first one–artist exhibition took place in 1974 at the Clocktower Institute for Art and Urban Resources, New York. Hunt has lived and worked in New York since 1976.

FRANCESCO CLEMENTE
Italian, born 1952

Son, 1984

Oil on linen
112⅛ x 91⅛ (284.7 x 231.4)
George B. and Jenny R. Mathews Fund, 1985

Son is one of a number of recent paintings of 1983–85 by Francesco Clemente which have abraded, "aged" surfaces rendered in a dark chiaroscuro of blacks and greens, and the appearance of nocturnal apparitions. In many of these works, Clemente's imagery is unusually concise and naturalistic, imbued with a ritualistic sense of drama. Viewpoints and scale are often unexpected or skewed, as in *Son*, where there is no reference point of a horizon line; the vantage as reflected seems totally psychological, or psychic, a mirror only of the mind's eye.

In *Son*, the iconic tree, with its strange mystical orbs, seems both a beatific and melancholic vision. Its title plays on the instinctual reading of a yellow globe in a landscape as a sun, thus here connoting a mythic image of cosmic scale. Combined with the tree—an age-old symbol of fertility in the East and the West—the title also incites the notion of procreation and associations with sexual organs, as they are the illumination in this desolate, perhaps barren landscape. The tree may also be seen as a surrogate self–portrait.

The cross–cultural iconography of the tree, an image with its roots in earth and reaches in heaven, is manifold—seen as the Tree of Life, Creativity, Knowledge, Good and Evil, or Death. Jungian psychology has interpreted the tree as symbolic of sexual duality, a recurrent theme in Clemente's oeuvre, for in Latin the names of trees have masculine endings yet are feminine in gender. The celestial Tree of Life typically bears signs of the Zodiac, suns or moons, as also found in the symbolism of alchemy, in which Clemente has long been interested; in India, a triple tree holding three suns is a specific image of the Trimurti.

S.K.

FRANCESCO CLEMENTE was born in Naples, Italy in 1952. As a child, he traveled and visited museums extensively, and had a strong classical education; he also composed poetry at a young age and started to paint at the age of eight, encouraged by his family. He had no formal training as an artist but studied architecture briefly at the University of Rome. In the early seventies, Clemente began to make the plethora of drawings that have since provided the foundation of his enigmatic, often erotic, iconography. Clemente has worked in a wide variety of media, including frescoes (initiated in 1980), watercolor, mosaic, books, miniatures, sculpture and installation and since 1980, has divided his time between Rome, Madras and New York, where he established a studio in 1982.

ACKNOWLEDGEMENTS

A project such as this requires the cooperative efforts and support of numerous staff members and colleagues.

First and foremost, I wish to express my deepest gratitude to Karen Lee Spaulding, the Gallery's Editor for Special Projects, for her fine editing and supervision of this book's production; she has made an enormous contribution to this publication with her fastidious and insightful handling of every aspect of this project.

The entries contained herein were all written by former or present staff members: Robert Evren, Katy Kline, Charlotta Kotik, Susan Krane, Ethel Moore, Steven Nash, Helen Raye and Emese Wood. We thank them for their informative texts and for their cooperation in the compilation of this book. Bette Blum, Administrator, Director's Office, handled in her usual efficient manner all administrative details. Judith Joyce, Assistant Editor-Registrar, expertly coordinated the myriad details involved in the photography of works of art; she was aided in her task by John Kushner, Building Superintendent and Gallery Installers Dave Maille and Zbynek Jonak. Biff Henrich, an artist in his own right as well as photographer, took with great care and expertise almost all the plates in this book. Marge Greenfield, Secretary/Administrative Office and Ida Koch, former Secretary to the Director aided in the preparation of the manuscript with skill and good cheer.

The realization of *125 Masterpieces* would not have been possible without Leta K. Stathacos, formerly Coordinator of Marketing Services at the Gallery. At Rizzoli, we are grateful to William Dworkin, Director of Sales and Lauren Shakely, Senior Editor, Art, for their perseverence and commitment throughout the inception and production of the book. Alex and Caroline Castro of Hollowpress in Baltimore designed this book with great sensitivity and style.

Finally, this project would not have been possible without the generous support of the Seymour H. Knox Foundation. To both Mr. Knox and the Foundation we extend our deepest thanks.

D.G.S.

Entries in complete form can be found in the following catalogues

P *Contemporary Art 1942–72: Collection of the Albright–Knox Art Gallery.* New York: Praeger Publishers, 1973.
R *Albright–Knox Art Gallery: Painting and Sculpture from Antiquity to 1942.* New York: Rizzoli International Publications, 1979.
H *Albright–Knox Art Gallery: Recent Acquisitions.* New York: Hudson Hills Press, 1987.

PHOTOGRAPHIC CREDITS

© Patricia Layman Bazelon, Buffalo, New York: Pages 6, 8 top

© Esto Ezra Stoller: Title page

Greenberg-May, Buffalo, New York: Pages 7, 9, 10

Biff Henrich, Buffalo, New York: Pages 8 bottom, 17, 19, 20, 23, 25, 29, 30, 33, 35, 38, 43, 49, 51, 53, 61, 65, 67, 69, 71, 73, 76, 80, 83, 85, 87, 89, 91, 92, 95, 99, 101, 102, 105, 106, 113, 117, 119, 125, 127, 129, 131, 133, 134, 136, 141, 143, 147, 150, 161, 163, 164, 168, 171, 175, 177, 179, 180, 183, 185, 189, 193, 194, 197, 199, 203, 205, 207, 208, 216, 218, 221, 223, 226, 228, 230, 233, 237, 238, 243, 245, 247, 251, 253, 255, 256, 258, 260

Peter T. Muscato: Pages 27, 54, 109, 149, 167, 191

National Gallery of Art, Photographic Services, Washington, D.C.: Page 36

PhotoTech, Buffalo, New York: Pages 59, 173

Runco Photo Studios Inc., Buffalo, New York: Pages 62, 159, 187, 201, 225, 249

Malcolm Varon, New York: Pages 111, 144, 240